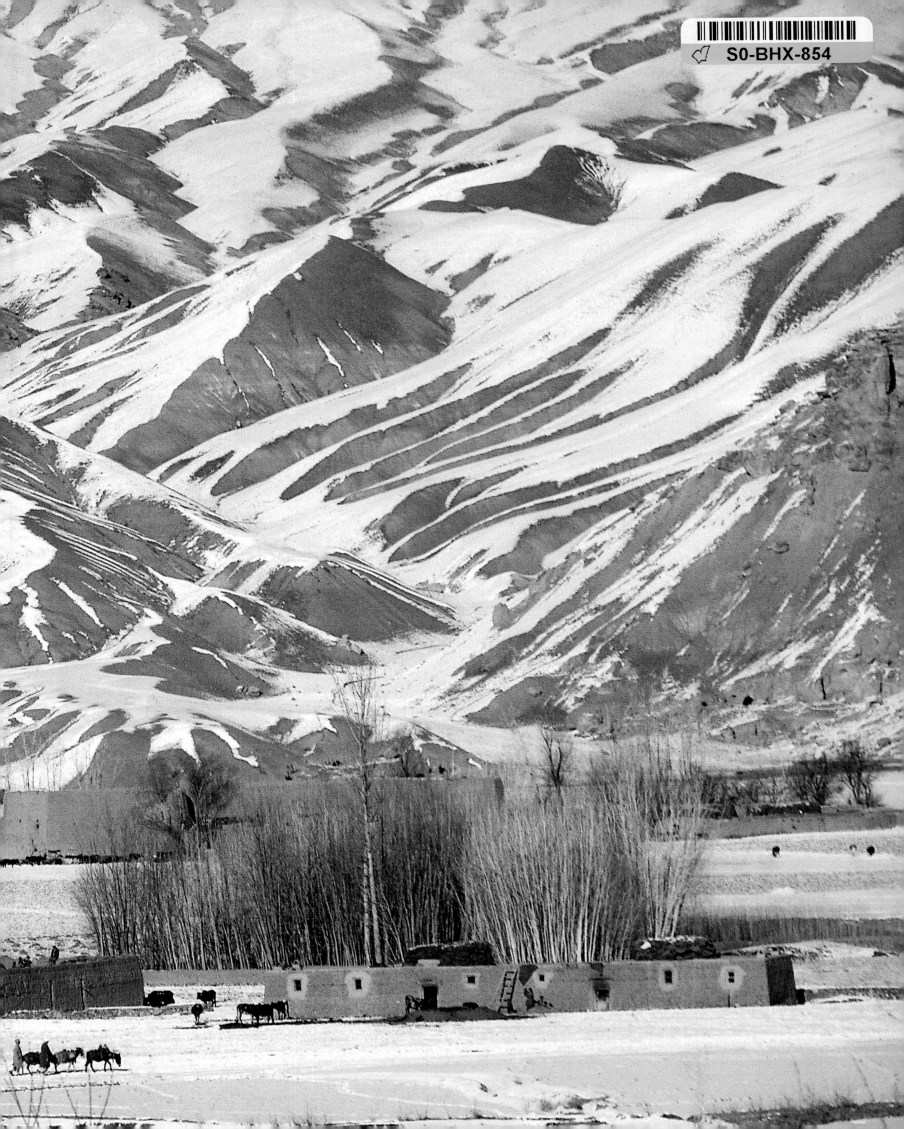

AFGHANISTAN

To the Afghan people who opened "the eye of the heart" for us.

AFGHANISTAN

Roland and Sabrina Michaud

Introduction by André Velter

Harry N. Abrams, Inc., Publishers

THE MIRROR AND THE TALISMAN

What gives a name its magic? How can a string of syllables suddenly take on such powers of attraction? We only need to pronounce the words "Guadalquivir," "Timbuktu," "Ecbatana," or "Ispahan," and already a dream unfolds, an imaginary journey that soon enough leads to very real travels, even to lasting passions. For many travelers, adventurers, scholars, poets, and truth seekers, Afghanistan was such a place.

However vague, the location of the country of the Afghan people was never completely mistaken. We just thought "Central Asia" and were soon near the kingdom on a stretch of the silk route, beyond the border of Iran, south of Bukhara, Samarkand, and Tashkent, north of Pakistan.…The most romantic envisioned direct access to Tibet, which did nothing to temper their wanderlust.

In fact, this vast corner of the world, where no shores were washed by ocean or sea, was a combination of contradictory attractions, giving rise to apparently irreconcilable approaches. Travelers headed toward this faraway country with the twofold sentiments of reaching a refuge and affronting a danger, expanding the scope of their freedom and discovering prohibitions everywhere, entering into the starkest light and moving alongside bloody crimes, being both welcomed and scorned, guests and infidels.

Strange fascination fed equally by harmony and fear. Strange fervor that celebrated the dignity of men, their endurance, their undaunted courage, and did not linger a moment in the cruel shadows where the women suffocated. It was as if Afghanistan, rampart and breach, fortress and crumbling ruin, were a lock open to all winds.

From the outset, the frontier post of *Islam Qala*, the Fortress of Islam, proclaimed that there was no need of walls, ditches, or protective spikes, and that the dust as far as the eye could see was defense enough. The arrogance of the name proved to be a clairvoyant intuition in the face of the immense *nothingness* stretching in all directions. The absence of a visible fortress encouraged the procurement of the most impregnable citadel, the one you built within yourself and carried with you.

But such an entry—so harsh, severe, and vertiginous—was followed in a few hours by an oasis that was all softness, refinement, and balance. Khorāsān unveiled its jewel, its pearl, its marvel: Herāt. From far away, we could see this verdant hollow that refreshed our eyes long before we reached its shade.

The first wheat fields were the color of straw; they formed a still arid wreath, dotted with low houses, pigeon lofts, and mud walls. From other circles, growing ever

smaller, brilliant leaves of mulberry, plane, and poplar trees suddenly appeared, leading the way to the radiant center where the bulbs of the great mosque stood. Incomparable violent turquoise light bonded with the sky as if born of an alchemy of emerald and azure, as though offering the most dazzling mirror to the hidden presence of God.

Walking through the town, the splendor first glimpsed revealed its wounds, yet without effacing any of the anticipated charm. Of course, the huge castle, where the learned rulers surrounded themselves with poets, calligraphers, painters, and musicians, was nothing more than a rostrum of unfired bricks, impressive because of its size and the parapet walk punctuated by crumbling towers that now only protected a maze of inner courts, galleries, and filthy rooms. Of course, the moats were used as trash dumps and the Musalla, the religious university, whose buildings, mosques, and tombs were once covered with sublime faience decorations, was dynamited in 1885 following a tyrannical and stupid order. Now the only witnesses to its past splendor were the remains of six minarets still standing and the crumbling dome that housed the sepulture of the Sultana Gauhar Shad, who founded the place in 1417.

And the litany continued, detailing one by one the assaults that the city endured throughout the ages or showing the ravages of recent and often grotesque mutations perpetuated in the name of progress. Though no longer the capital of an autonomous empire, no longer the crossroads of caravans linking Samarkand to India, no longer the favored residence of artists and mystics, Herāt remained a haven.

Time was lighter here than anywhere else in Afghanistan. The tragic and horrifying hours of History were erased as though by magic through the somewhat nostalgic memory of a brilliant past, when the intoxication of being, thinking, and living naturally transcended other intoxications that no one dreamed of banishing.

What survived, what created this inexplicable enchantment was bound by a few winged words, some intense calligraphy, a few miniatures painted with the tip of a brush made of a single squirrel hair. The words Ansari, Jāmā, and Bannai, the skittish, barely visible traces of Behzūd, haunted our days and nights more forcefully than the destruction and carnage carried out by Genghis Khan and Tamerlane. The pyramids of skulls piled up on the site of the city wiped out by relentless fury—aimed at a "final solution"—did not in the end condemn to forgetfulness he who foretold that *one dawn was enough for the sun to illuminate the world.*

Herāt, pillaged several times, razed, and given back to the desert, guarded this subtle, immaterial, yet always perceptible heritage. In the evening near Ansari's tomb, when a chant floated in the air, it was the destructive times that fell apart, and everyone could, for an instant, partake of an uplifting destiny, liberated from all ties and infinitely free.

Such an experience was a saving grace, perhaps the most necessary before moving on, before leaving an oasis that was not easy to leave. A spell was cast that made homebodies of the restless, even those most weary of a sedentary life. At the threshold of all roads, all pathways, Herāt strangely held you in its embrace—as you would imagine an enamored princess holding back, through smiles, seductions, and tears, the knight, the minstrel, or the bard who wanted to leave her palace and set out on adventures.

Very quickly, heading north toward Qala Nau, Maimāna, and Mazār-i-Sharīf, east in the direction of Chaghcharān and Bāmiān, and south to Shāndand and Lashkar Gah, the bond was broken. It was not only a matter of landscapes, fine sand dunes, jagged rocks, and briar-filled canyons, it was a changing of worlds, cultures, and civilizations. We were turning our backs on Persia to enter open country.

At the first nomad camp, we understood that before appreciating the welcoming company of men, we had to keep several hounds with clipped ears at bay. We had to learn how to brandish a heavy club, to master our fear. The beasts, baring their teeth, knew how to gauge the weakness and the anguish of the visitor quite accurately. Acting just as aggressive was not a bad reflex. It was actually the best thing to do, and, in all situations, we learned to adapt by relying on our instincts, without, at any price, behaving like a lost friend of man.

Relationships were all the more real, since truth had a taste of gunflint and the least trifle could bring about a settling of scores. Honor was the cardinal virtue for better or worse. For the respect of life and death, for vows exchanged, help given, hospitality accorded, but also to perpetuate long-standing vendettas, absurd vengeance following a wink too exaggerated or a flower offered with insolence.

Customs and mentalities differed from one region to another, between towns, ethnic origins, and social classes. A Pashtun shepherd did not behave like a Turkoman caravaneer; a Hazara porter had nothing in common with an Uzbek beggar; a Nuristani smuggler did not follow the same code as a Baluchi trafficker; a Kirghiz chief did not give orders in the same way as a Tajik governor. The education and practices of the Kabul aristocracy did not please the rulers of Ghazni and Kandahār. The Socratic bent of the well-off merchants of the bazaars scandalized the nomads. Even the prayer that everyone recited up to five times a day under rigorously identical terms was directed to a God who, though one and the same, had different faces.

In spite of all these singularities, oppositions, resentments, and conflicts, declared or hidden, there was also a feeling of common belonging. To be Afghan was part of a combat identity that suddenly took on meaning when the time arose to fight against an invader or an occupying army. Internal quarrels were never resolved but put to rest until the intruder was driven out.

Afterwards, the tribes and clans resumed their never-ending discussions, disputes, extortions, and other demonstrations of power, as if the war—whether holy or not—were just an intermission in the ongoing match being played out for centuries between the Persians of Central Asia, the Indo-European mountain people, Mongolian survivors, and a few Turko-Tartar peoples on a territory as large as France, Switzerland, and Benelux put together.

Tajiks, Pashtuns, Hazaras, Uzbeks, and Turkomans fought over rather than shared the fertile valleys, the best high-altitude pastures, springs, and water holes—the rare enclaves where mountains and desert offered hospitality to men. The roughly outlined spheres of influence were never definitely defined. To its inhabitants, Afghanistan did not appear to be a country of established order or a safe kingdom. Existence here was harsh and precarious. It required both fierce defense and unnecessary risk.

The daily labor of peasants, shepherds, caravaneers, and artisans was exhausting, repetitive, subject to a strong network of social prescriptions and all types of constraints. Yet the countryside, the high mountain pastures and caravansaries did not, at first glance, suggest heavy oppression or forced labor any more than did the bazaars. The harmony found here and there—on a threshing floor on a day of harvest, in the trail of a herd of sheep climbing a pass, or in the pandemonium of a forge—seemed so natural that it was necessary to tear yourself from the spellbinding grip to acknowledge that here there must be a secret to unravel or a mystery to unlock.

The passing of time, the precision of gestures, the grace of attitudes, the intensity of looks exchanged, the calm or the gusto—everything convinced the observer of the return to a legendary age when each individual and each thing joyously found its proper place in an unchanging order. Without being naive or too influenced by fantasies of oriental tales, the visitor, nevertheless, had the impression of being confronted by a forgotten reality, to the point of suddenly becoming the spectator of an ancient art of living and dying.

It was like glancing up from a very rich medieval book of hours and becoming aware that the images were real, actually there to be looked upon. Images of a caravan of Bactrian camels heading out in the morning on the route of Marco Polo, a turbaned crowd passionately watching the combat of two red-beaked partridges, an old man riding on his donkey under flowering apricot trees, carriages stirring up a trail of white dust on the edge of the desert, a potter whose earthen hands were just like the walls of his mud house, or a watchmaker repairing watches though his day was regulated only by the sun's path across the sky.

Why did such serene, even joyful visions suddenly make your heart jump? Why did nostalgia for this world impose itself when we were contemplating its activities, games, creations, and rituals? Why did it all seem doomed?

And in the name of what? Such questions could not go unasked on Afghan soil. You only needed to walk on top of the half-crumbled ramparts of Balkh to physically feel this unrelenting wind that, century after century, has dispersed empires, civilizations, and beliefs.

It was here that Alexander married Roxana and found fresh horses for his calvary. The city, one of the most populated in the known world, was called Bactria. The eye now passed like a breeze across the enclosure walls that Tamerlane had cut through in some places. So as not to be overcome by melancholy, we decided to take the road to Tashkurghān, which in itself was a fabulous defiance of the laws of impermanence.

The city, removed from the traffic that connected Mazār-i-Sharīf to Kabul, was cast aside, left to itself, and here time was suspended. At the horizon, the snow-covered Hindu Kush, surrounding it, a belt of orchards enclosed by walls of dried mud. In the center, Afghanistan's most beautiful bazaar, with its roof connecting the earthen domes but letting a powdery soft light filter through, spreading fine rays above the footpaths and stalls. Near the river, teahouses and kebab merchants; and everywhere, dromedaries, horses, donkeys coming out of the caravansary or taking refuge there again just before nightfall.

Tashkurghān was an intact relic, a living legend. The seasons here had a taste of eternity, a flavor that was indescribable and no doubt too tenuous to turn back, distract, or counter indefinitely the course of History and its procession of odious crimes. Tashkurghān is no more. The present irrupted during the Soviet occupation under the modern form of total destruction. Since then, it seems that all of Afghanistan mourns its soul and has sunk into despair.

In disaster as in the absence of disaster, remain the same, a Sufi master advised. The precept was addressed to a disciple. How could it be taken in and implemented by a martyred country, even if this country has always had a mystic thread and was often able to rise again? Maybe it was based on memory, a spirit found again through images and stories, a luminous rebound that resembled hope and had the power of revelation.

To evoke, like a dervish distributing with open hands riches that do not belong to him, a horseback ride through Badakhshān, treks across Nuristan to the "Old Madman's Pass," nights teeming with an abundance of stars toward Lashkar Gah, the sun and the gusts of wind in the maze of the Red City, the orange trees blossoming in winter in Jalālābād, a nap in a rope bed under the mulberry trees of Panshir, millstones turning wheat into flour in the great silence of the Valley of Light, the songs of Charif-e-Shiberghani in the streets of Mazār, the sudden appearance of the lakes of Band-i-Amir on the horizon and the space struck by beauty, the kite with a broken string that disappeared into the sky of Kundūz....

Then to offer visions that were not mirages but reflections of light glowing from faces, gestures, silhouettes, deserts, mountains, villages, and even from the dust of footpaths and objects. To find again in each image its almost miraculous magnetic charge and its pure power to reveal.

Henceforth, one of Afghanistan's rare treasures are the photographs that Roland and Sabrina Michaud have taken through the decades from Seistan to Pamir, Turkistan to Hazarajat; along the banks of the Hilmand and the Amu Darya rivers, from Andkhüi to Kamdesh. As if nothing escaped them, as though they were always there, intuitively and patiently waiting at the appointed hour, when the dawn was crystalline and the twilight welcoming, or when snow had just fallen at the feet of two traveling dancers.

Their work represents both the lost mirror and the potential talisman of a kingdom in need of renaissance: an inexhaustible reserve of beauty and meaning. The universe it reveals is ideal, exempt from endless ravages and murders, part of a design that always exalts, ennobles, and magnifies. The voyages of Roland and Sabrina Michaud on the tracks of Afghanistan do not only lead to Faizābād, Zaranj, or Kabul; they open onto pathways no longer subject to space and time.

André Velter

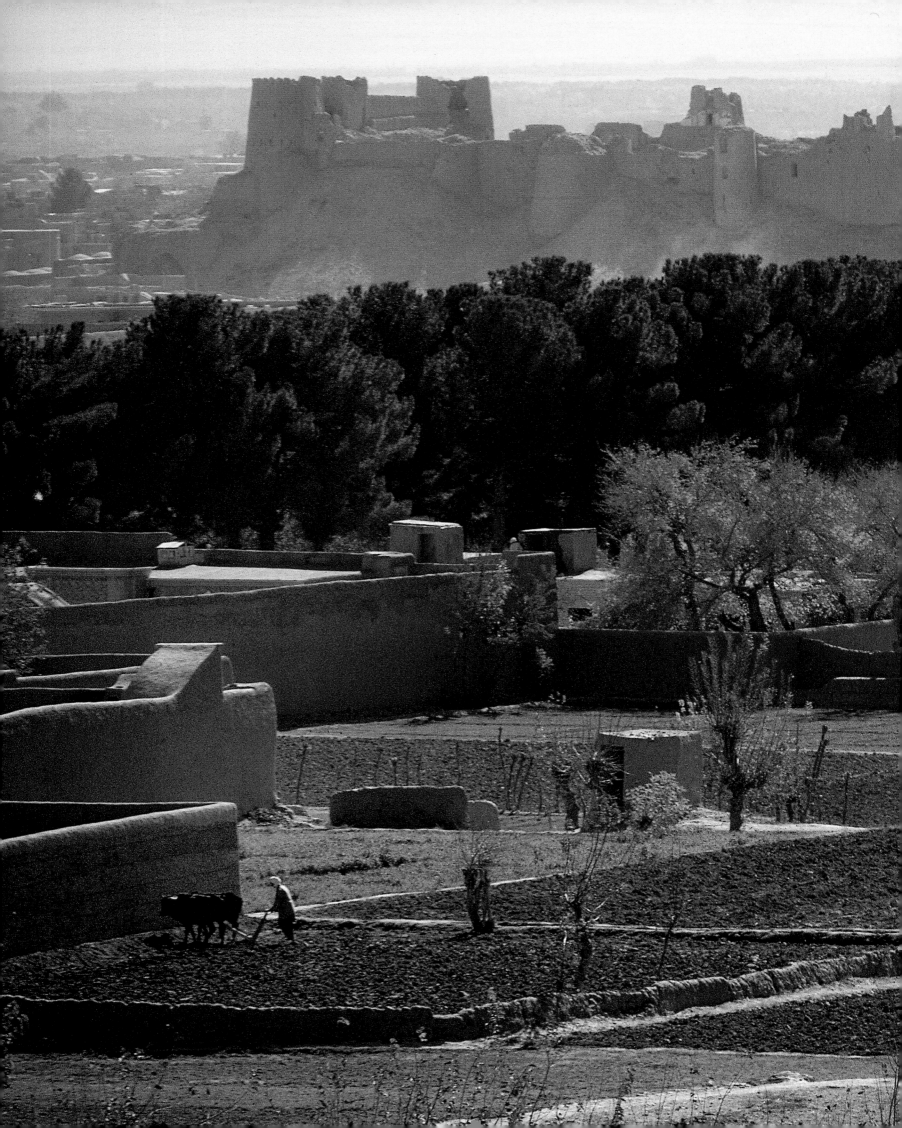

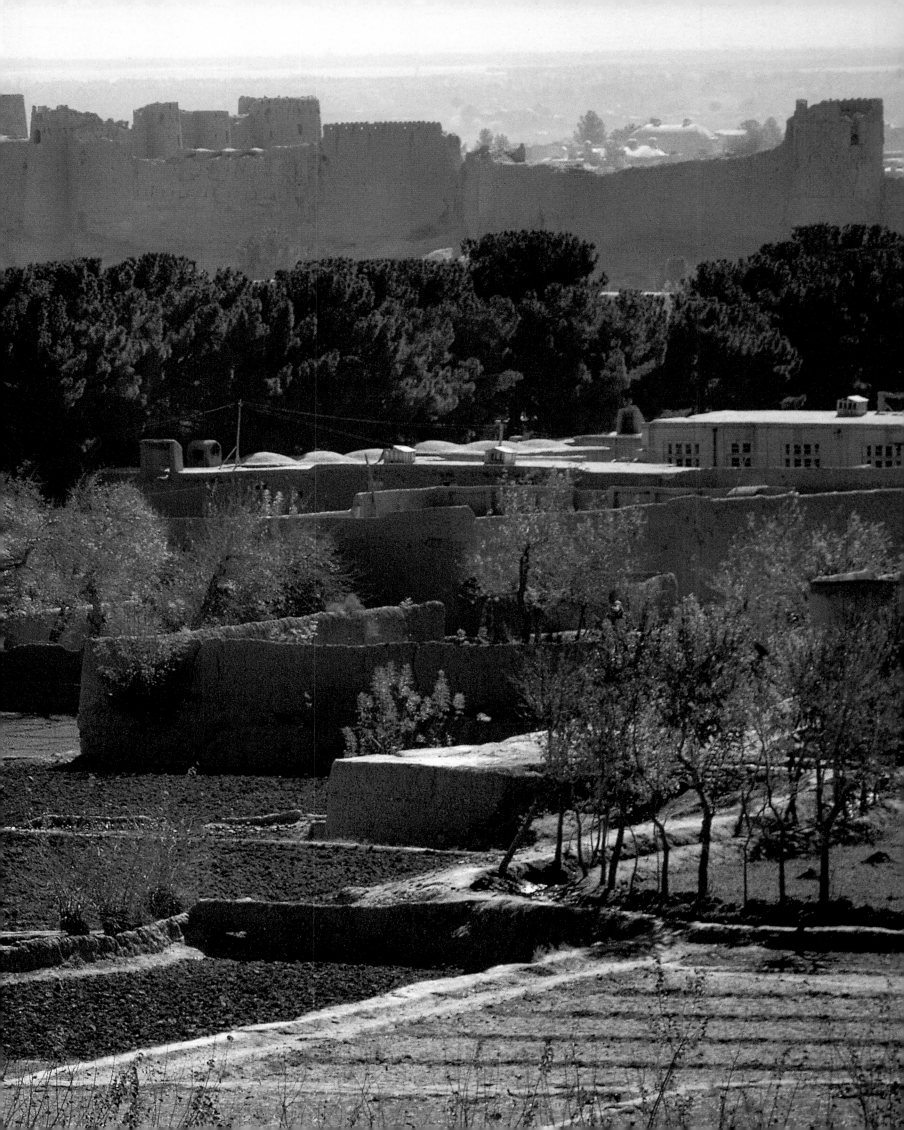

Imagine yourself the rose, and you will become the rose;

if you want the unstable nightingale, you become the nightingale.

You are the particle; the truth lies in the Whole.

And if one day you think the Whole, you too will become the Whole.

JĀMĪ

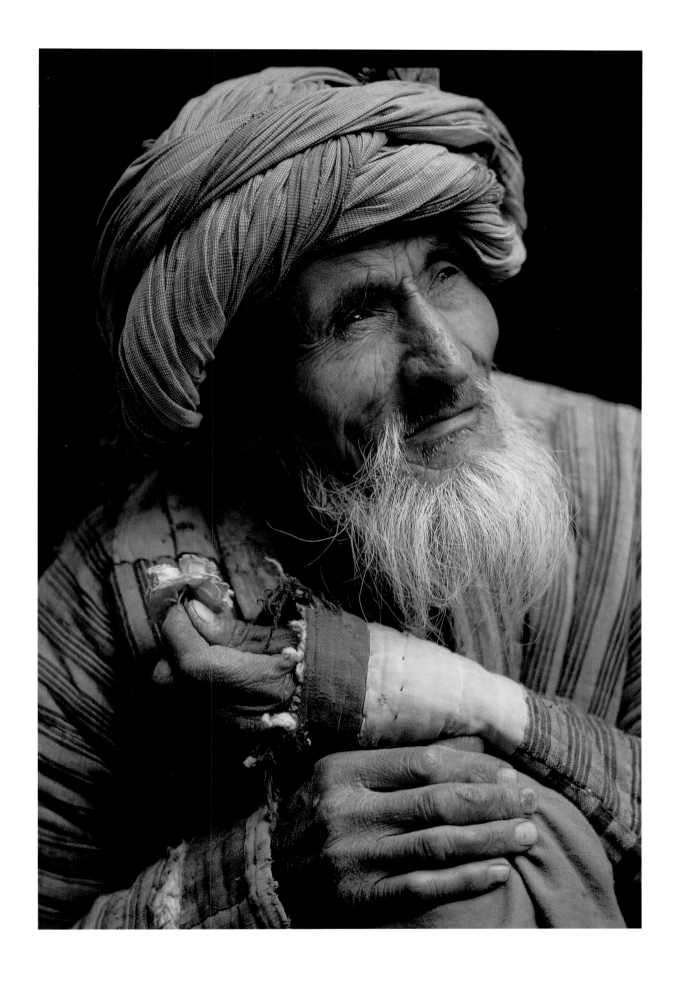

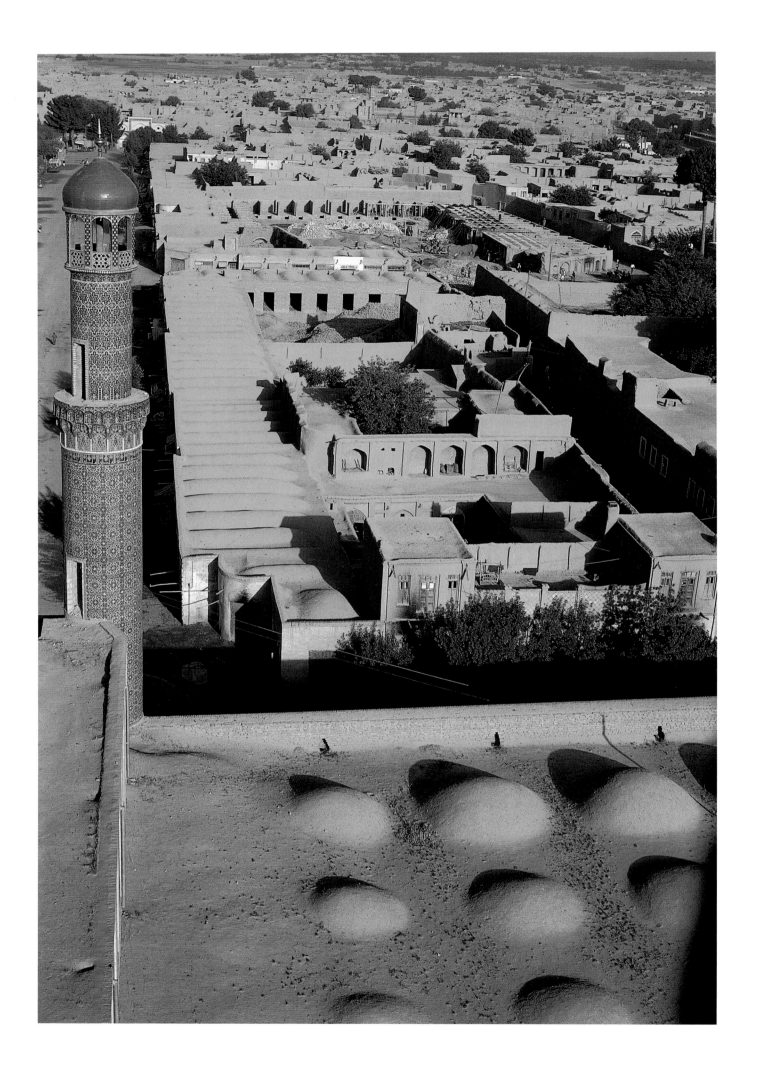

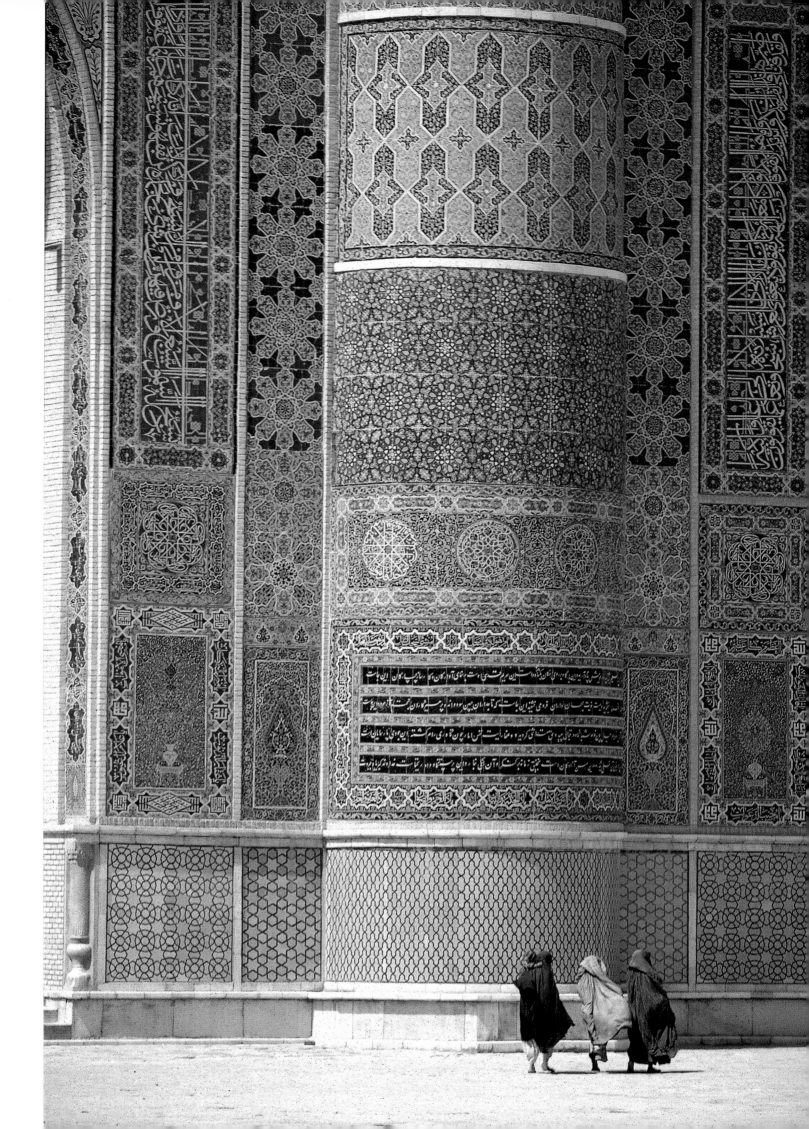

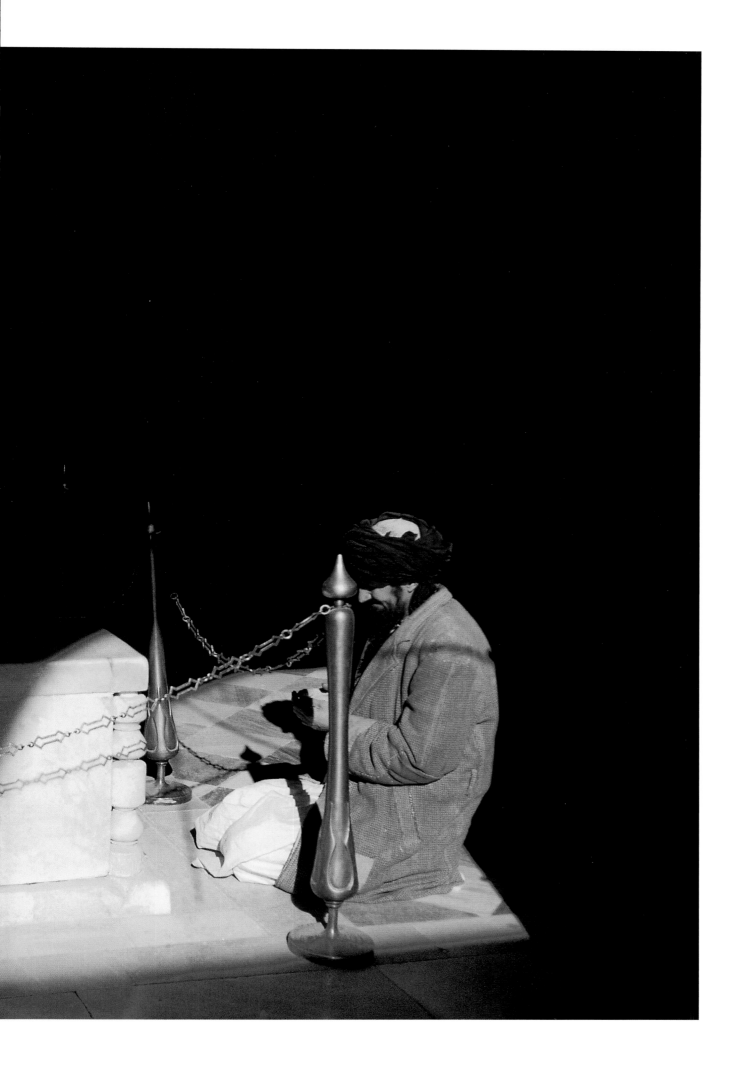

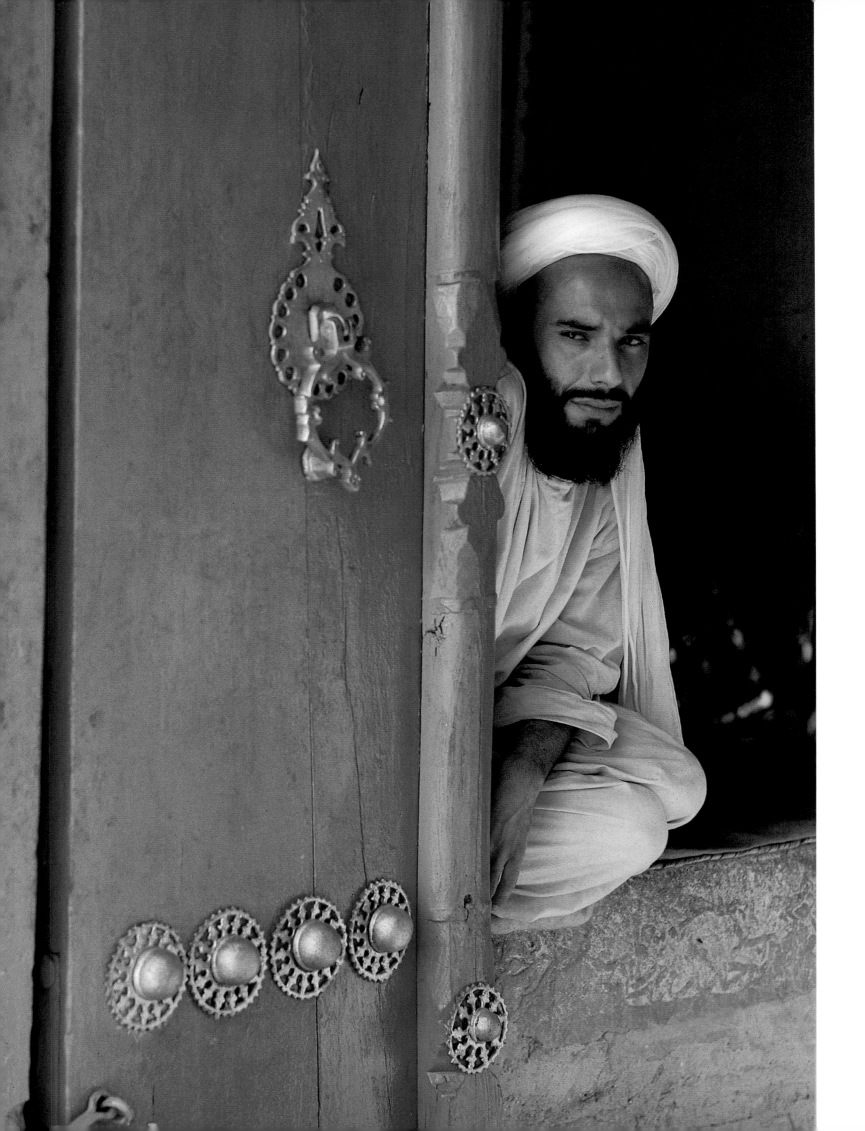

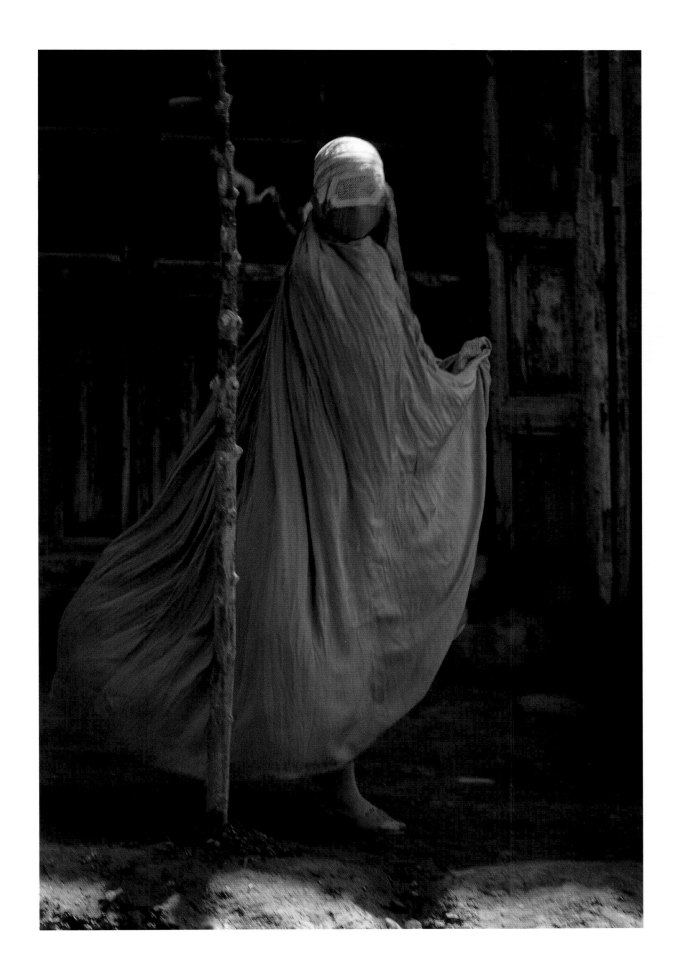

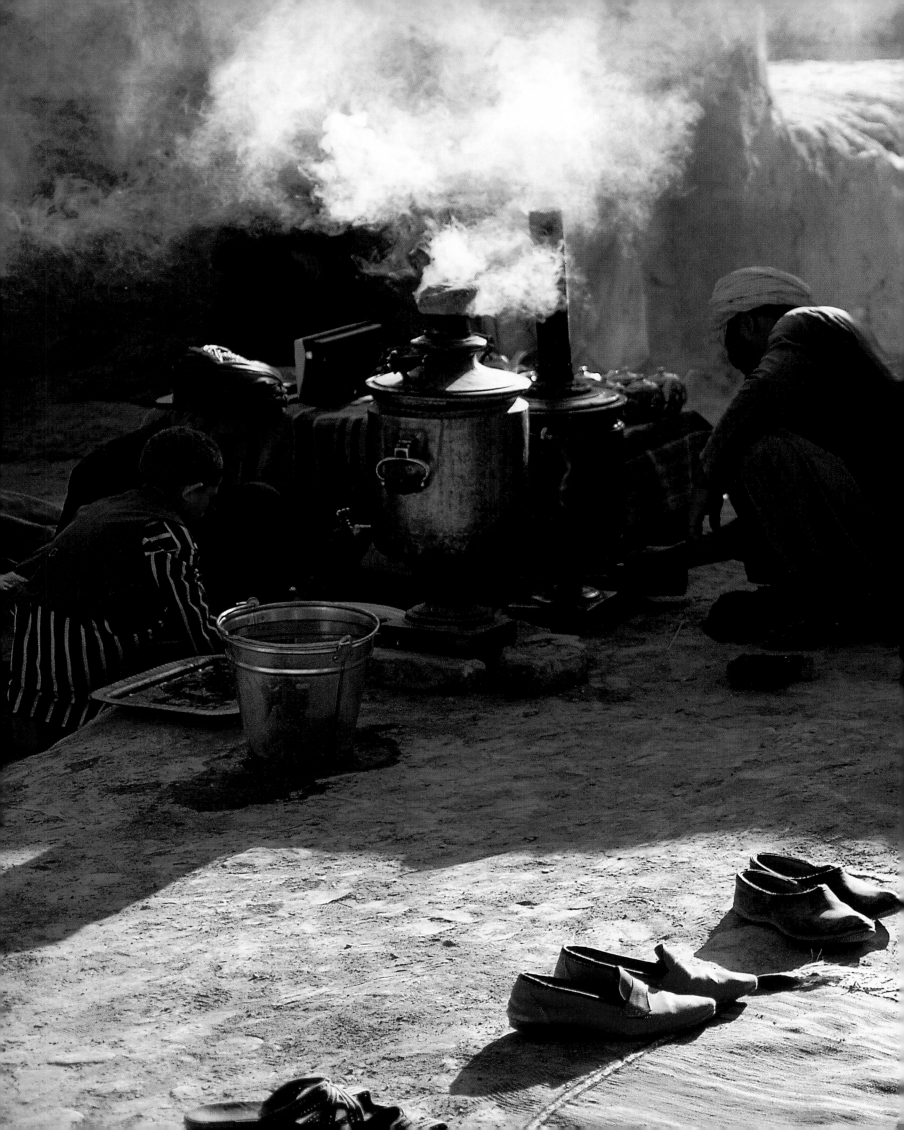

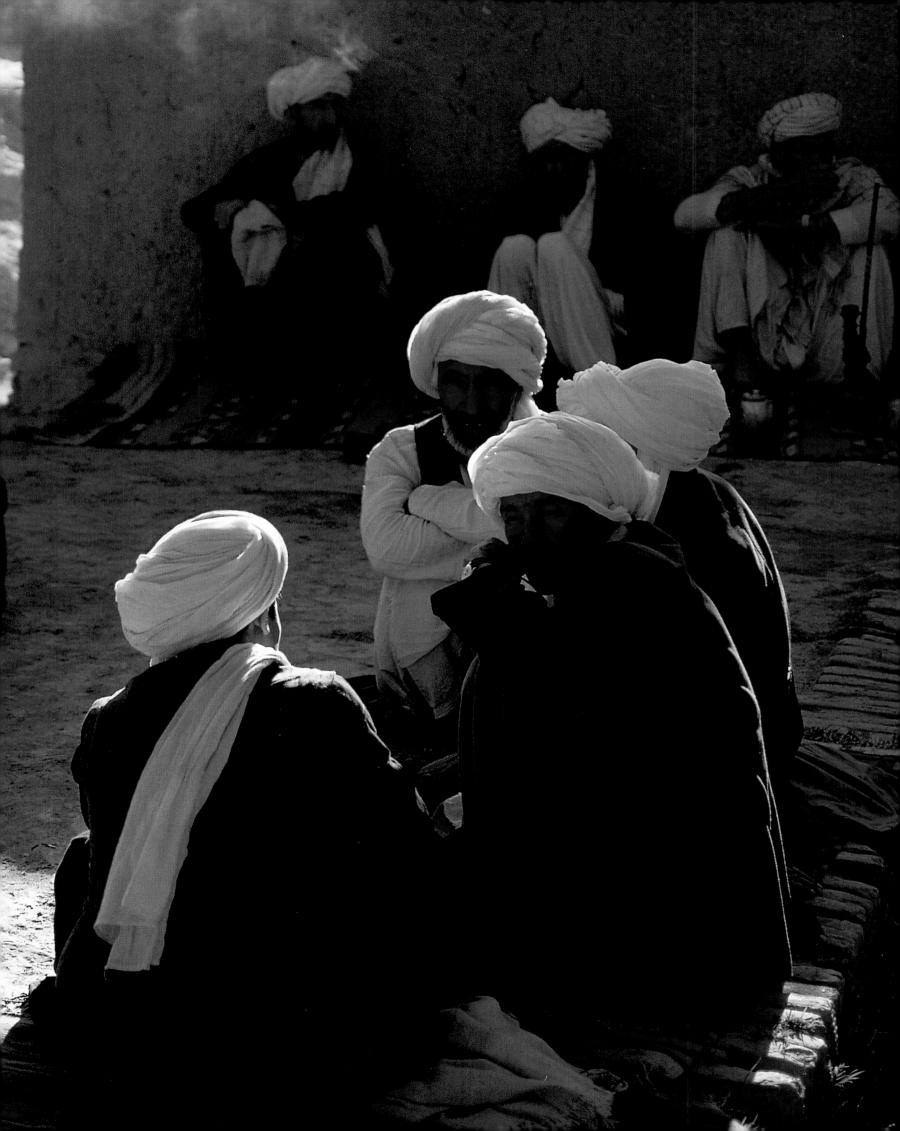

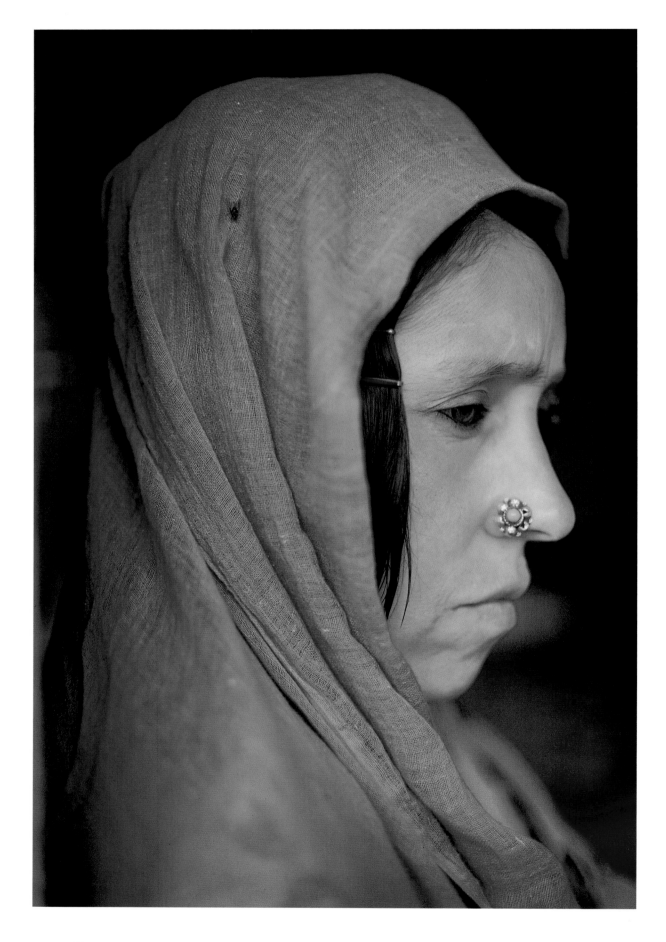

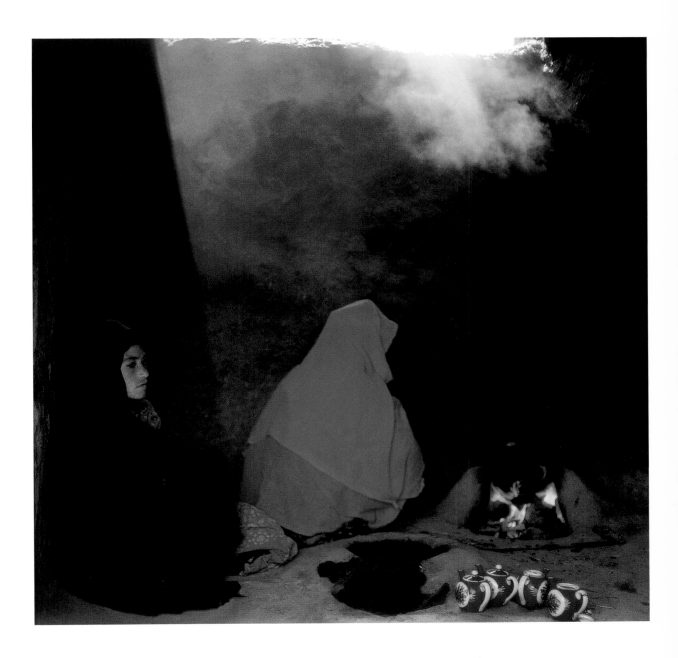

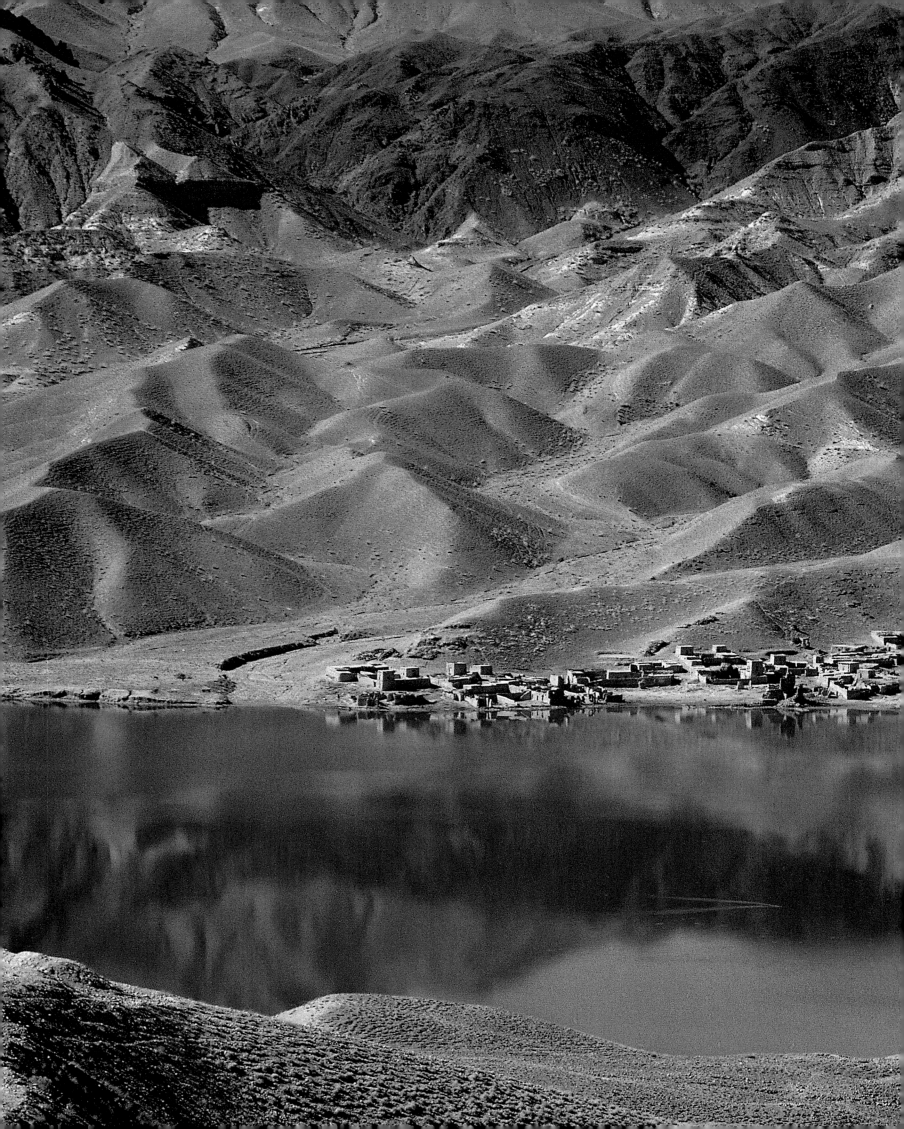

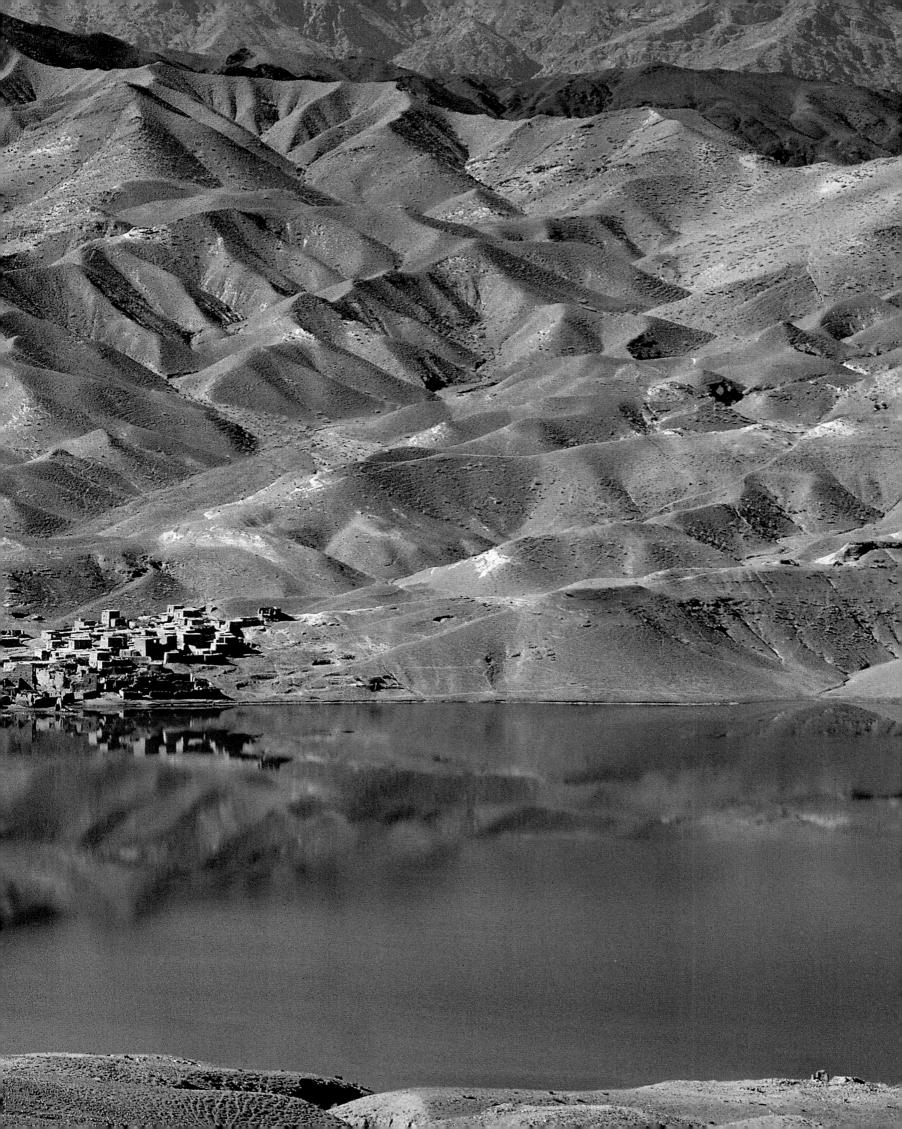

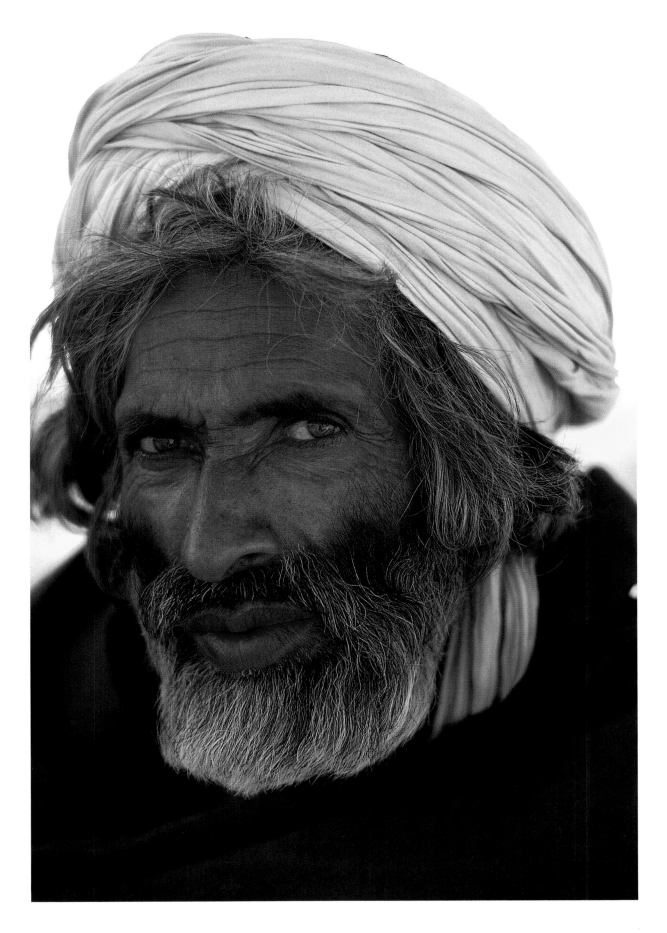

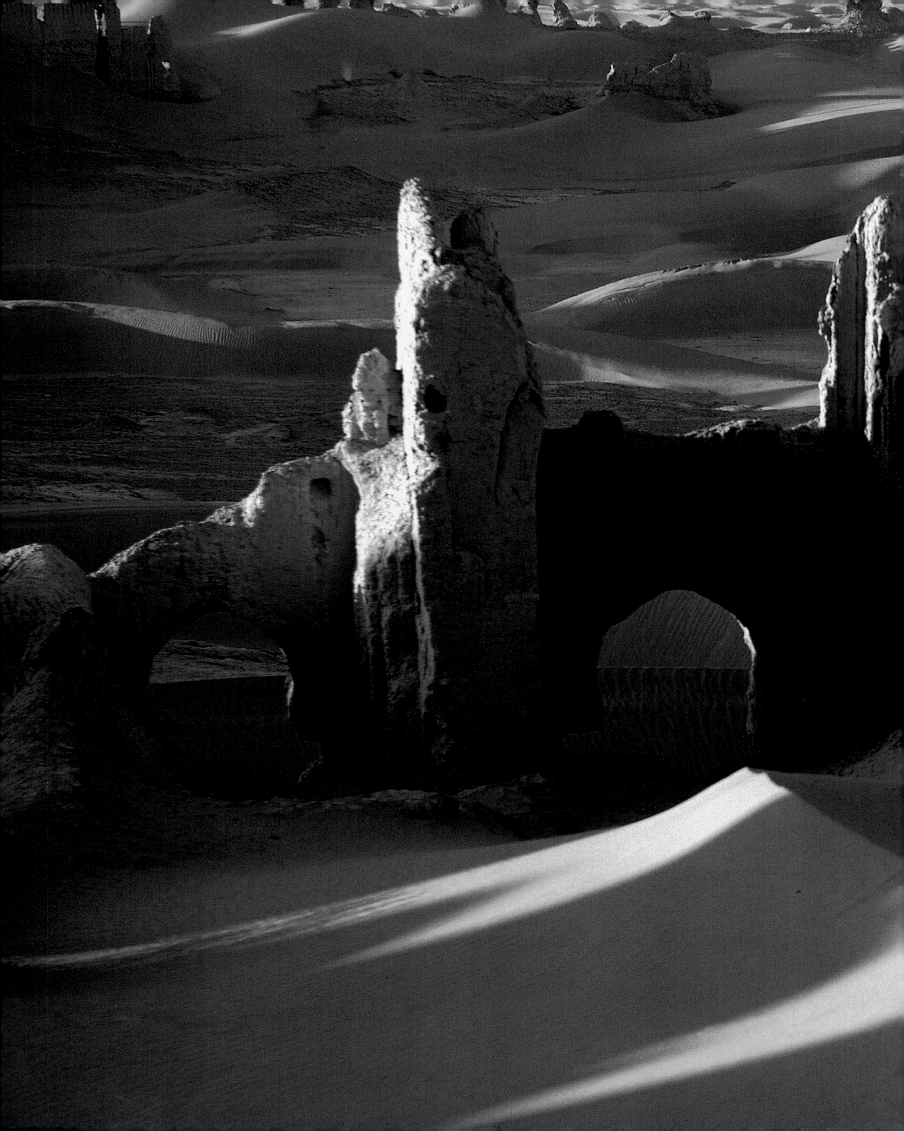

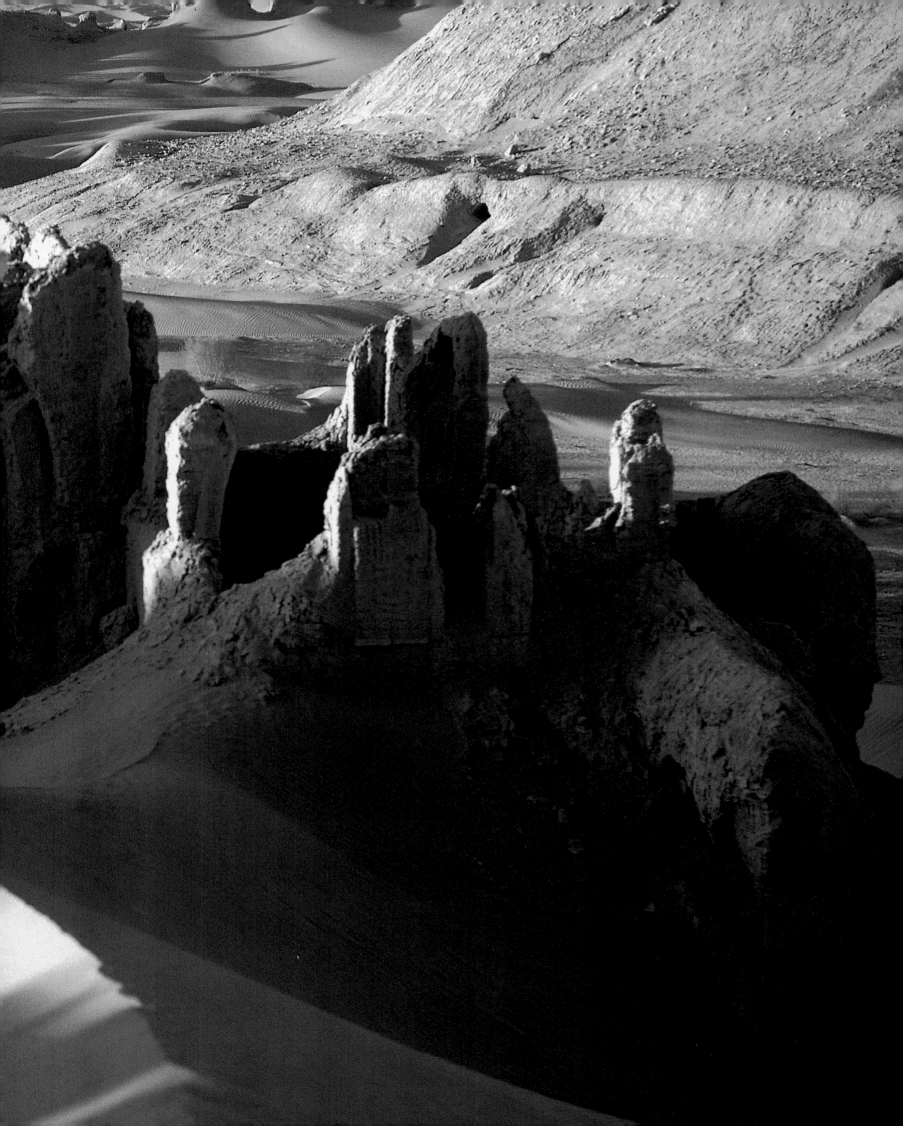

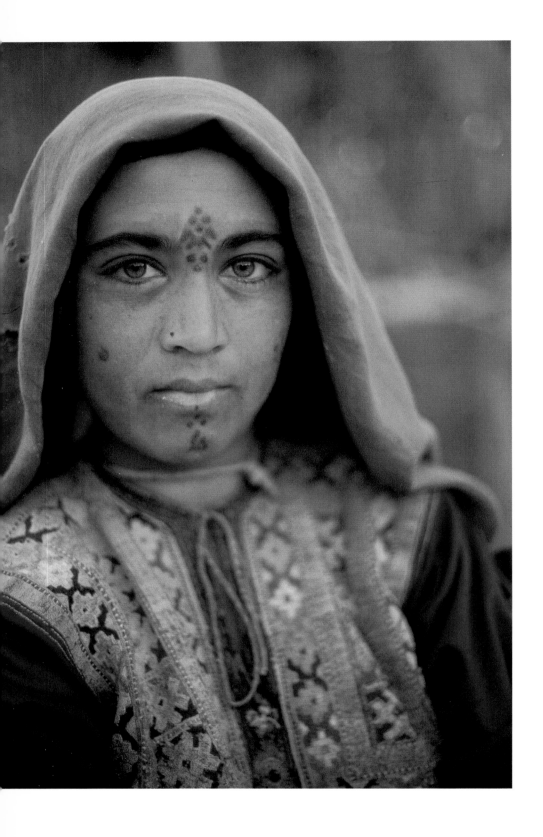

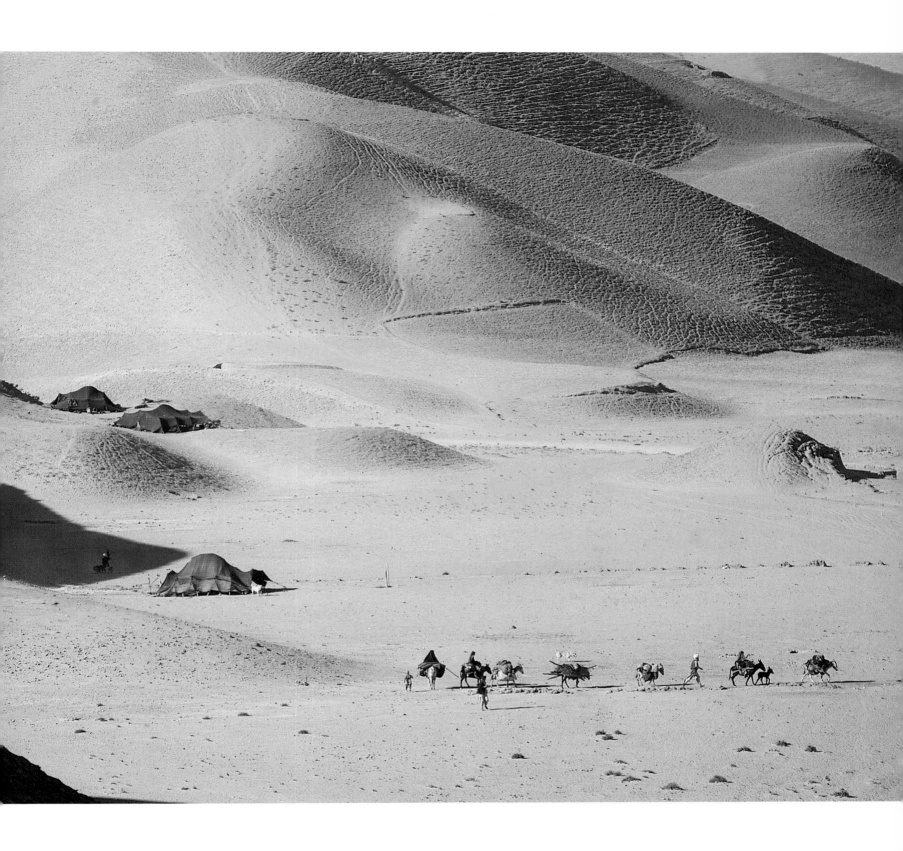

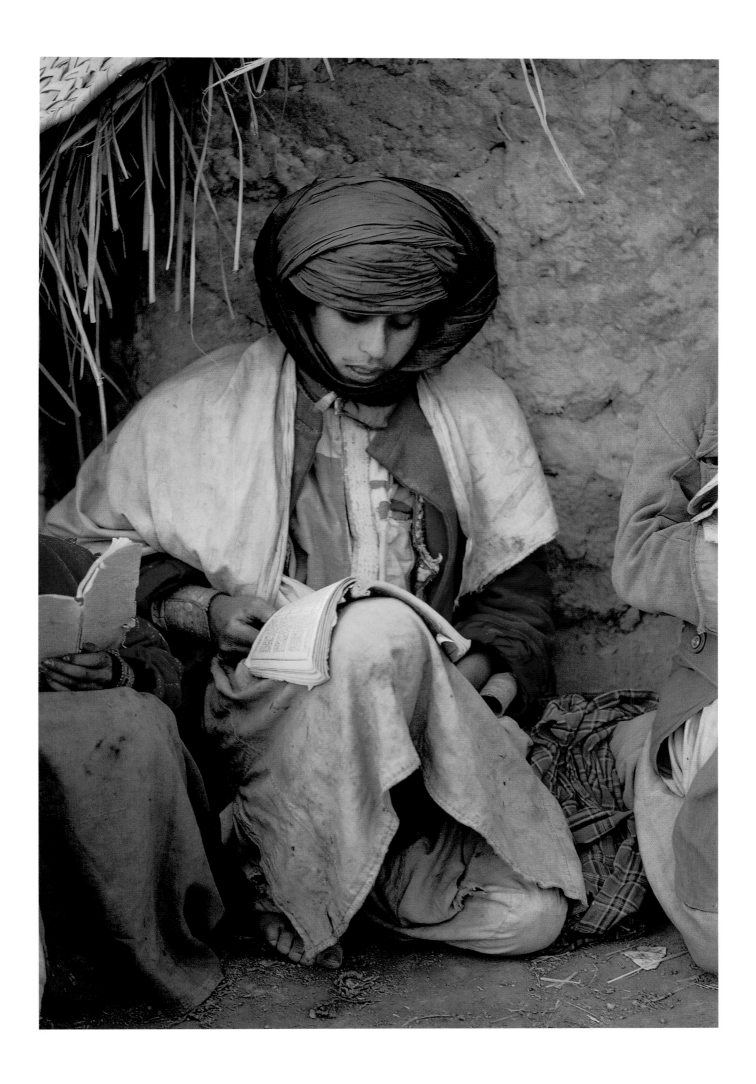

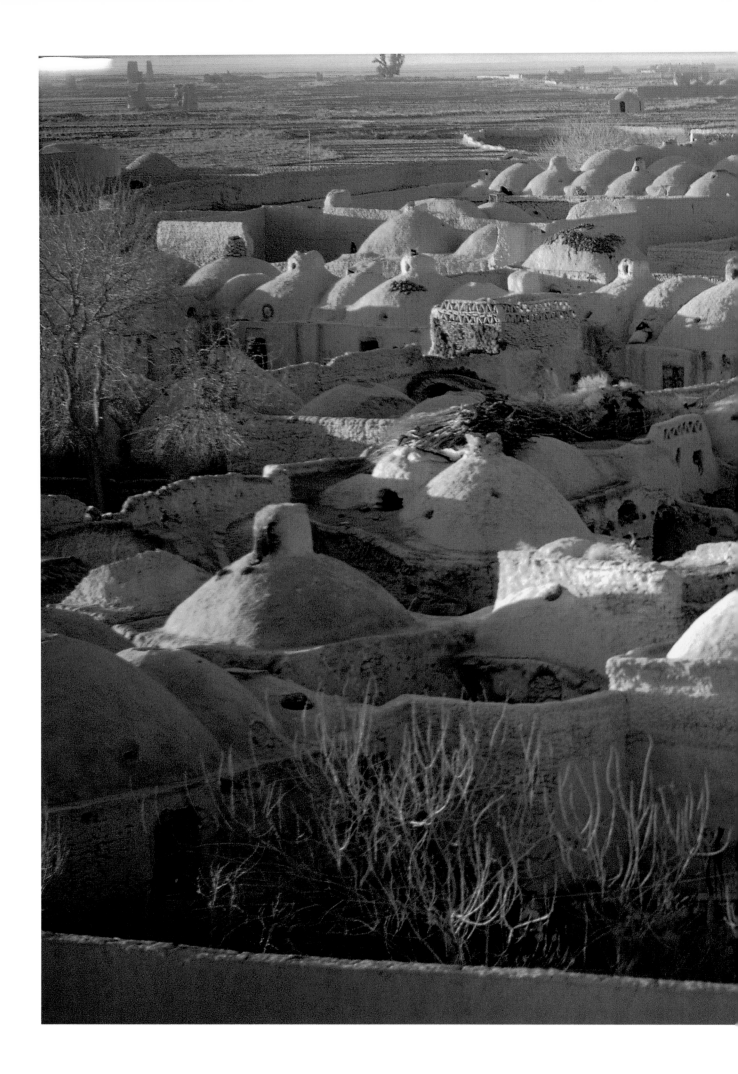

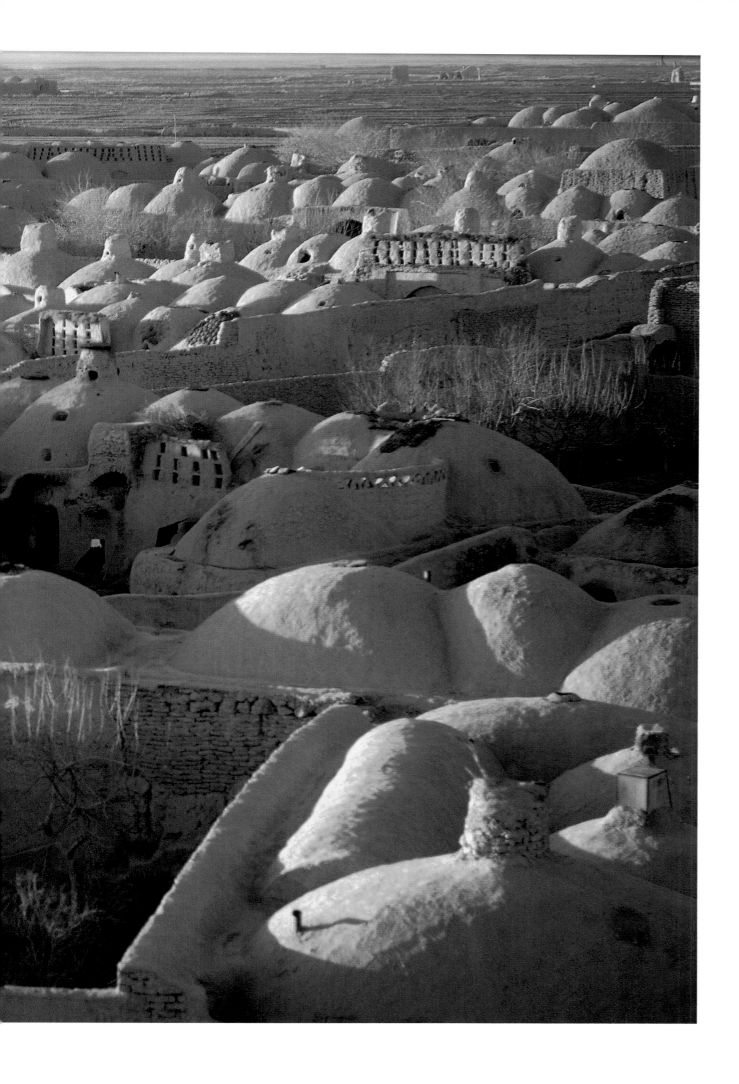

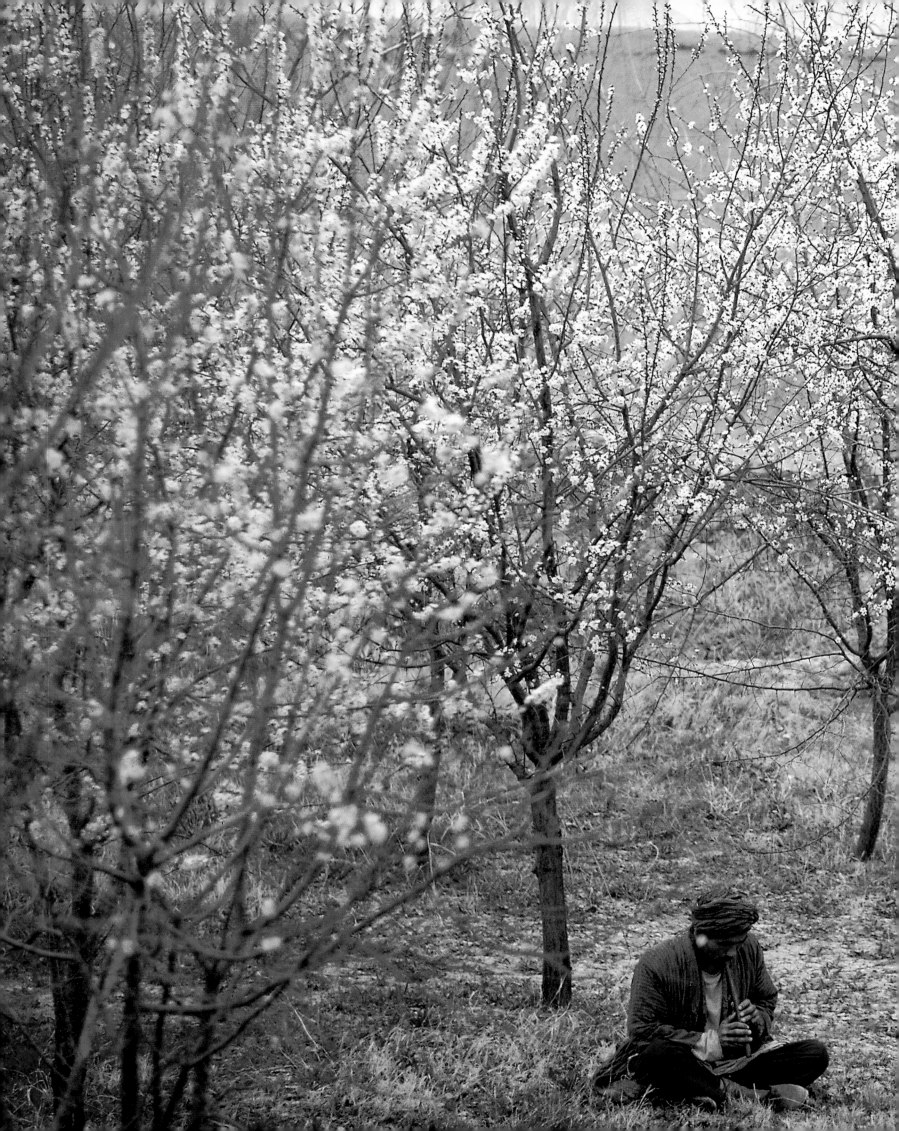

Here there is an appetite for the essential, constantly
sustained by the spectacle of a nature in which
man appears as a humble accident, by the subtlety
and slowness of a life in which frugality kills pettiness.

NICOLAS BOUVIER

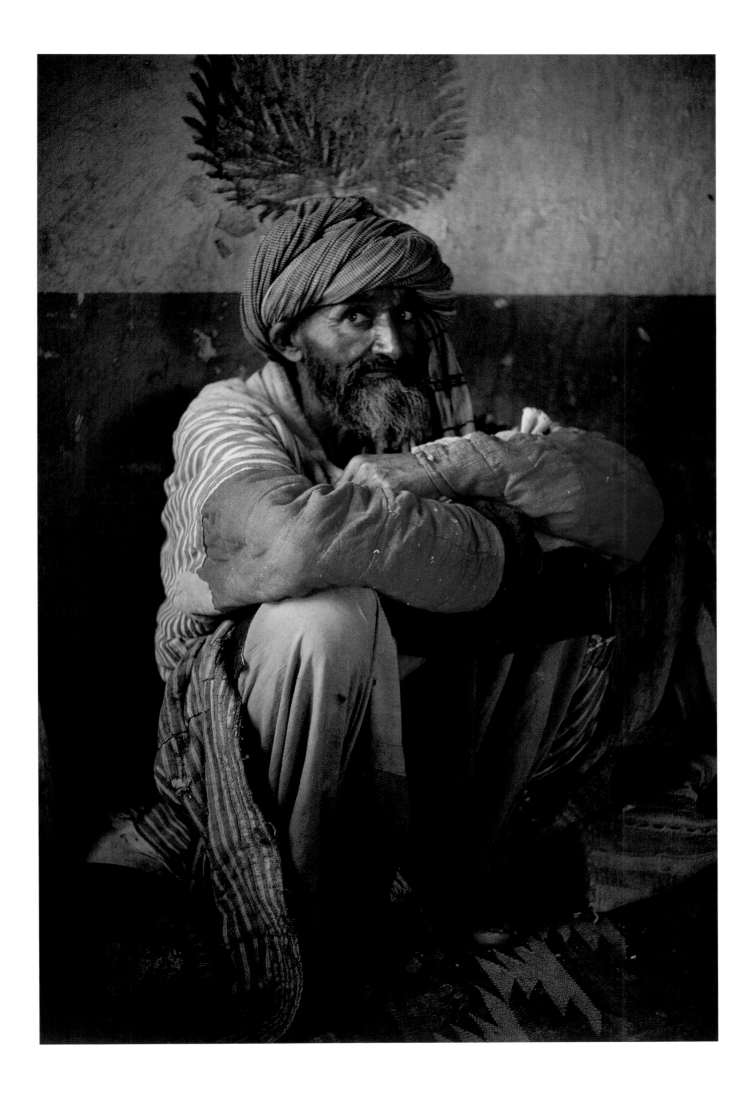

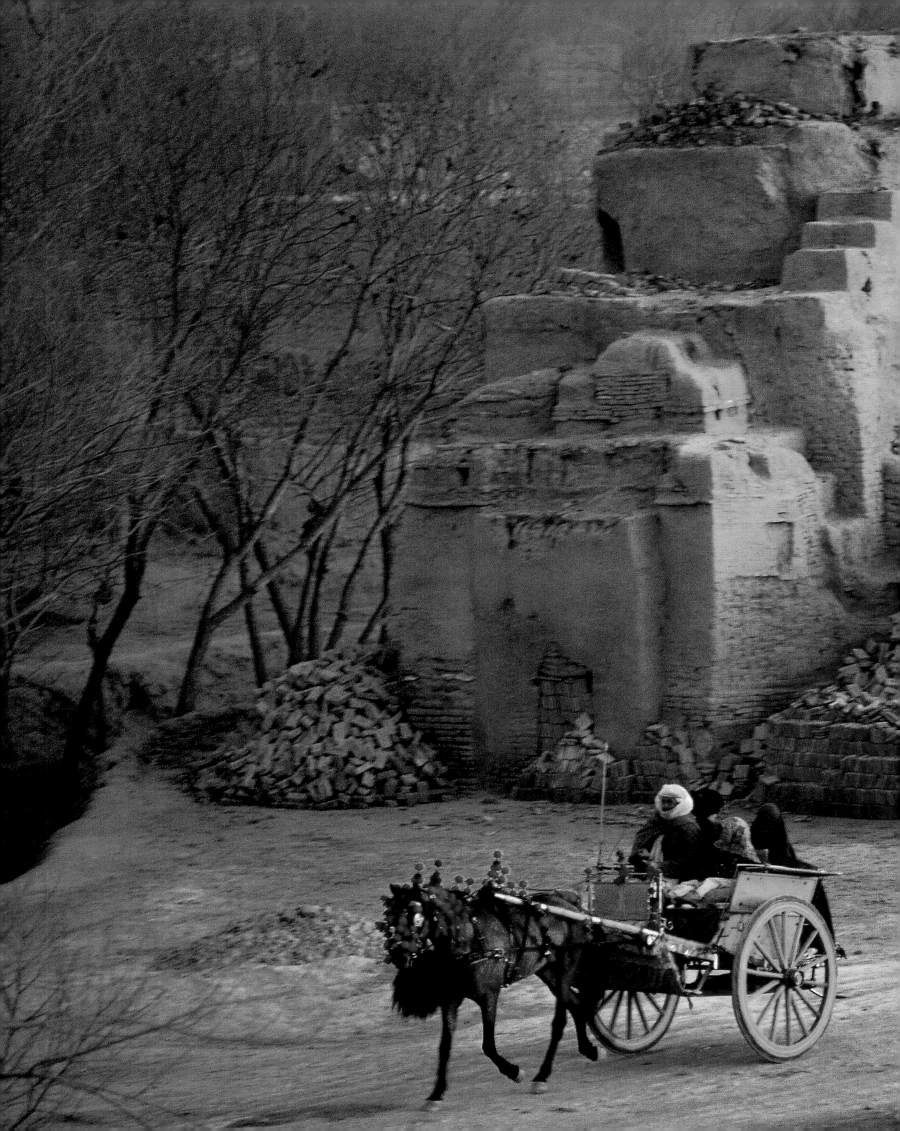

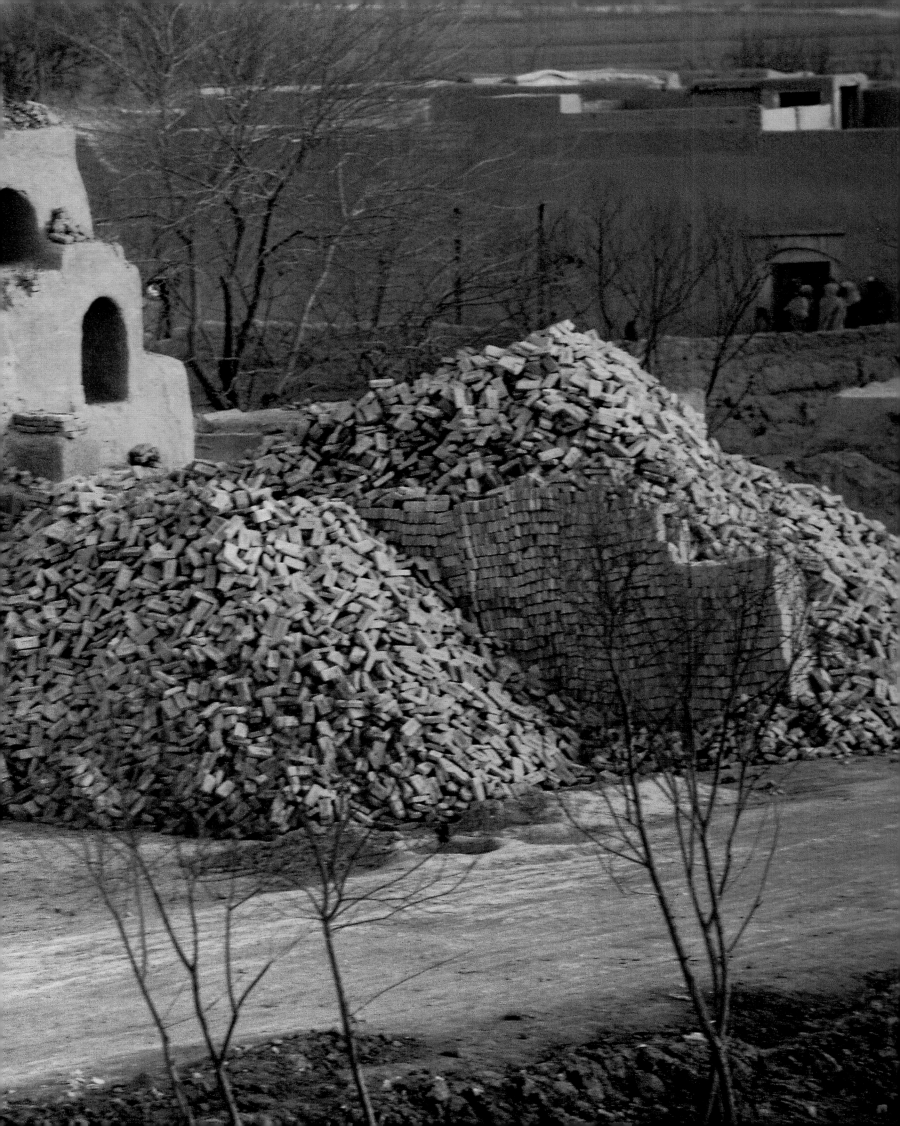

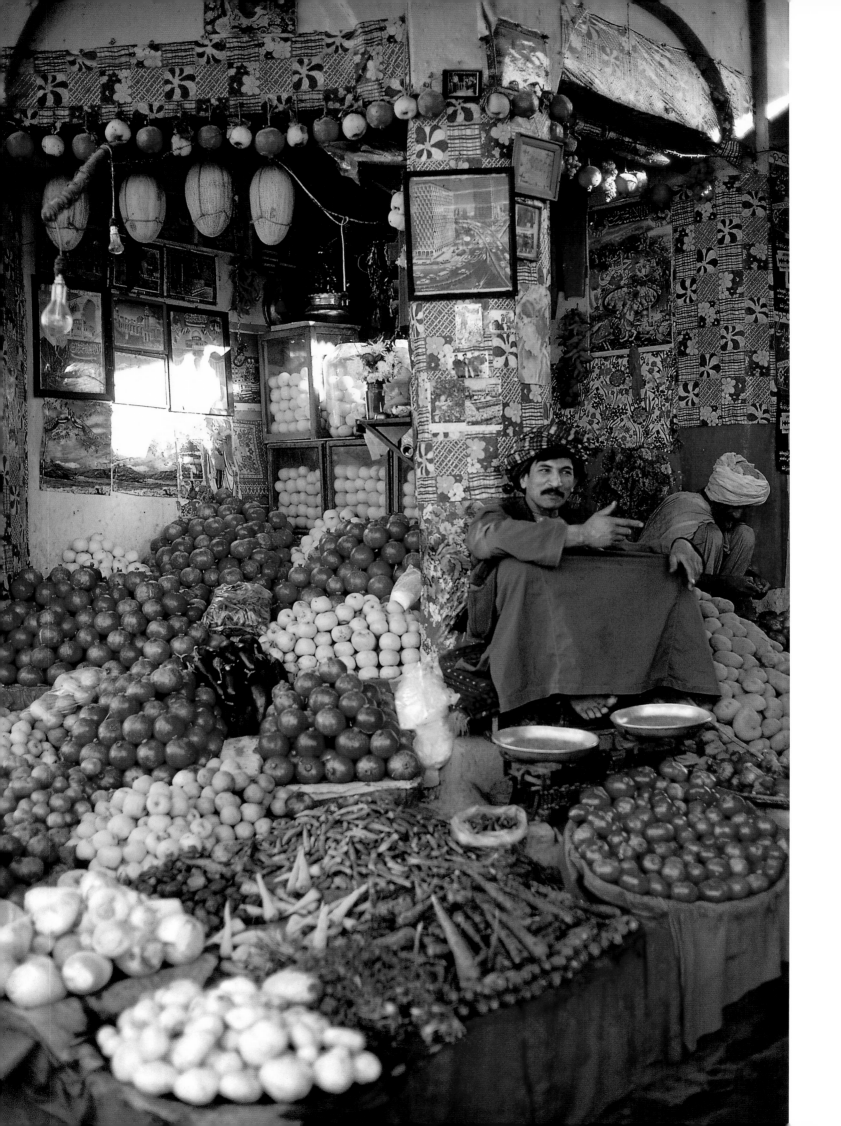

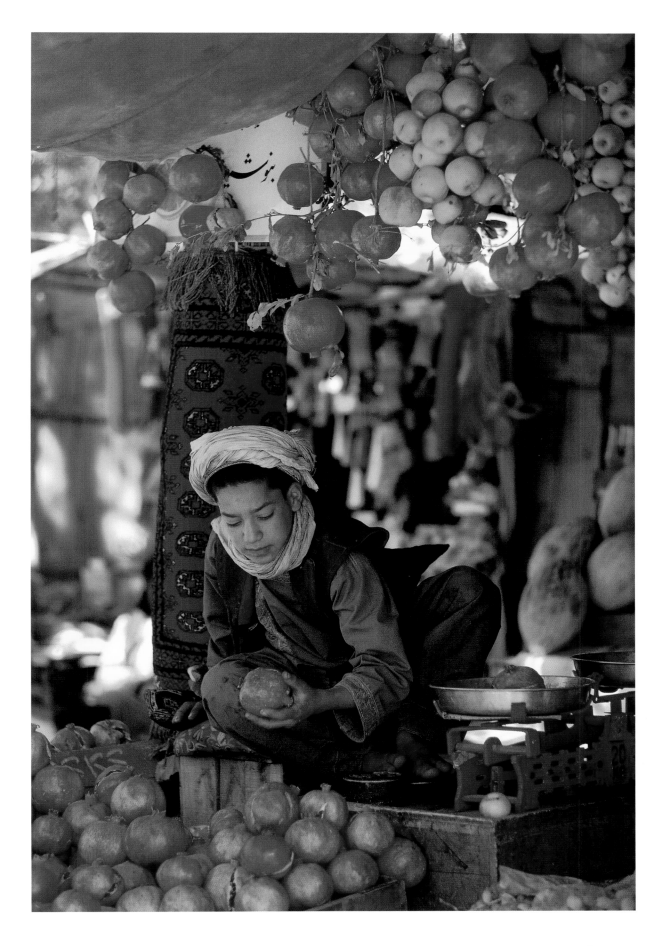

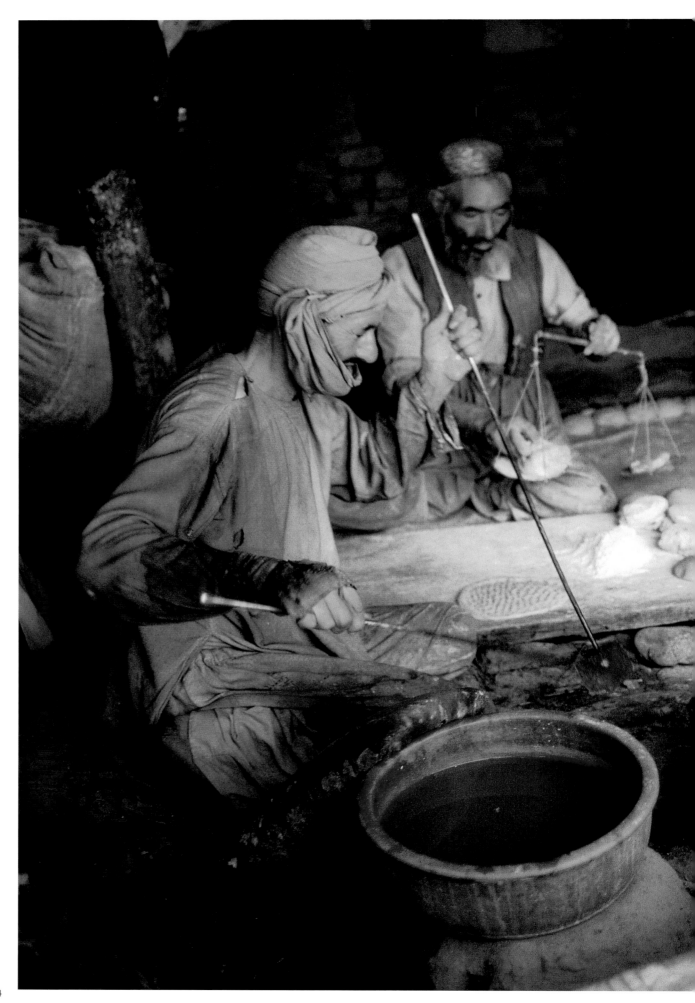

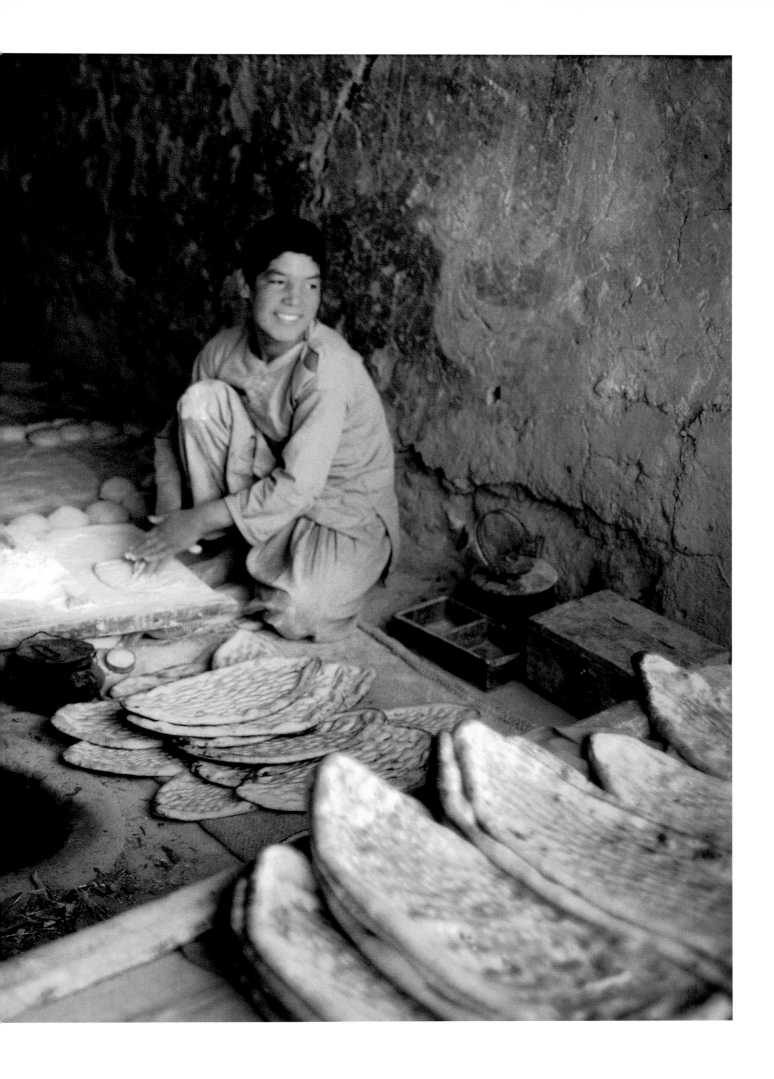

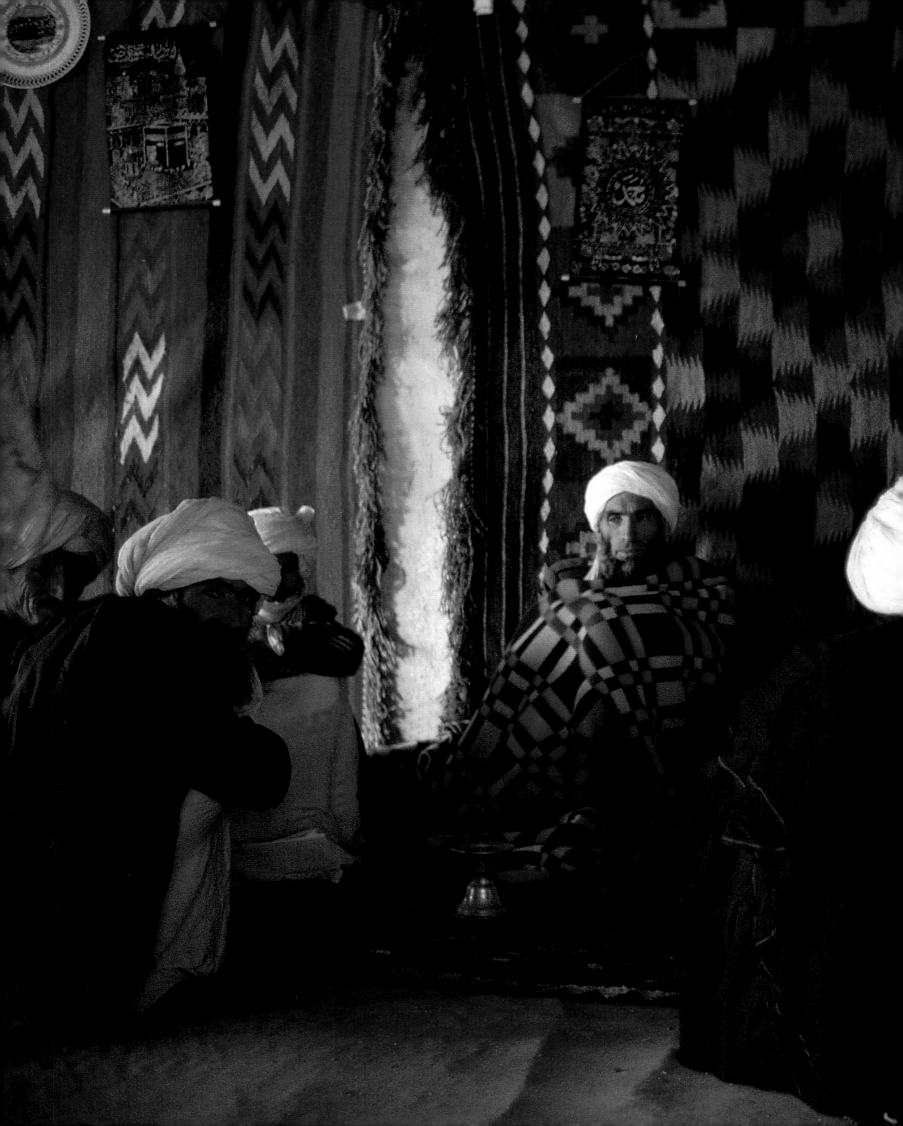

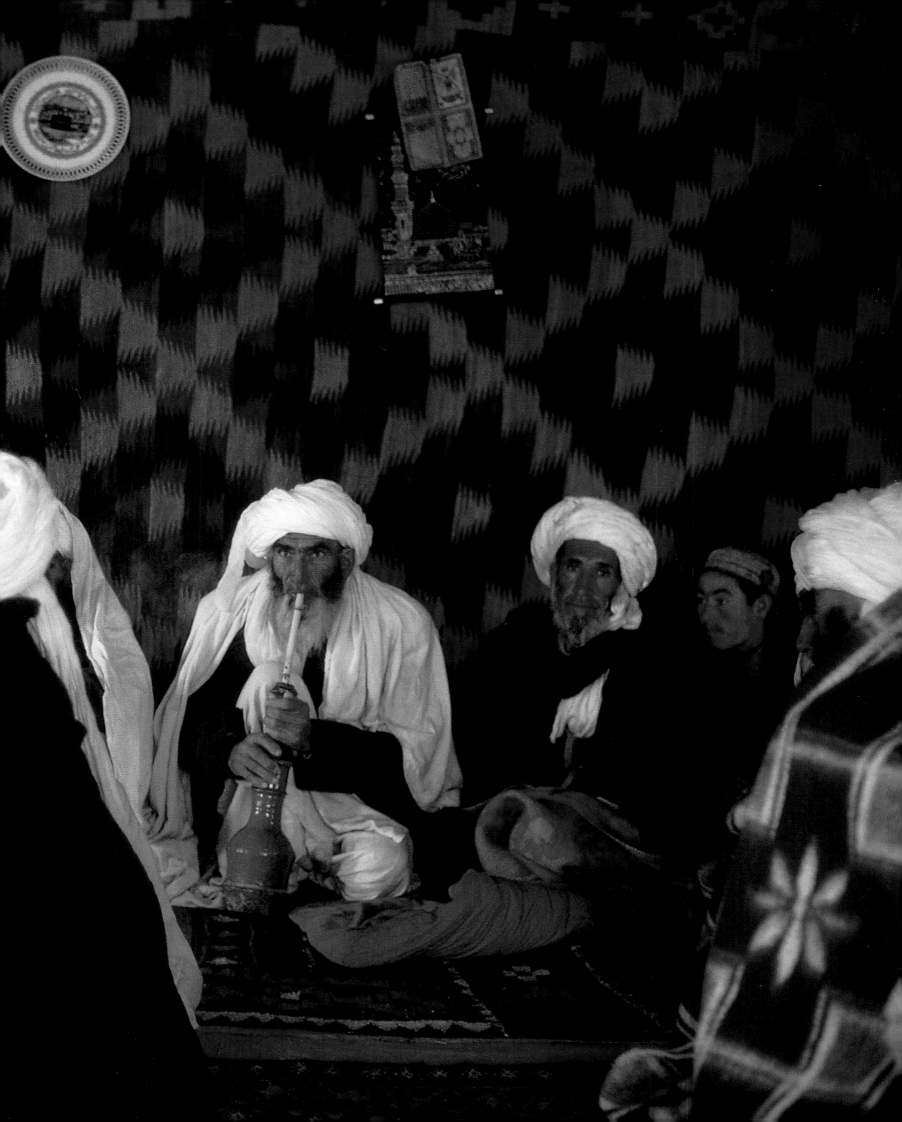

Vigor and nobility of features—this is one of the most handsome peoples in the world—harmony of movement, the color of the fabrics blend with this instinctive dignity of a shepherd, peasant, mountain man, warrior, nomad.

JOSEPH KESSEL

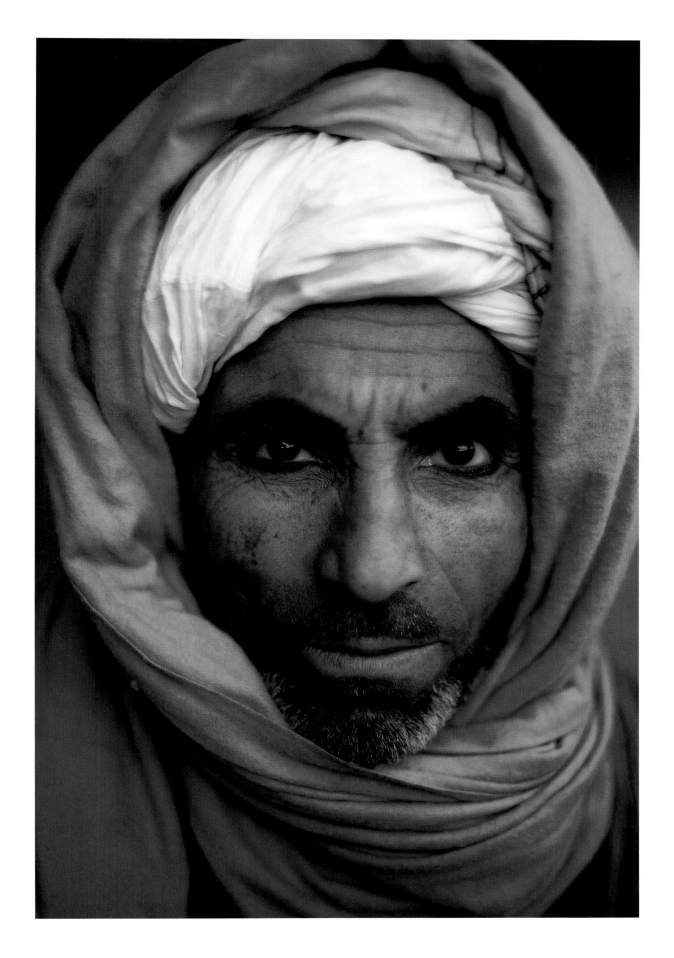

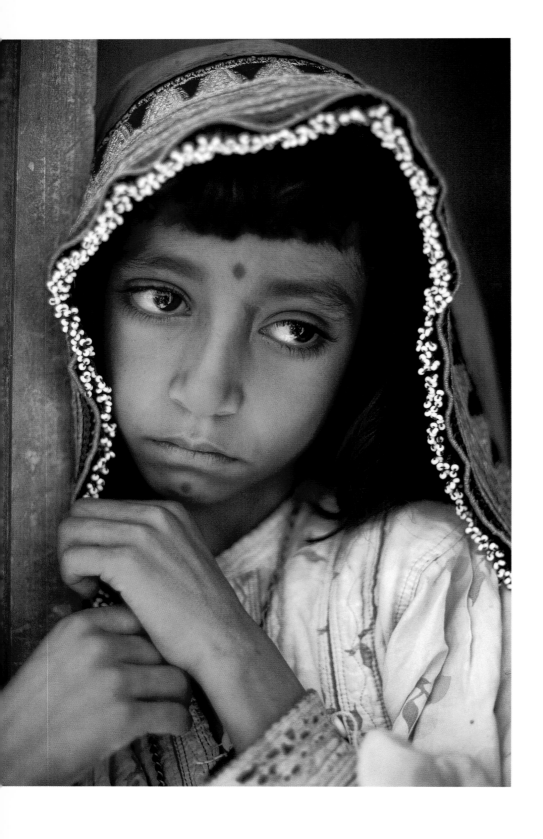

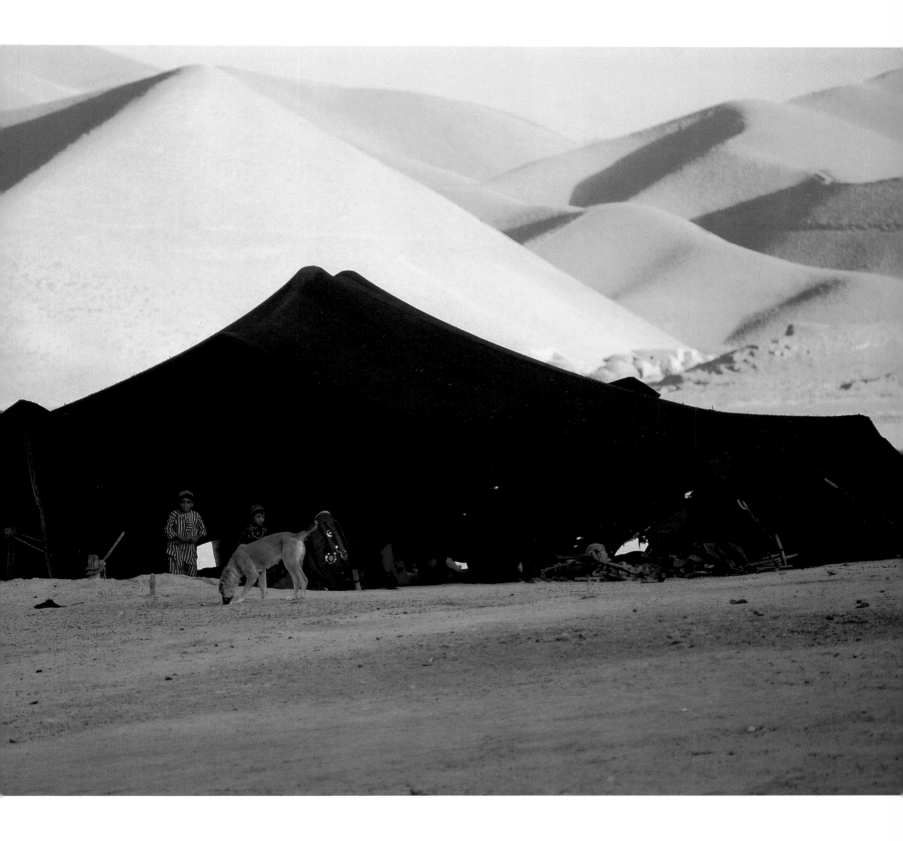

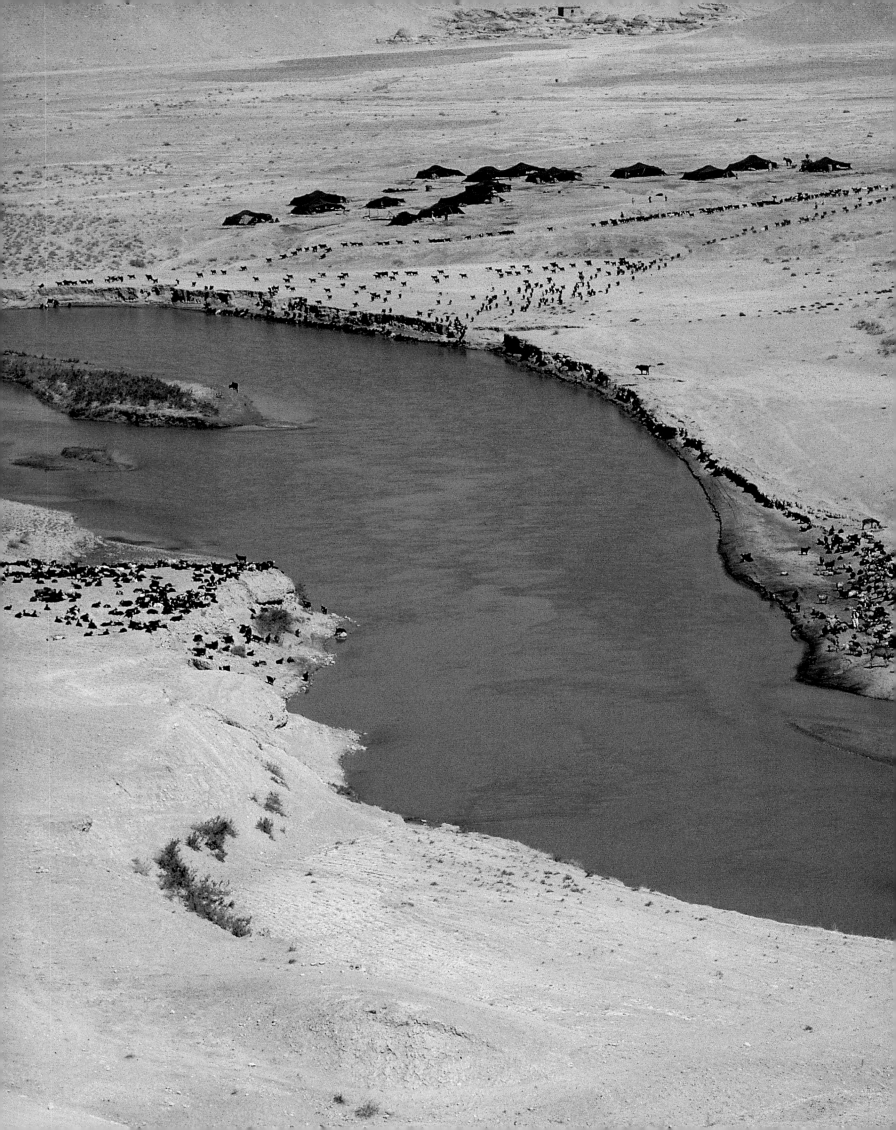

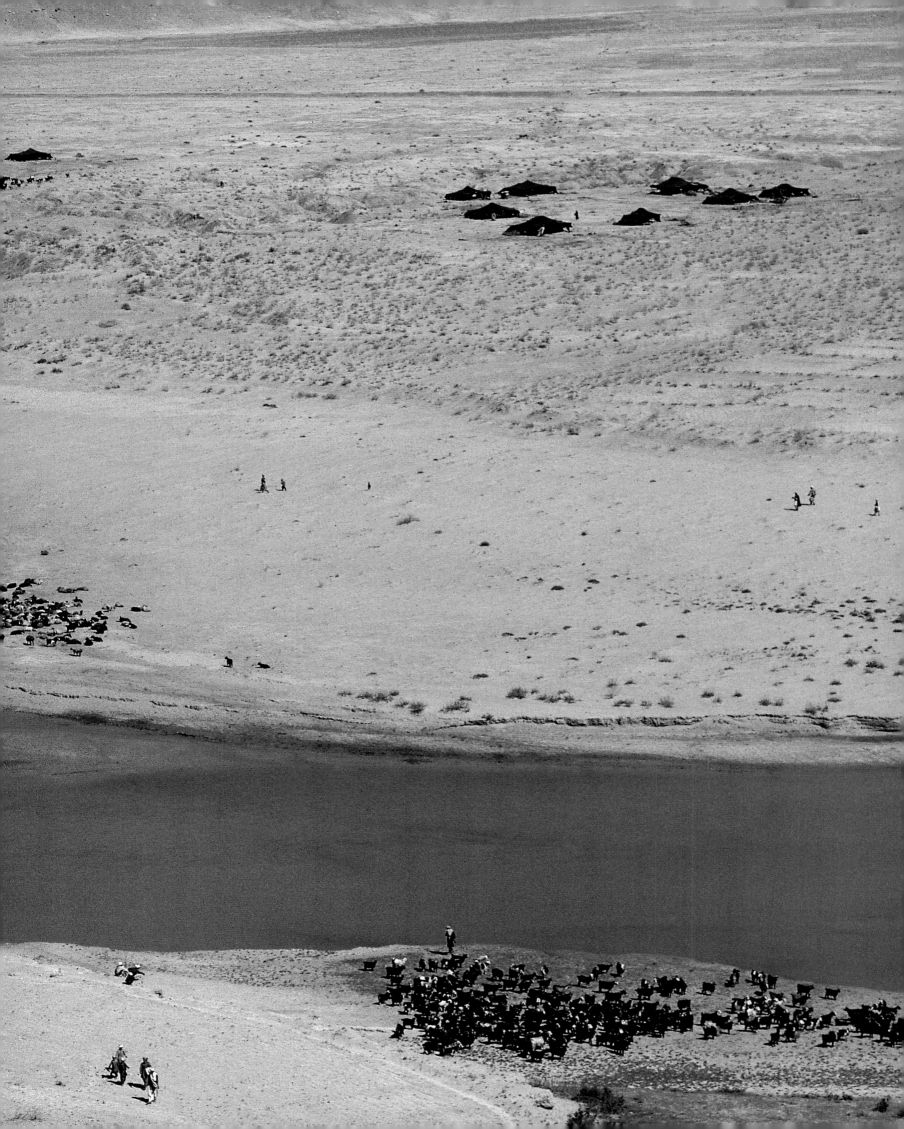

In secret I burn, in secret I weep,

I am the Pashtun woman, who cannot unveil her love.

ANONYMOUS SONG

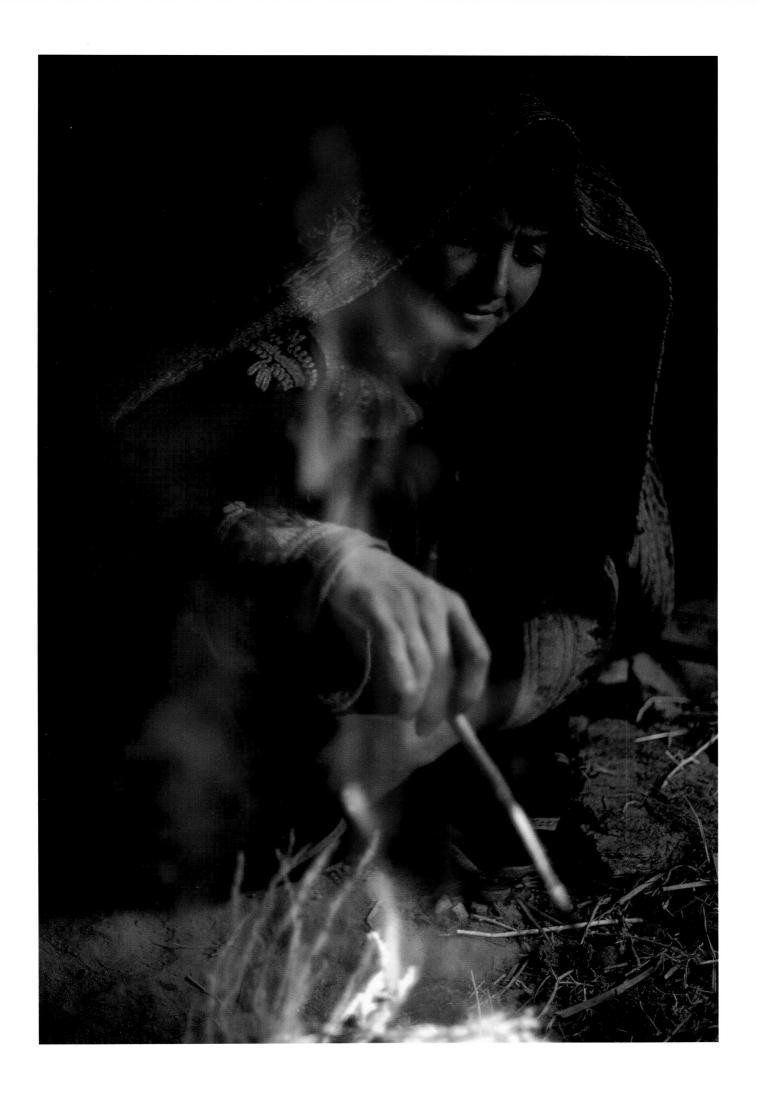

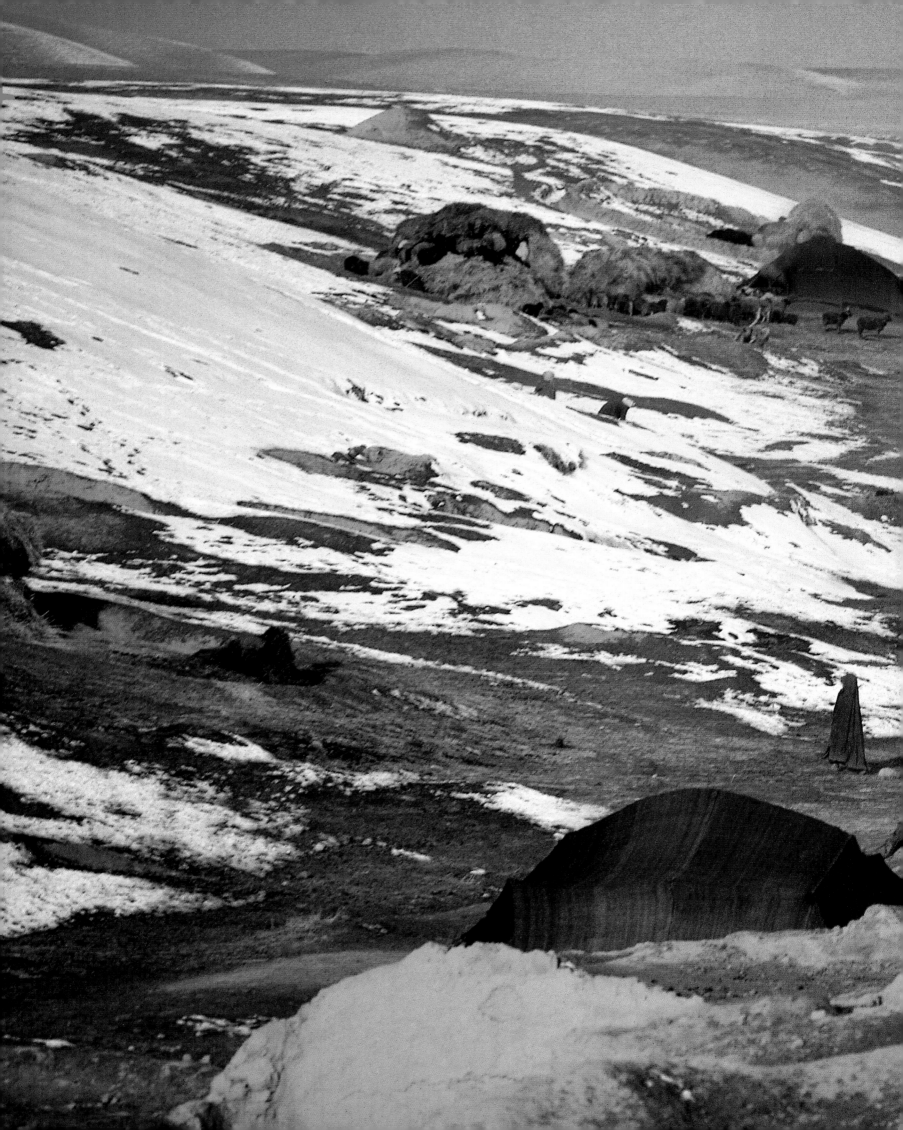

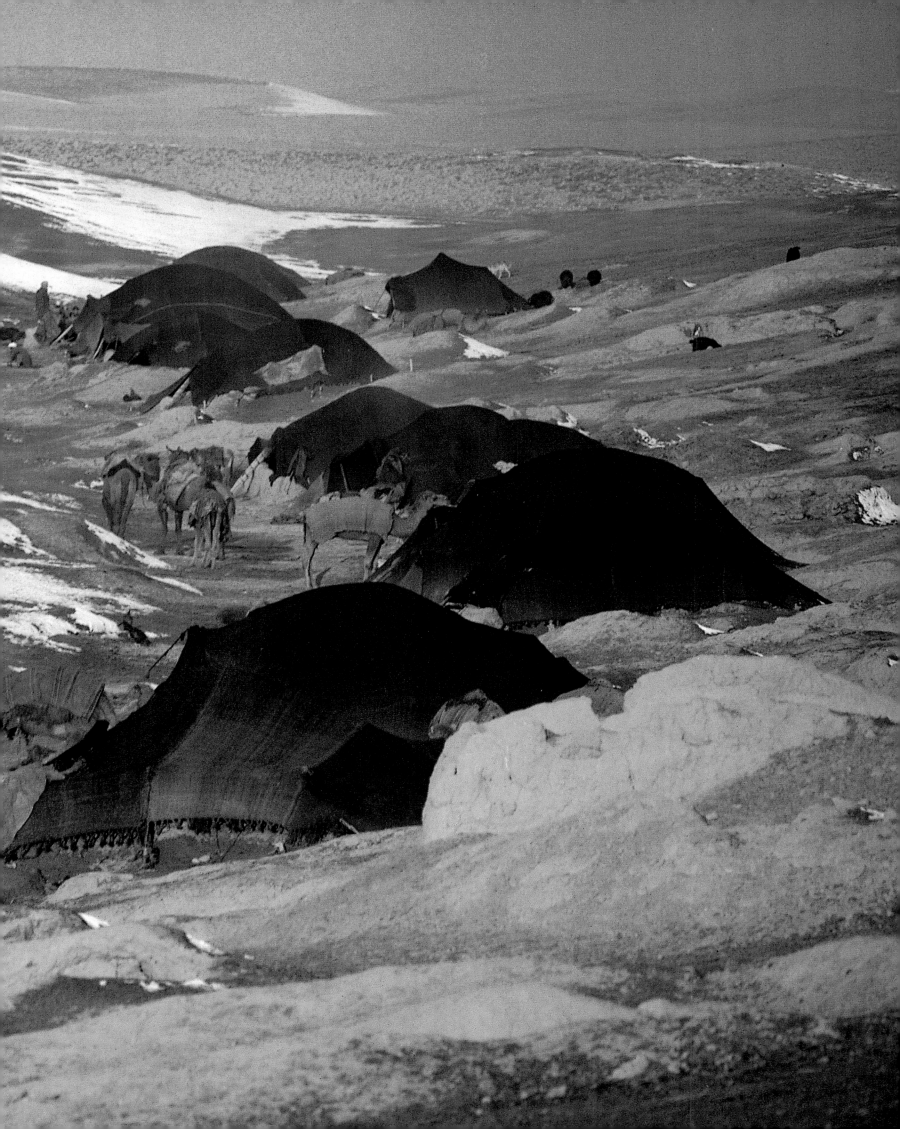

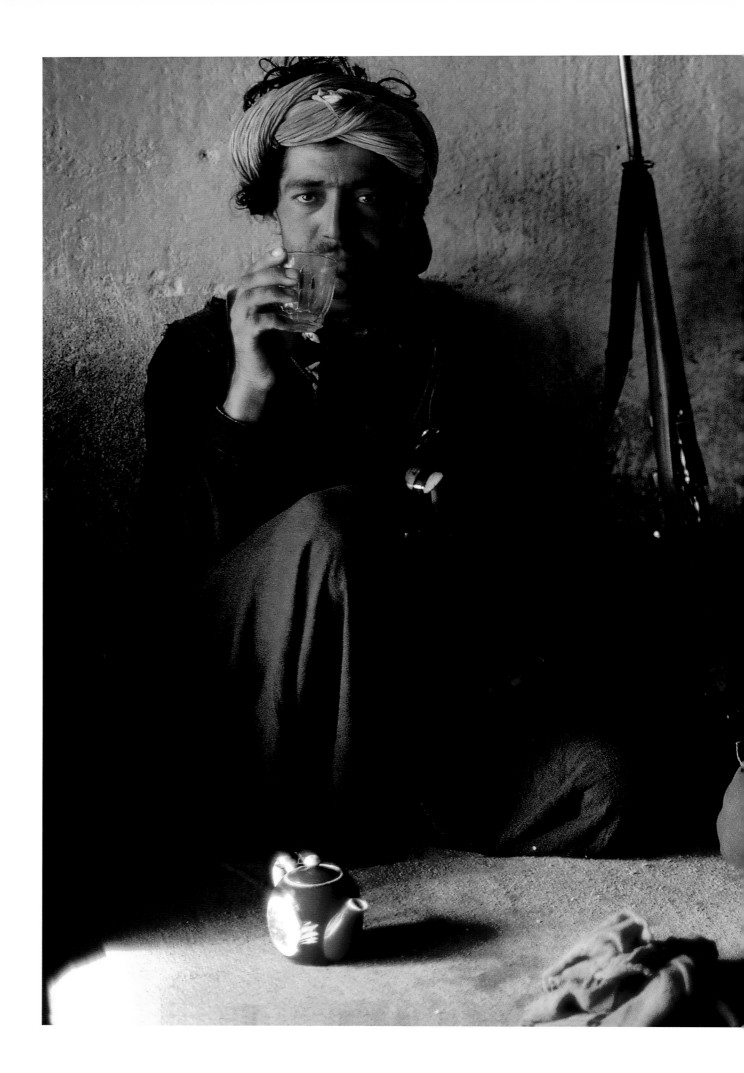

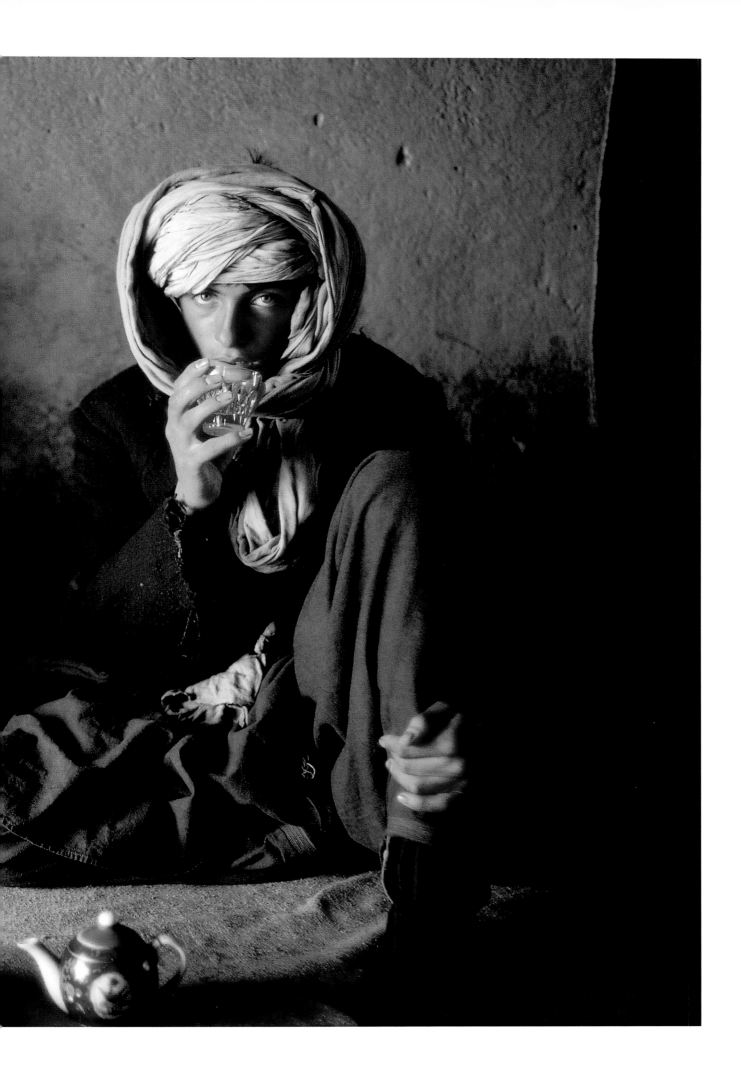

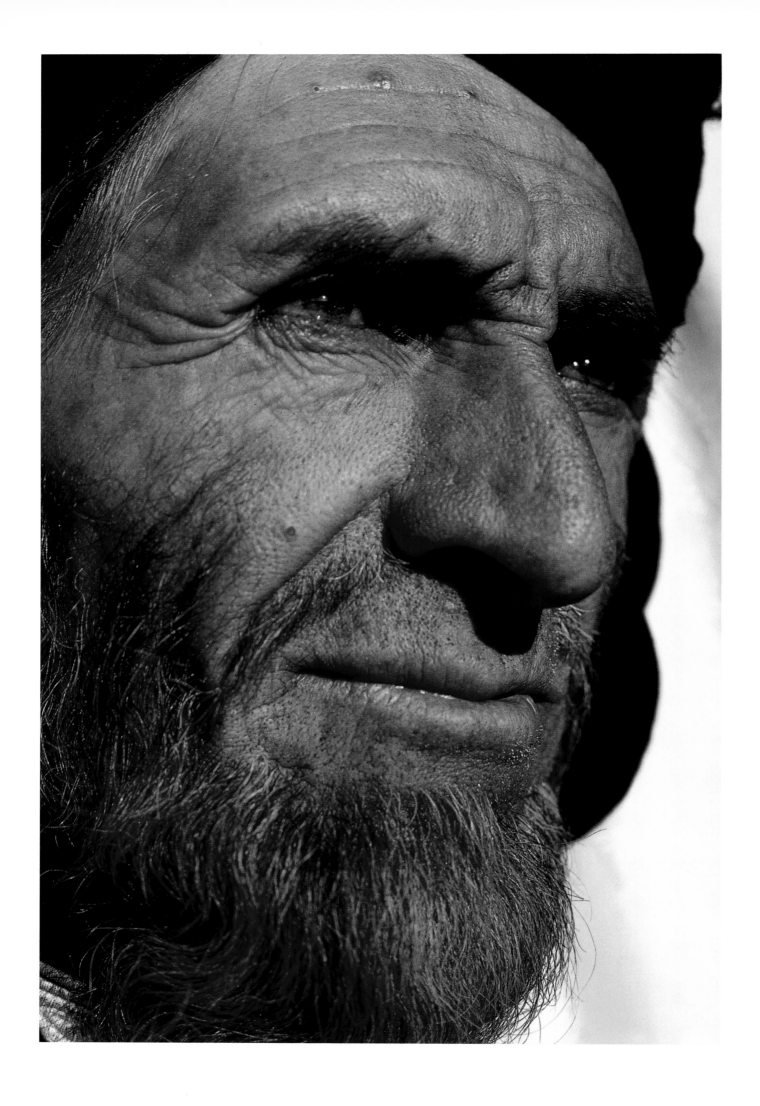

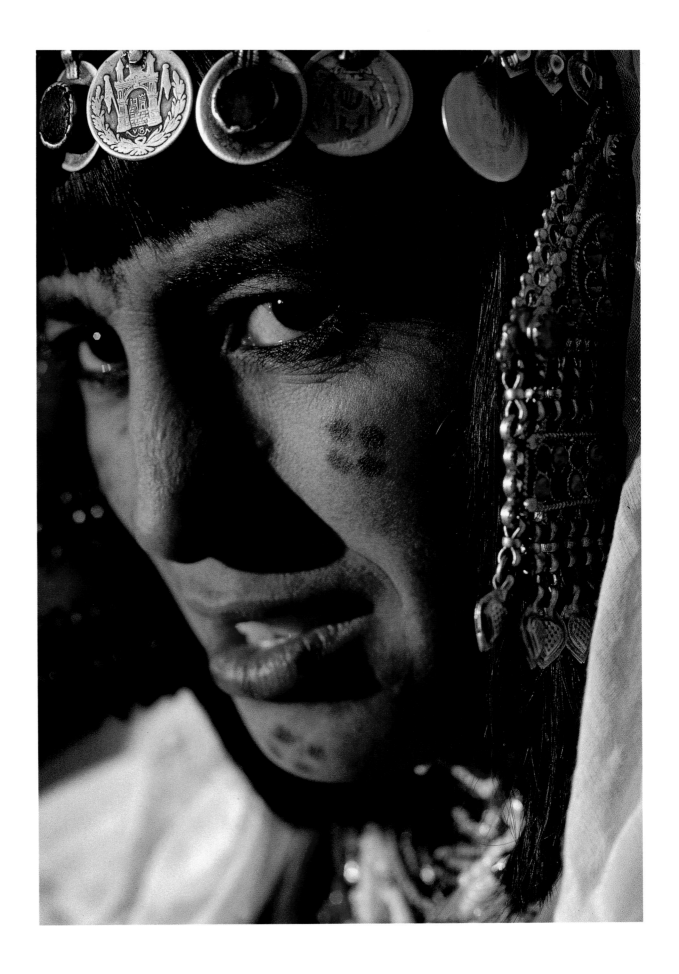

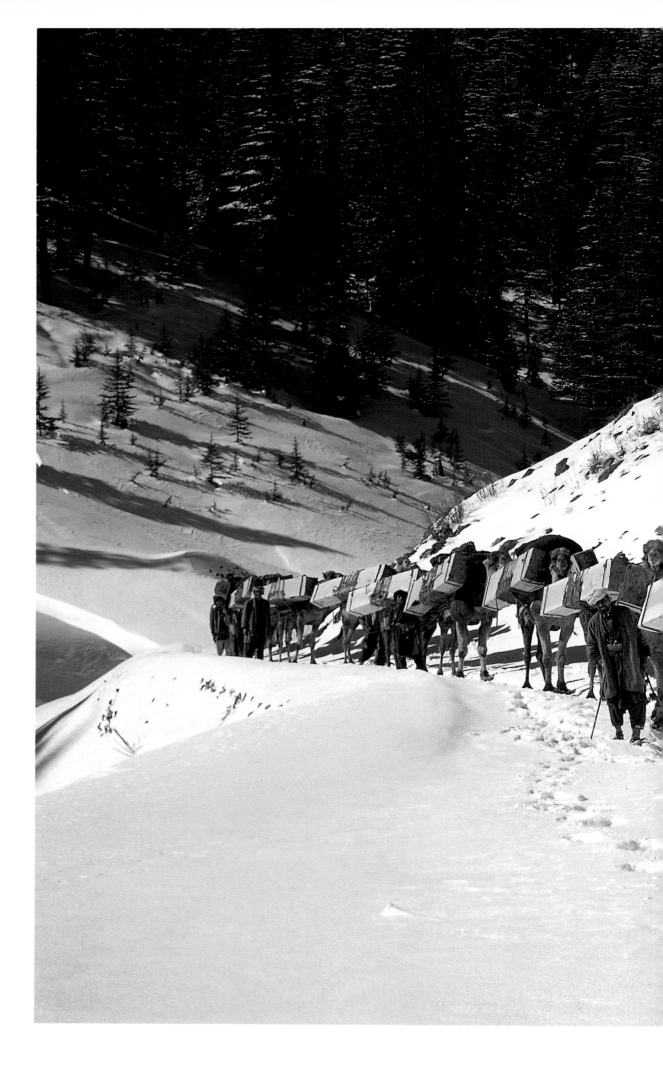

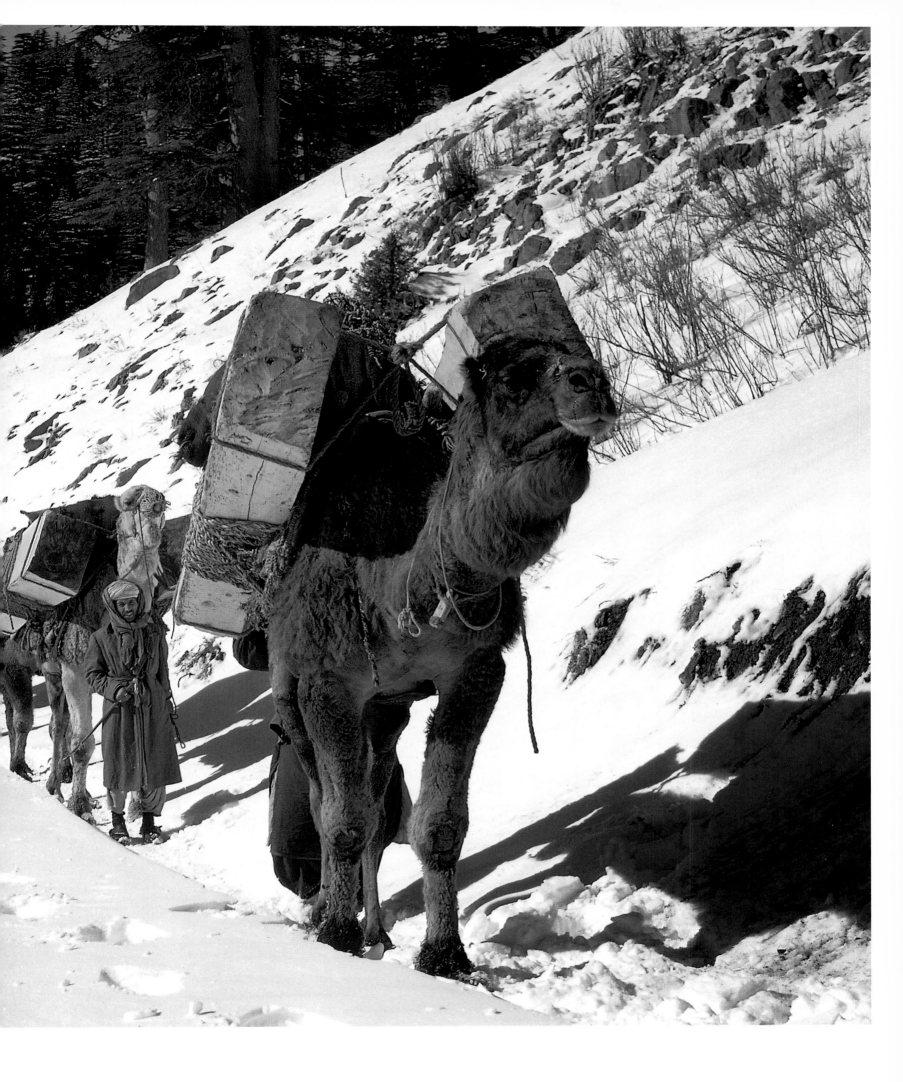

They call it Kafiristan.

By my reckoning it's the top right hand corner of Afghanistan,

not more than 300 miles from Peshawar…

It's one mass of mountains and peaks and glaciers…

and together we start forward into those bitter cold mountainous parts,

and never a road broader than the back of your hand.

RUDYARD KIPLING

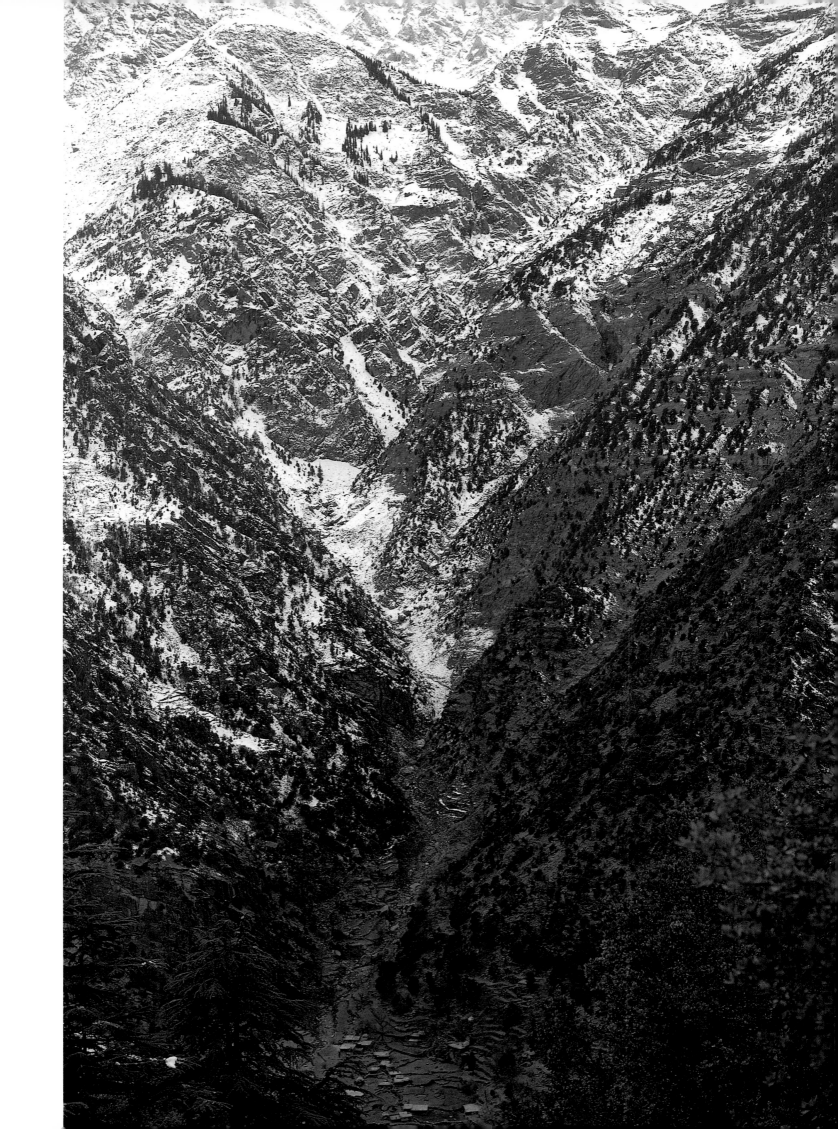

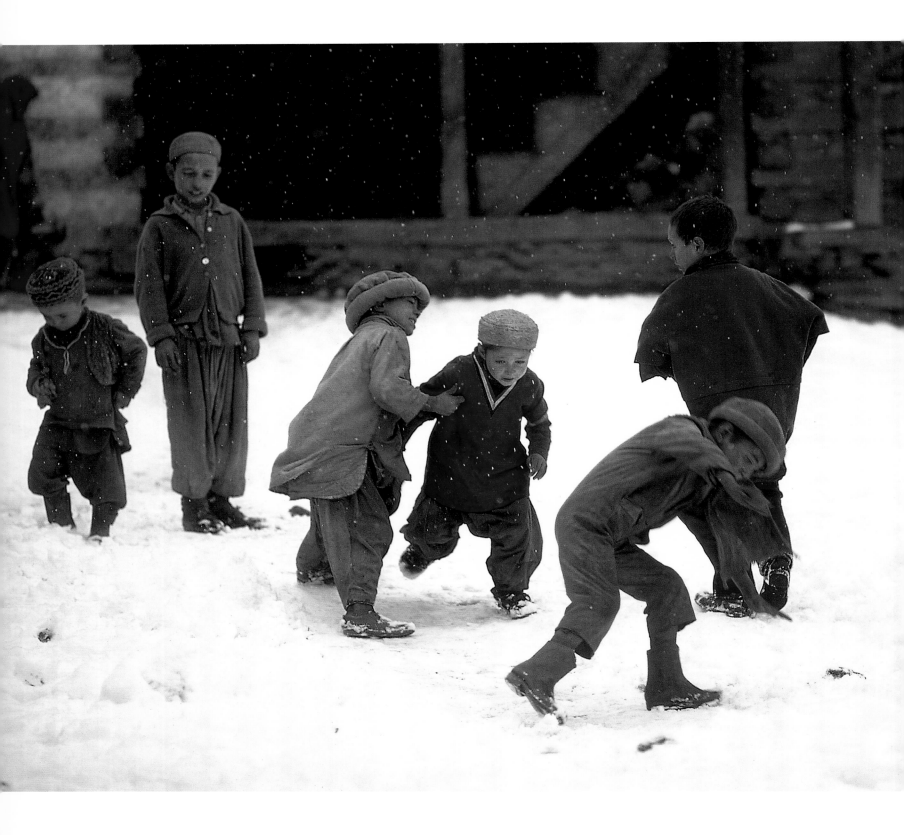

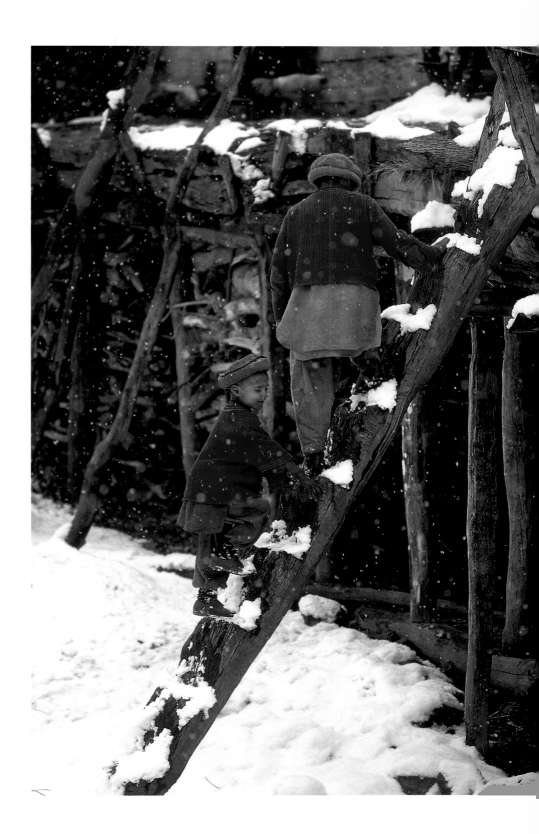

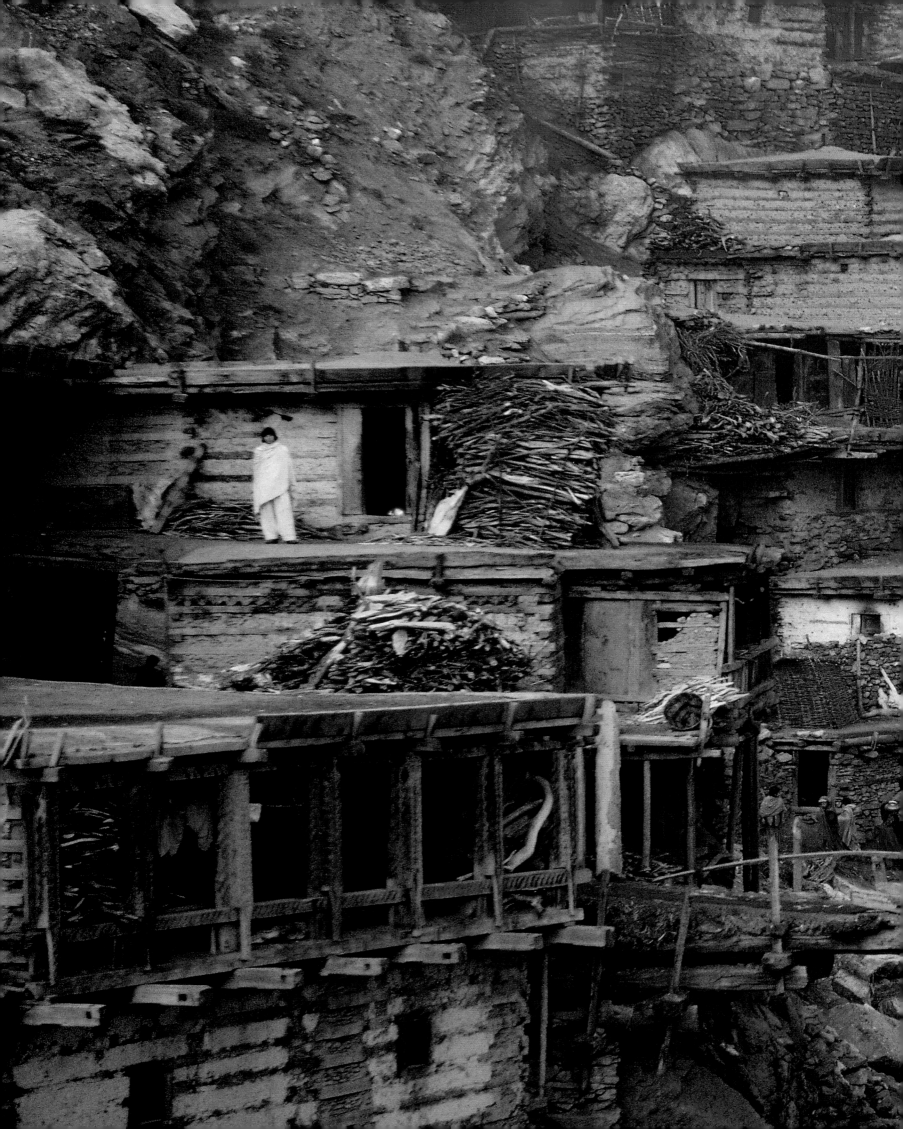

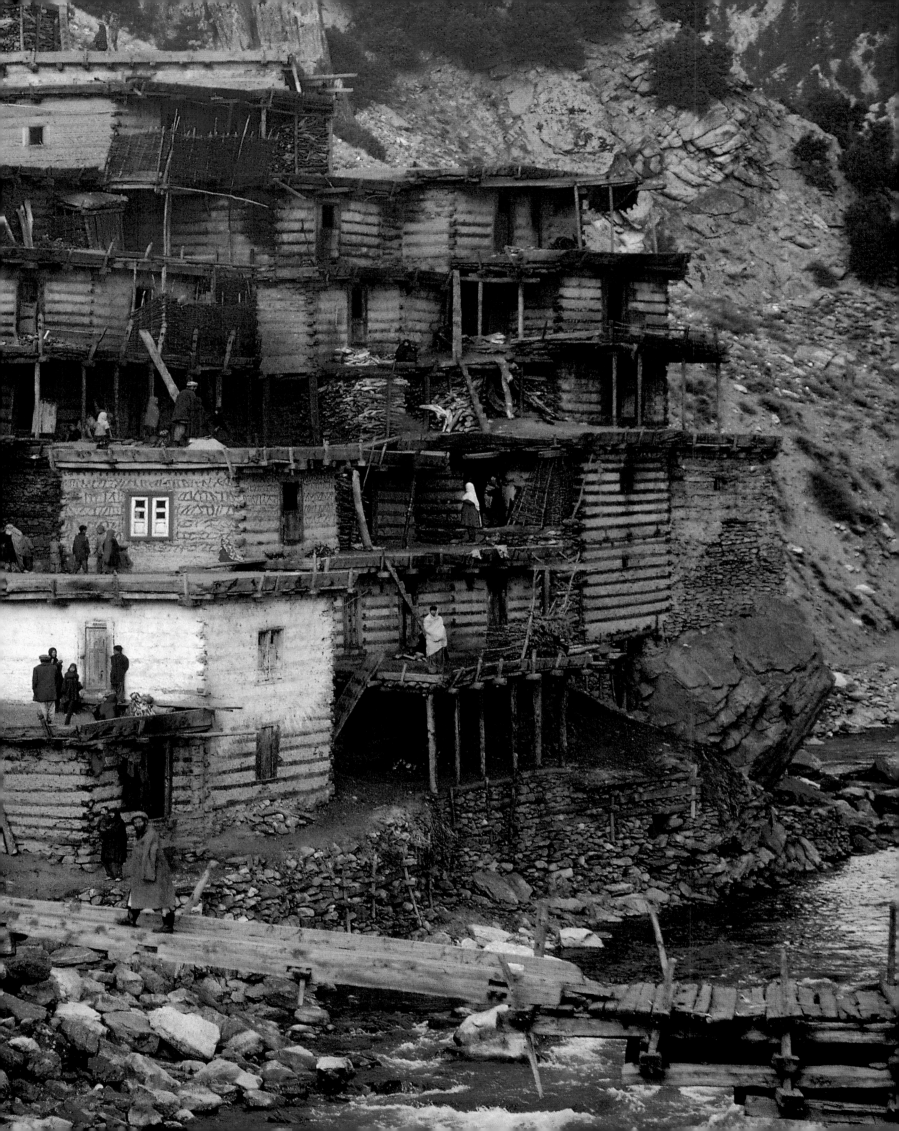

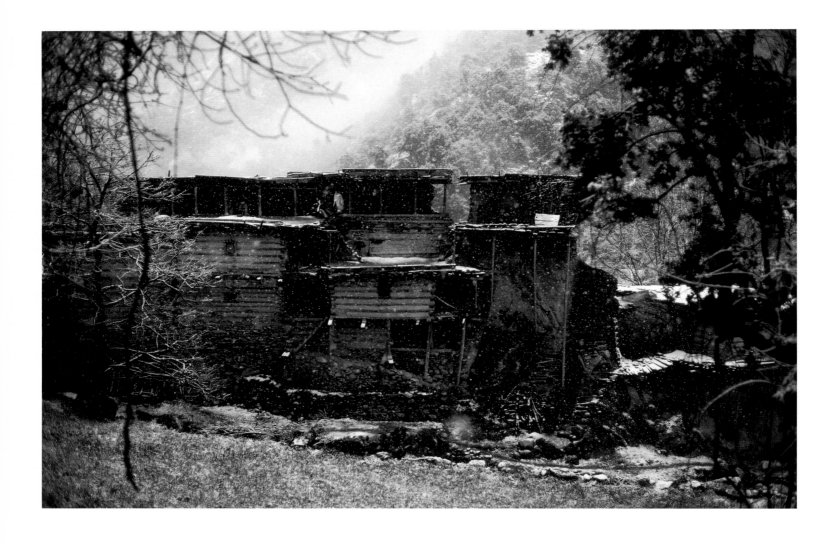

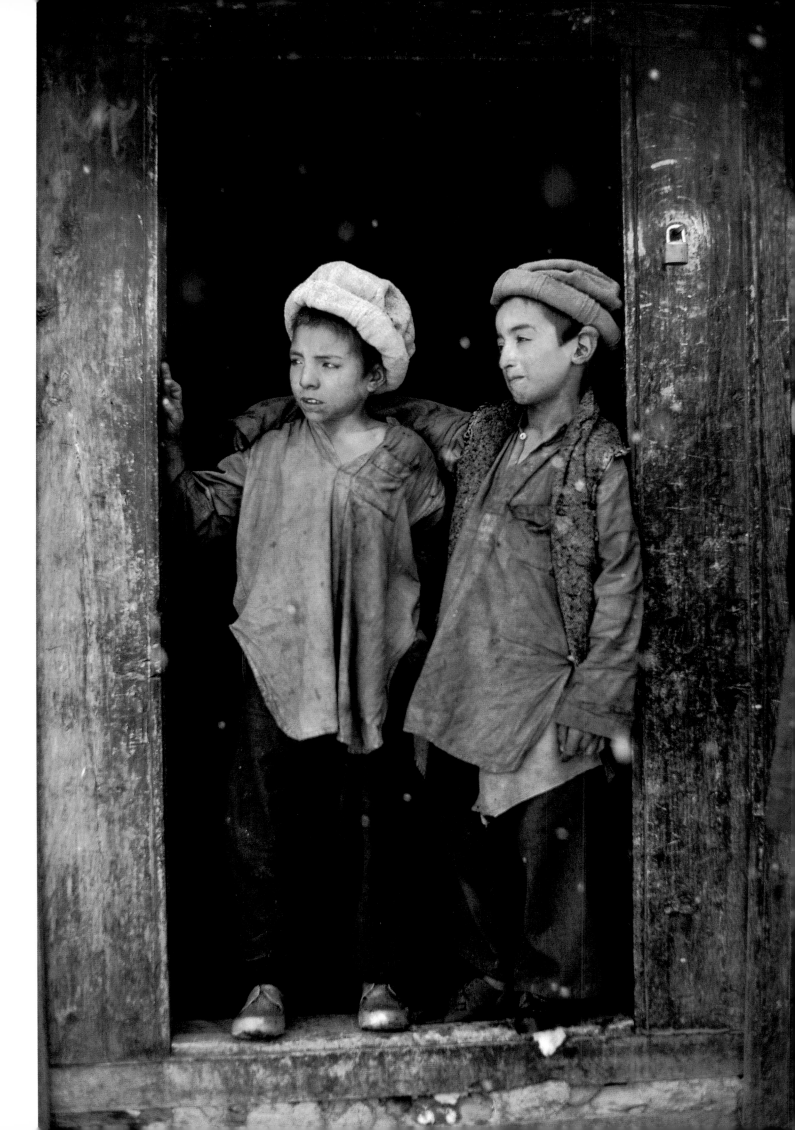

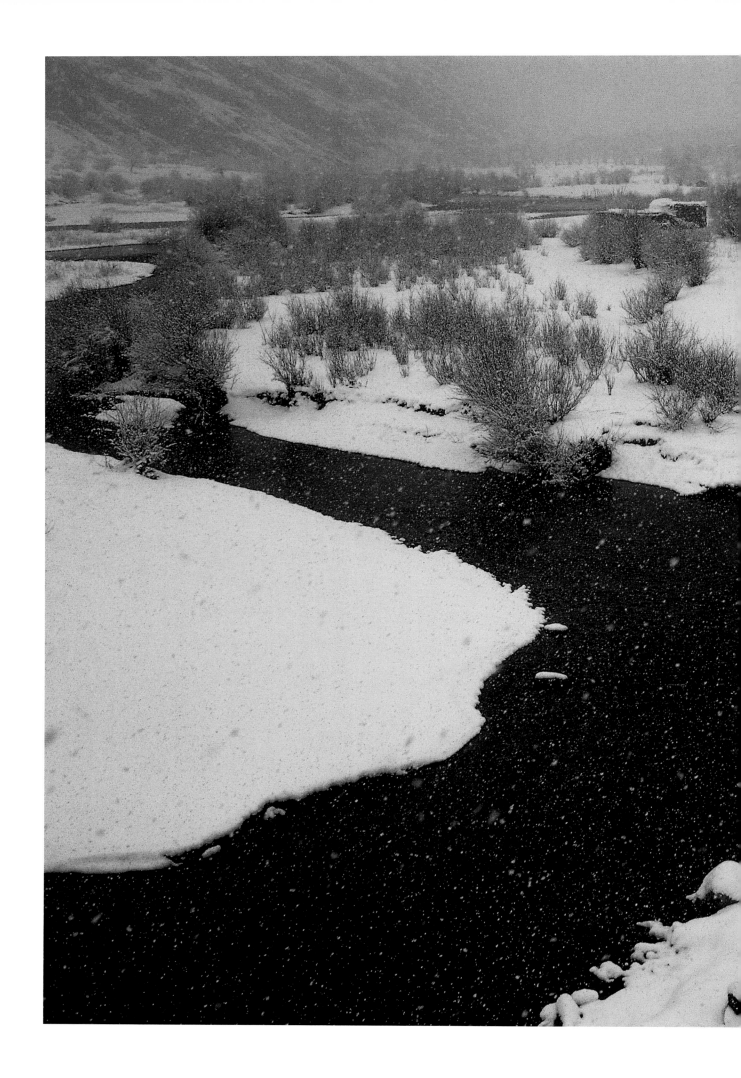

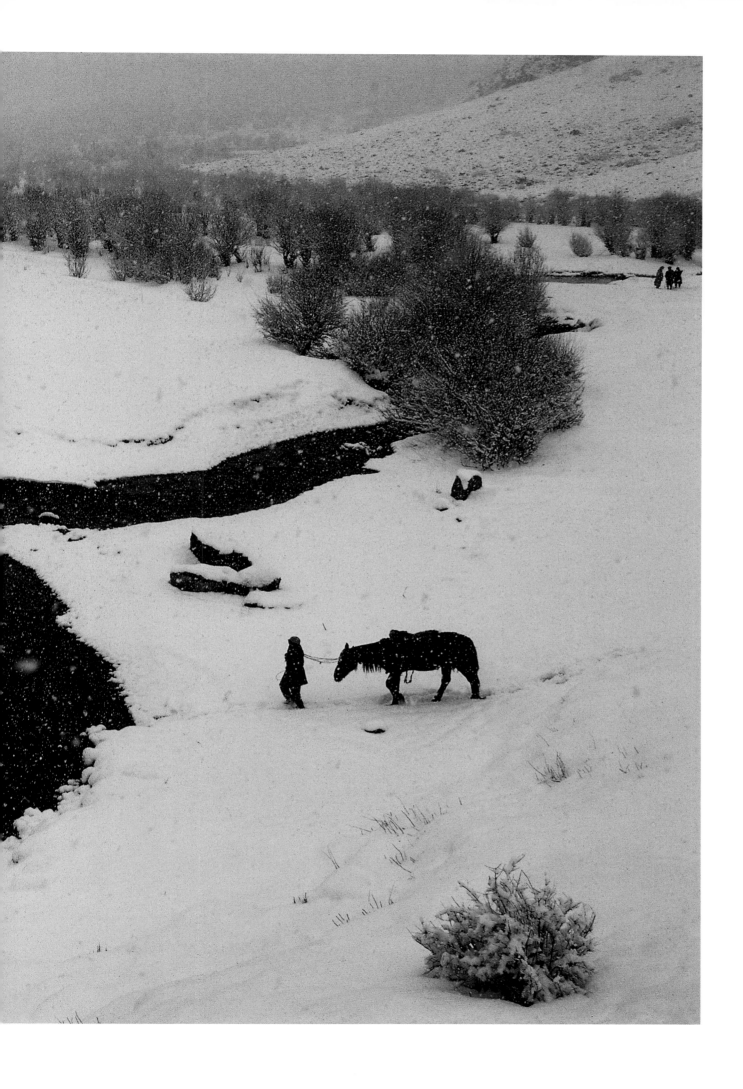

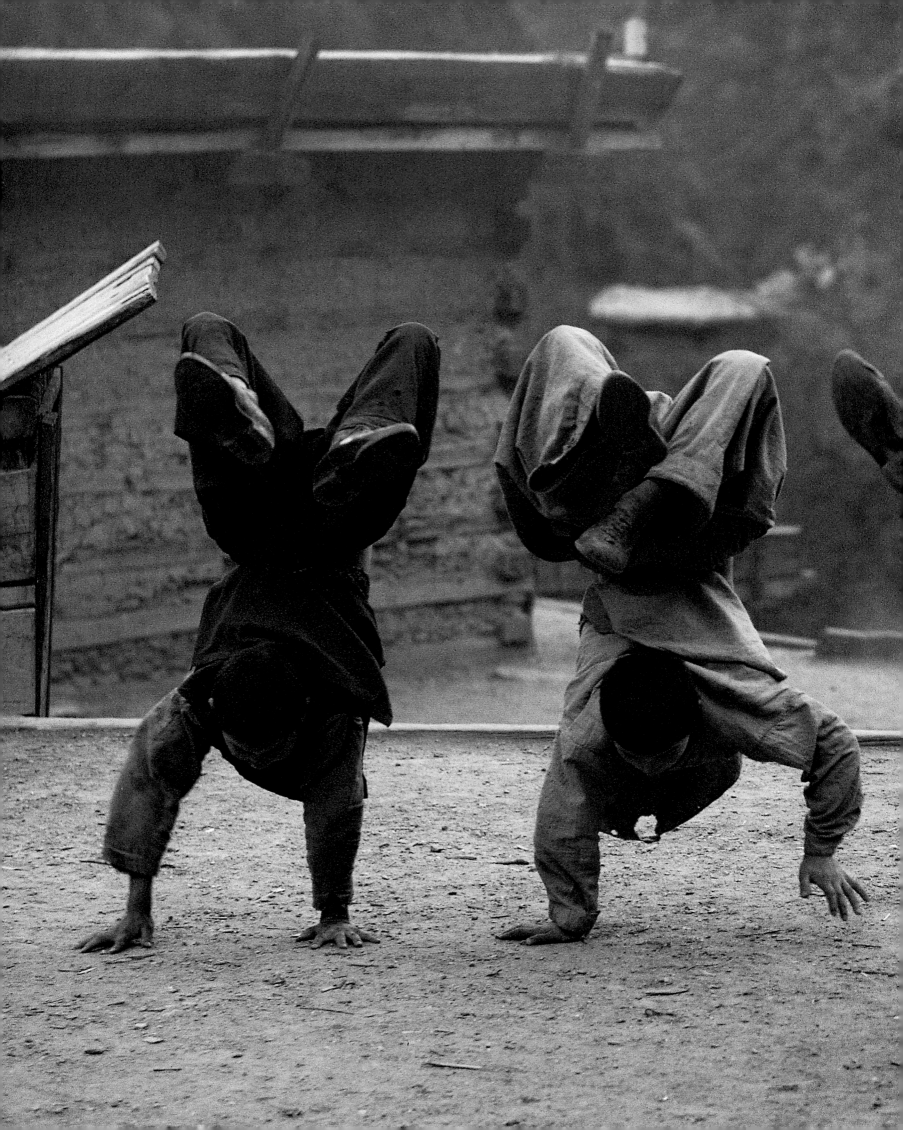

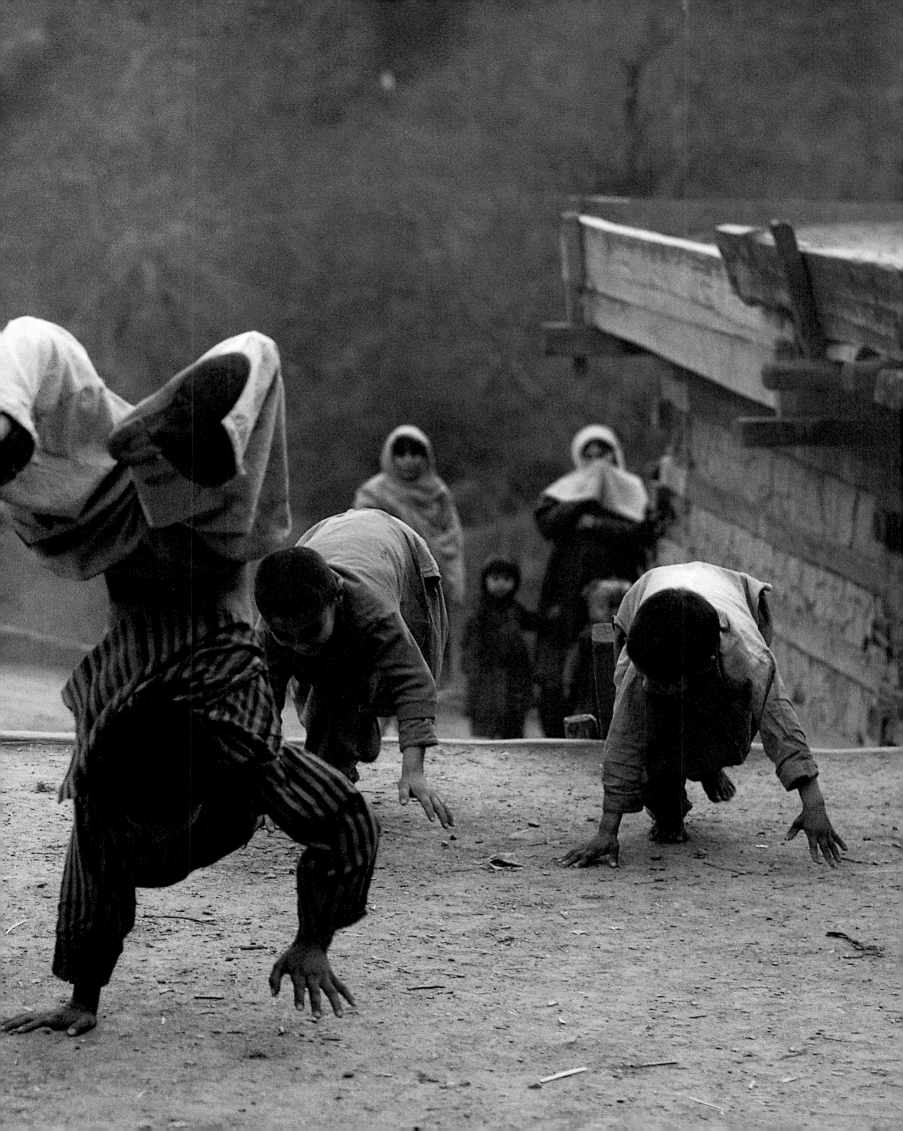

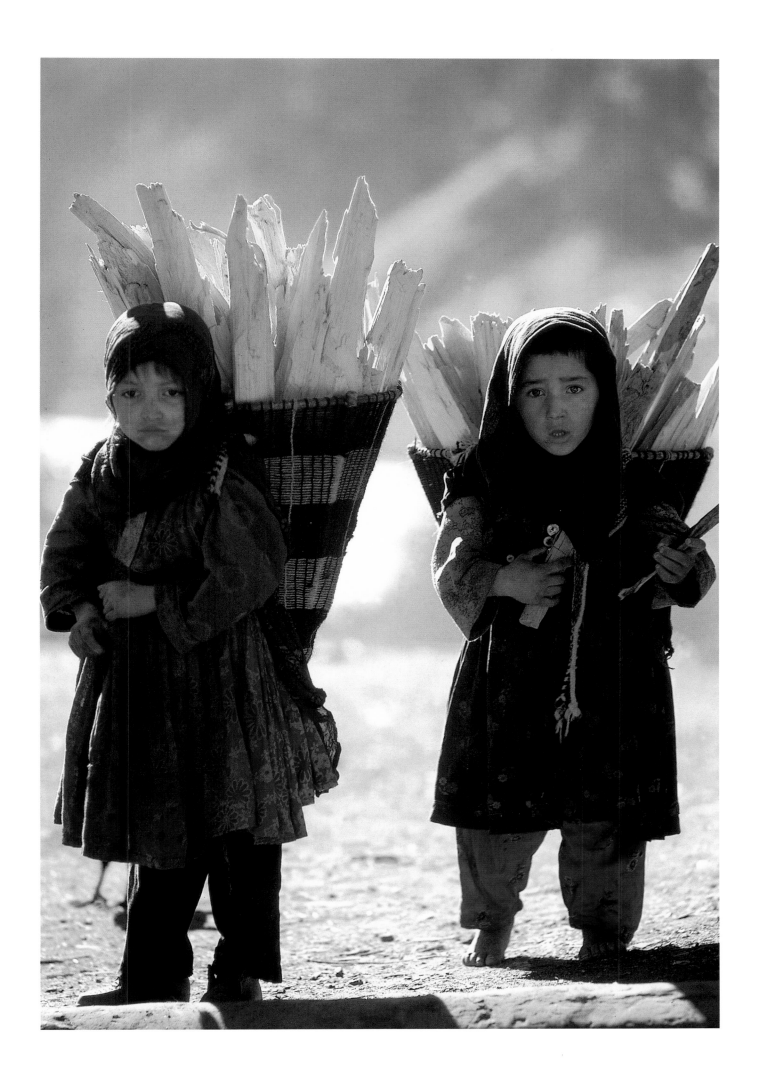

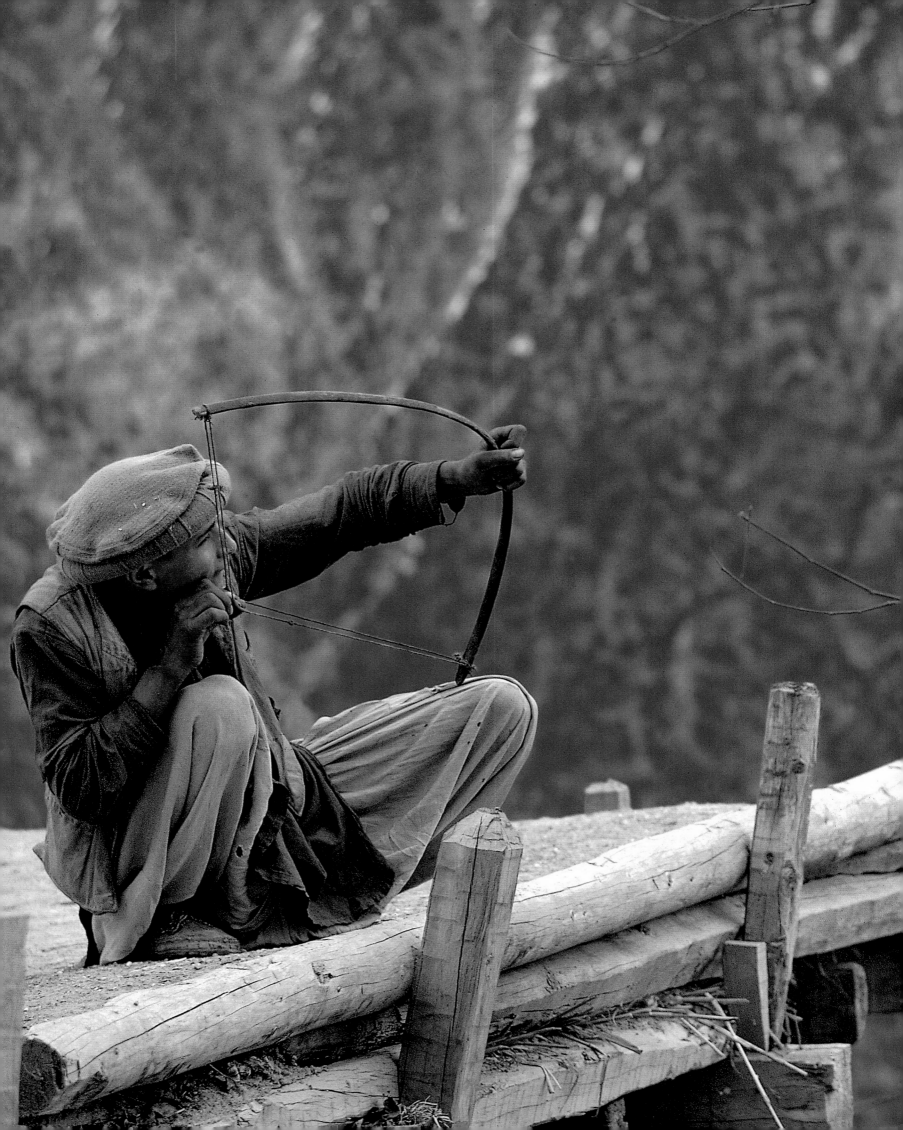

When the traveler from the south beholds Kabul,

its ring of poplars, its mauve mountains

where a fine layer of snow is smoking, and the kites

that vibrate in the autumn sky above the bazaar,

he flatters himself on that he has come to the end of the world.

On the contrary, he has just reached its center.

NICOLAS BOUVIER

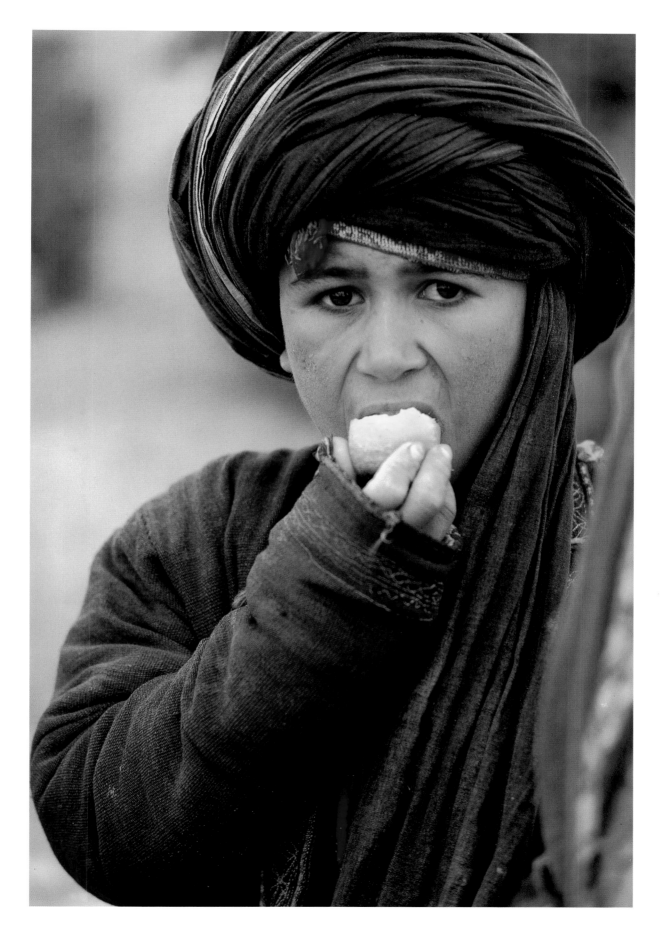

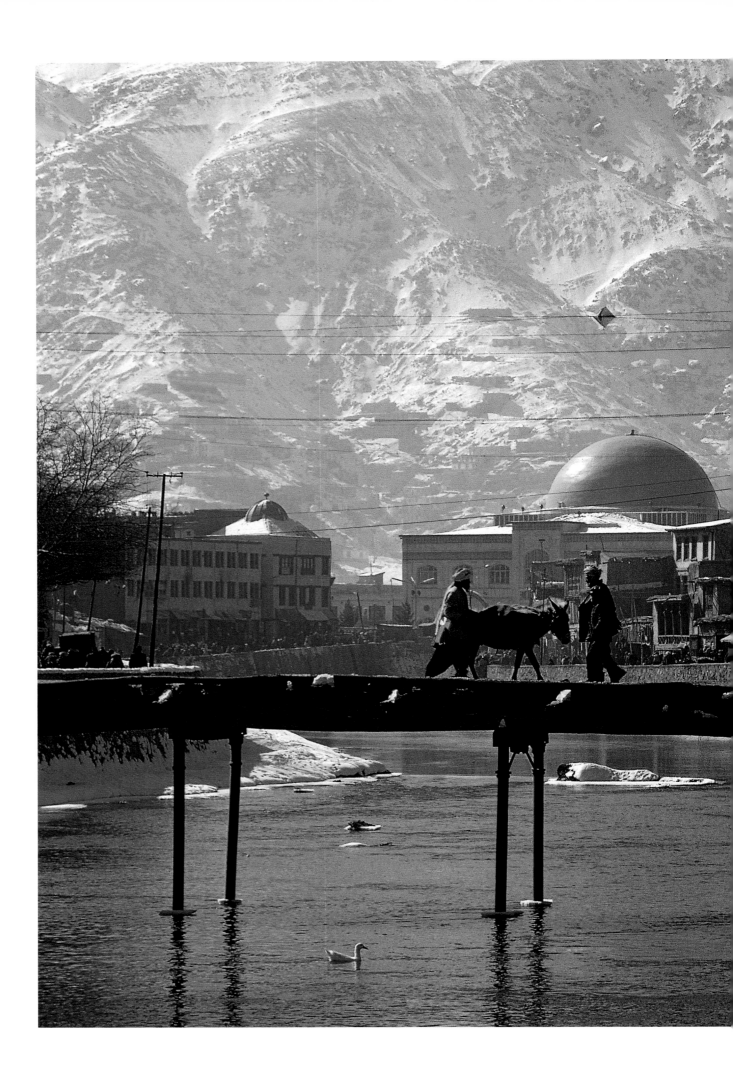

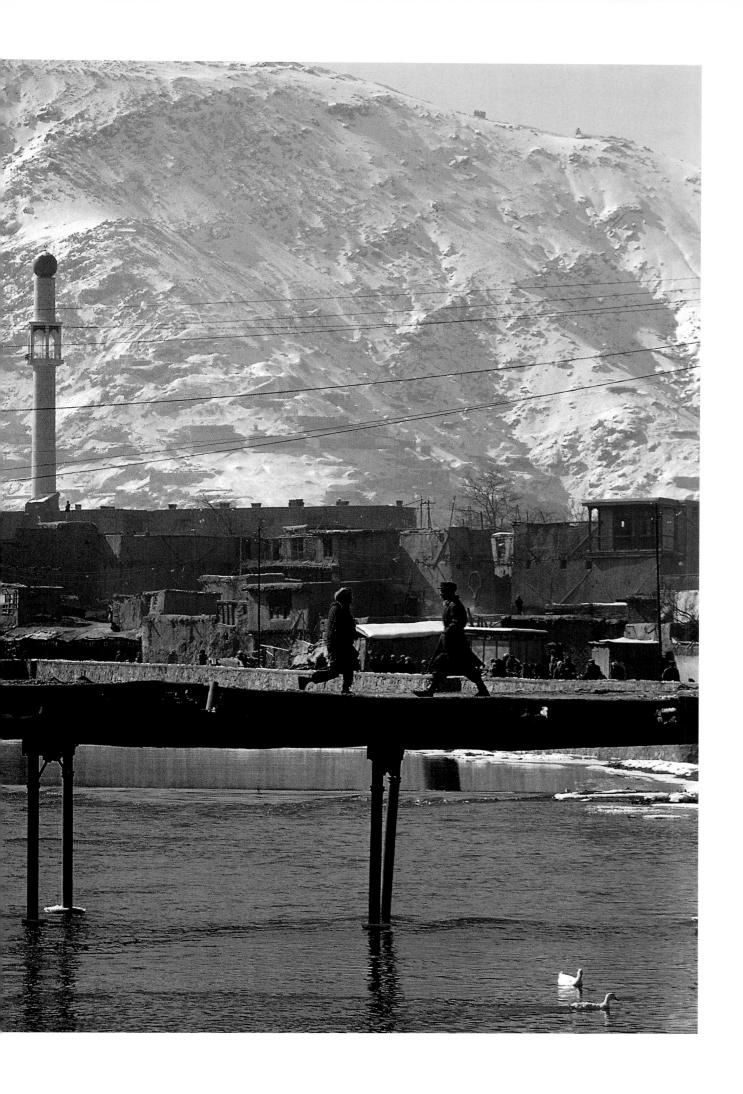

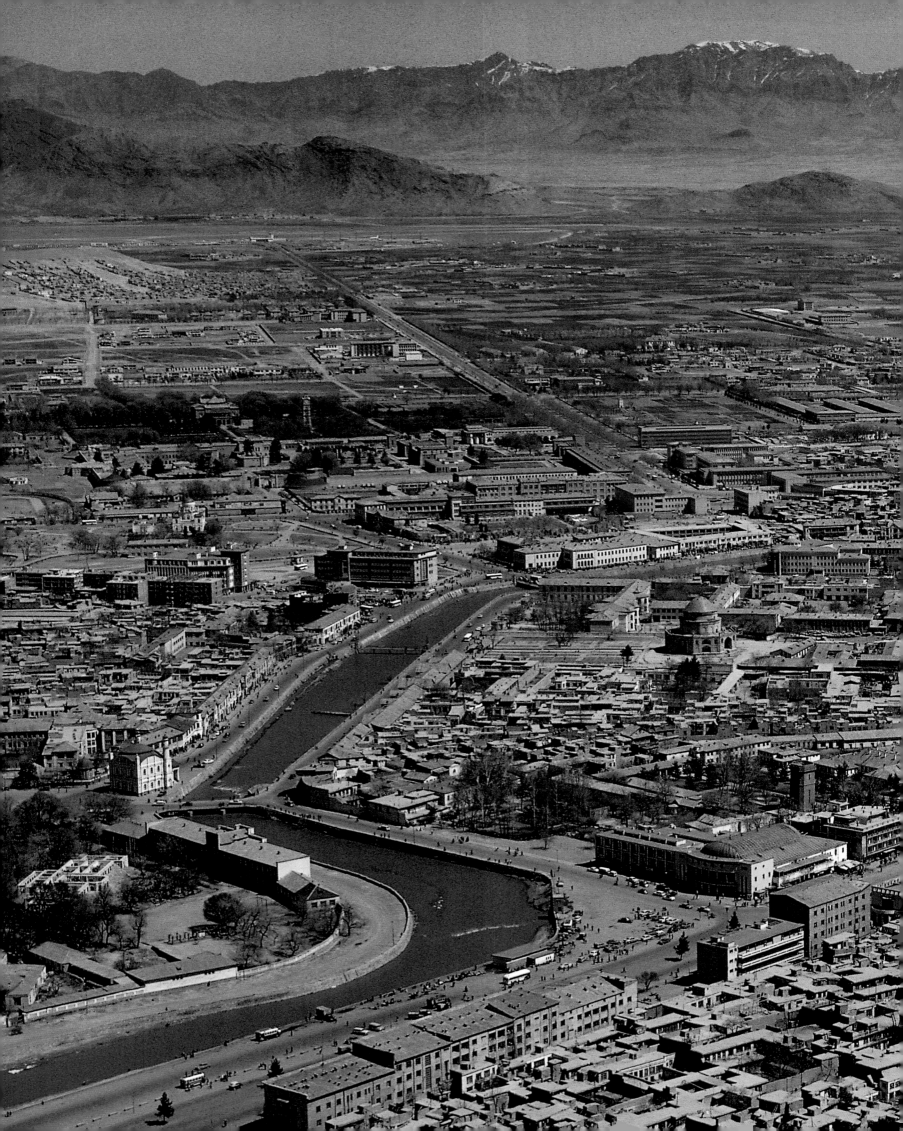

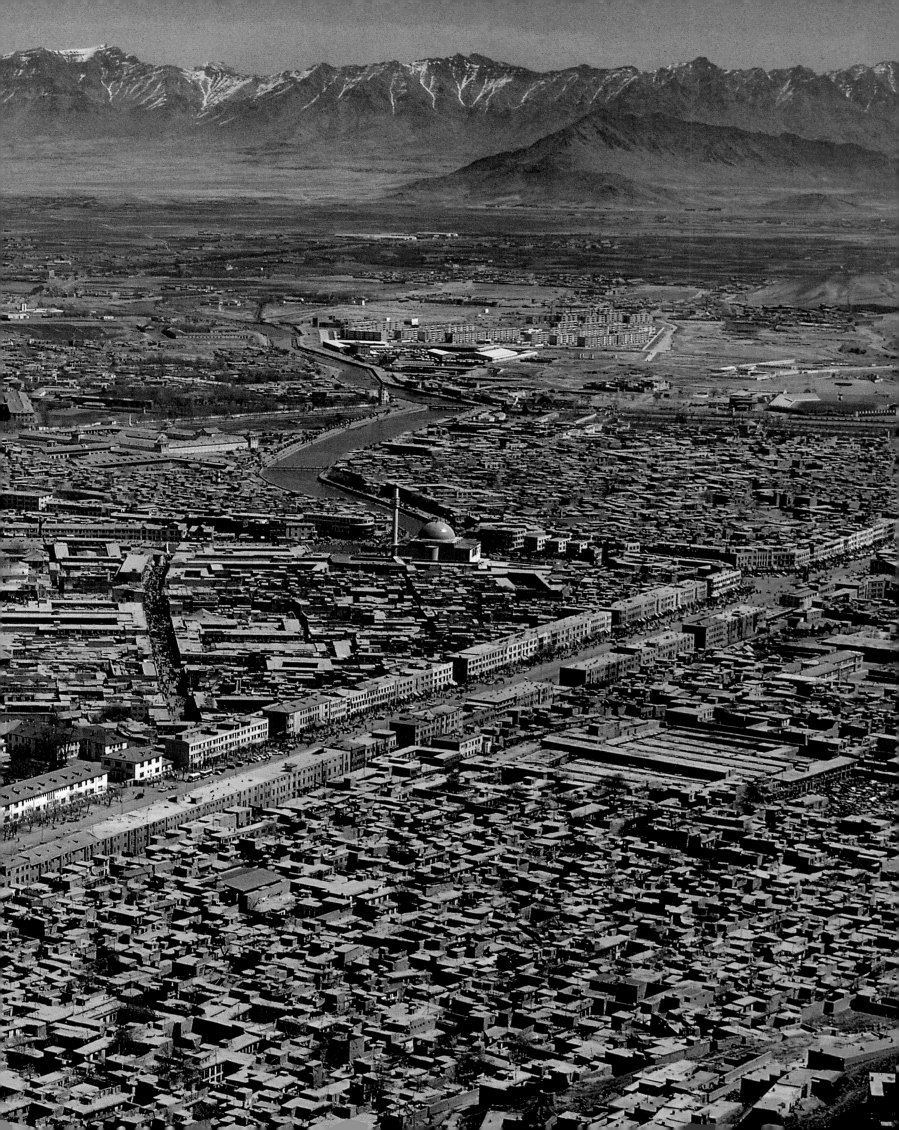

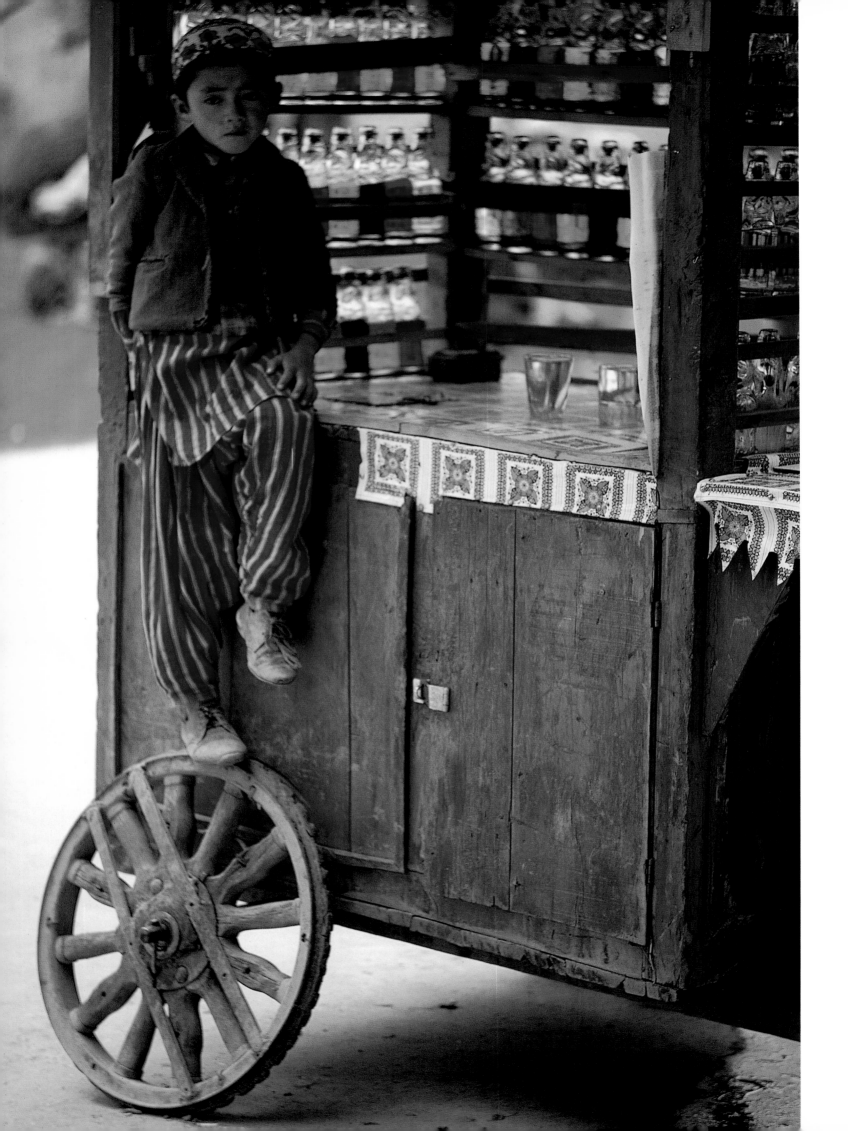

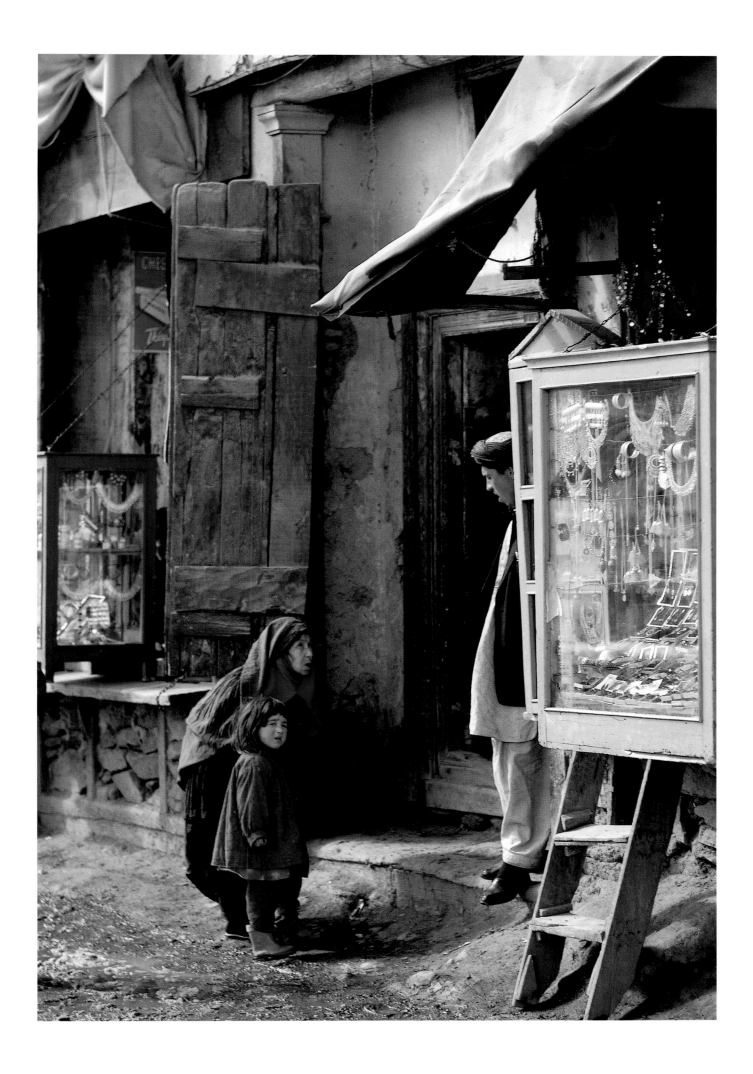

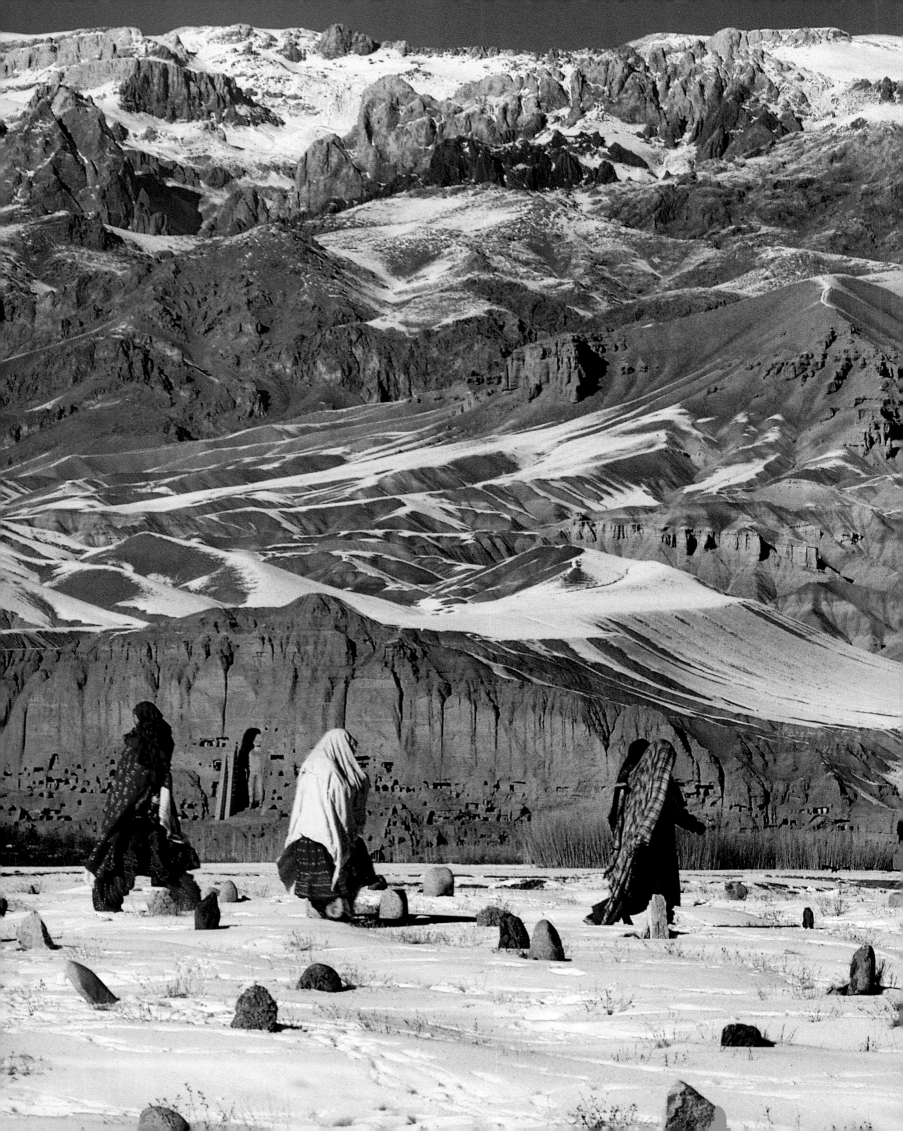

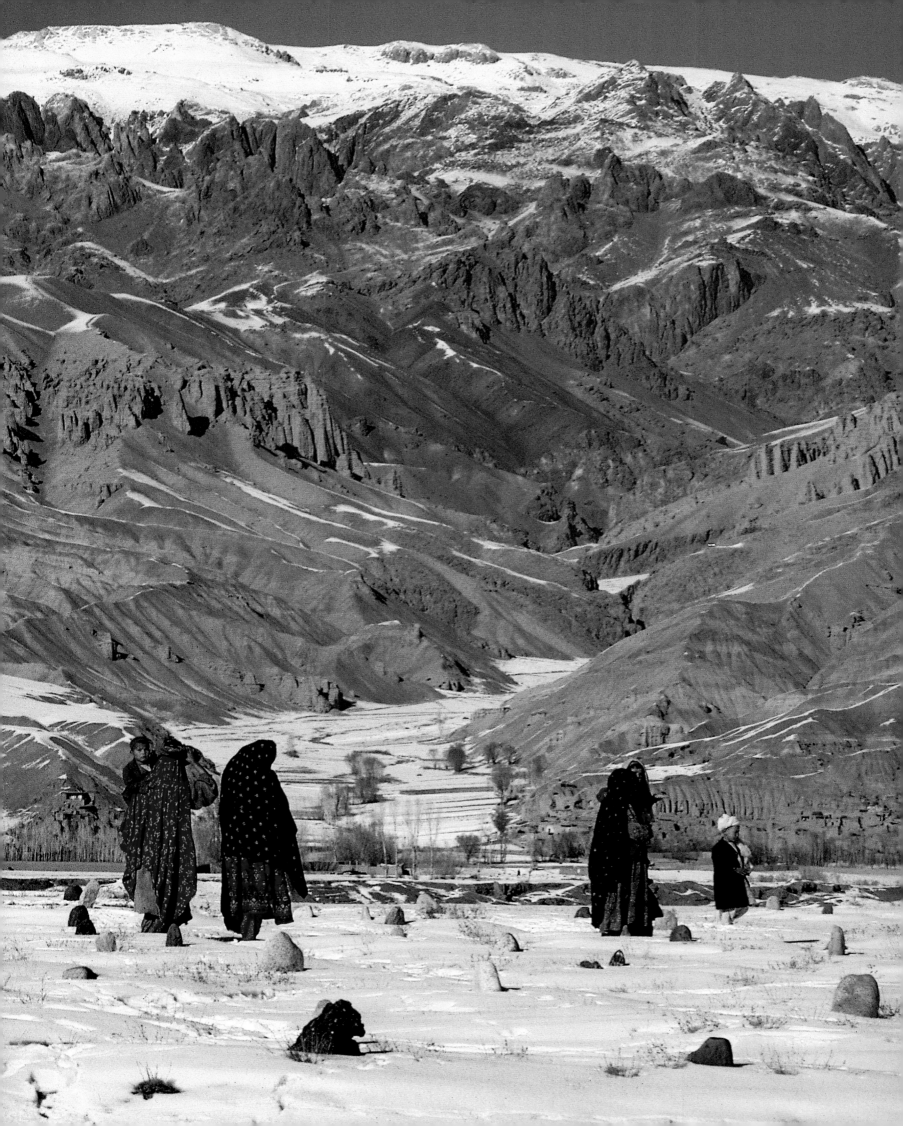

The traveller surveying from the height of Ghūlghūleh,

the vast and mysterious idols, and the multitude of caves around him,

will scarcely fail to be absorbed in deep reflection

and wonder.…The desolate spot itself

has a peculiar solemnity,

not merely from its lovely and startling evidences of past grandeur,

but because nature appears to have invested it

with a character of mystery and awe.

CHARLES MASSON

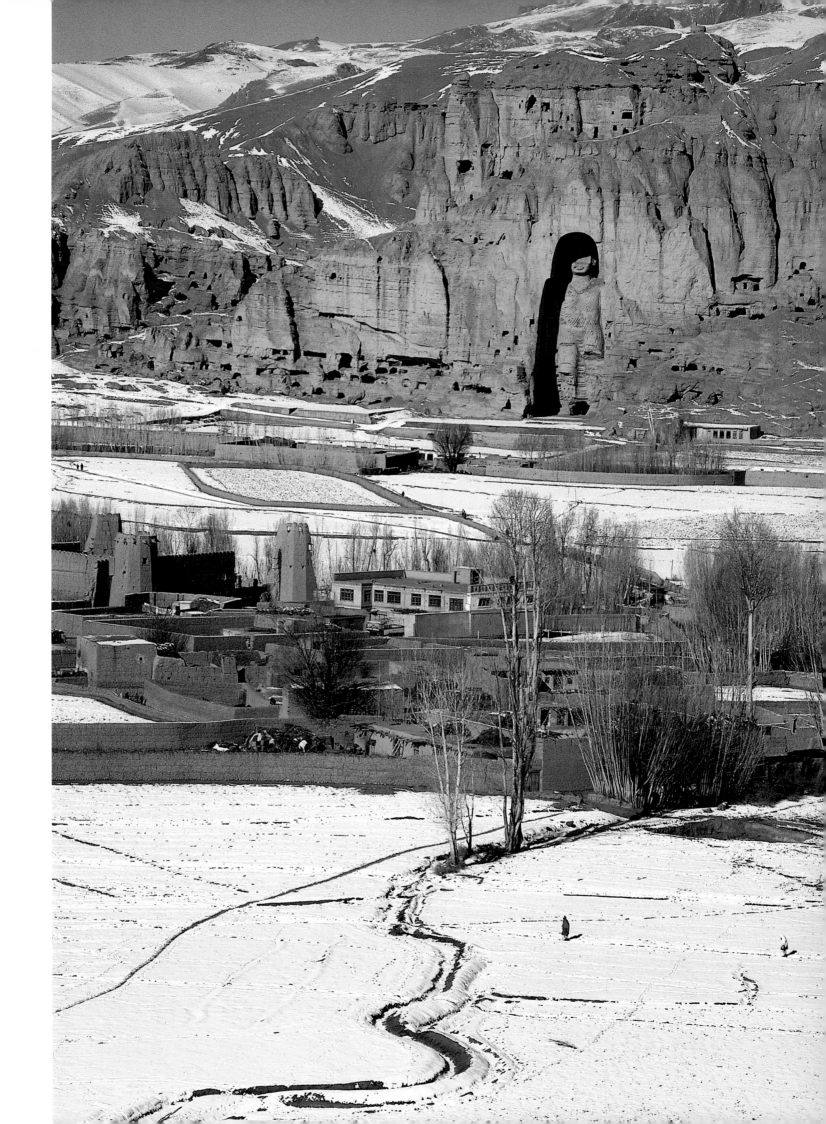

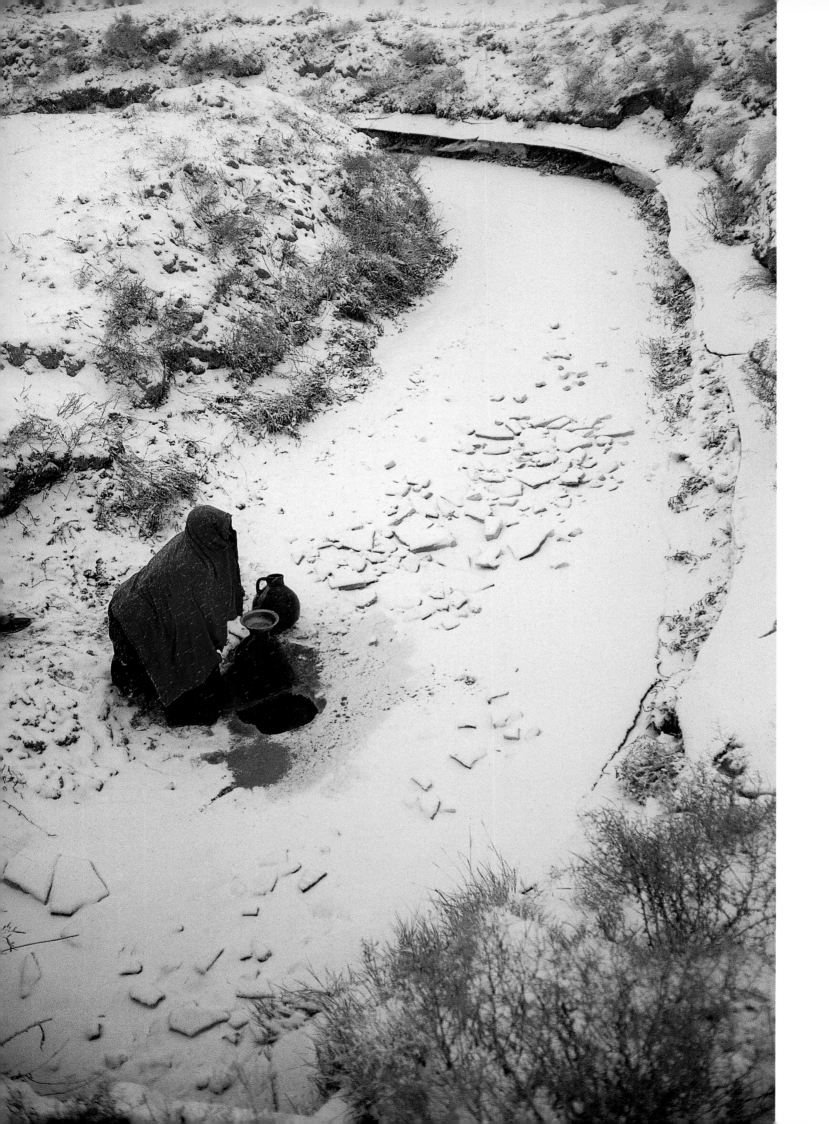

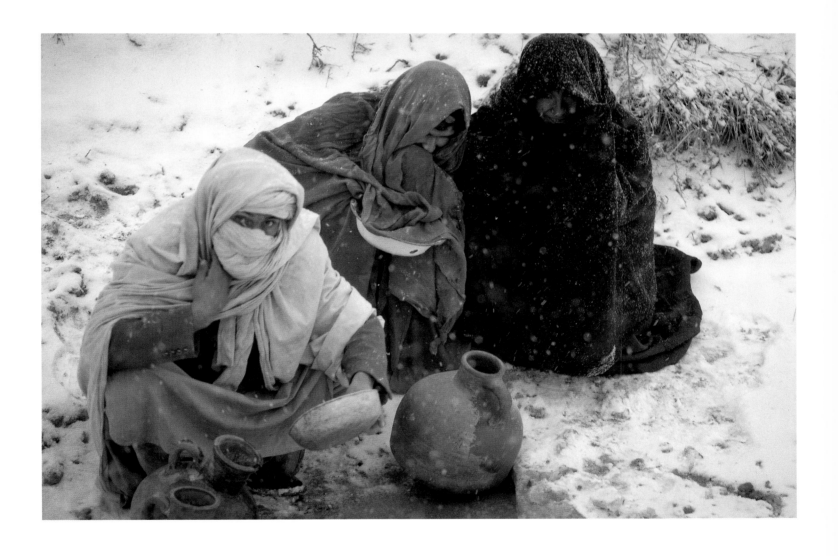

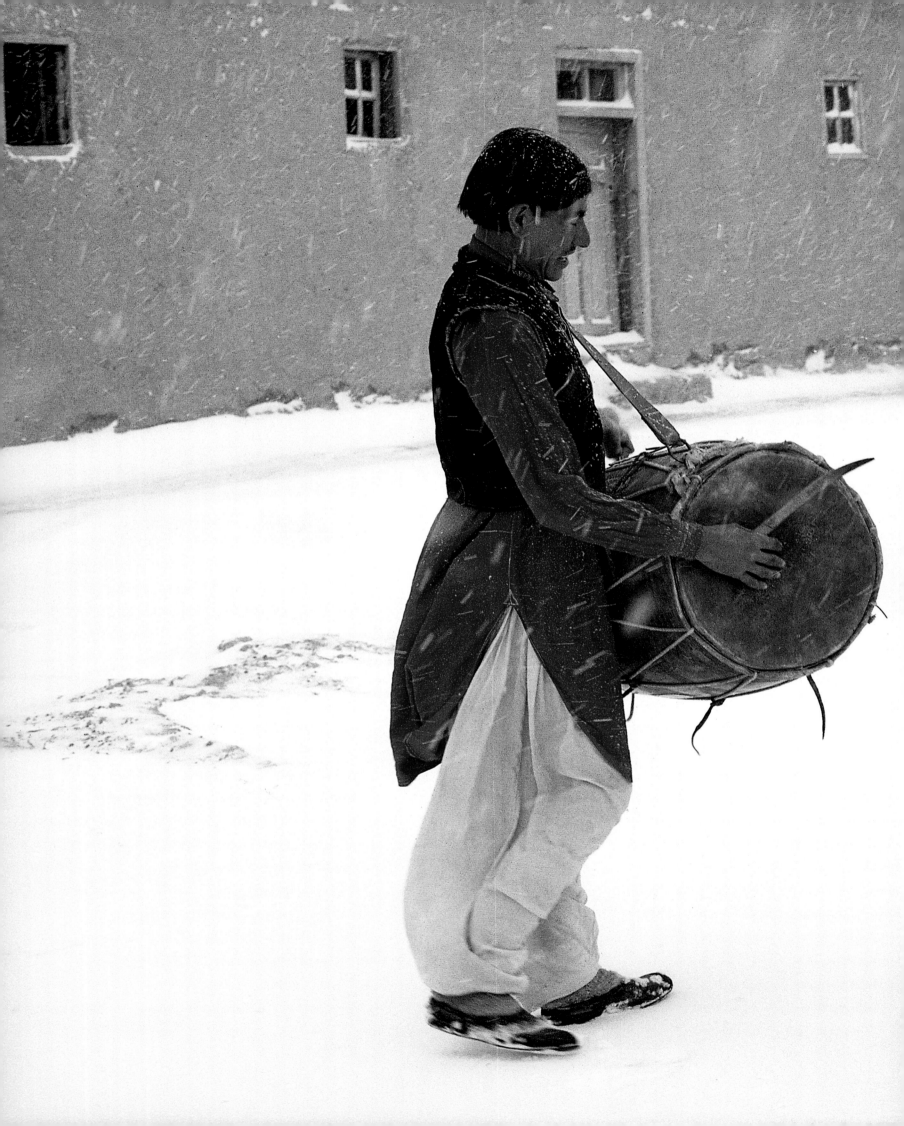

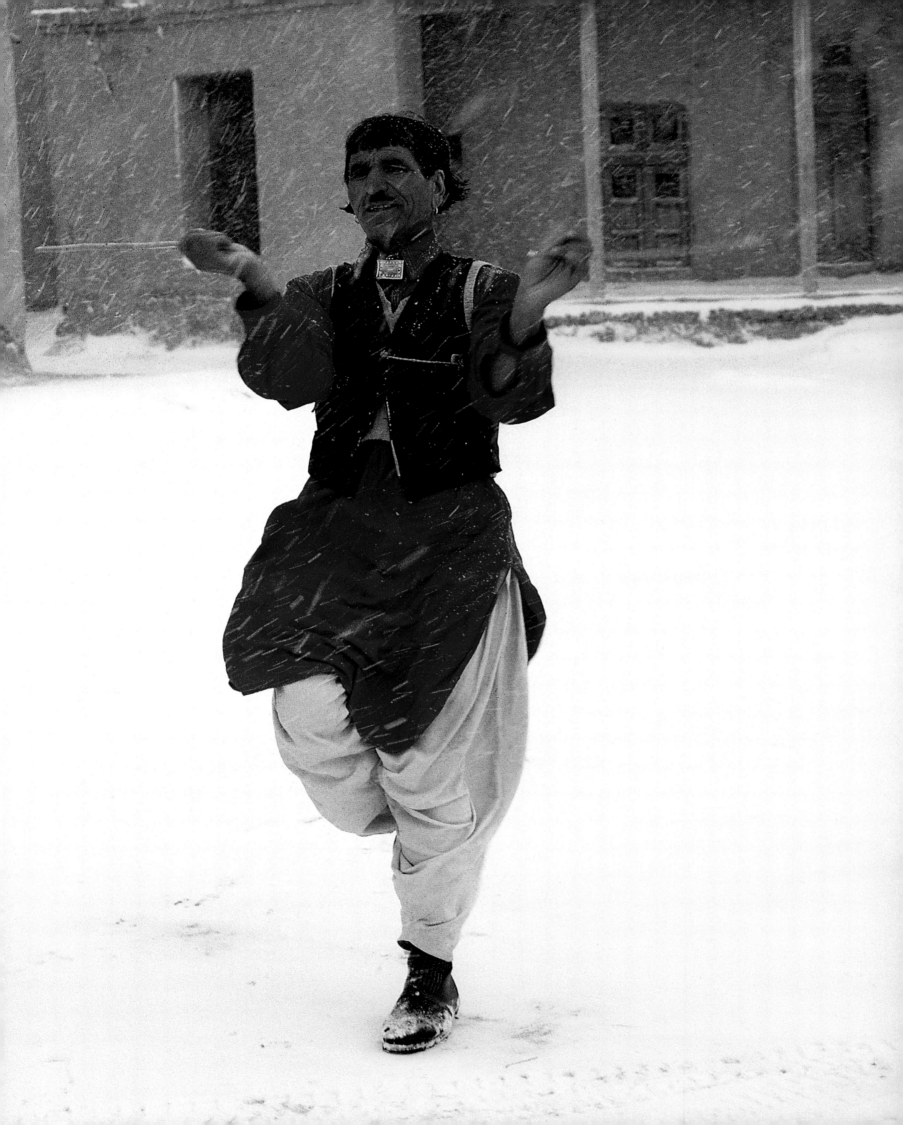

I am a wisp of straw to you,

O violent wind:

how can I know where I will fall?

RŪMĪ

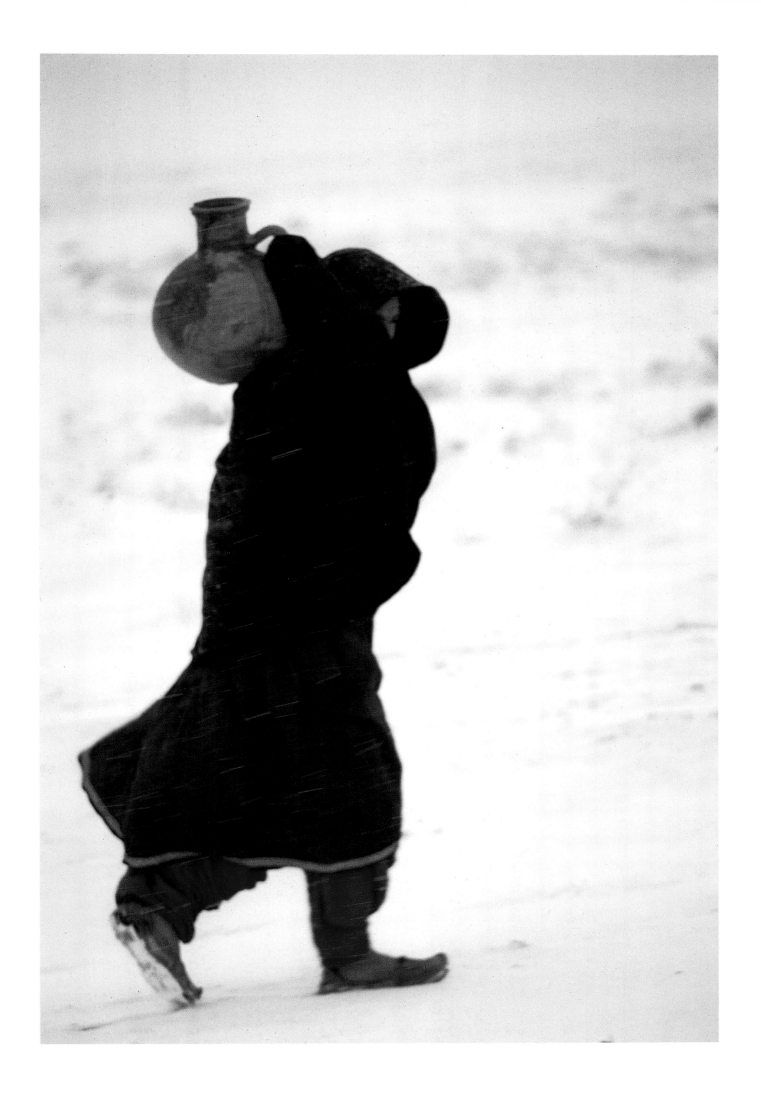

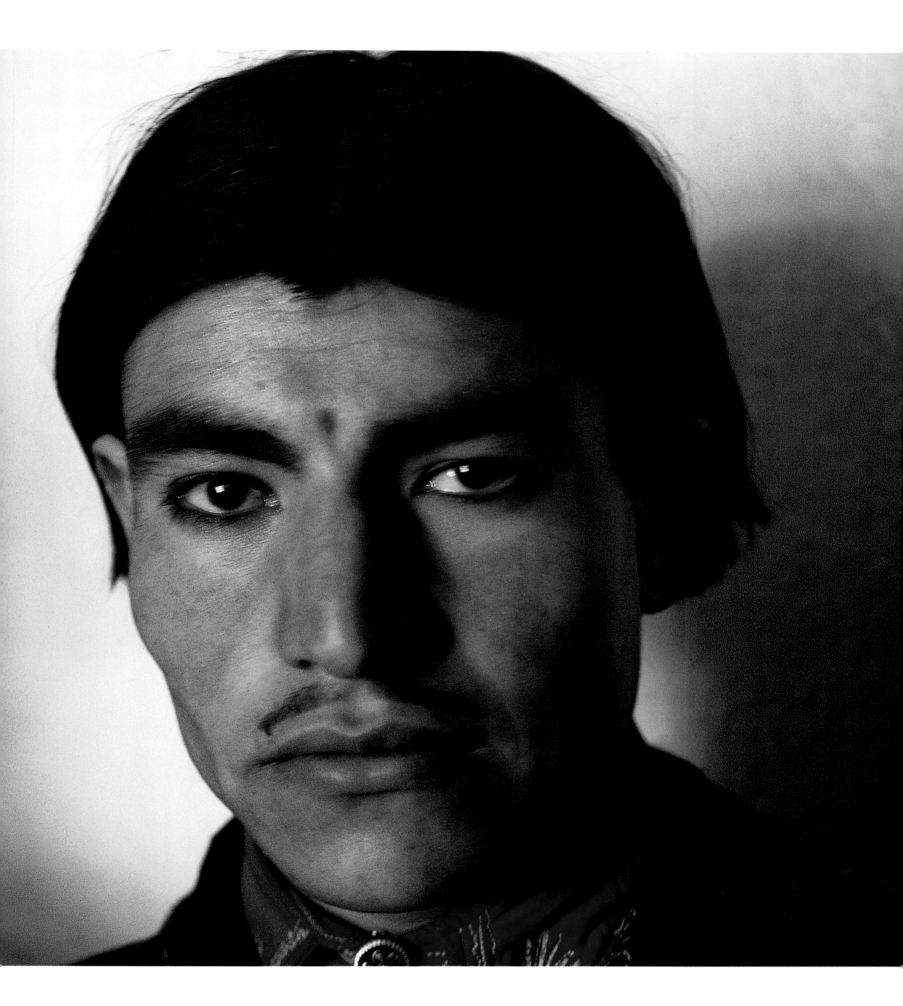

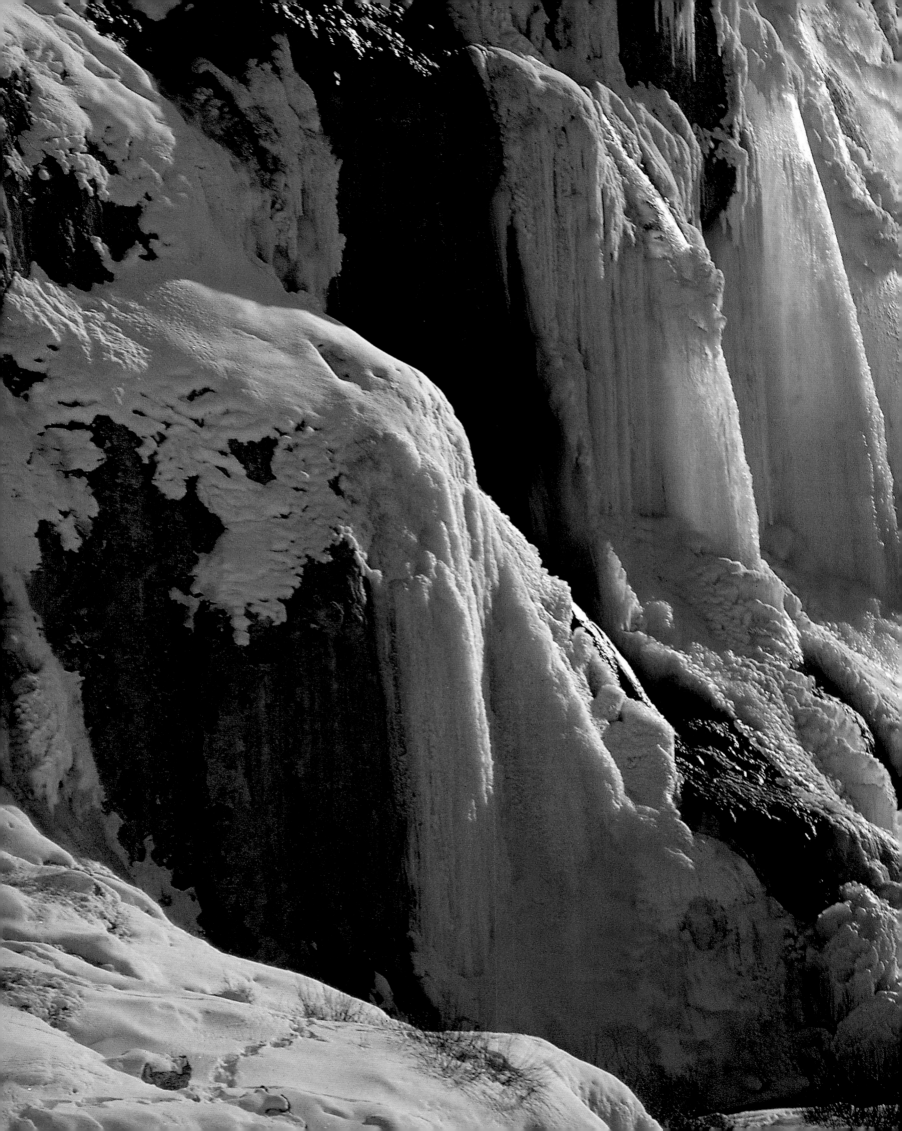

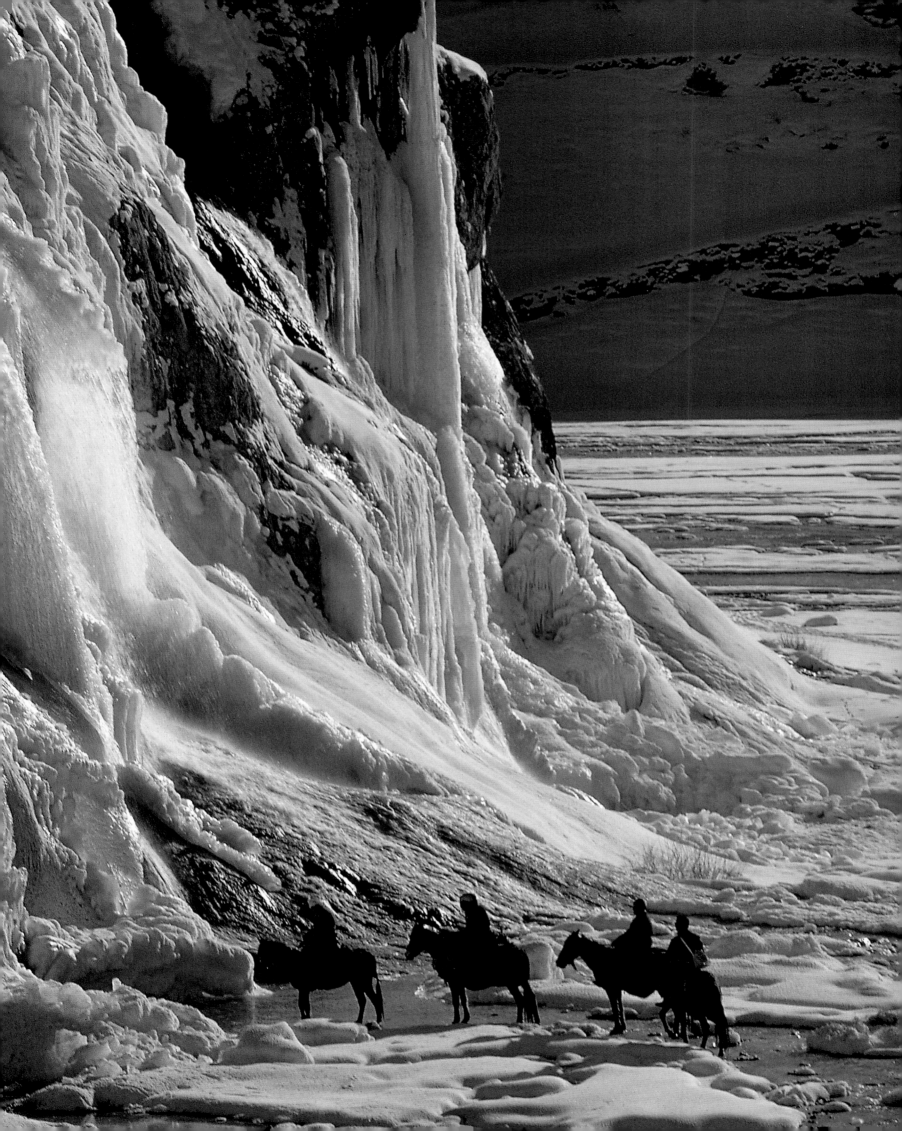

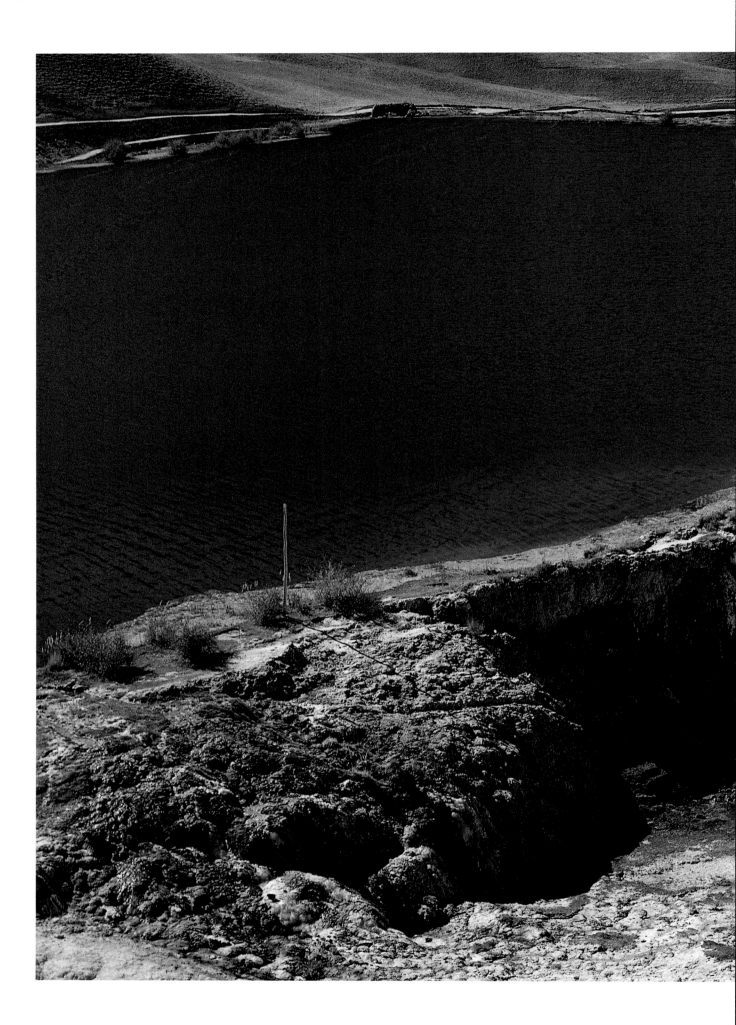

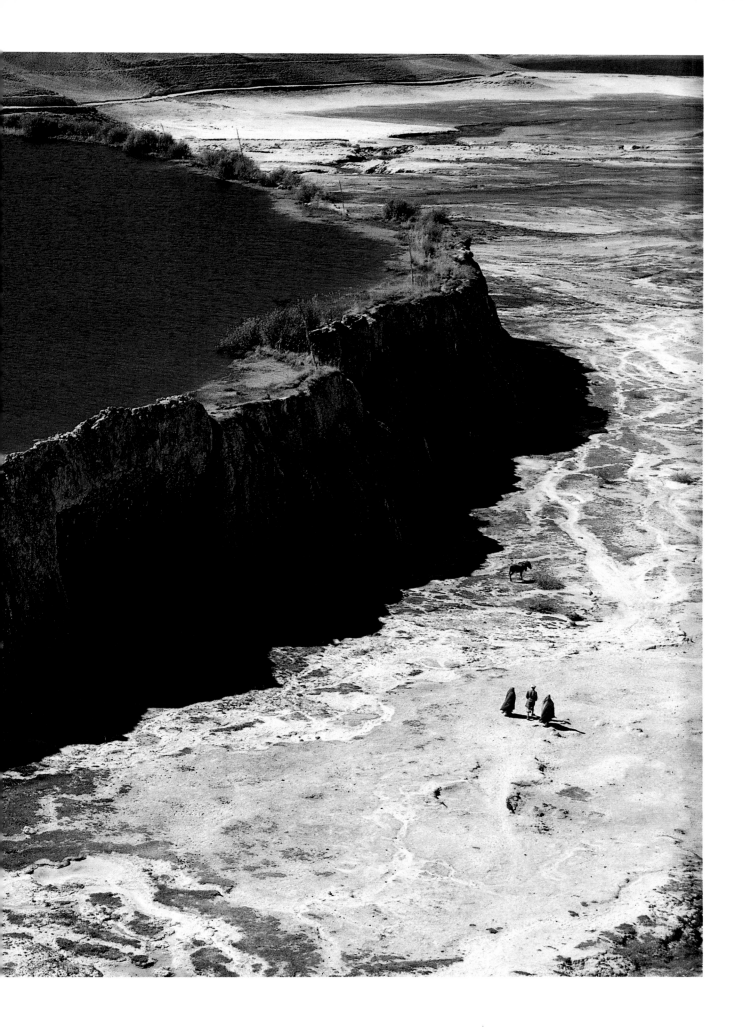

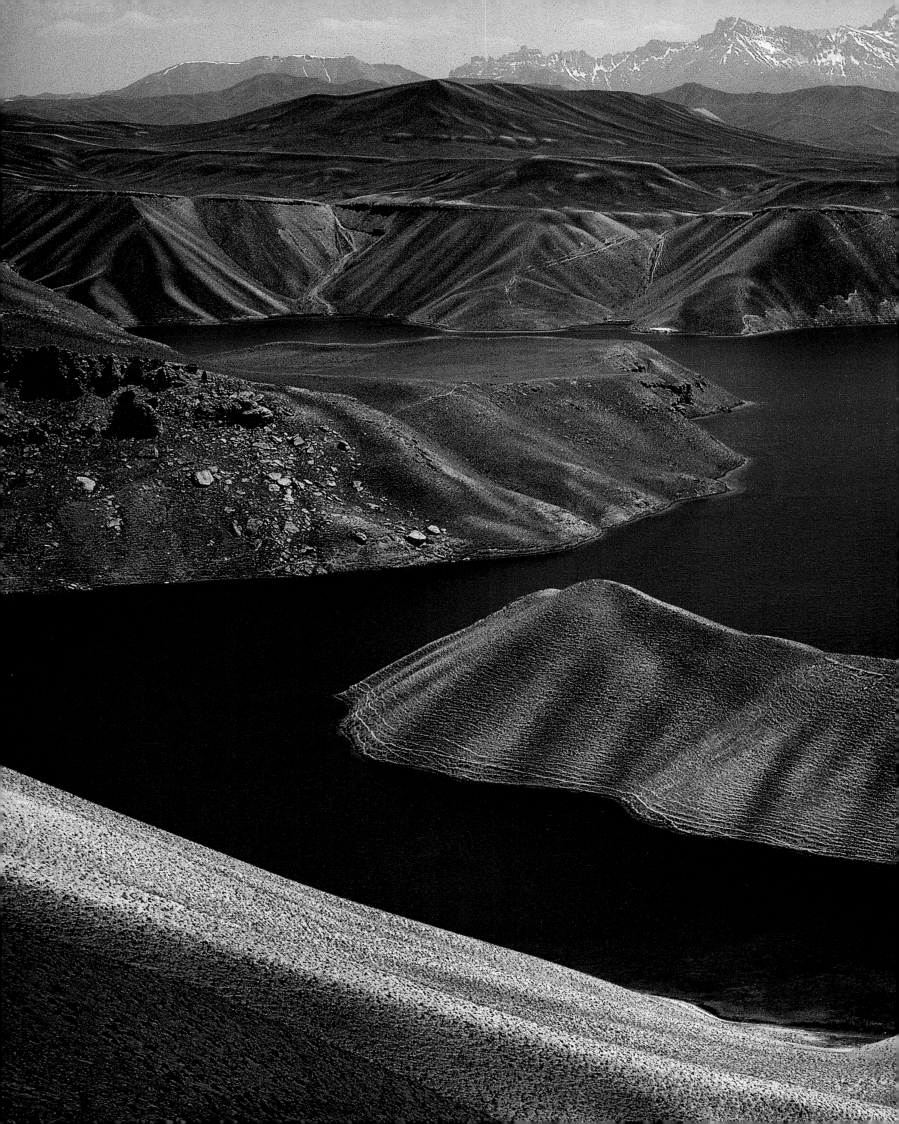

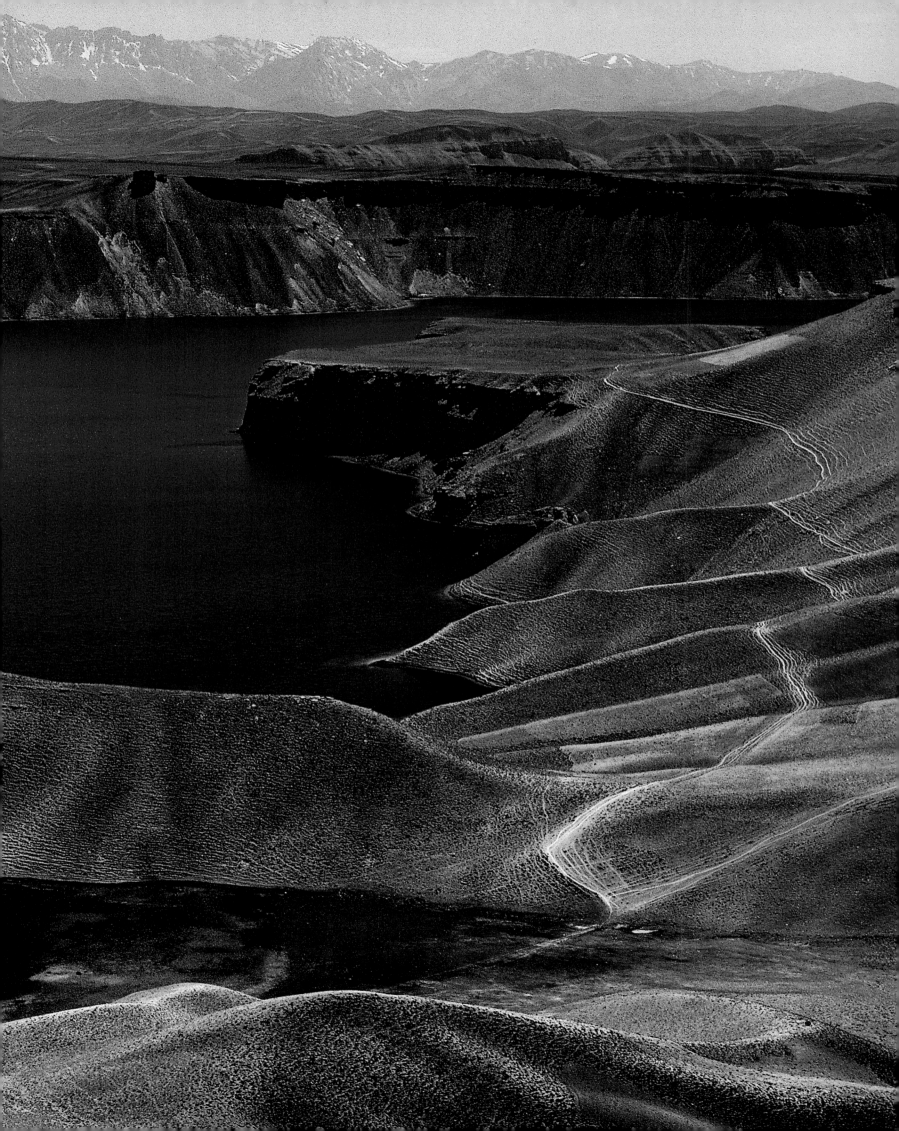

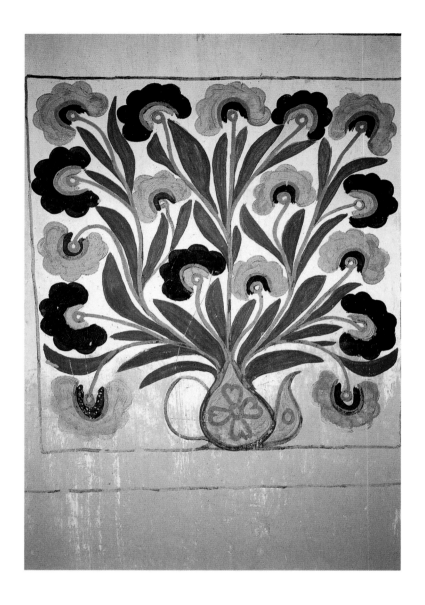

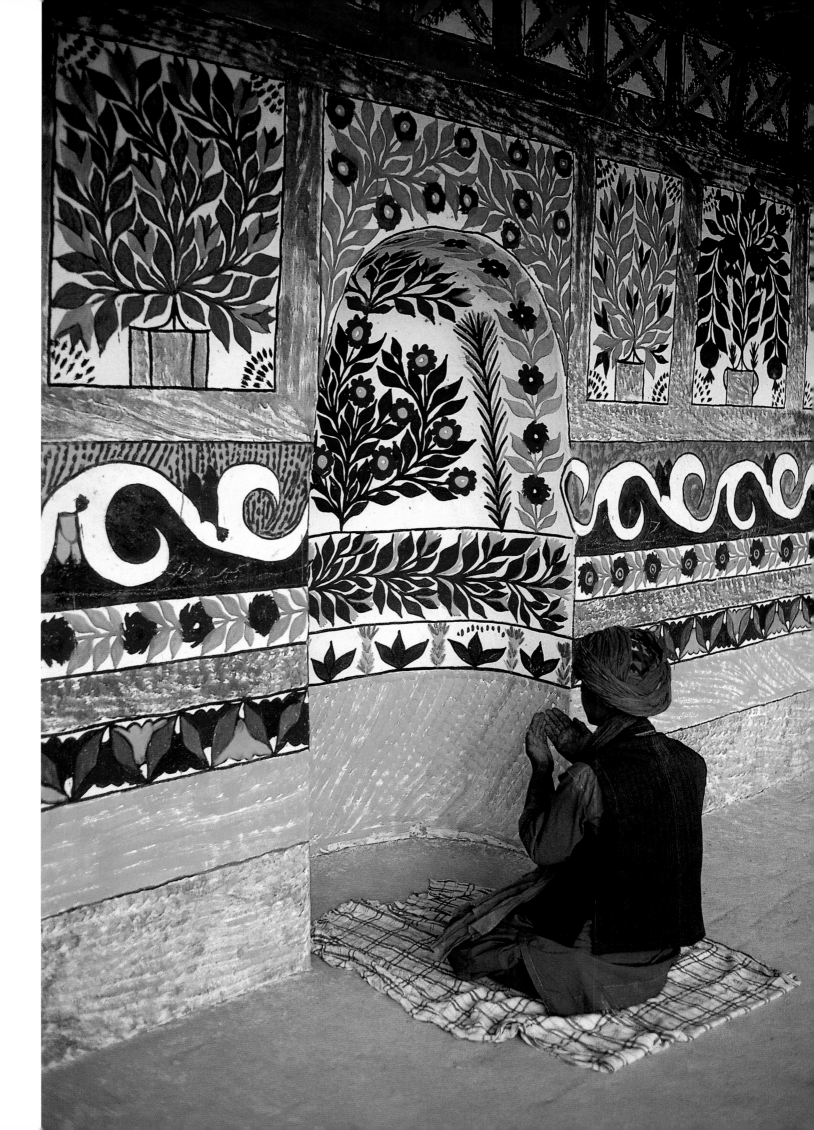

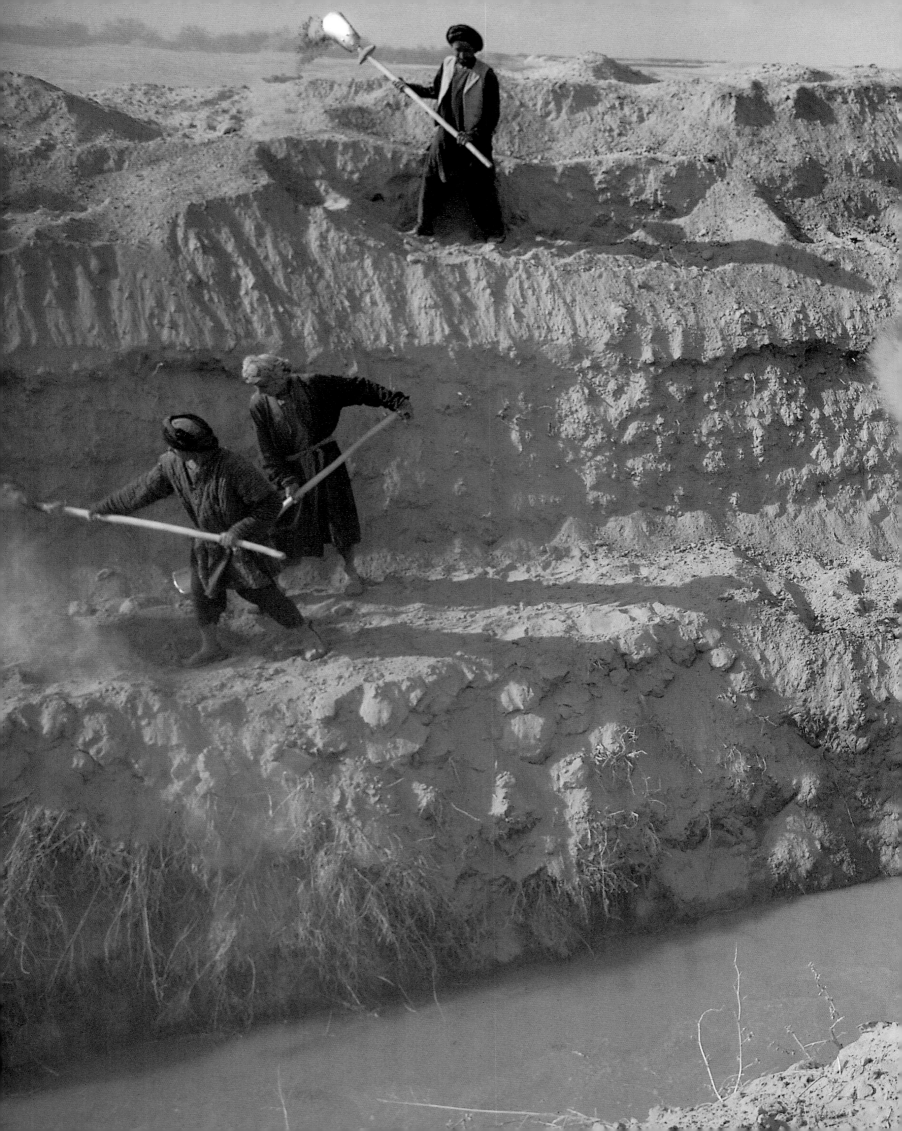

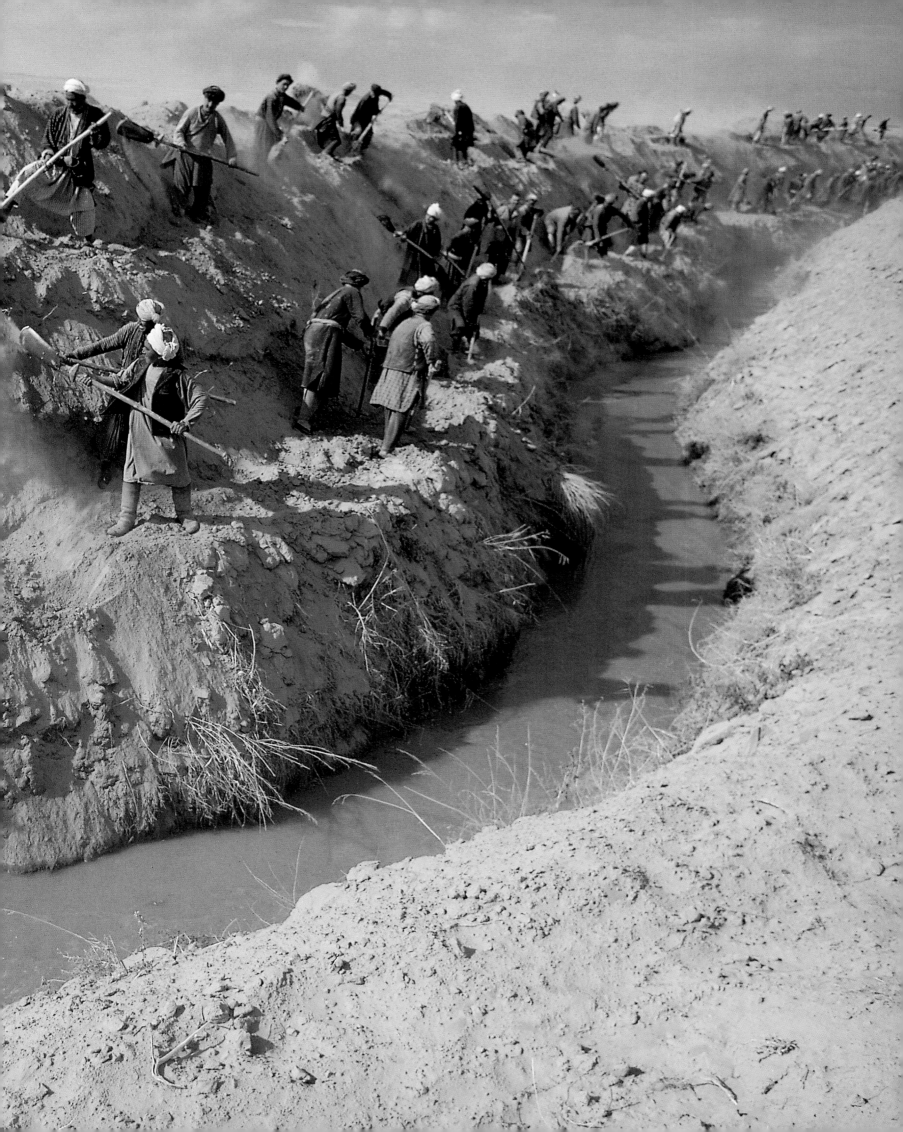

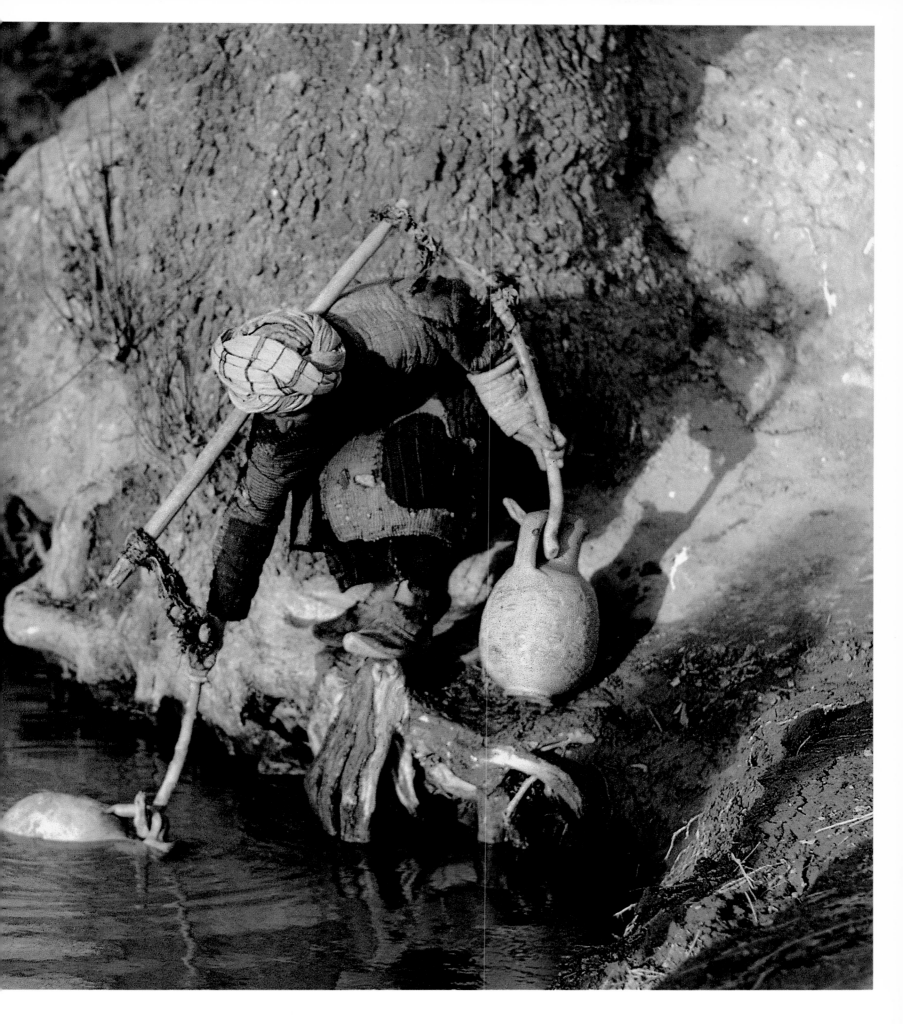

The earth is hard, the sky is far.

SAYING OF CENTRAL ASIA

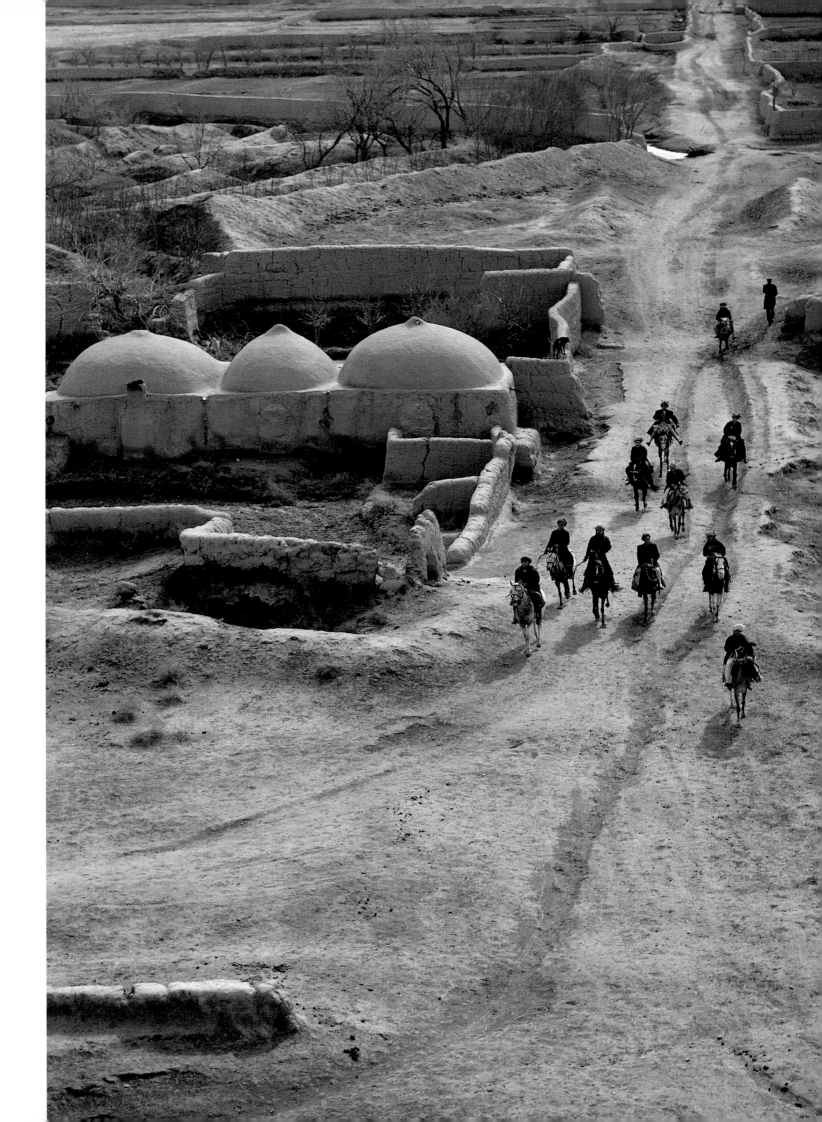

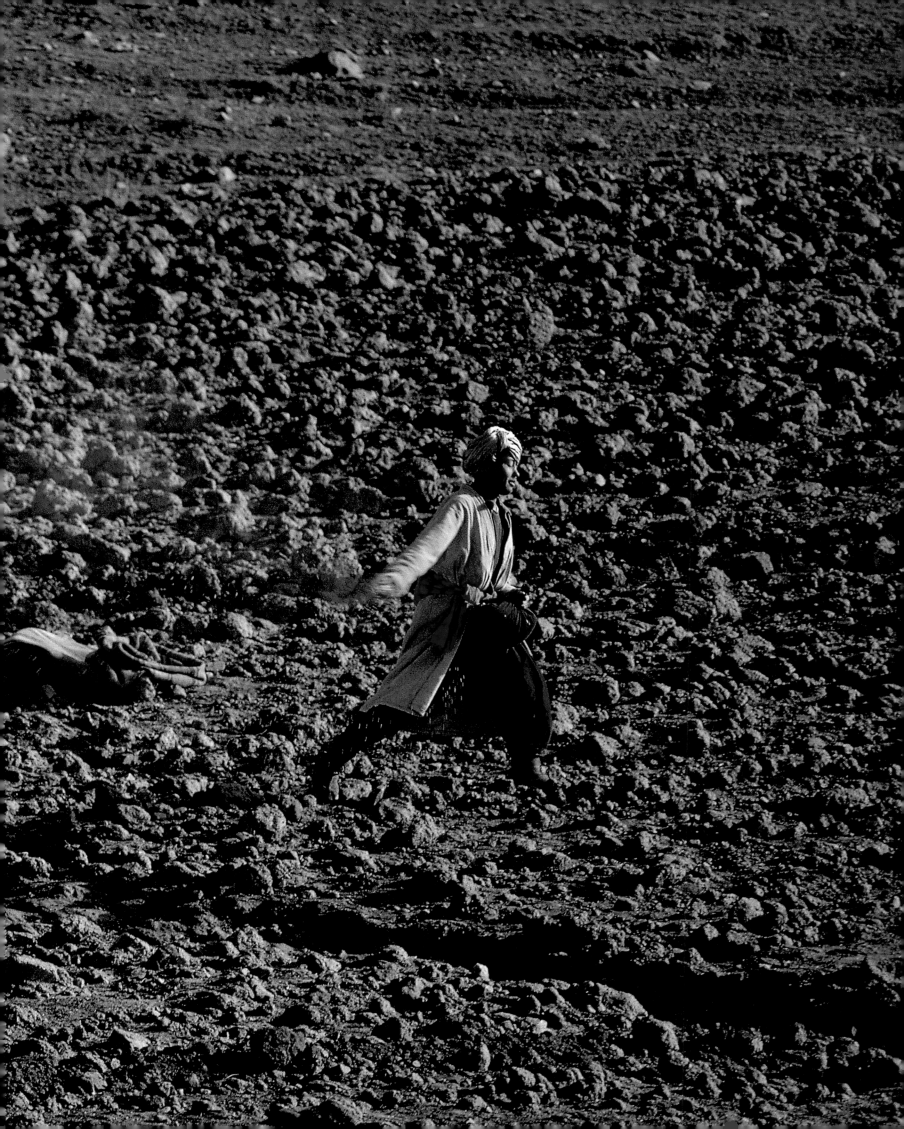

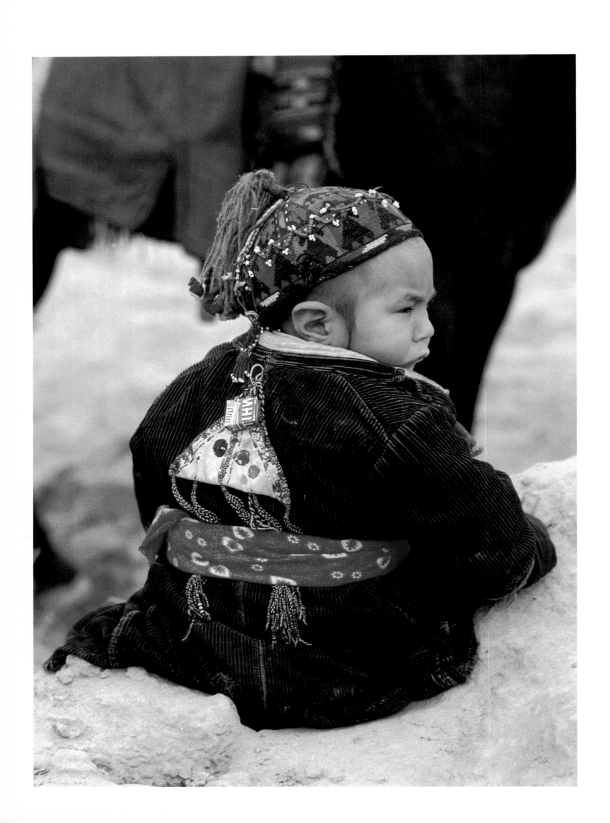

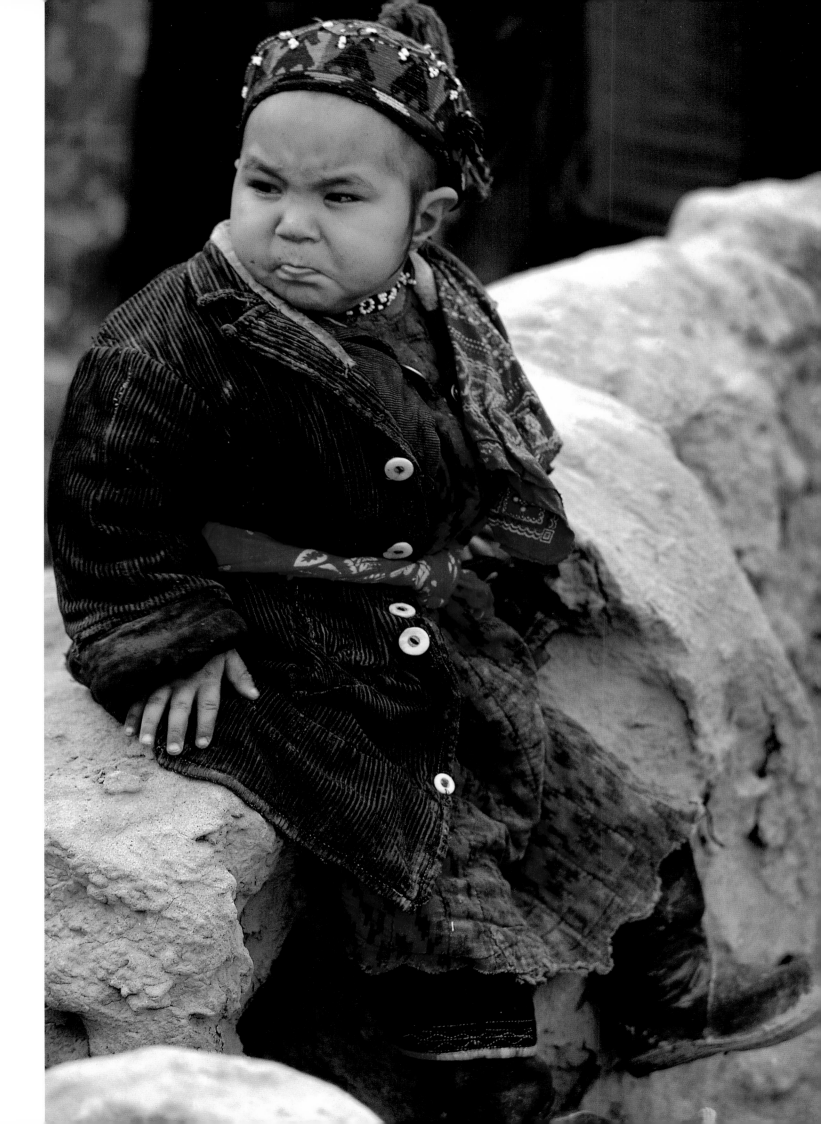

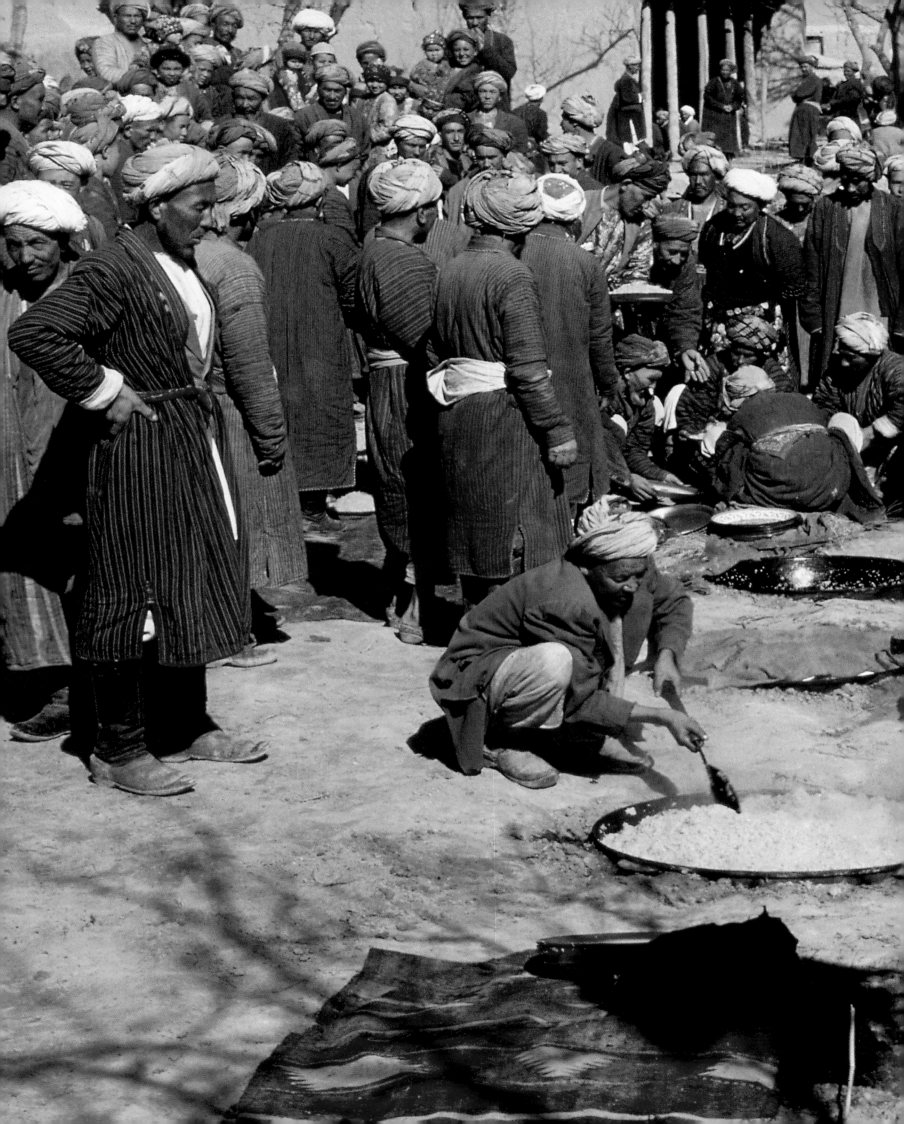

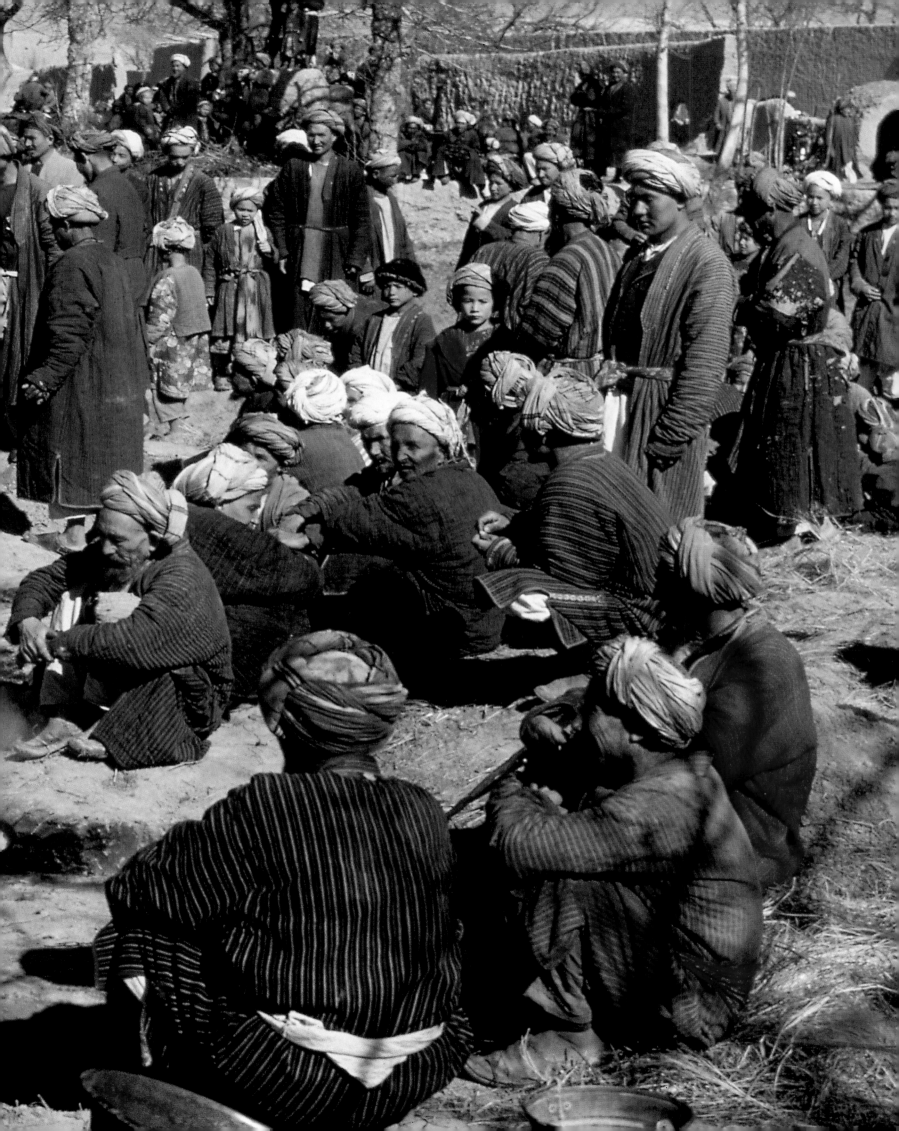

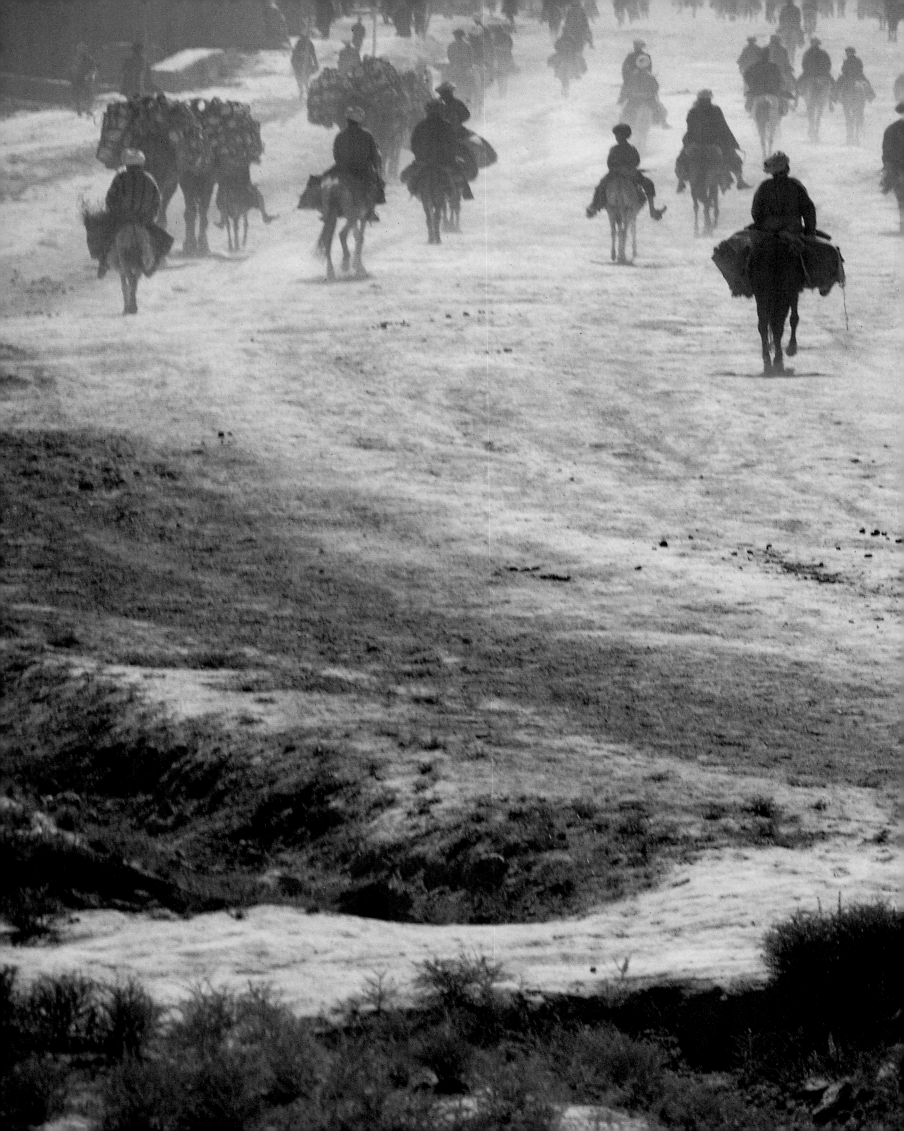

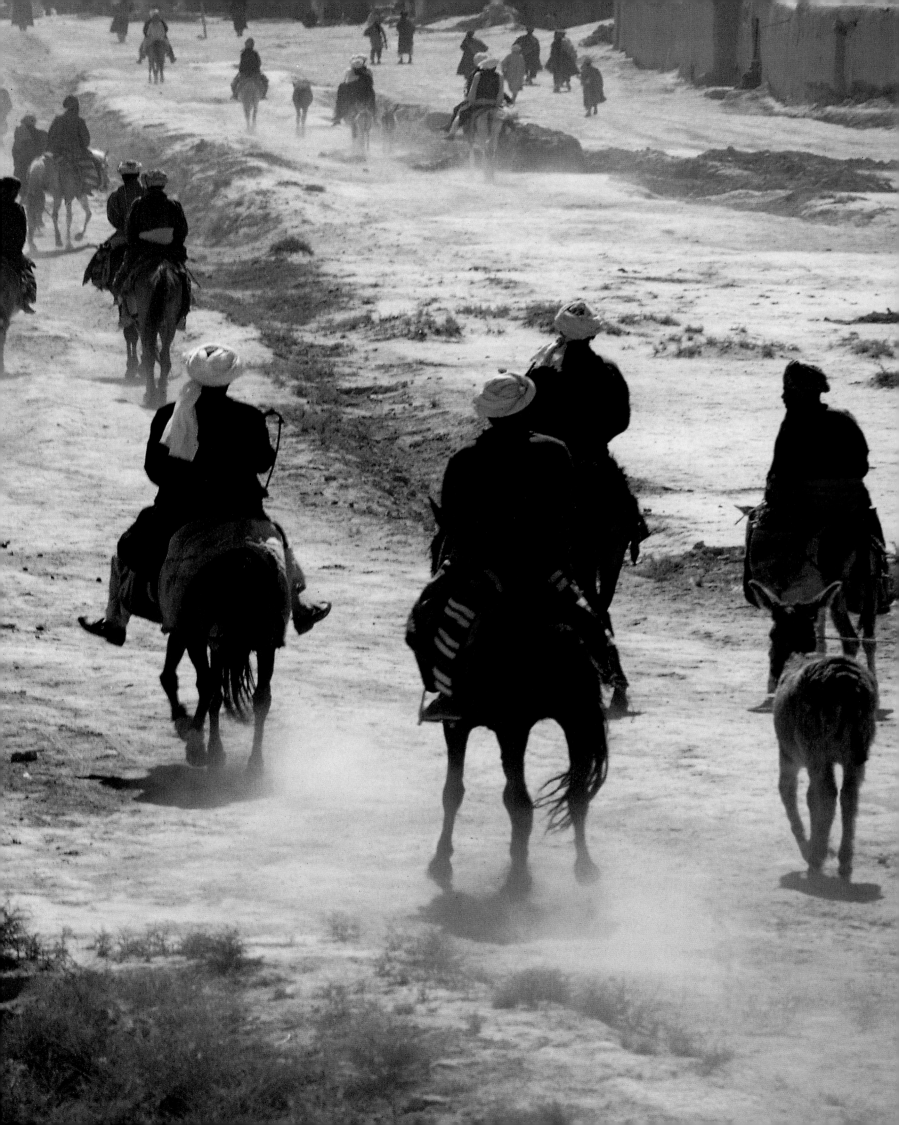

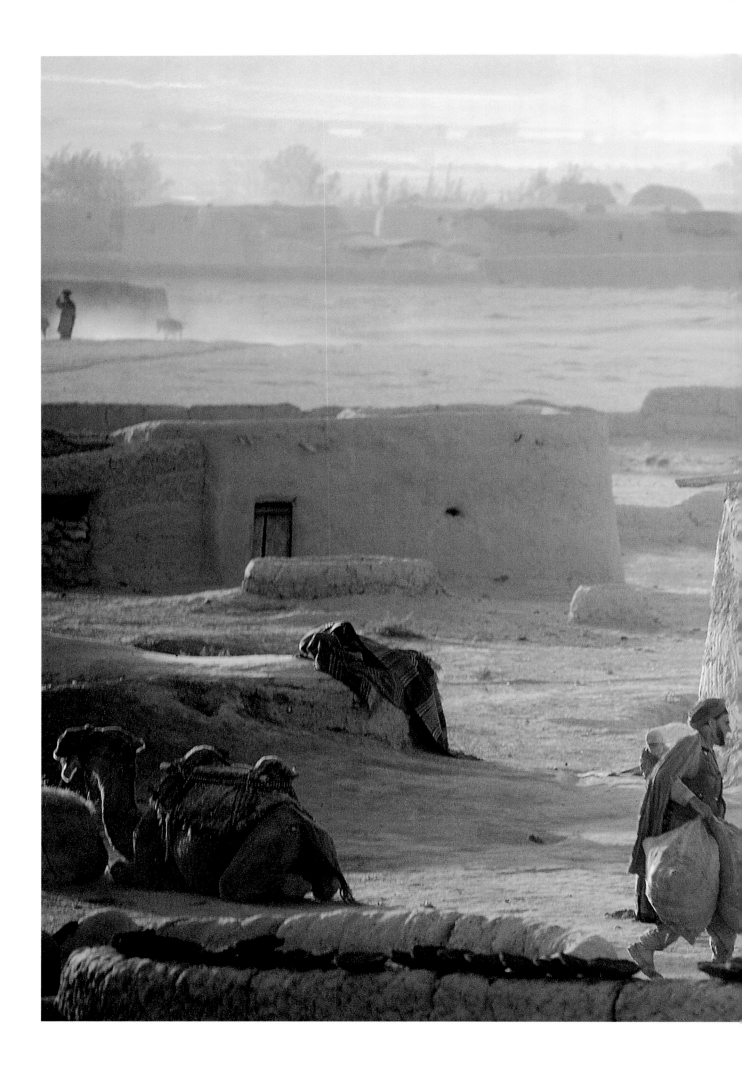

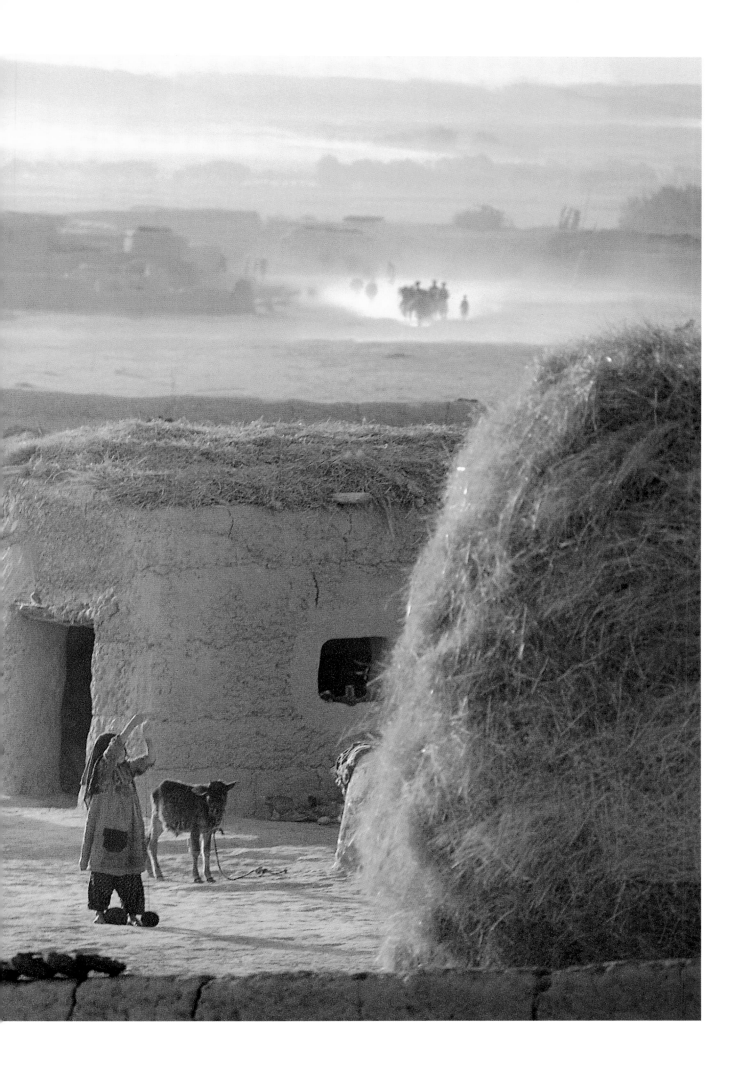

Outdoors, not a leaf, and indoors, not a piece of furniture:
the walls, the sky, and God.

ANDRÉ MALRAUX

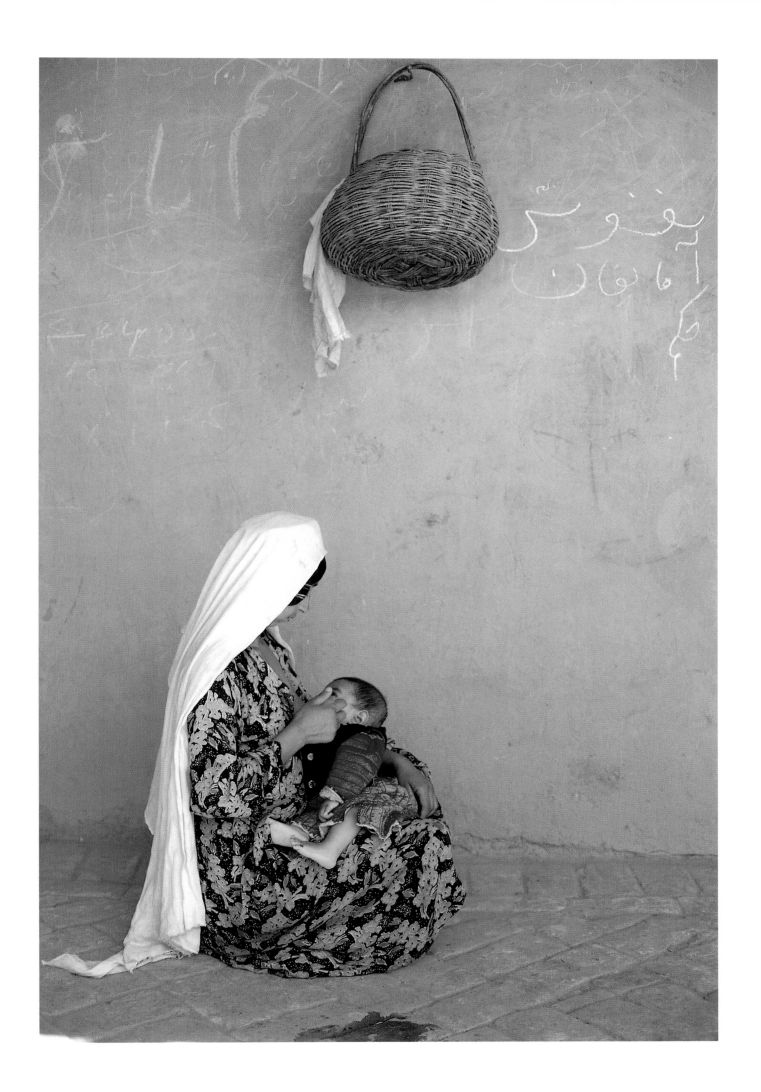

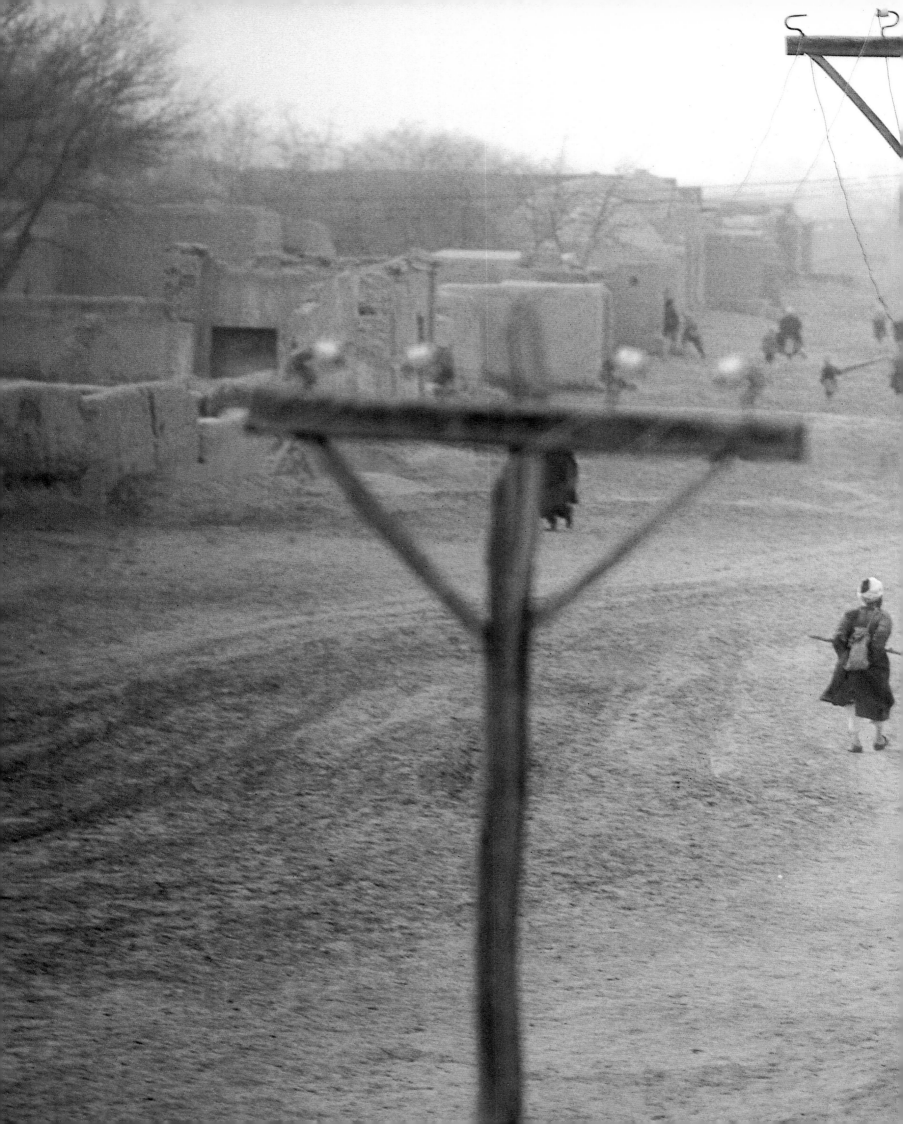

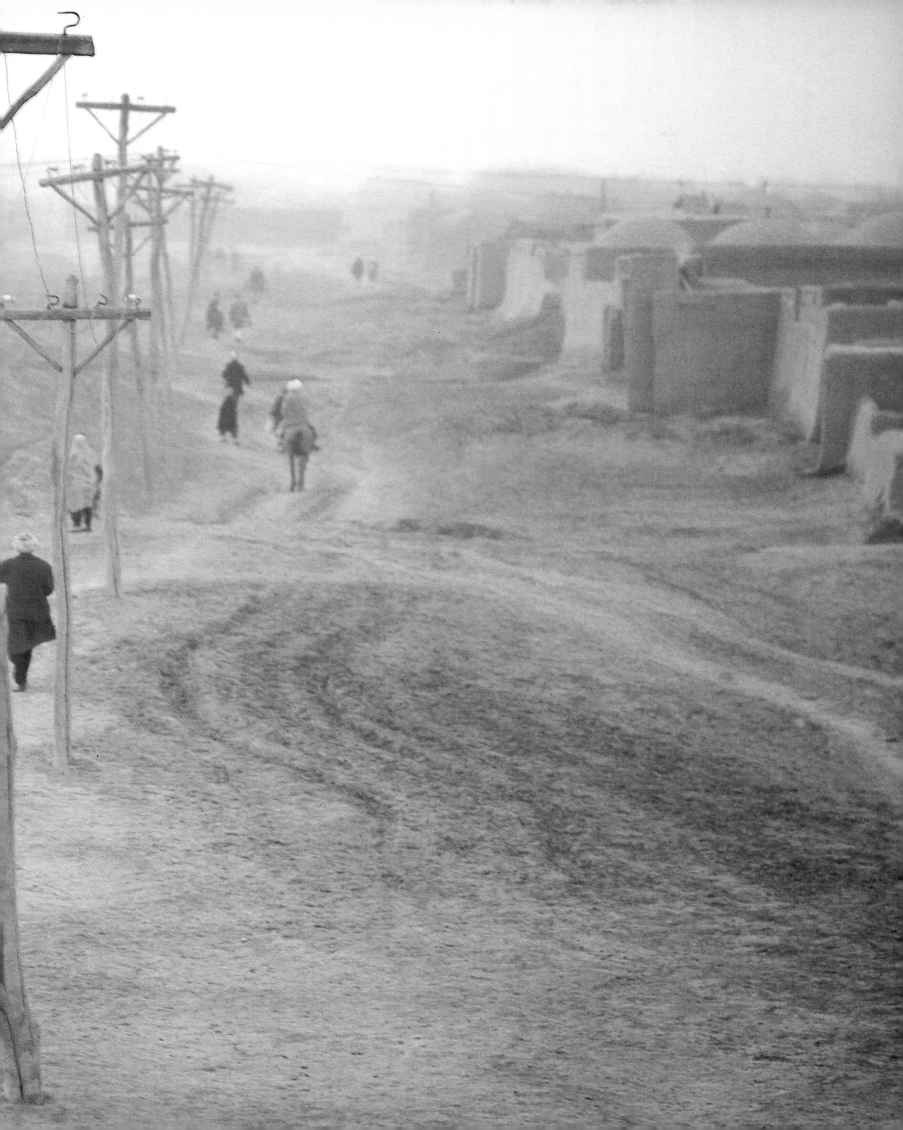

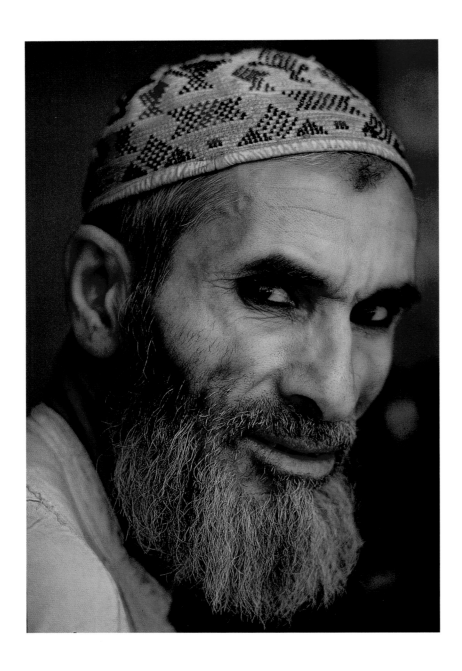

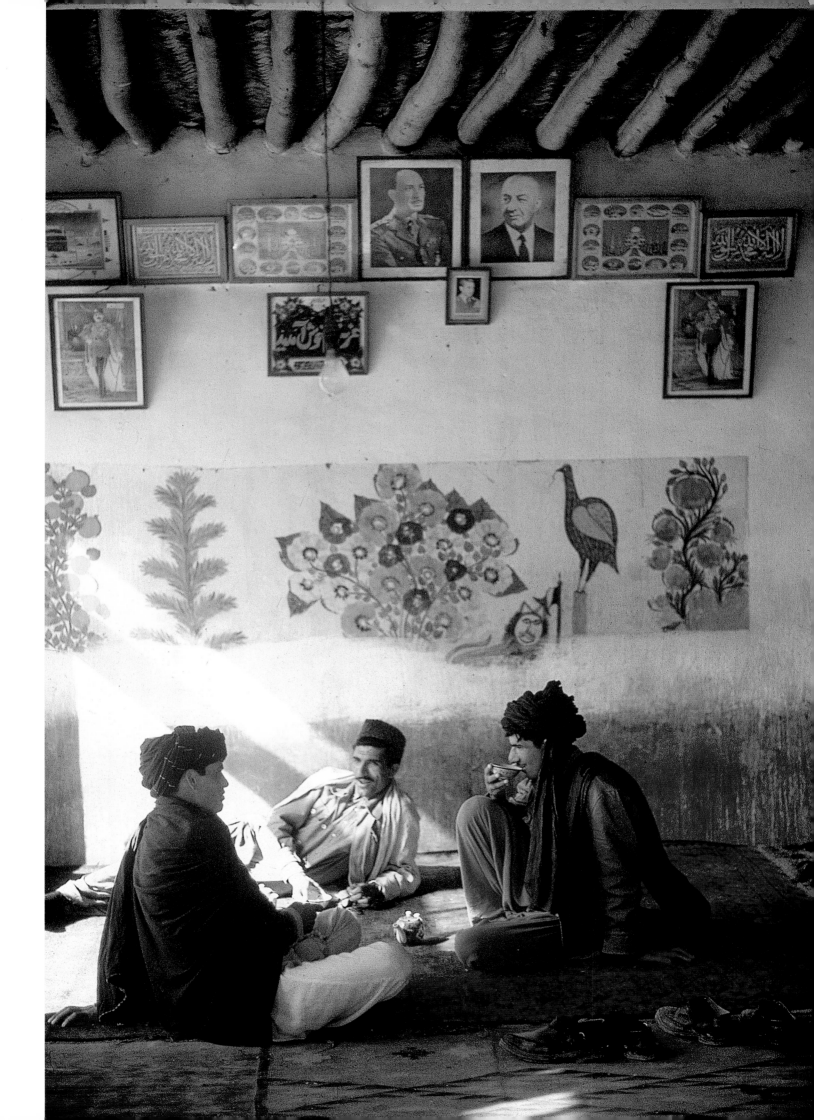

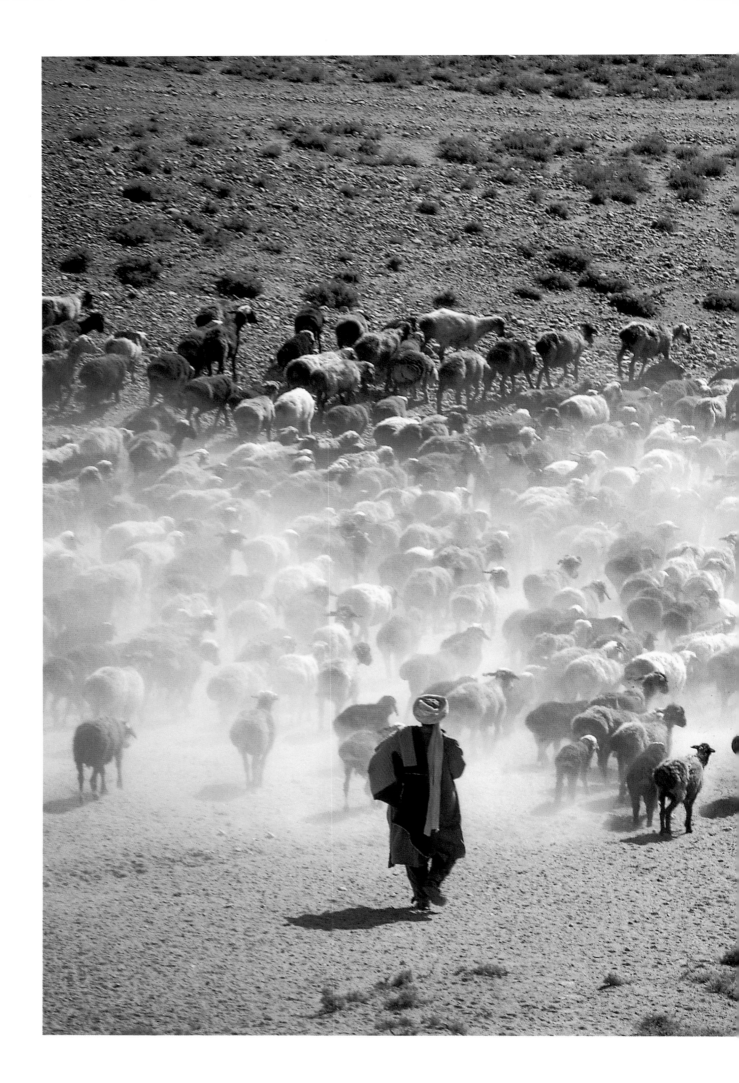

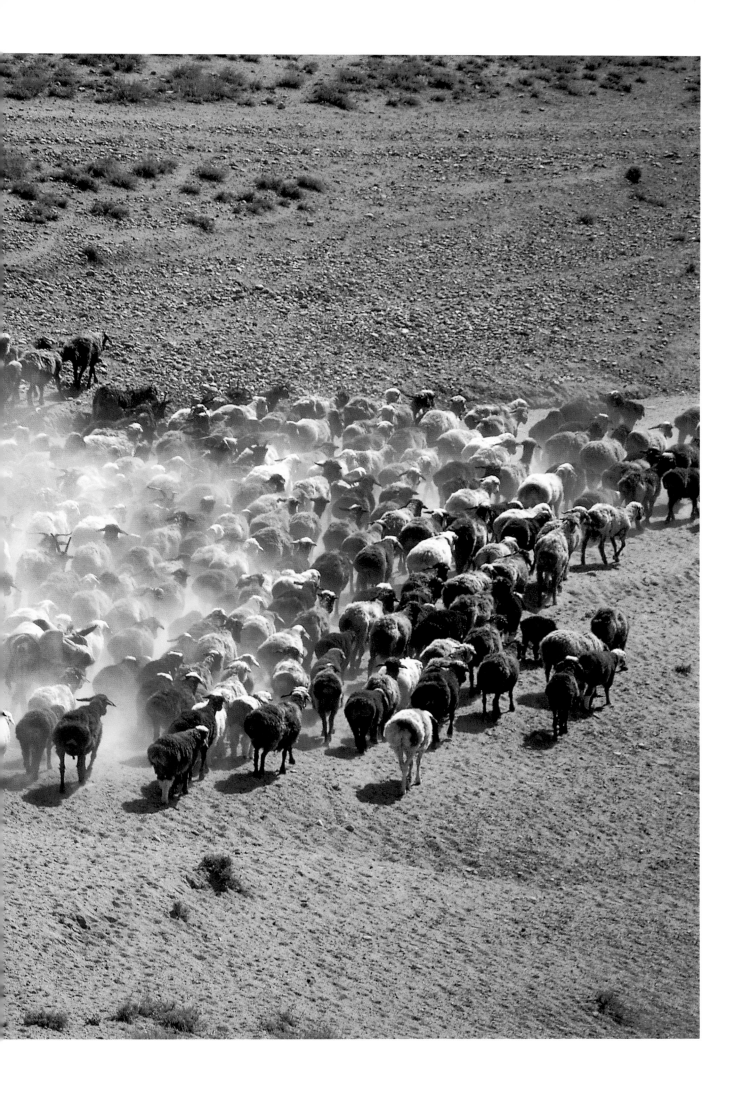

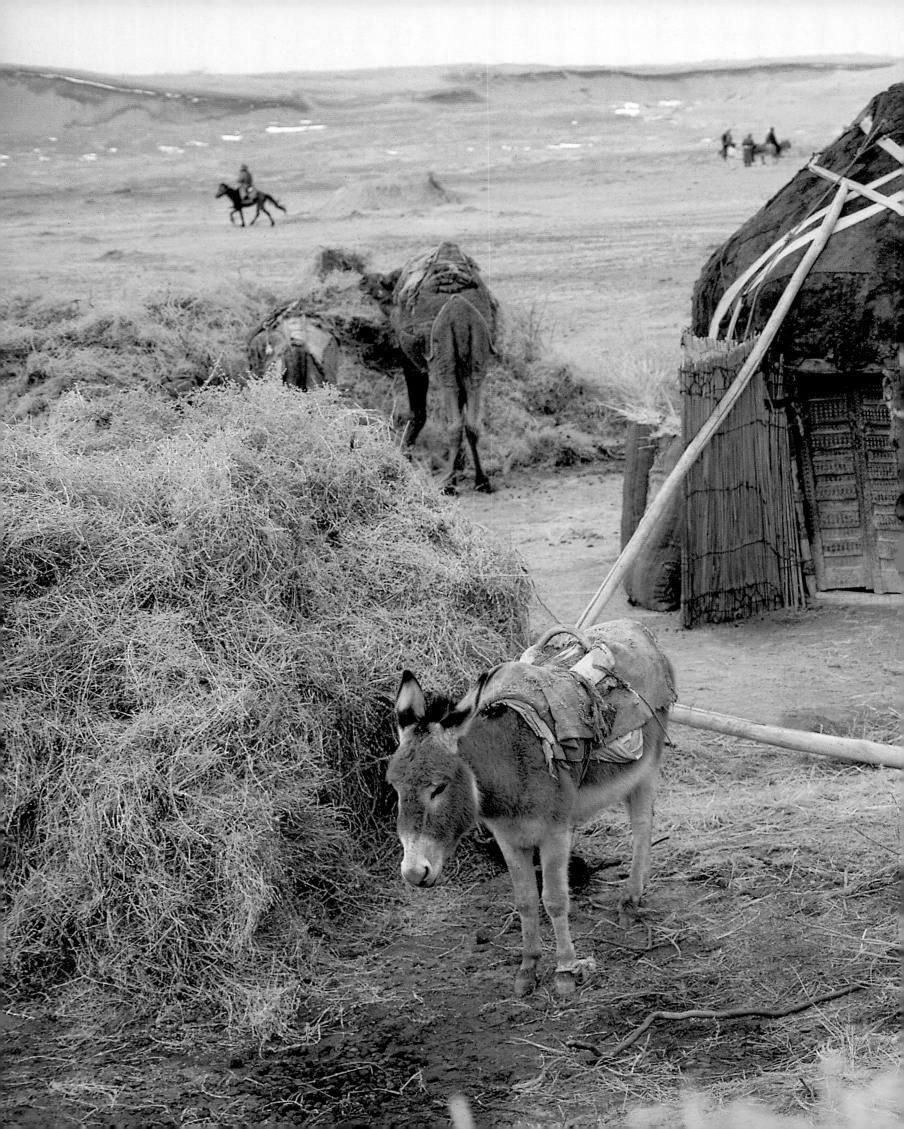

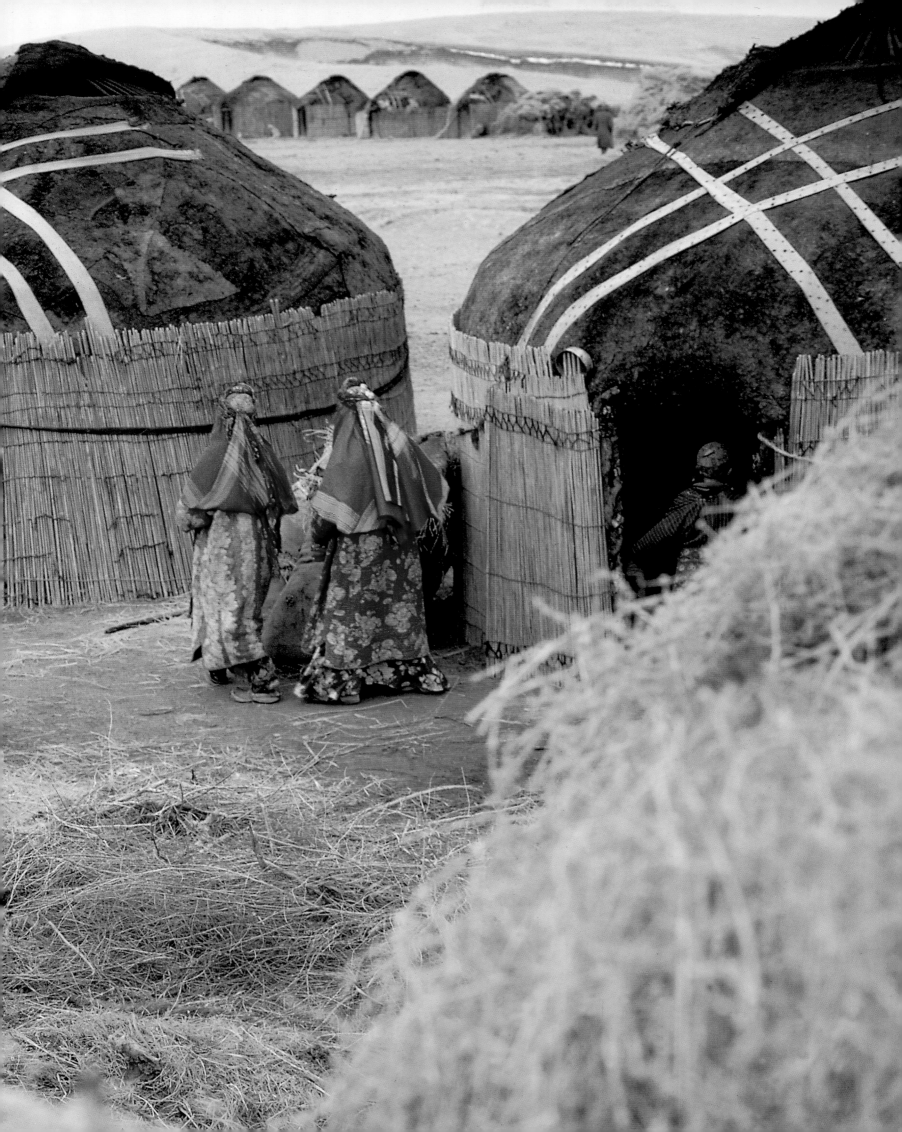

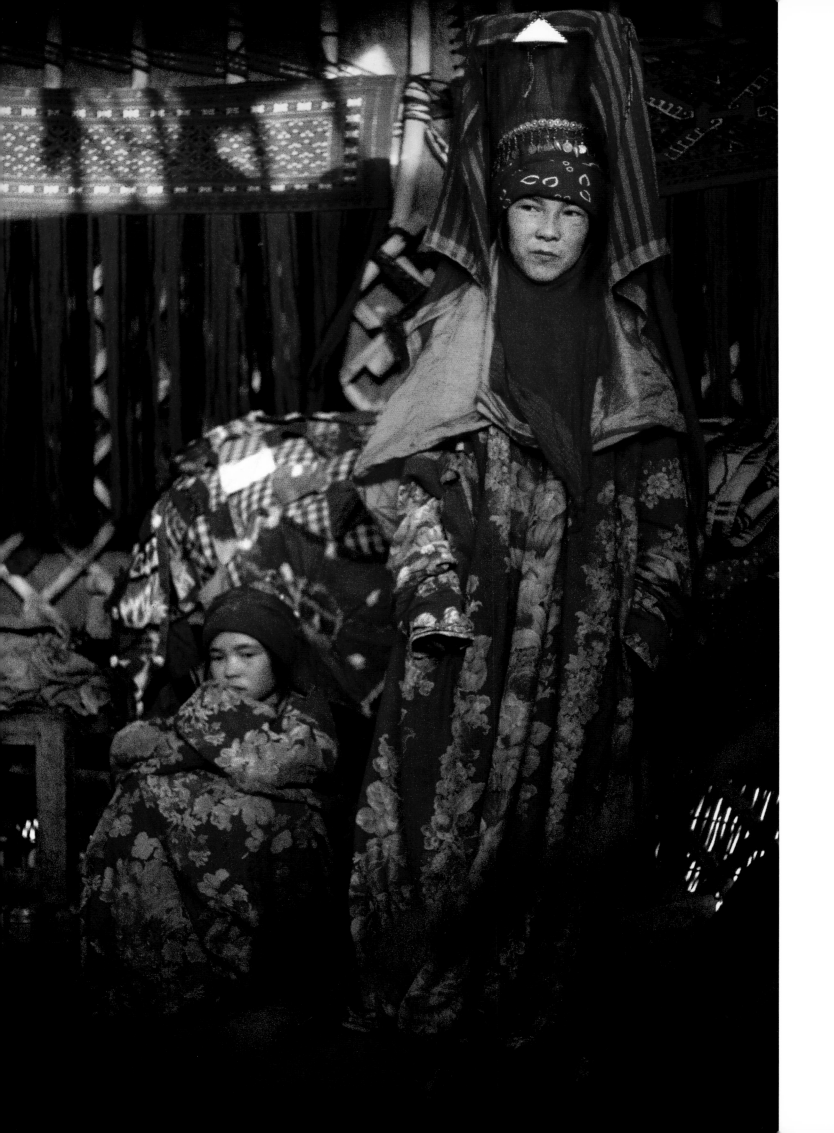

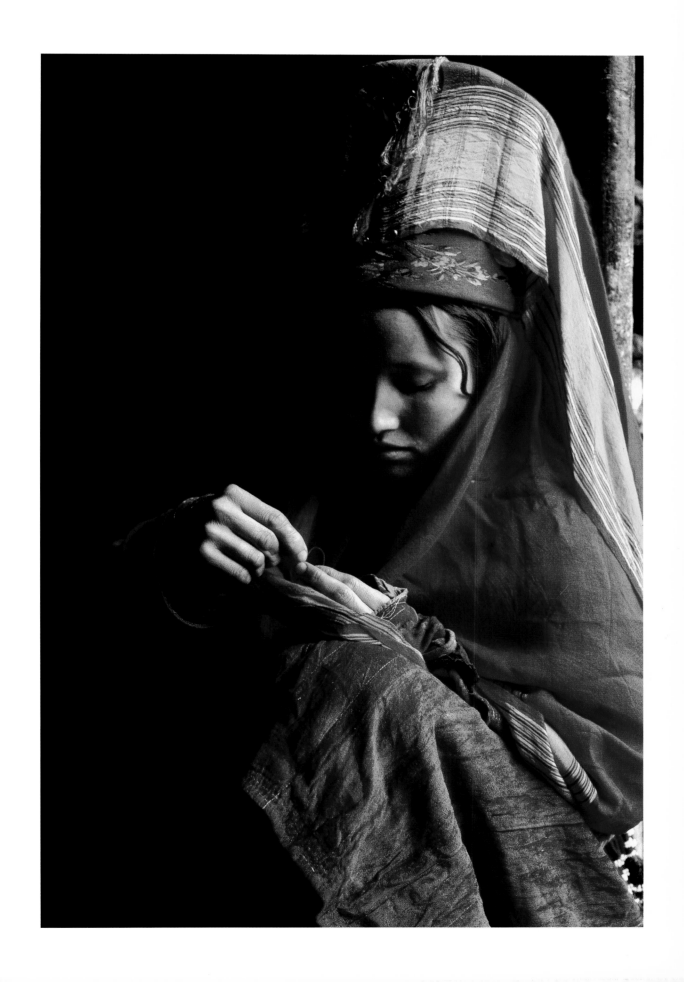

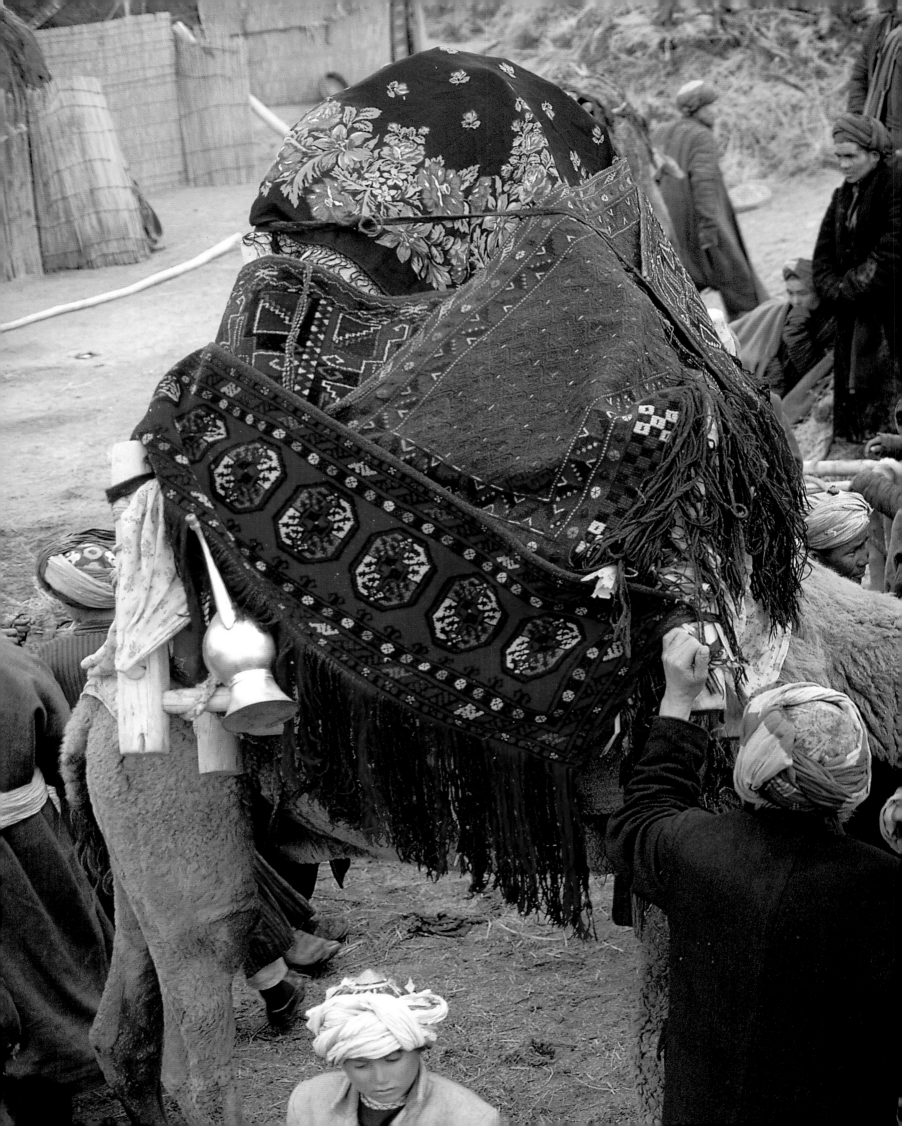

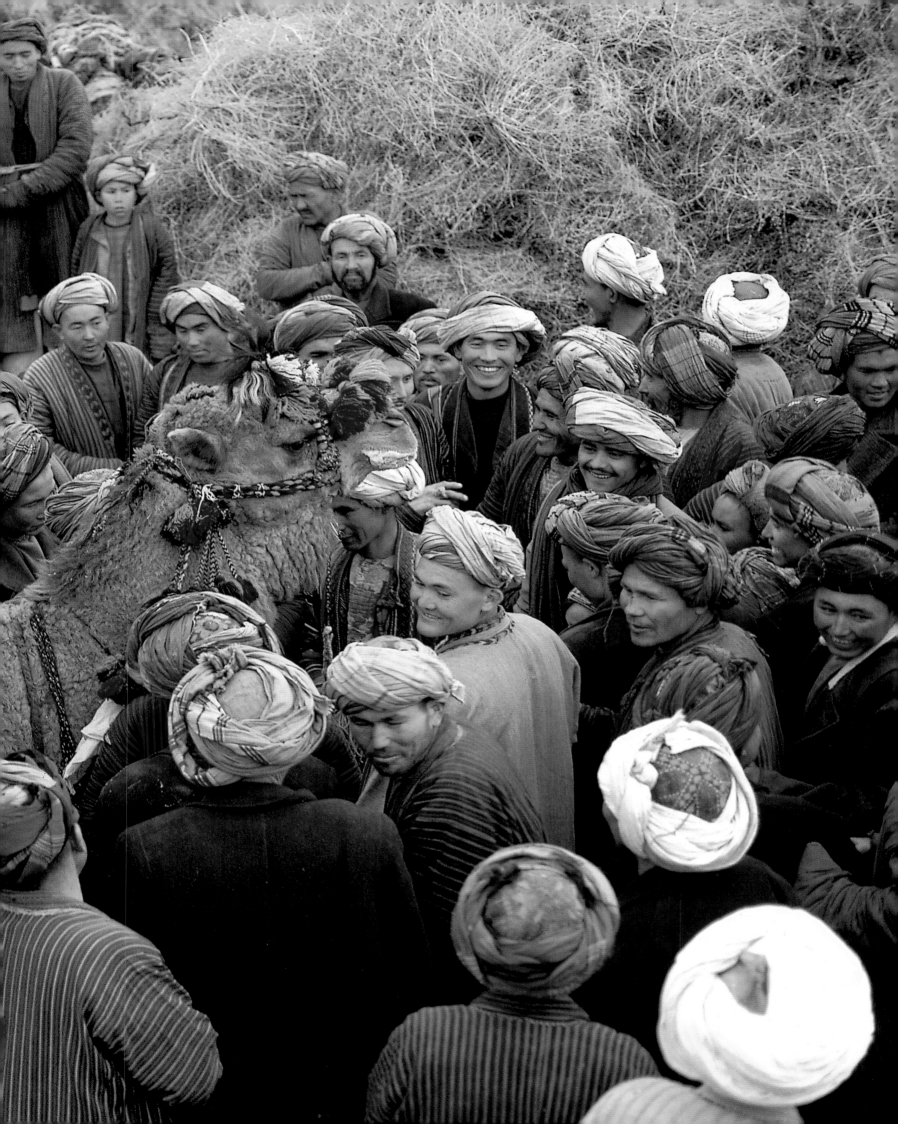

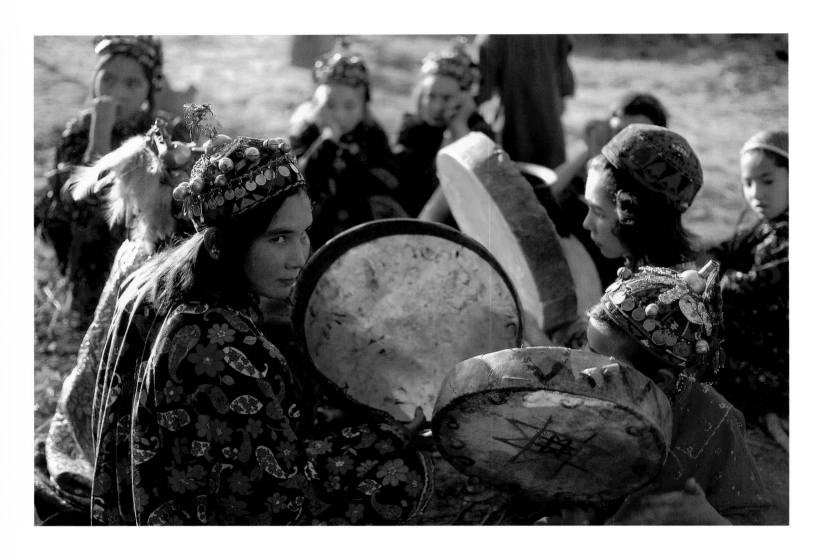

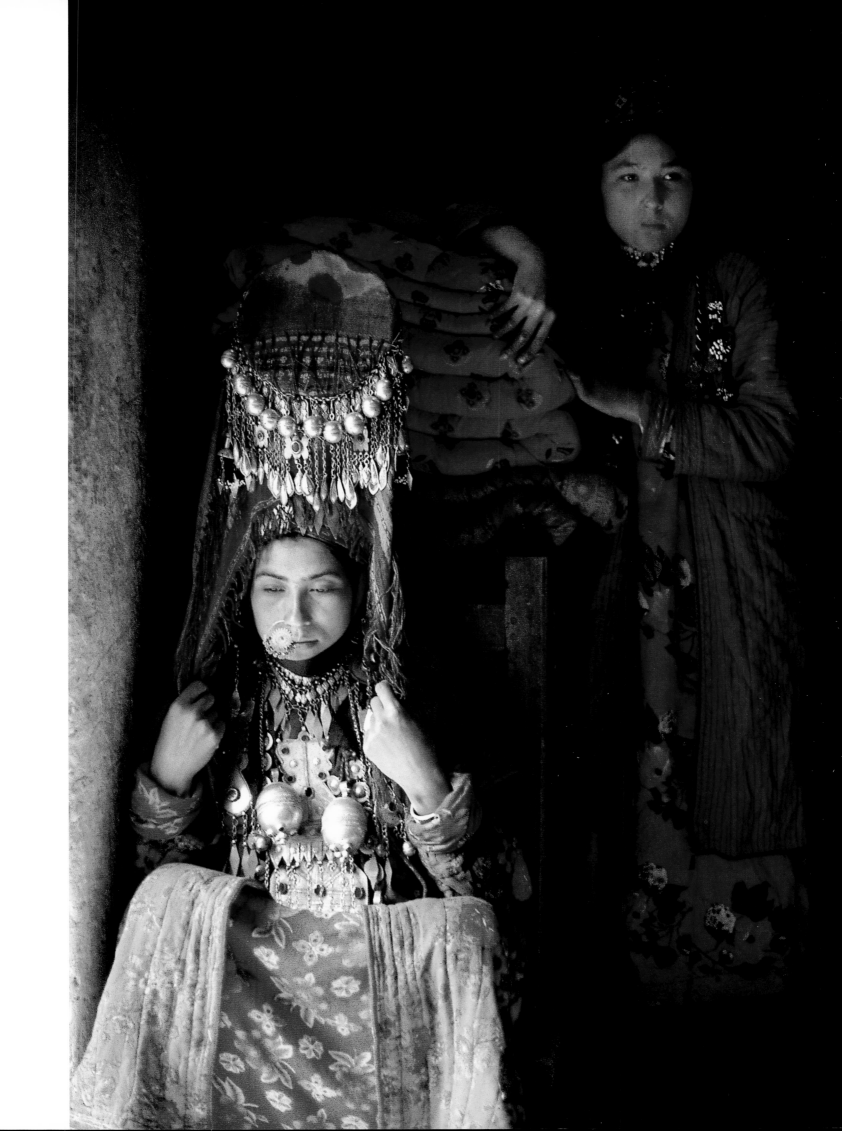

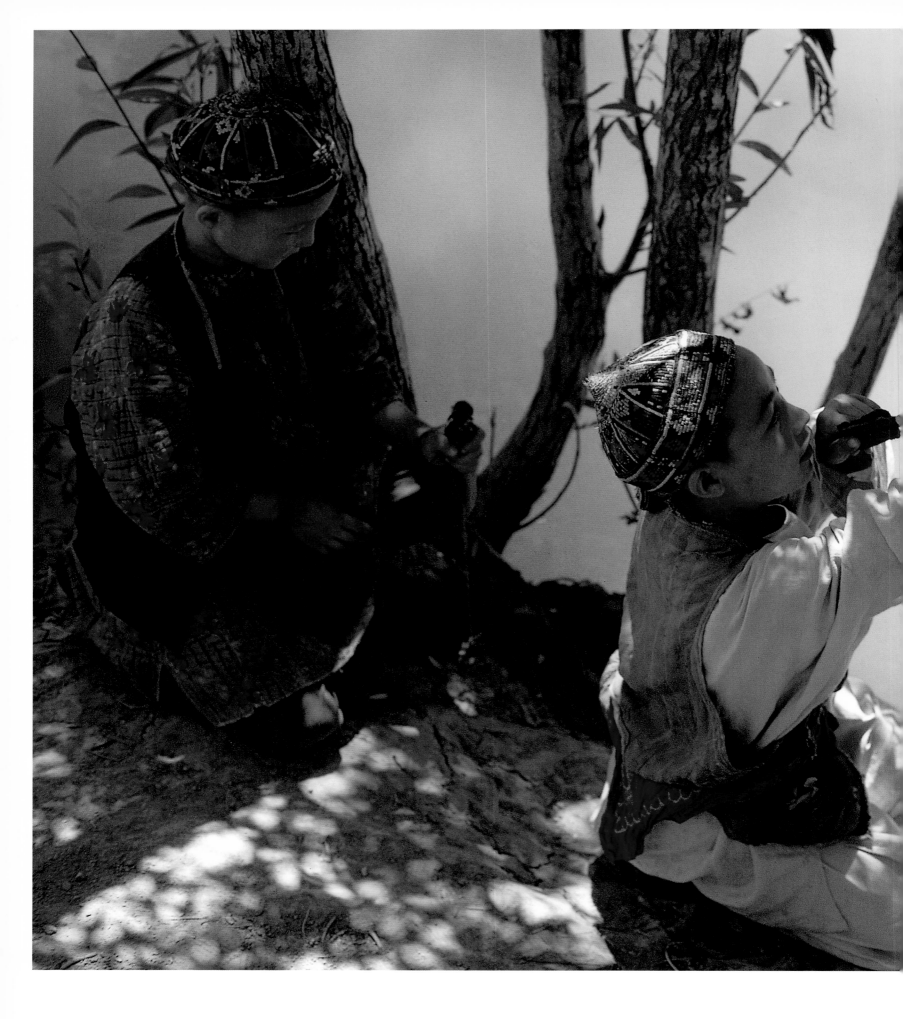

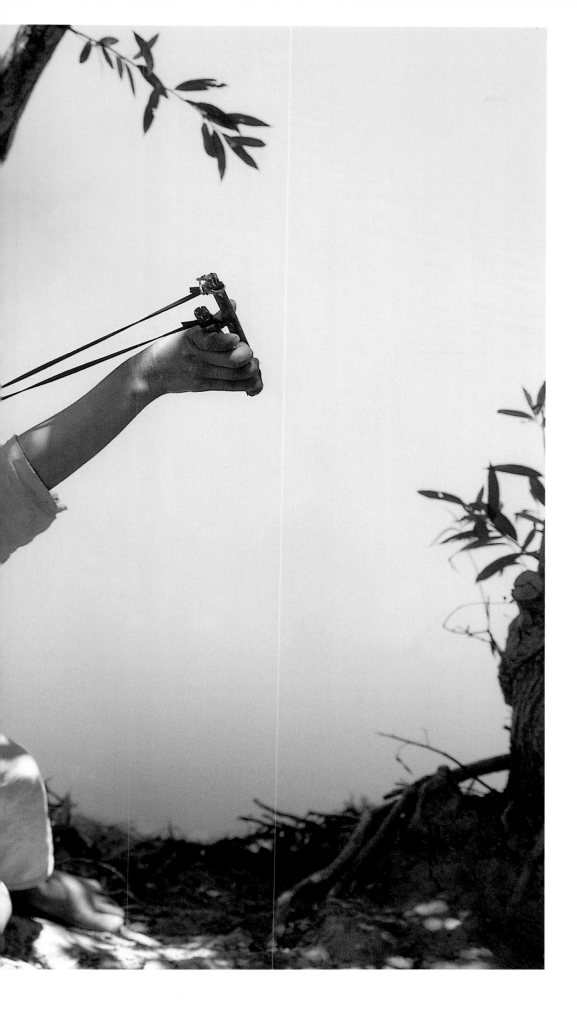

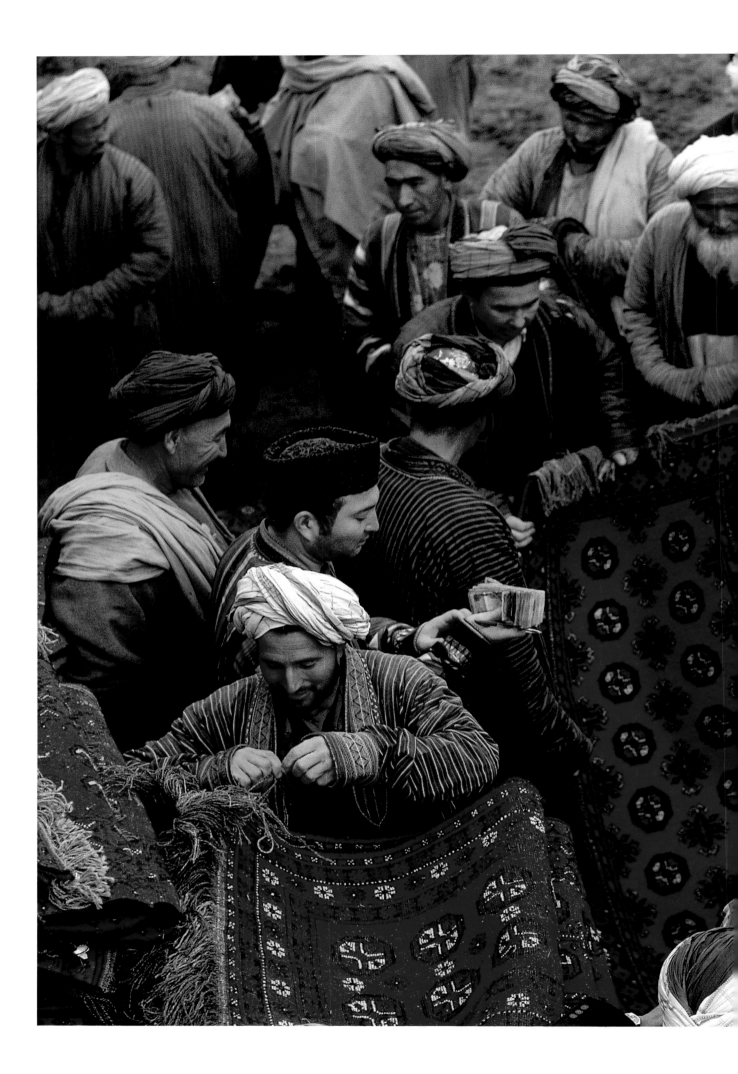

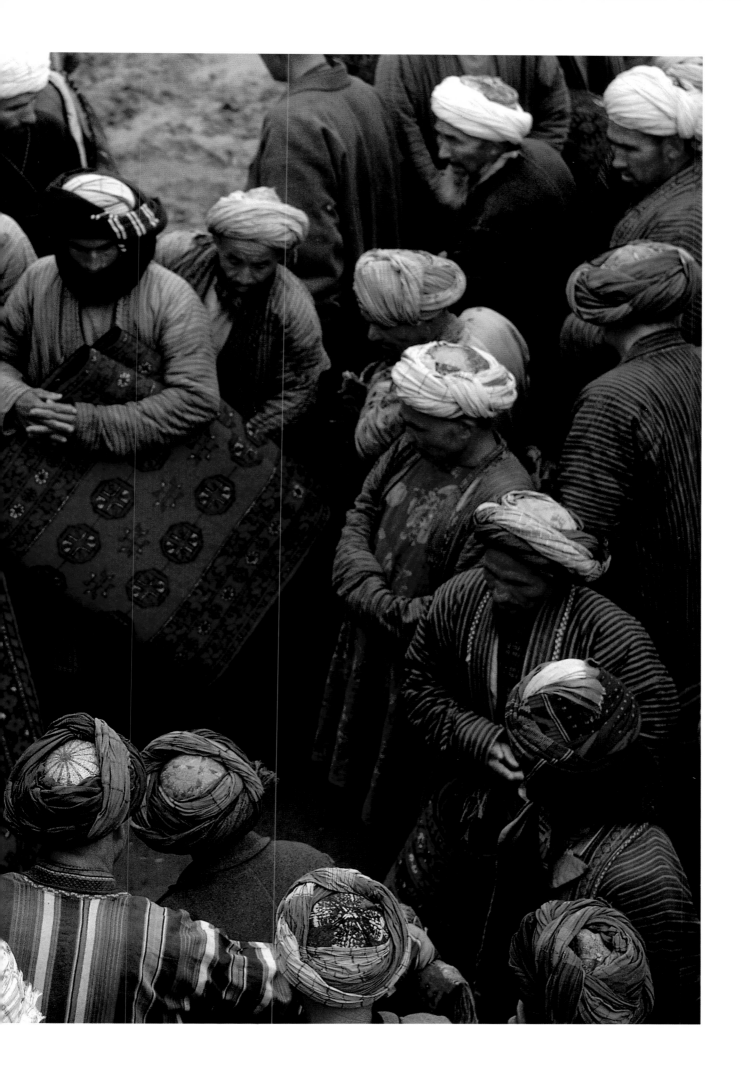

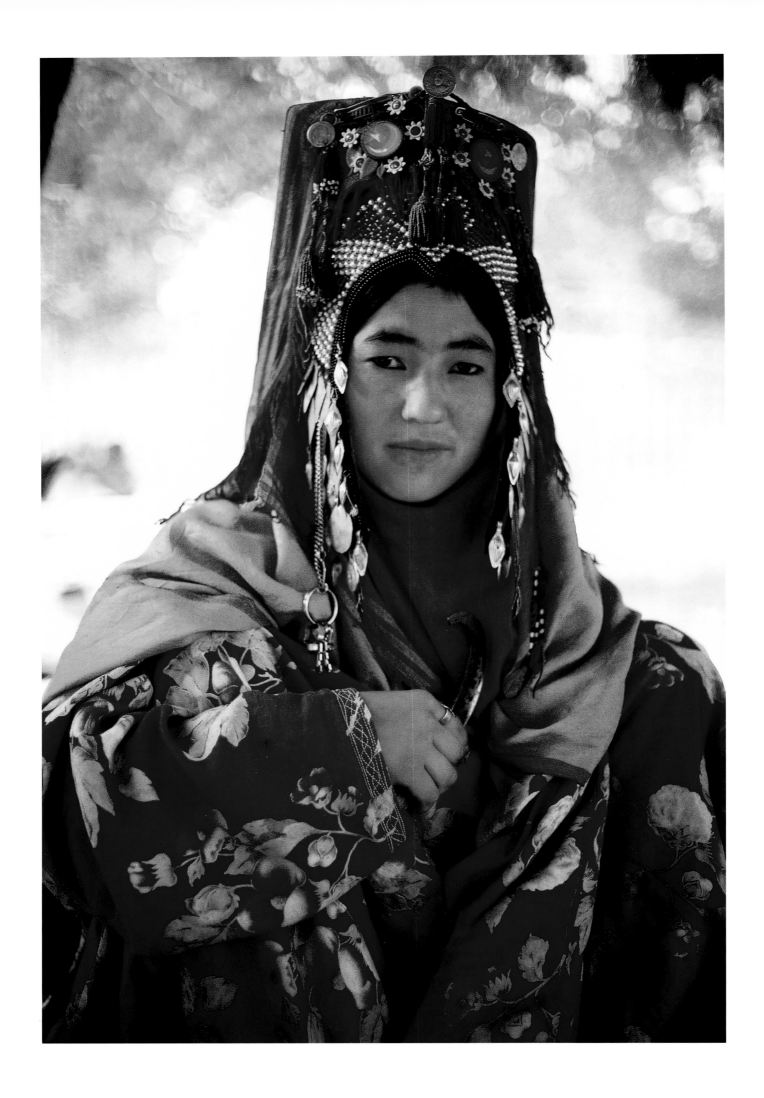

I like the calm and the peacefulness of these women
and, if the carpets reflect their inner life,
then I can even like their submission.
Could the carpets be so beautiful
if they didn't reveal a beautiful soul?

SABRINA MICHAUD

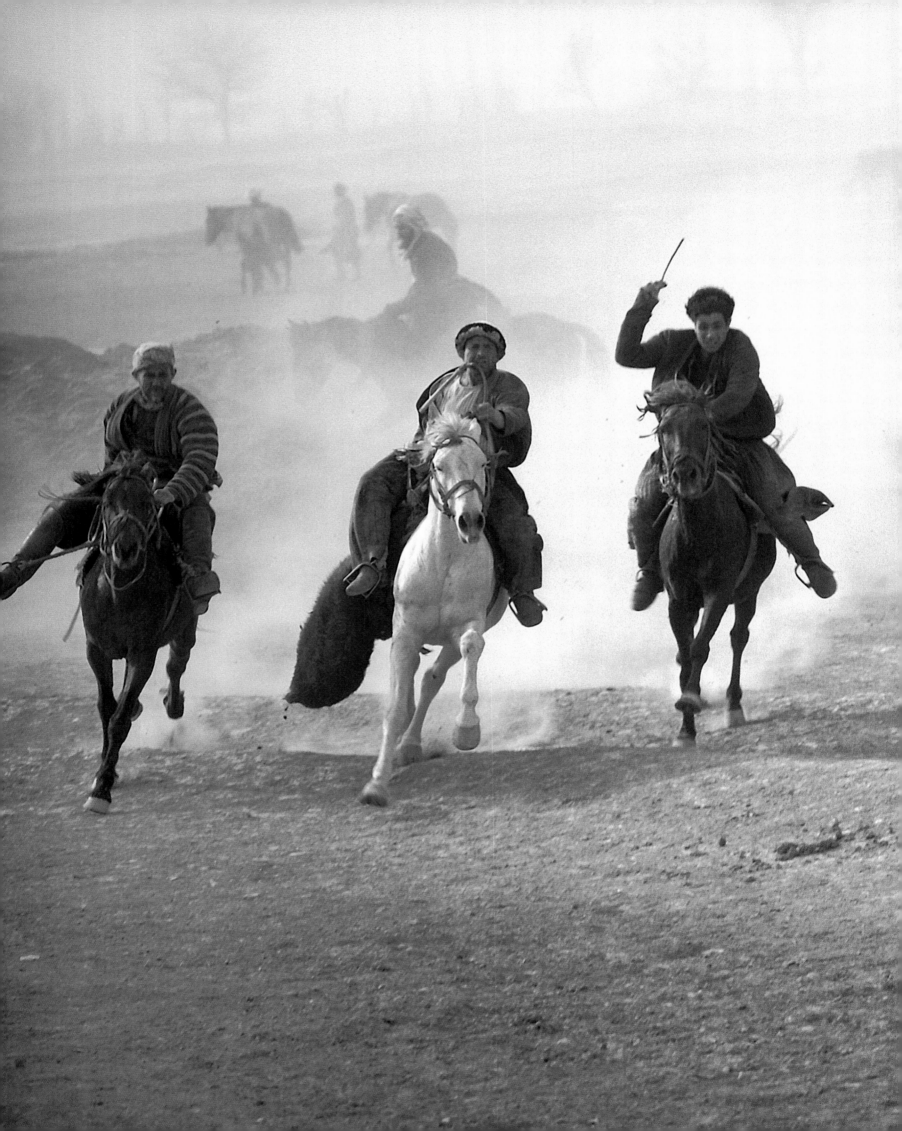

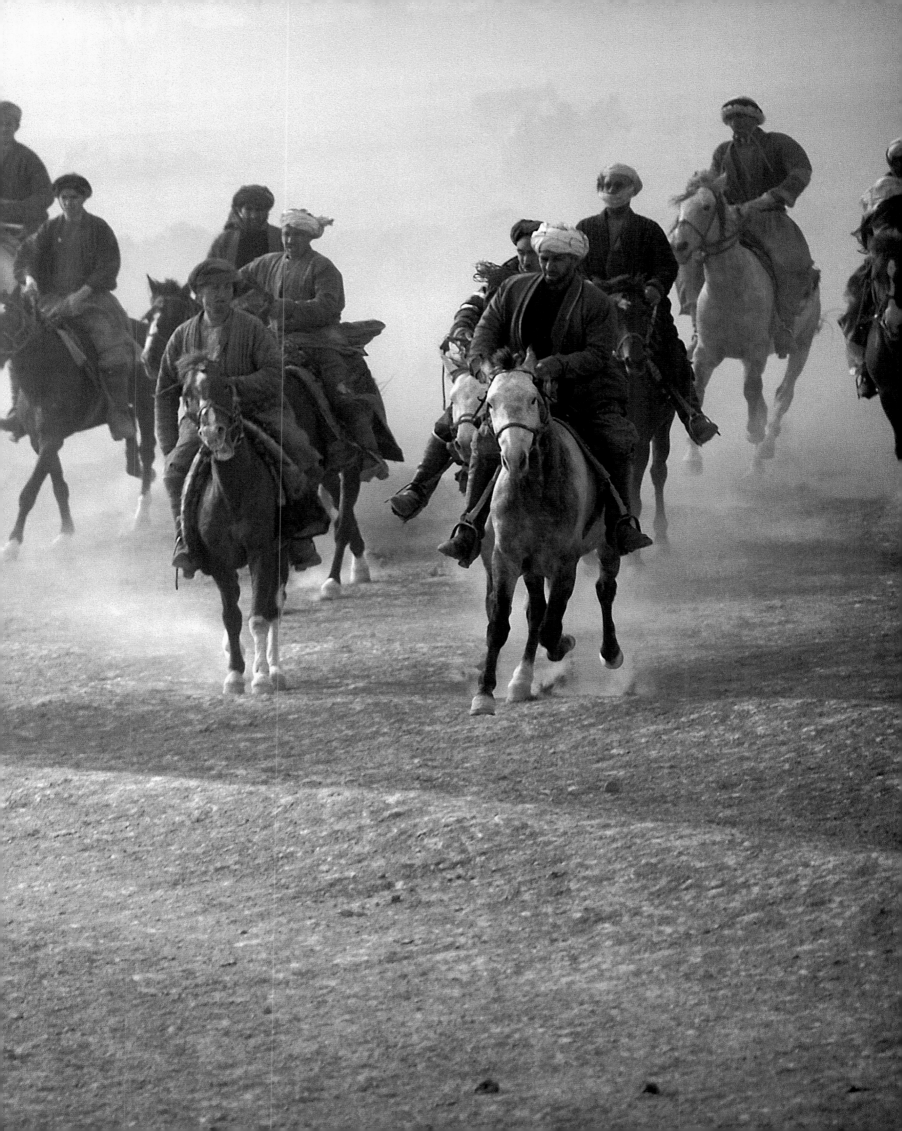

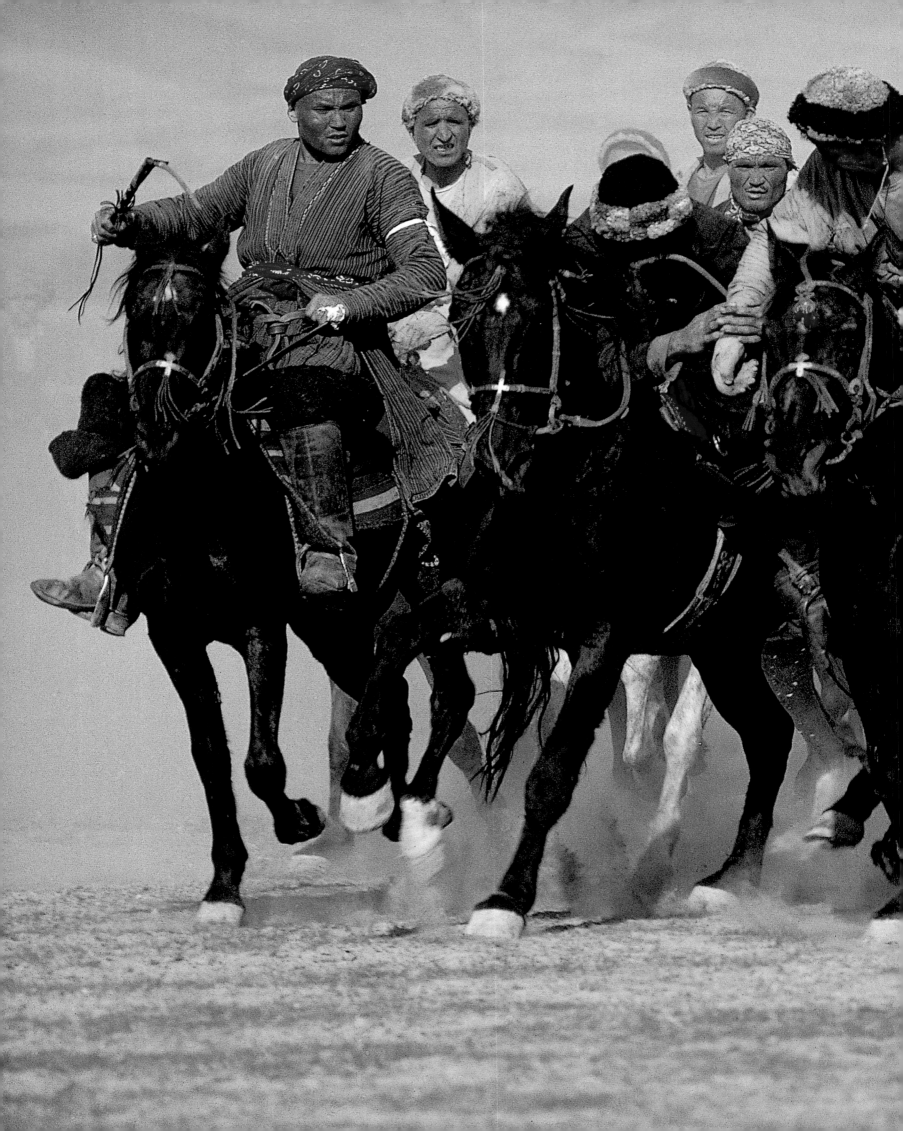

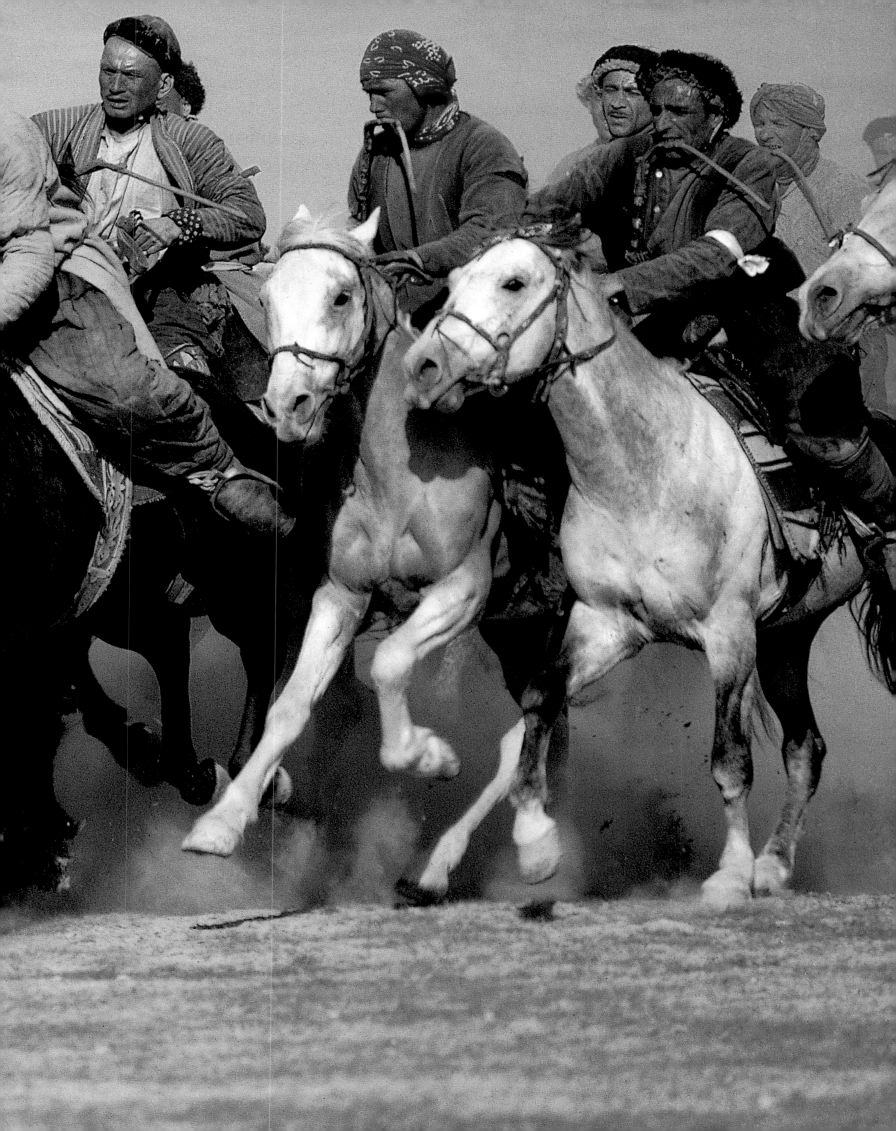

Amid these sweltering enclosures

with their walls of cracked clay, I have caressed

beautiful, strong horses trained for jousting

with a splendid brutality. The hands of their

Mongol riders have gently brushed my palms.

JOSEPH KESSEL

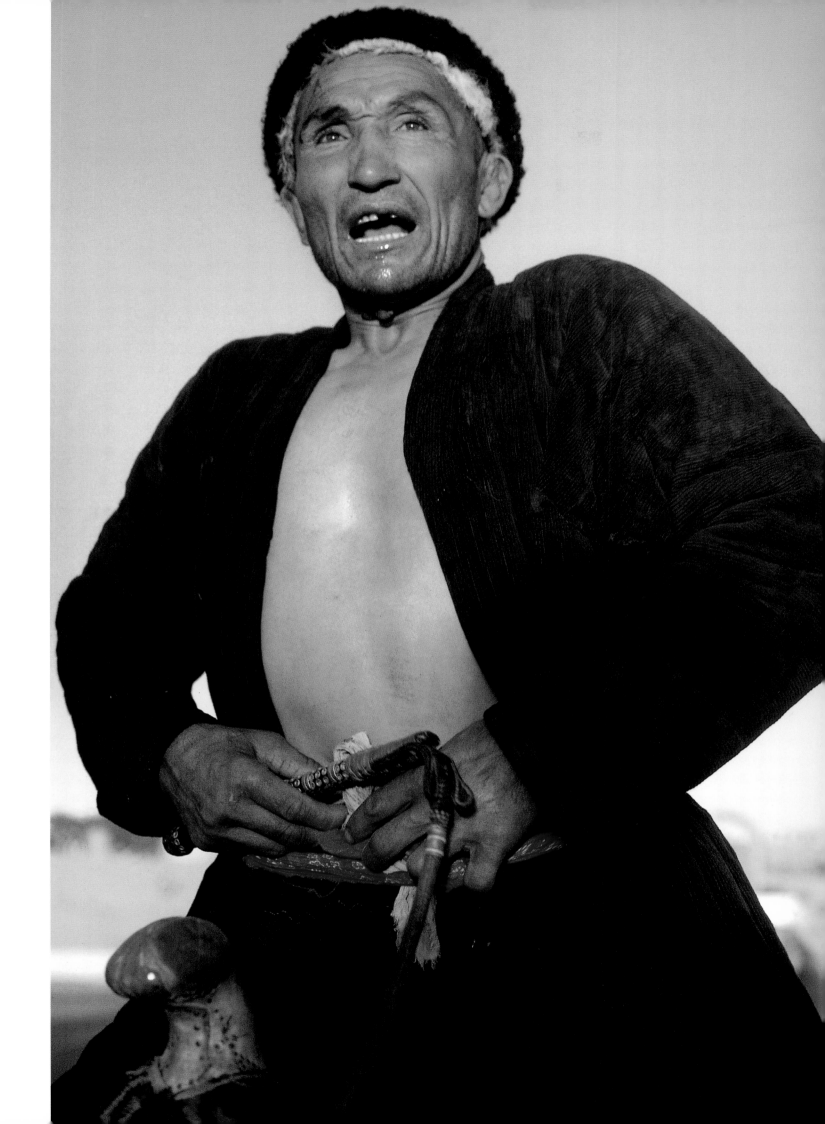

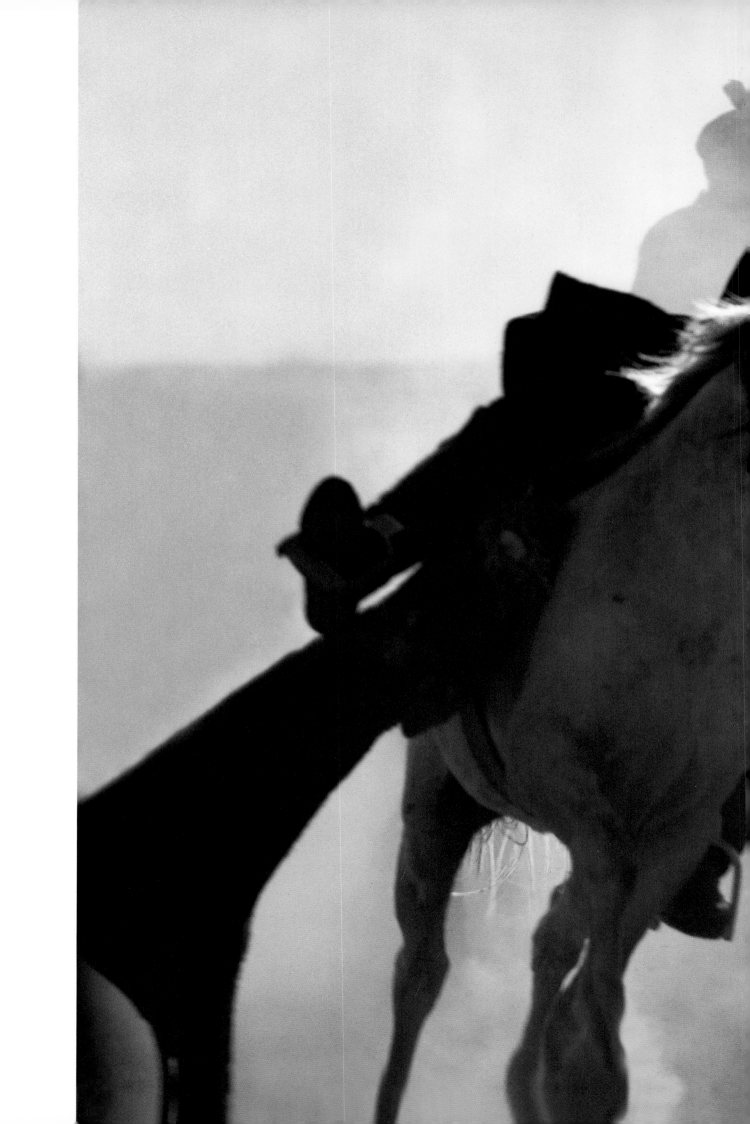

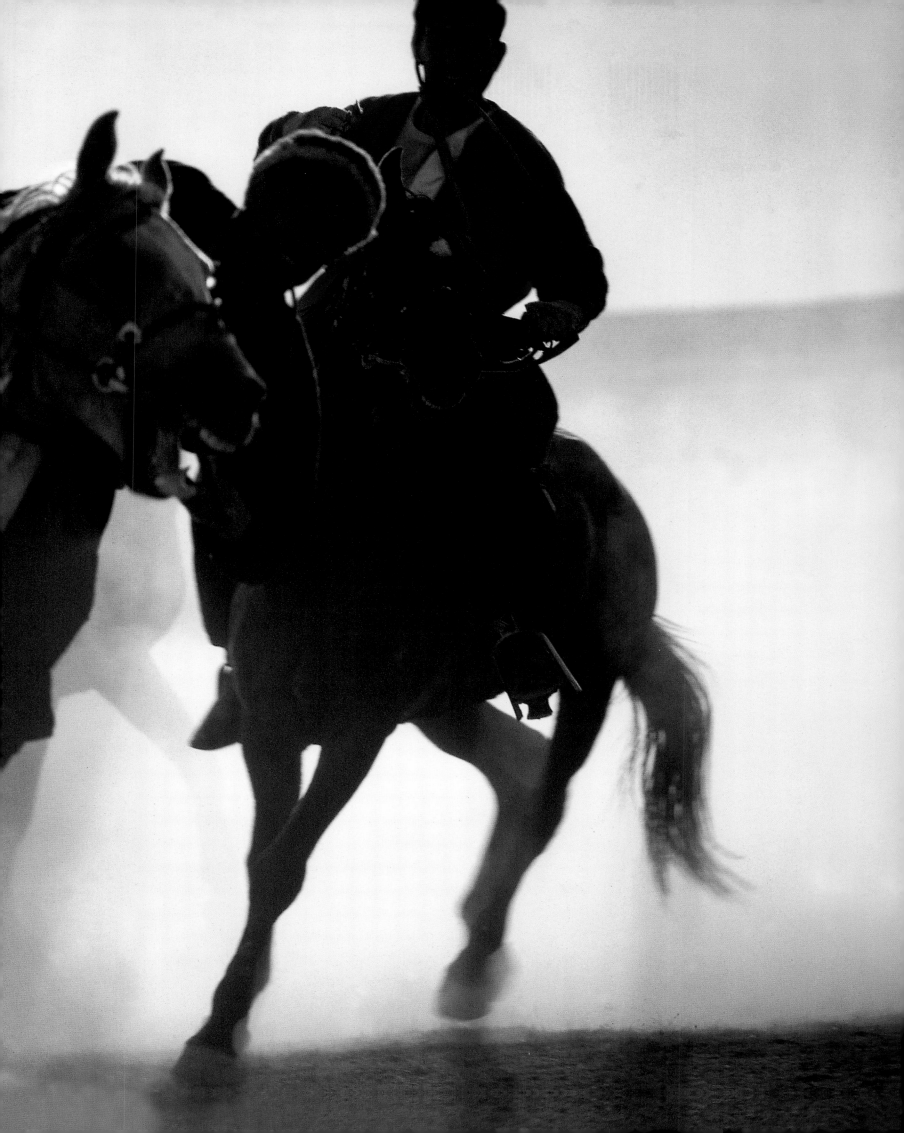

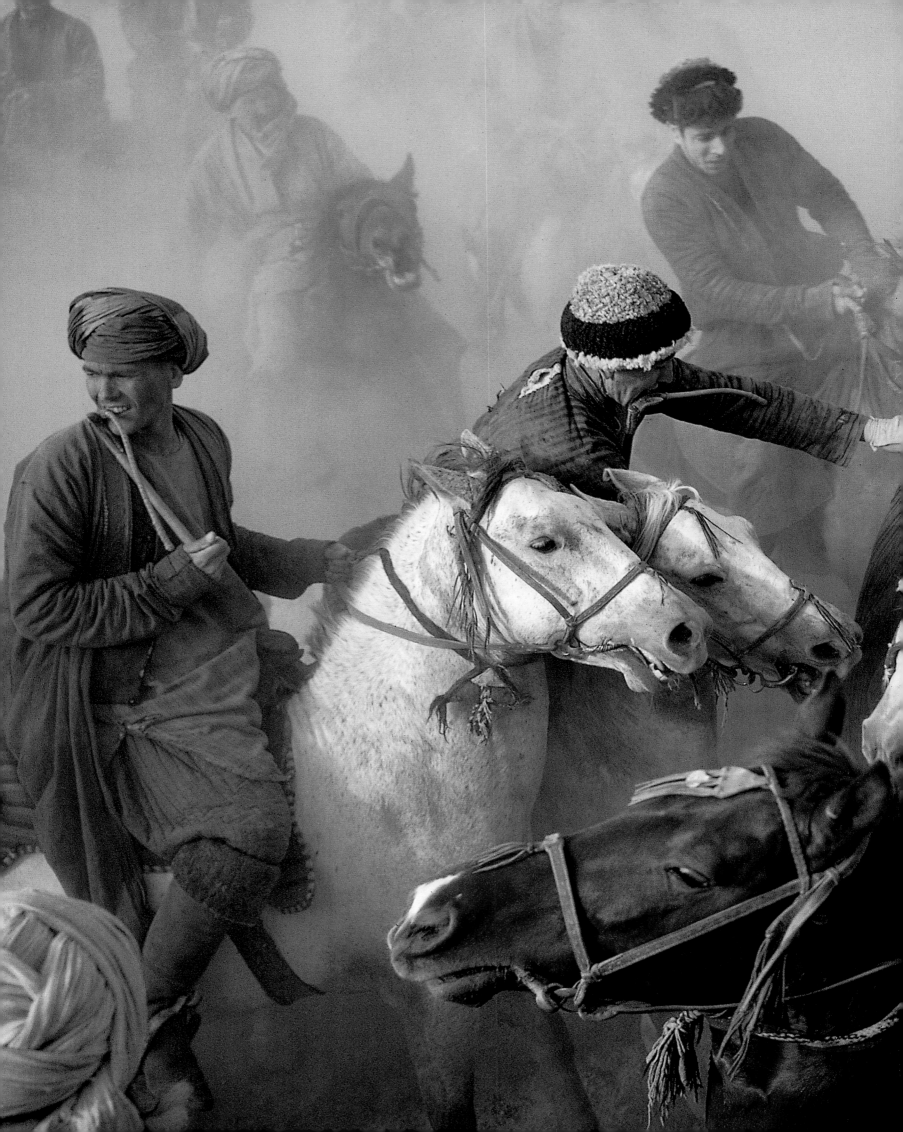

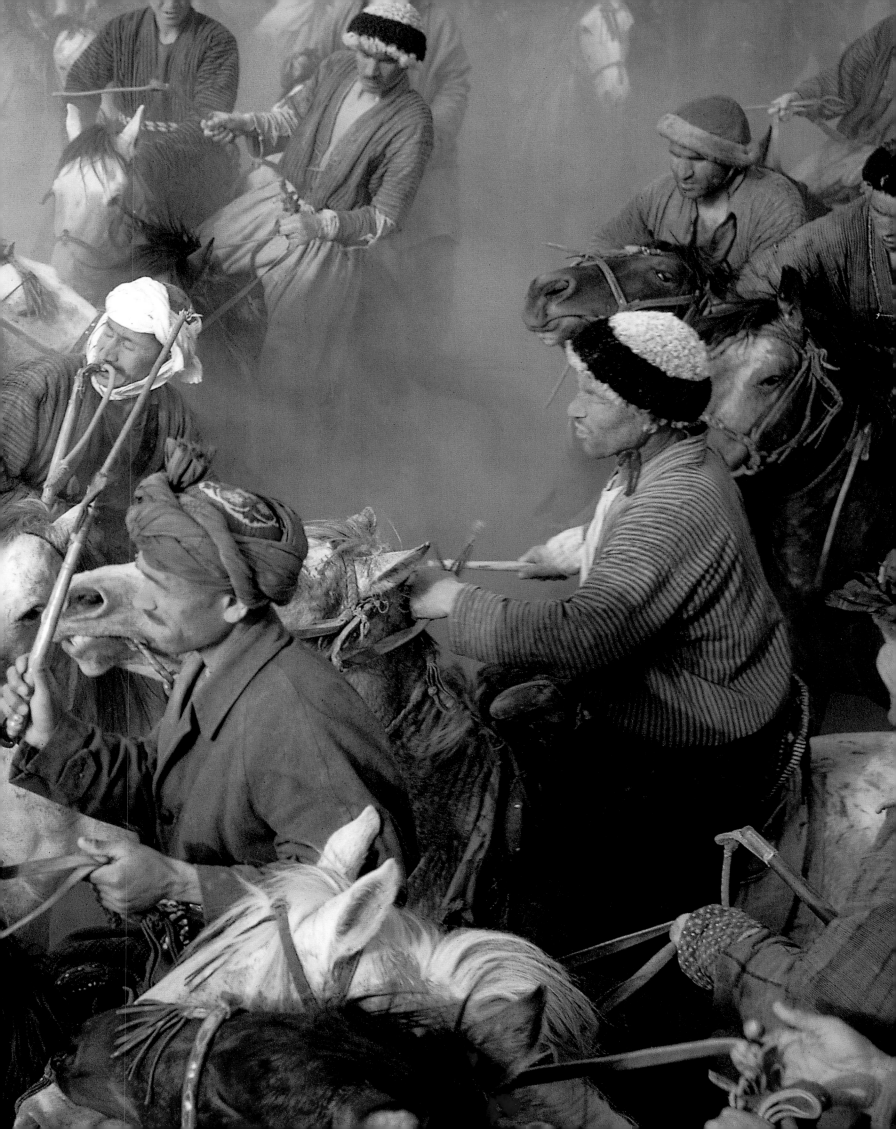

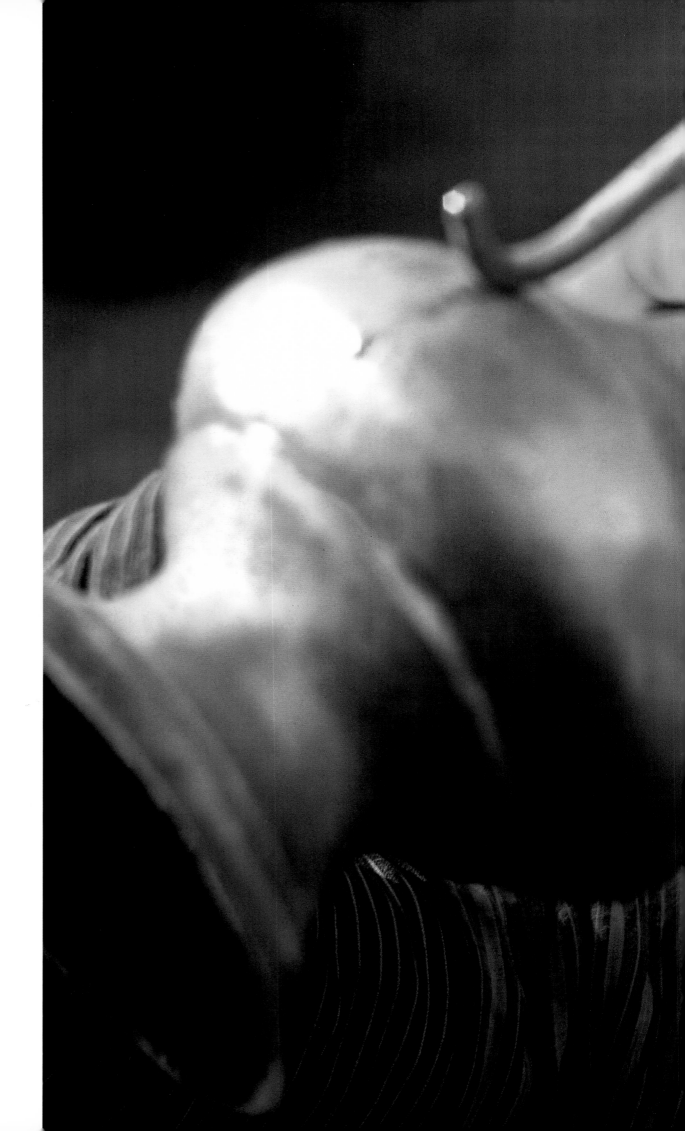

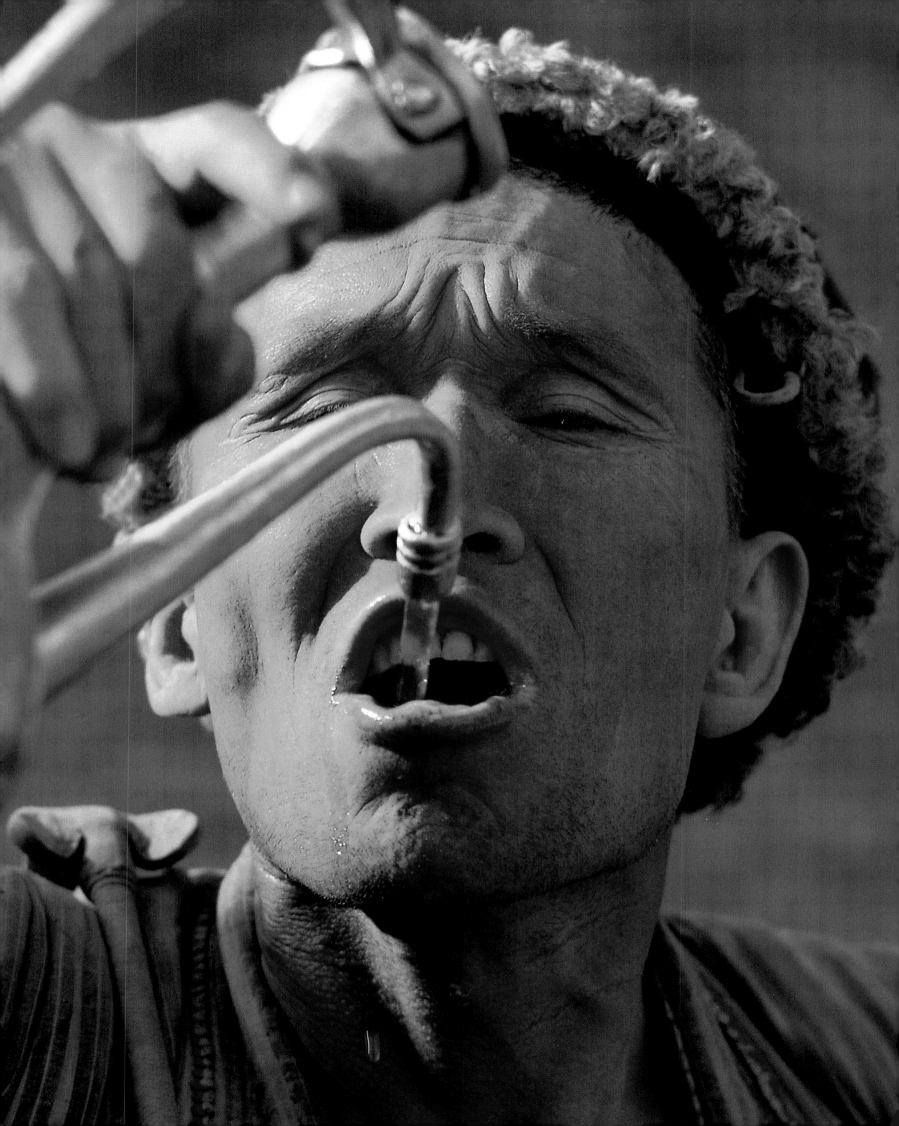

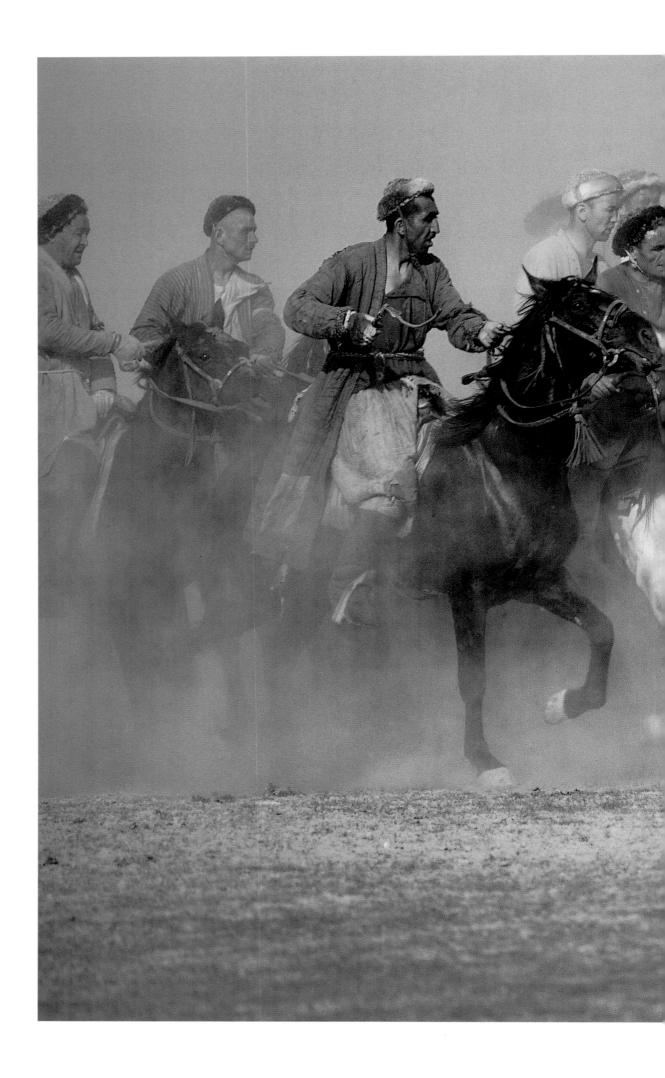

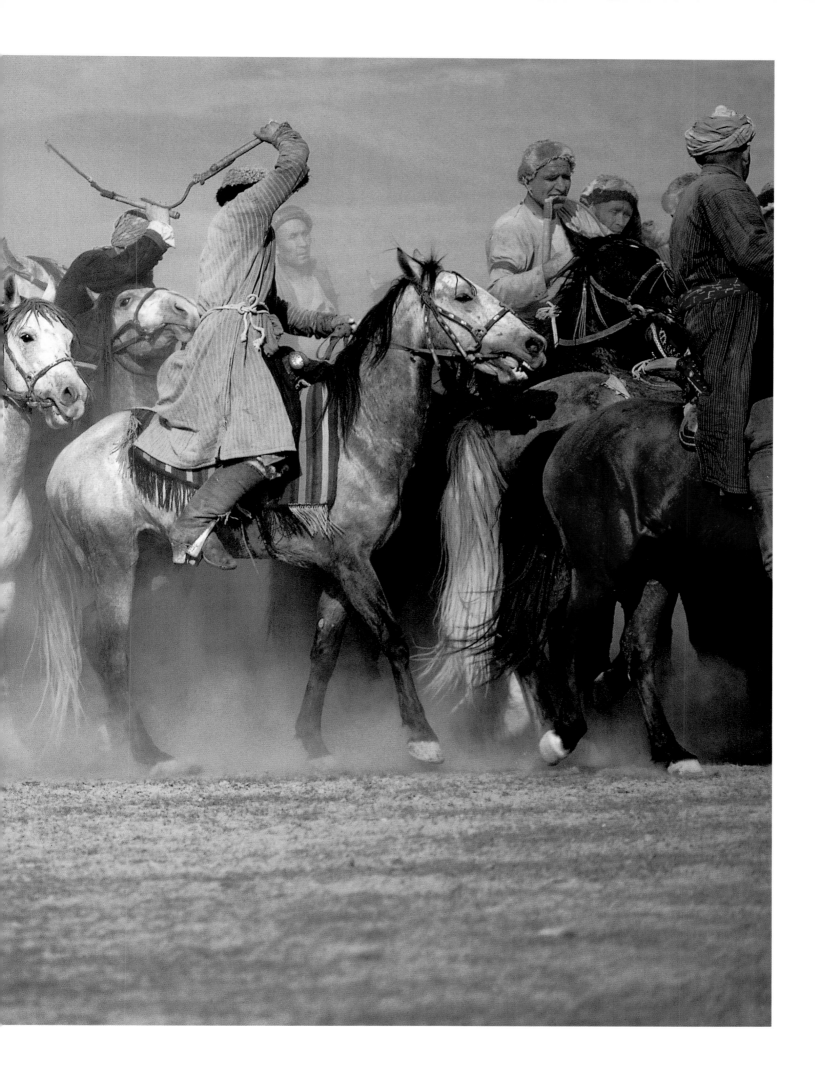

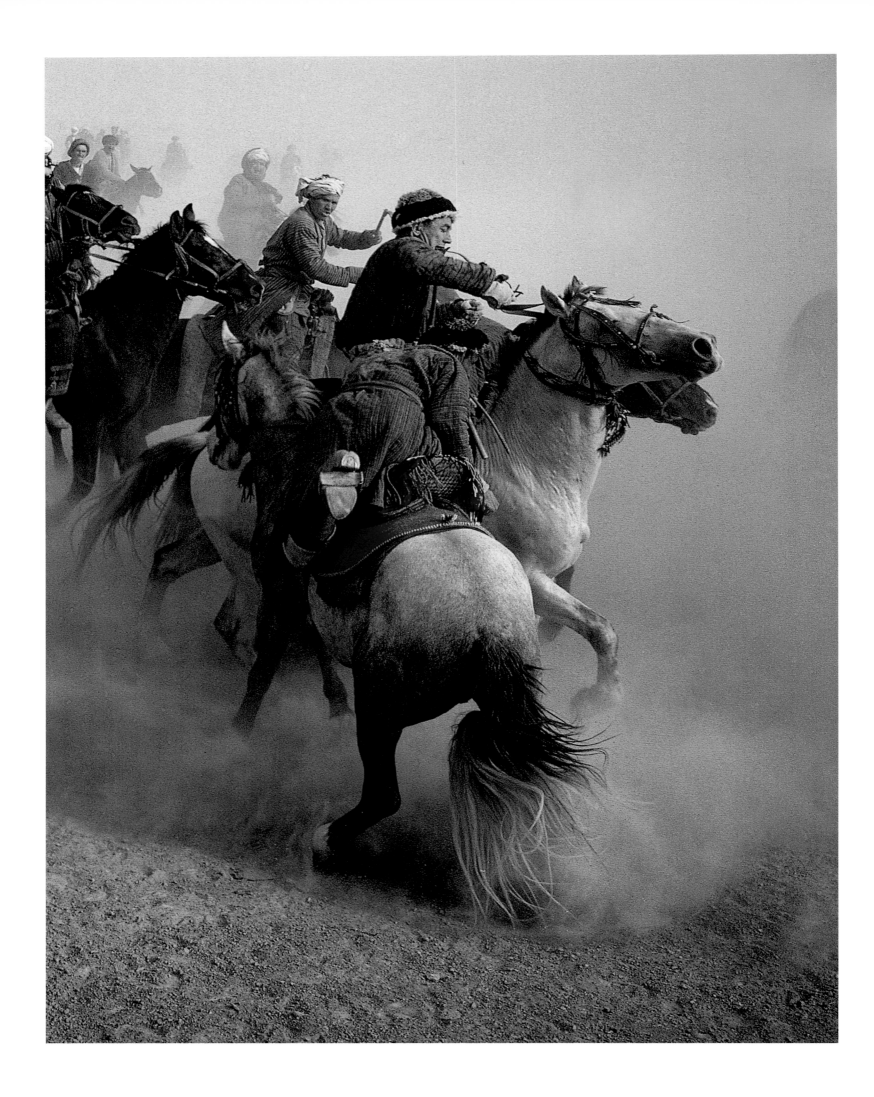

Far off, the steppe rises up in a cloud of dust.

A frenetic stampede is sketched against the naked hills.

The far-off rumble grows like rolling thunder.

One immense cry drowns the plain. From the horizon,

hundreds of horsemen descend on us like a sandstorm....

The hammering of boots makes the earth groan.

This sport on horseback is the bozkashi *of Afghan Turkistan.*

SABRINA MICHAUD

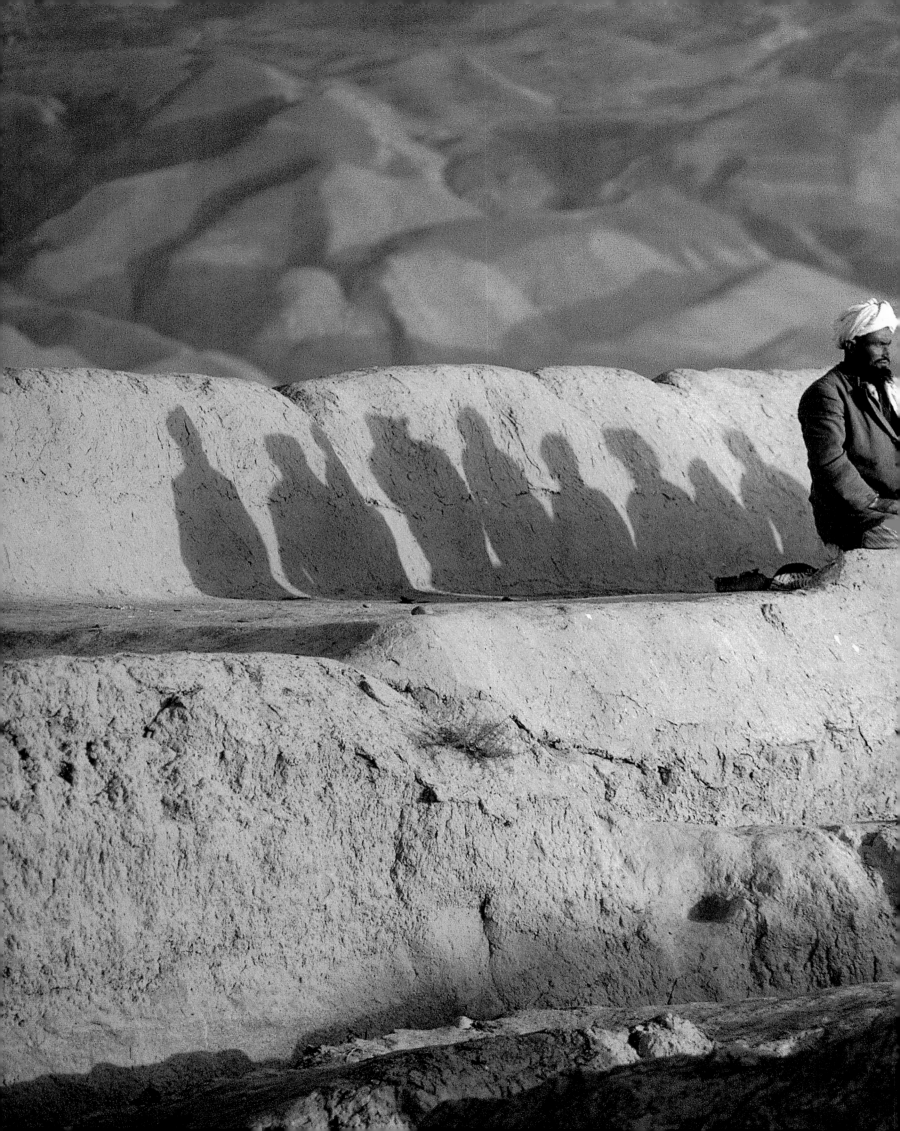

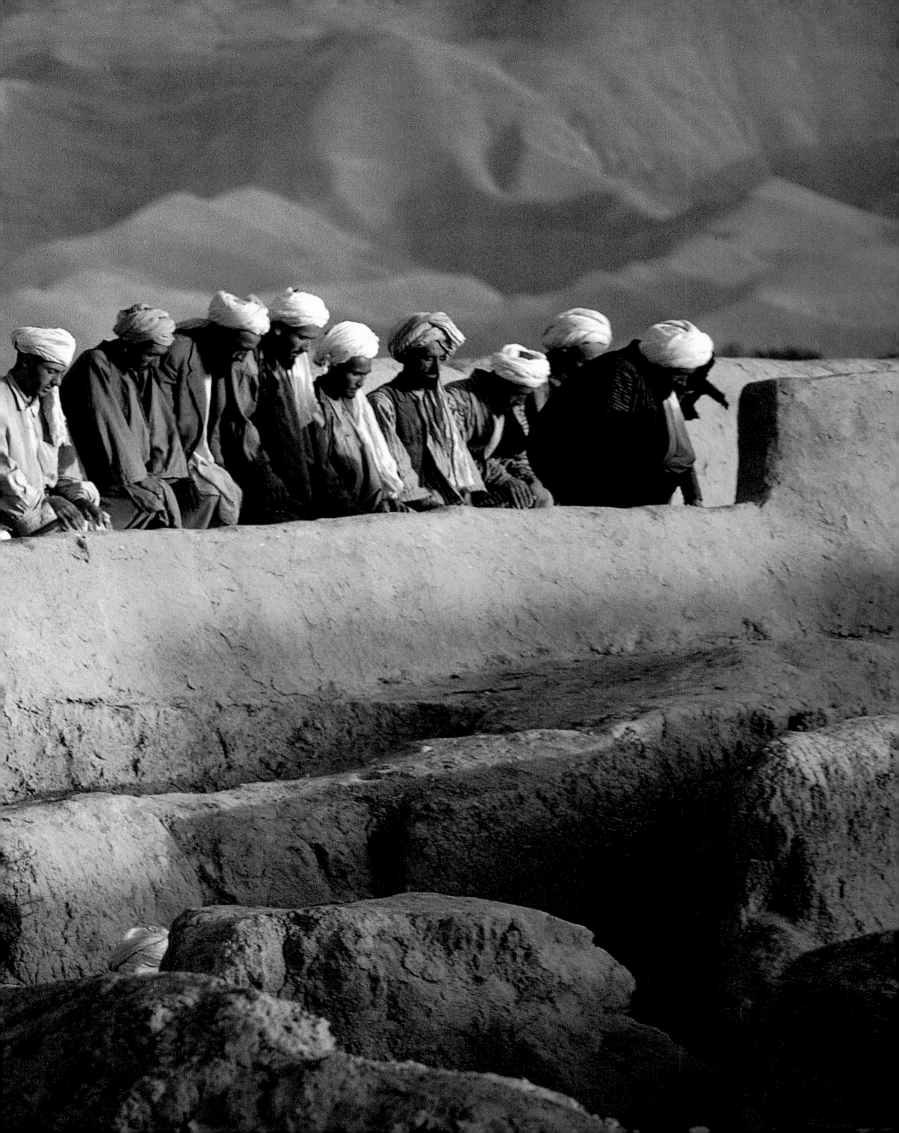

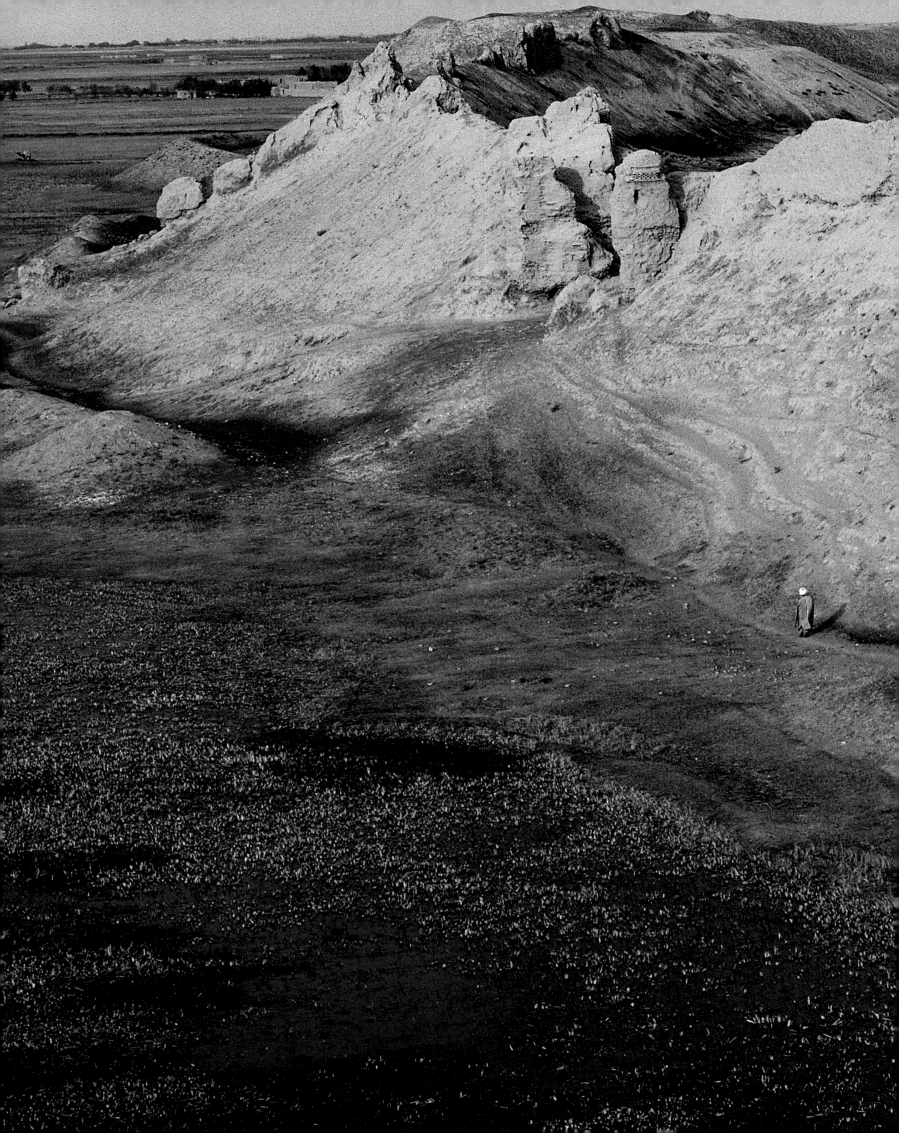

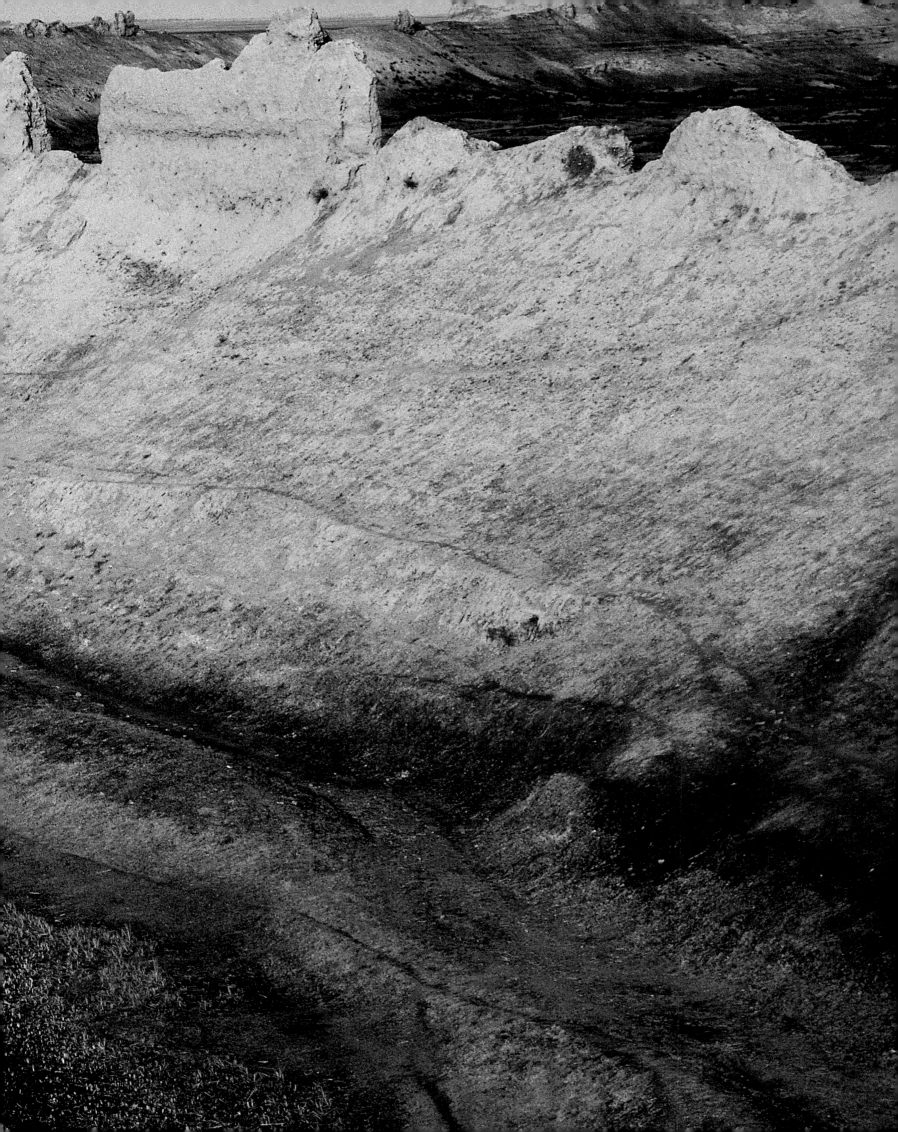

What use has he of his soul who has known You

What use has he of offspring and family?

When you drive one mad,

you give him both this world and the next:

what use has the madman for this world or the next?

ANSARI

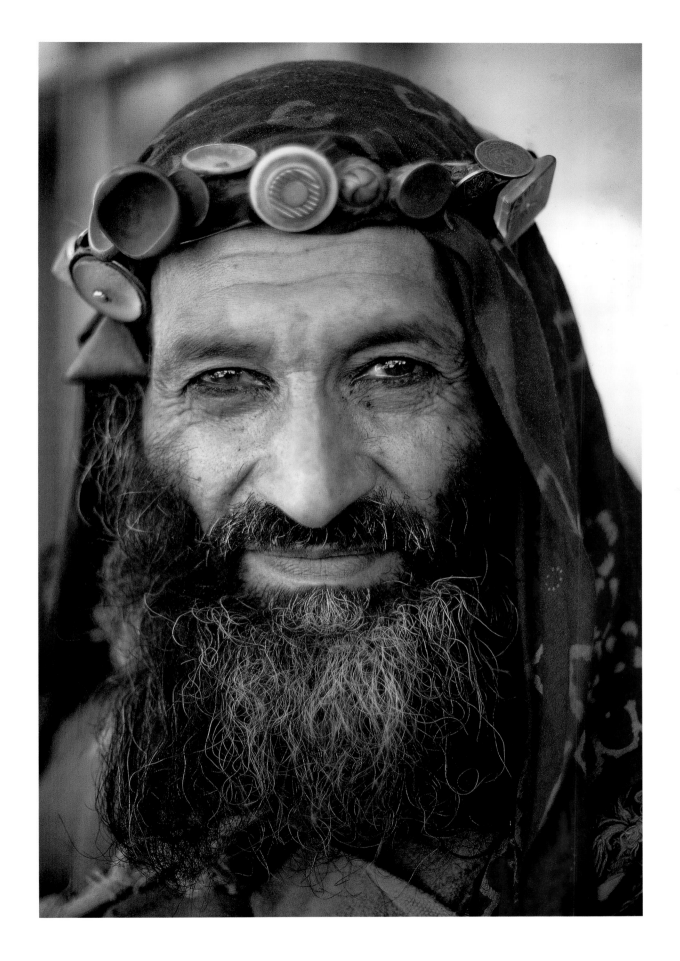

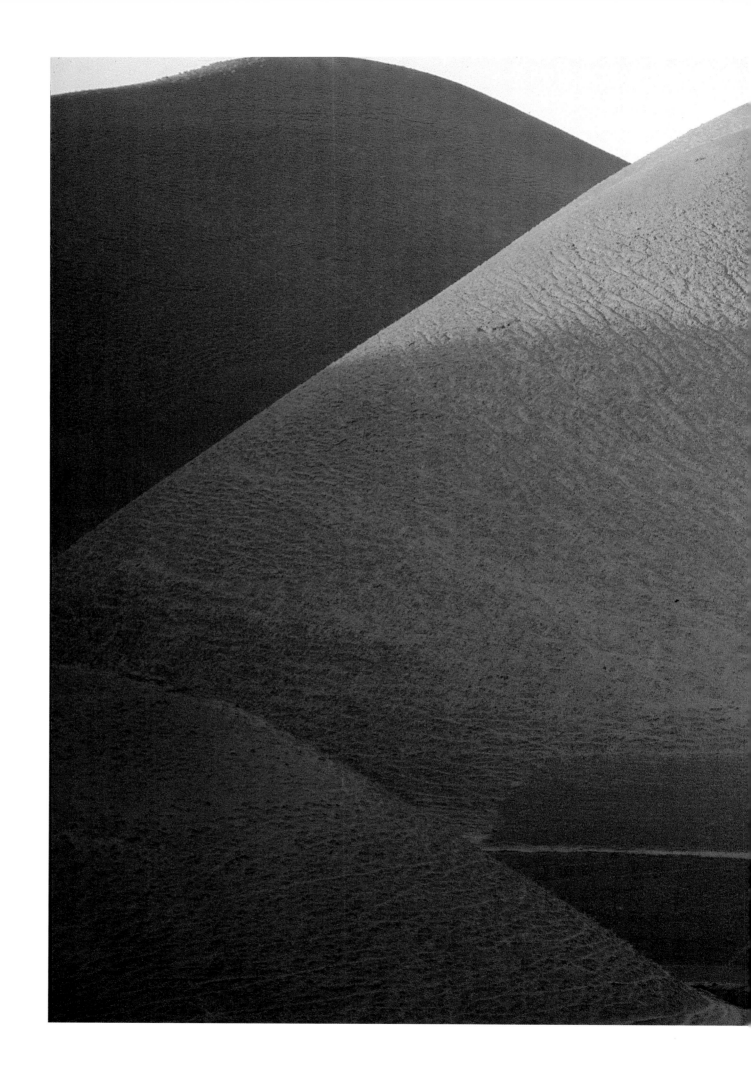

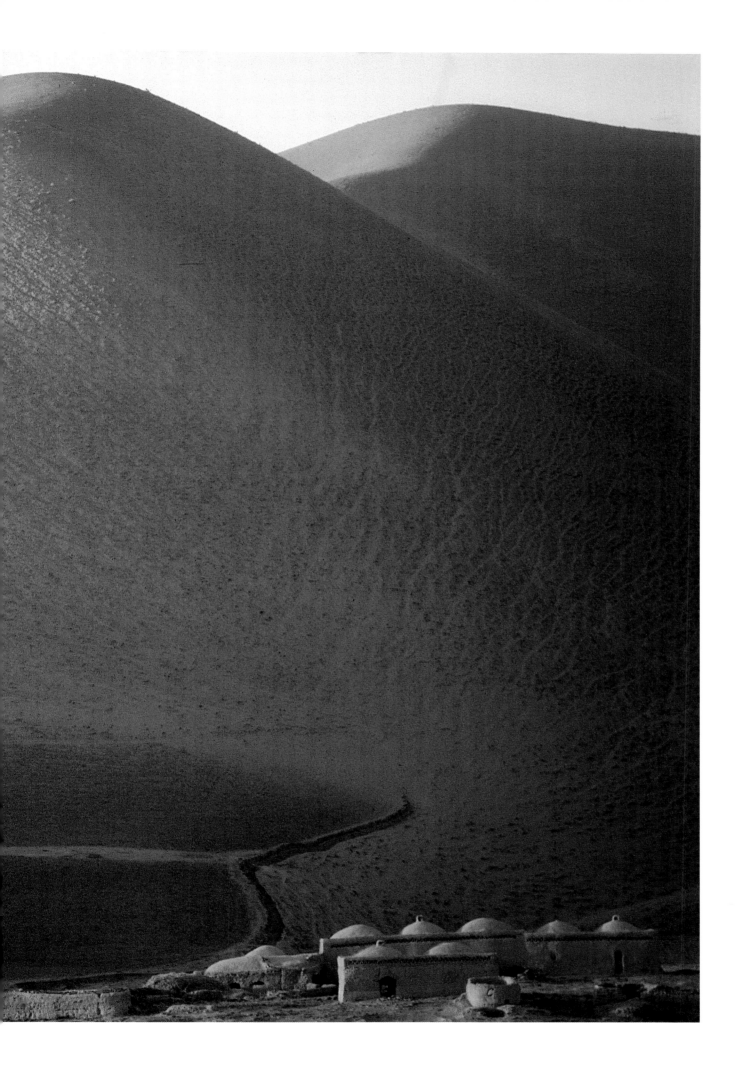

With the soul's ear, listen to the cry of the lovers

The thousand murmurings deep inside the emerald cupola.

RŪMĪ

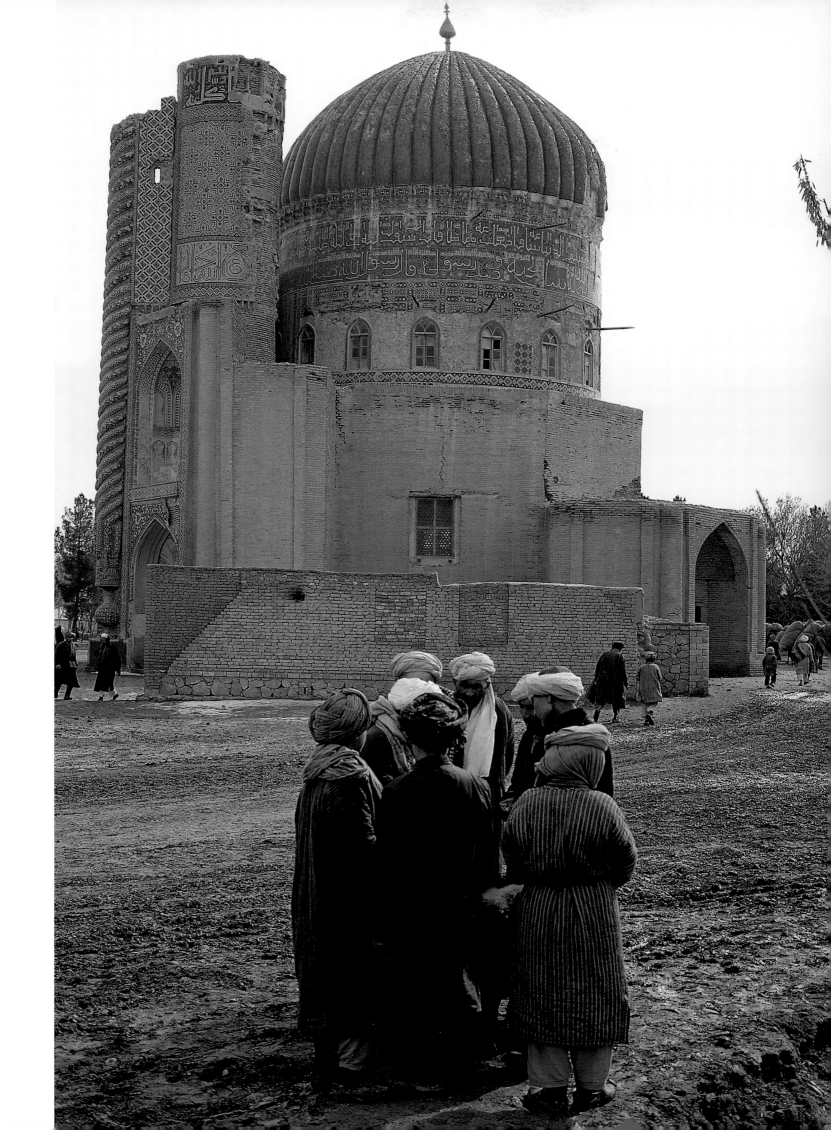

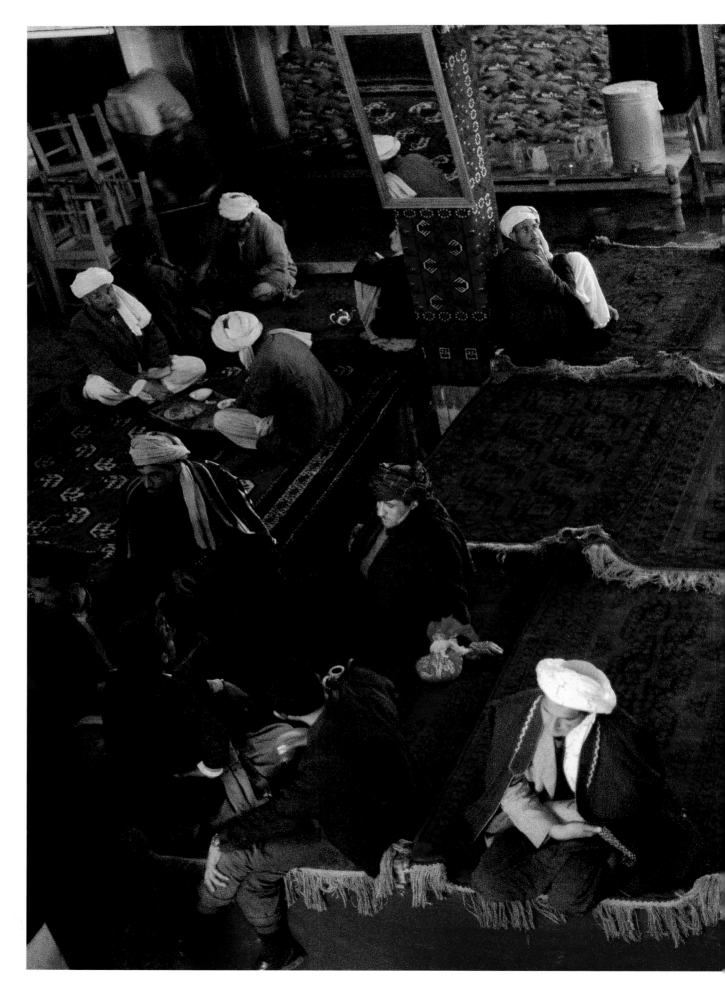

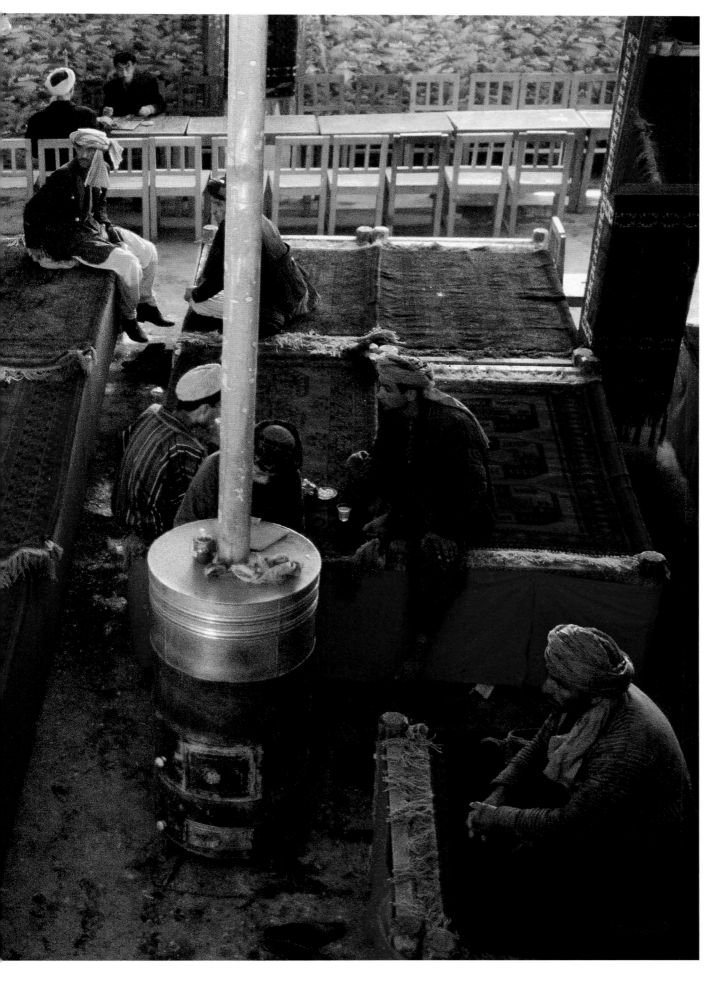

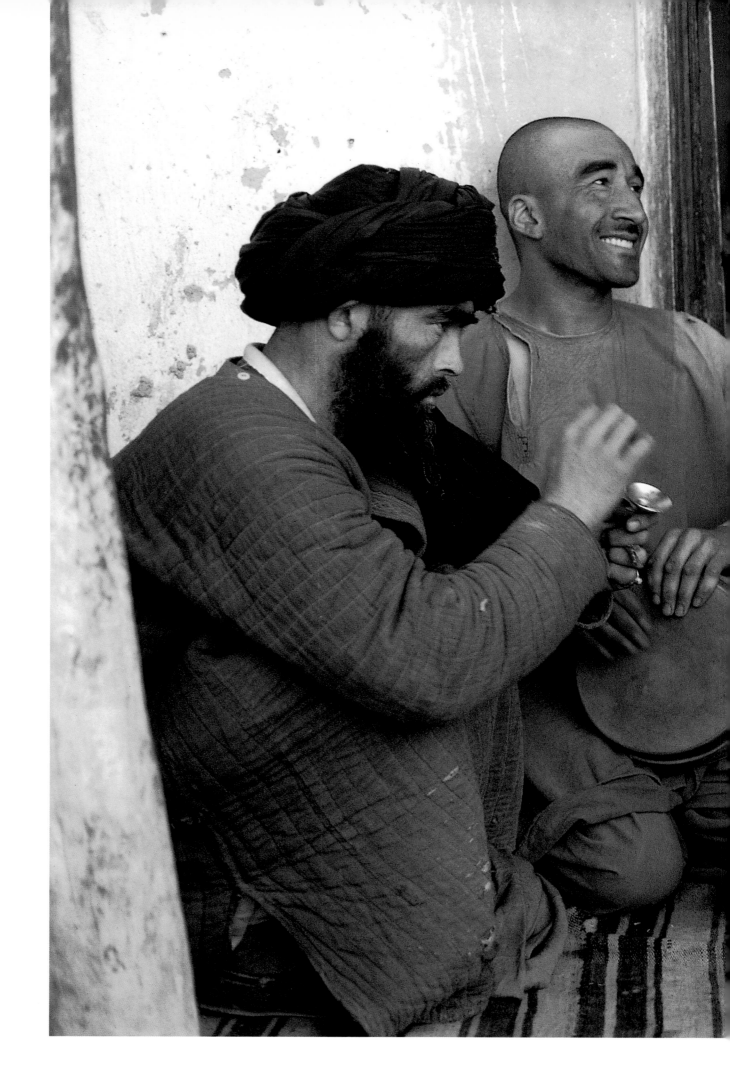

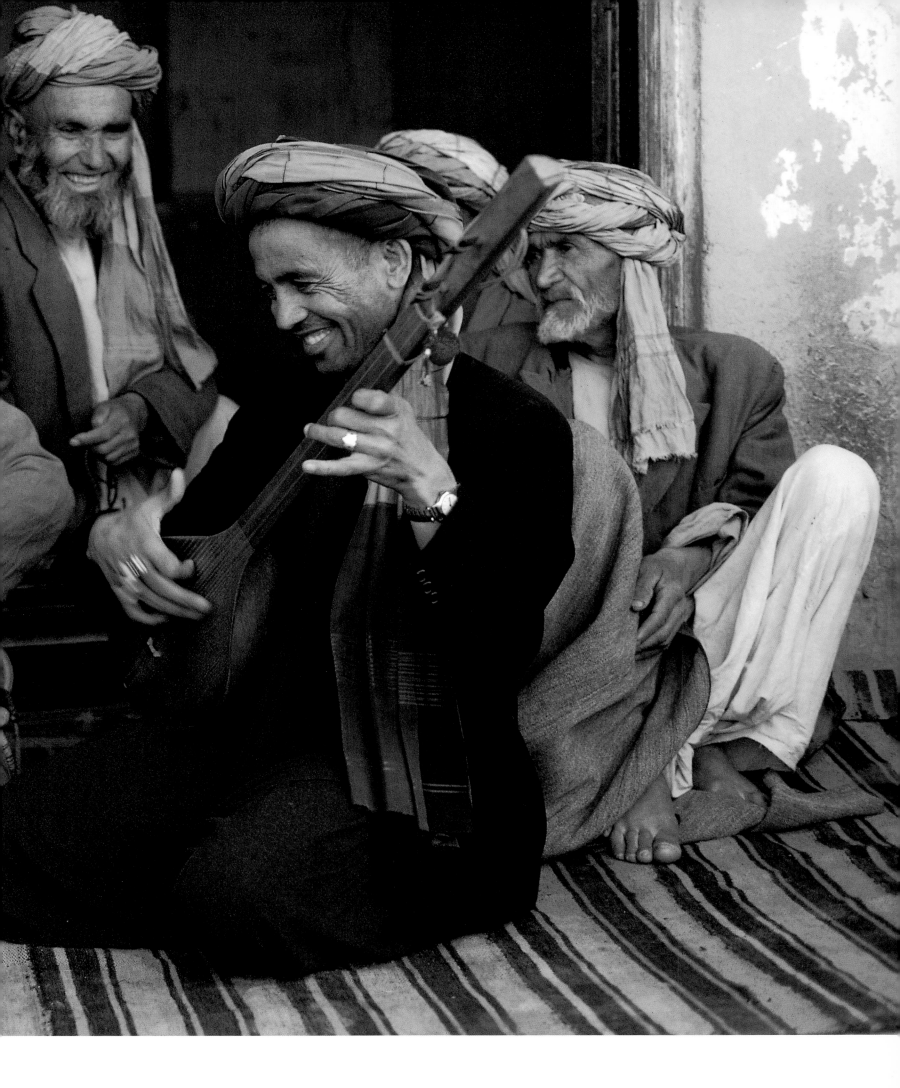

God prescribes perfection in everything.

HADITH

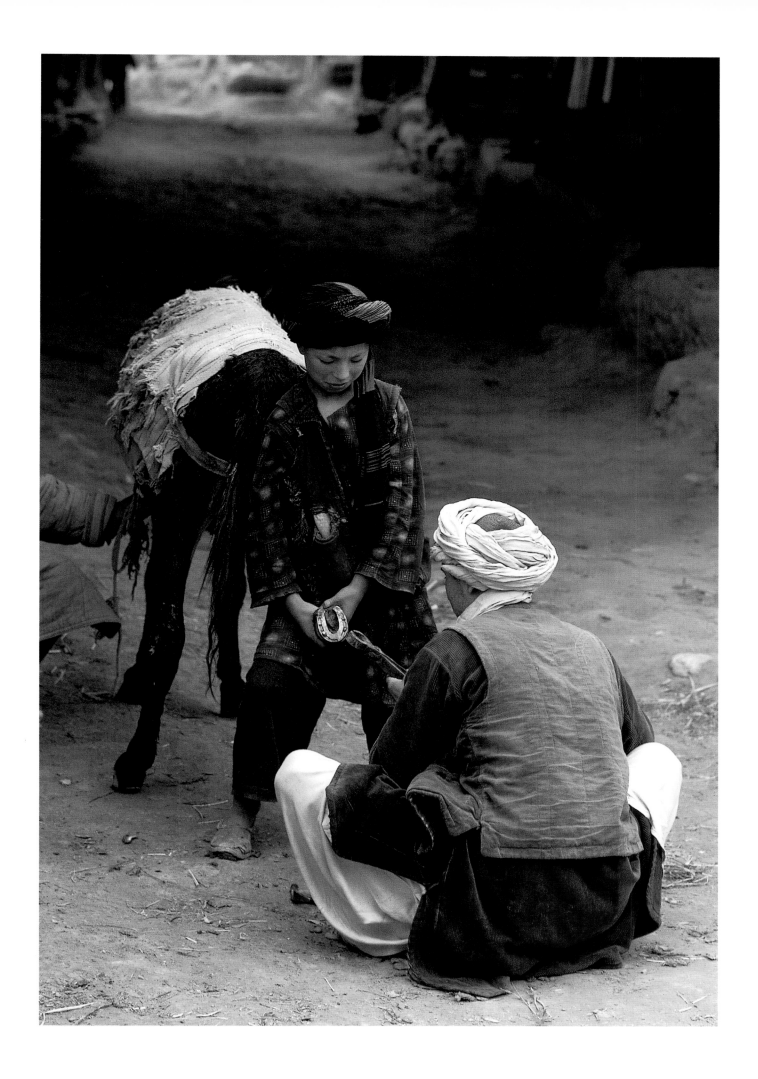

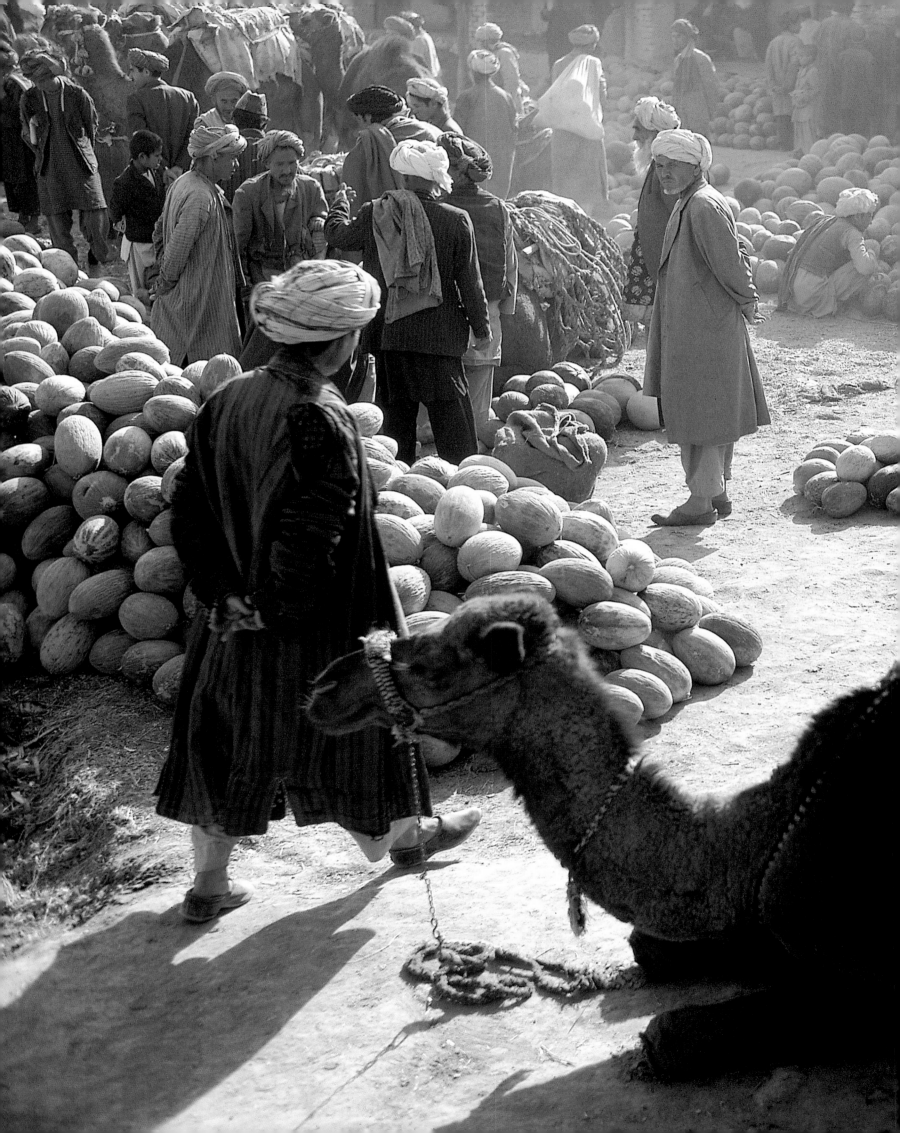

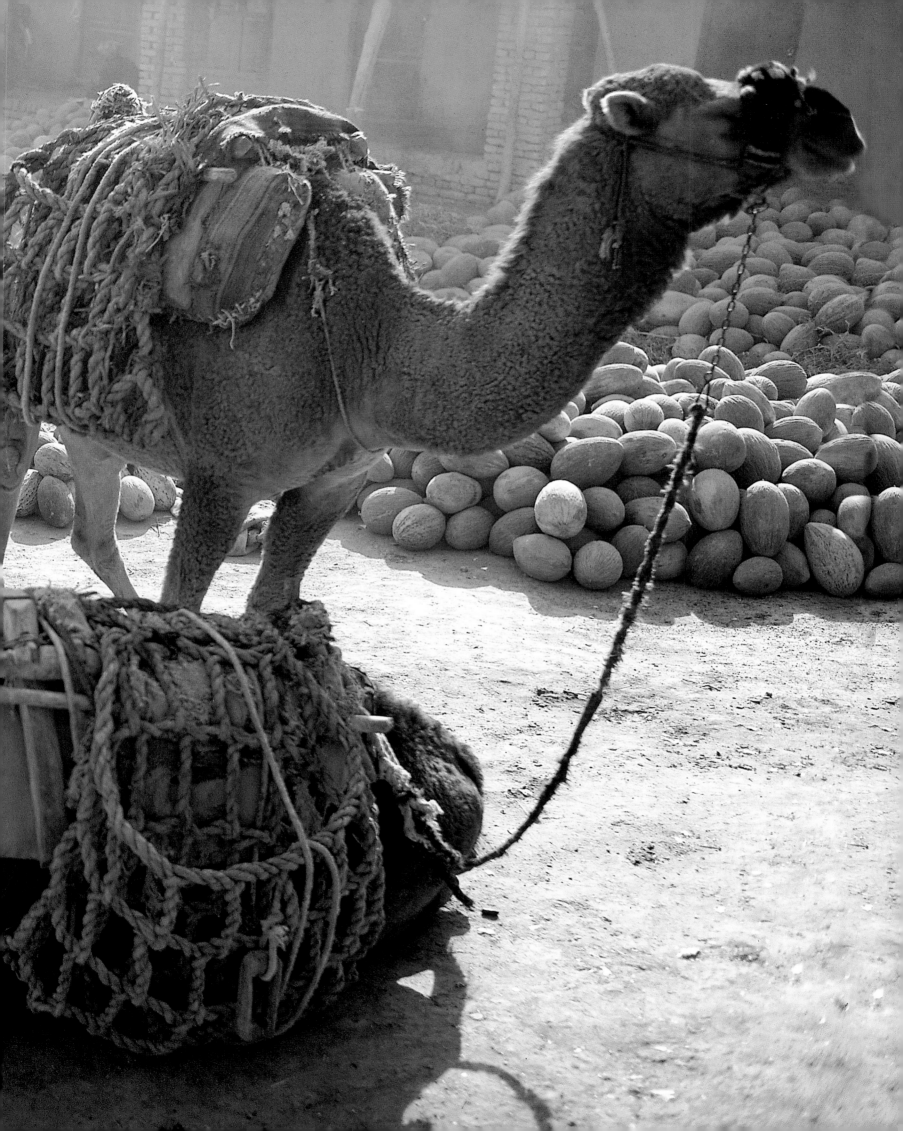

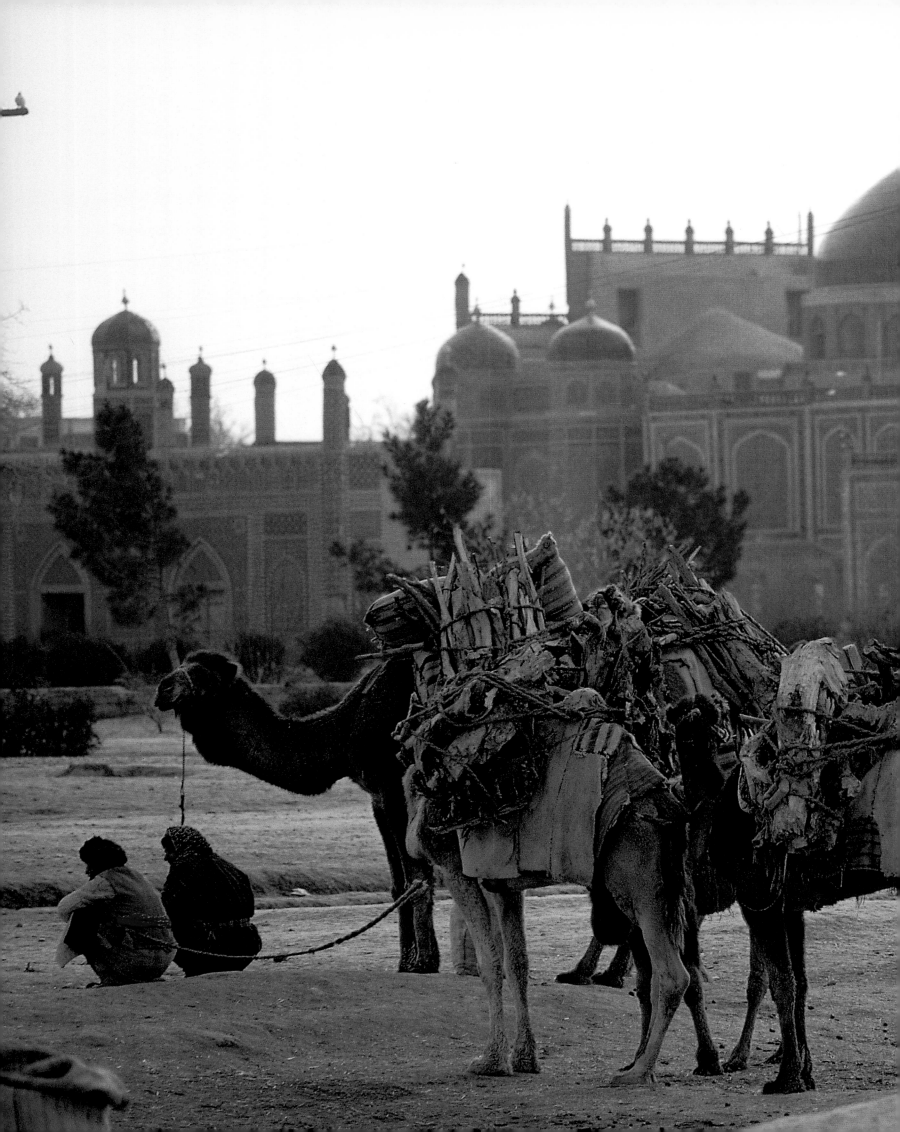

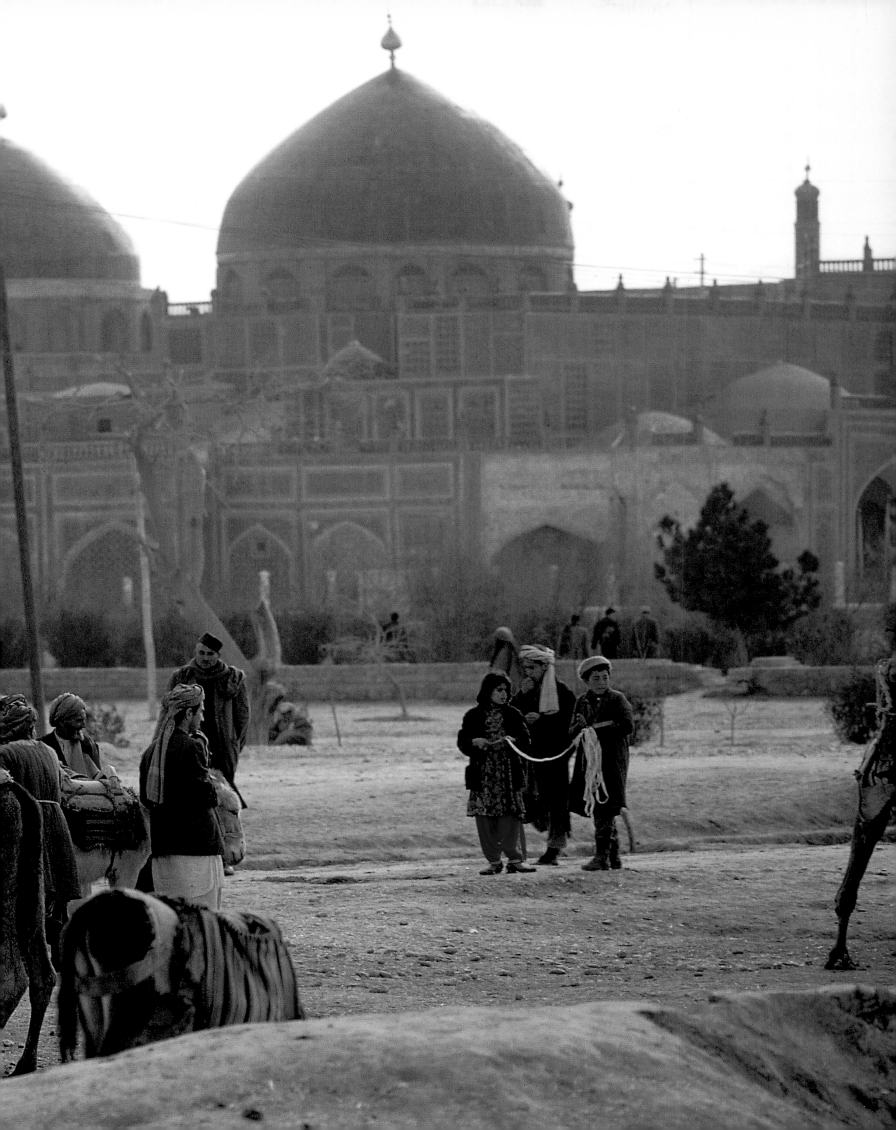

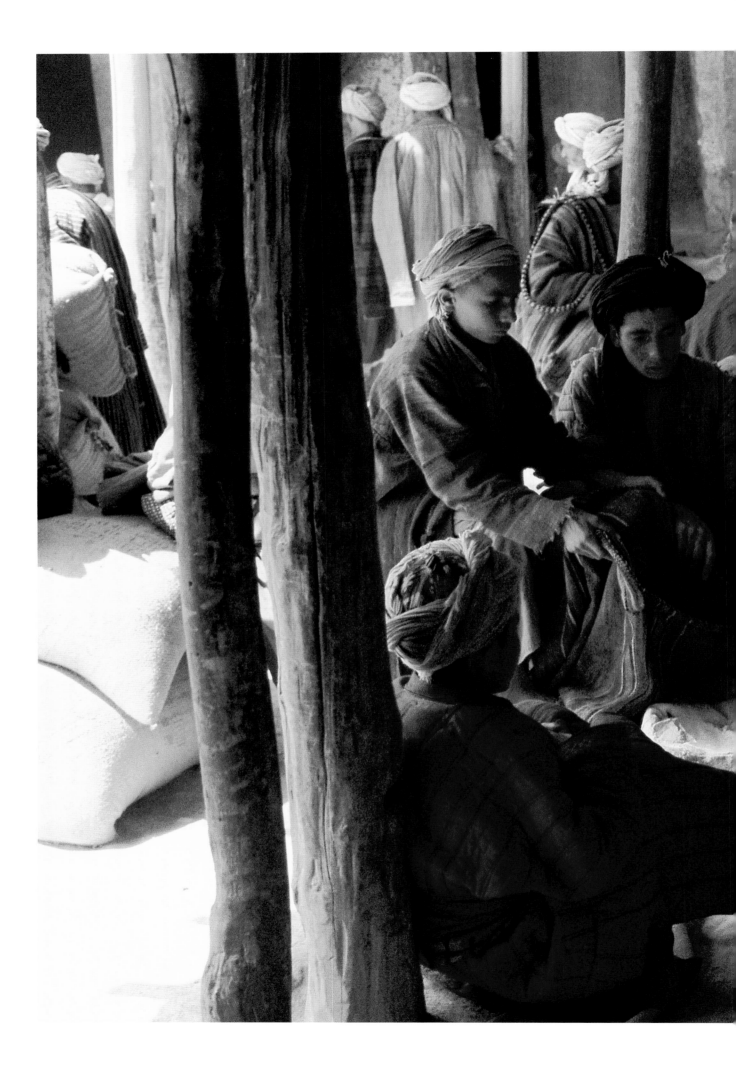

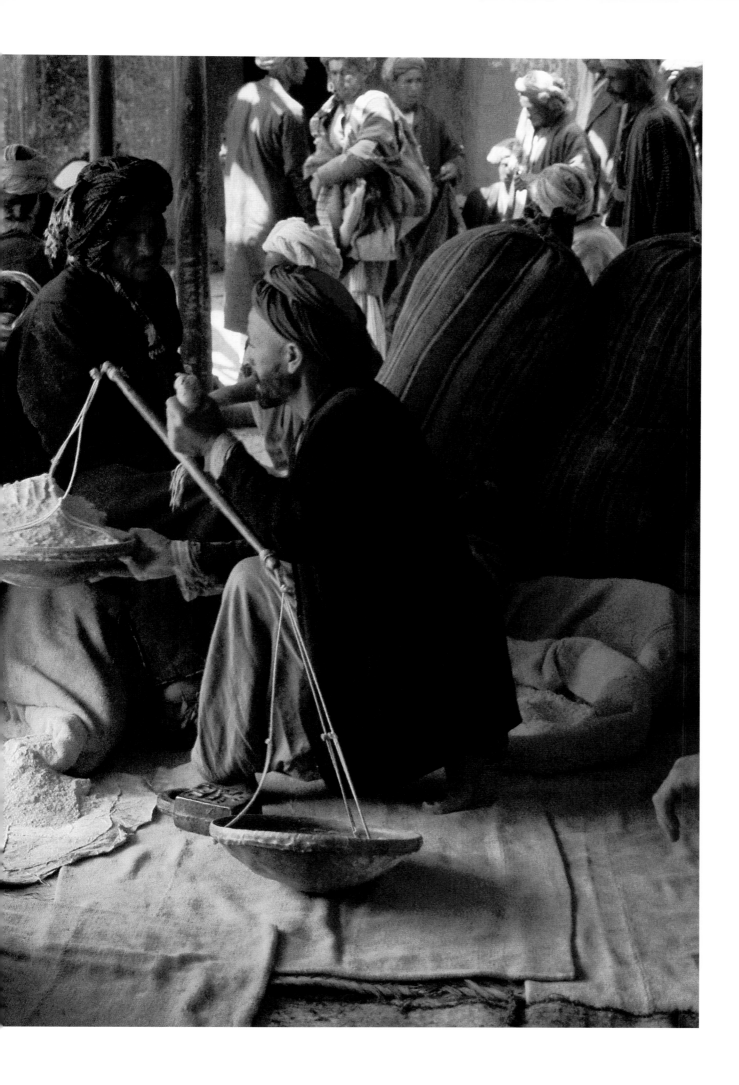

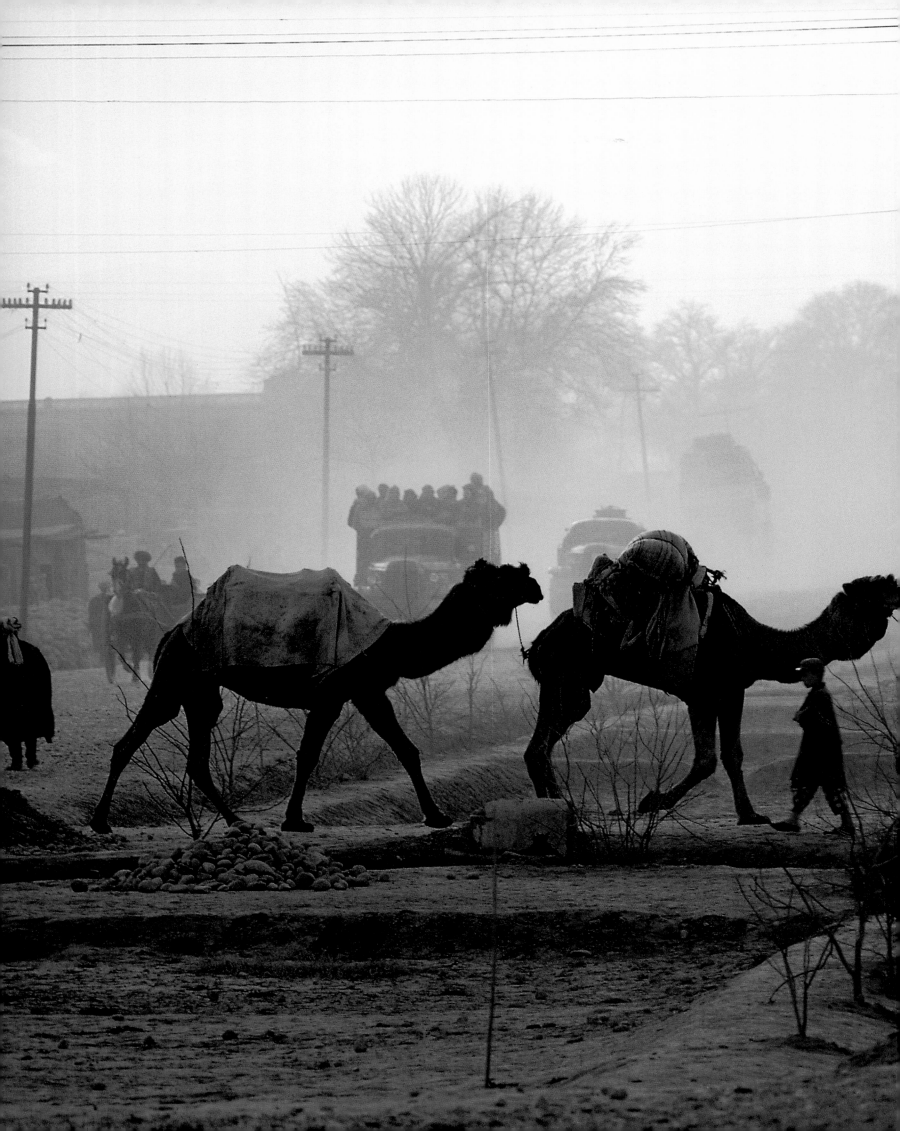

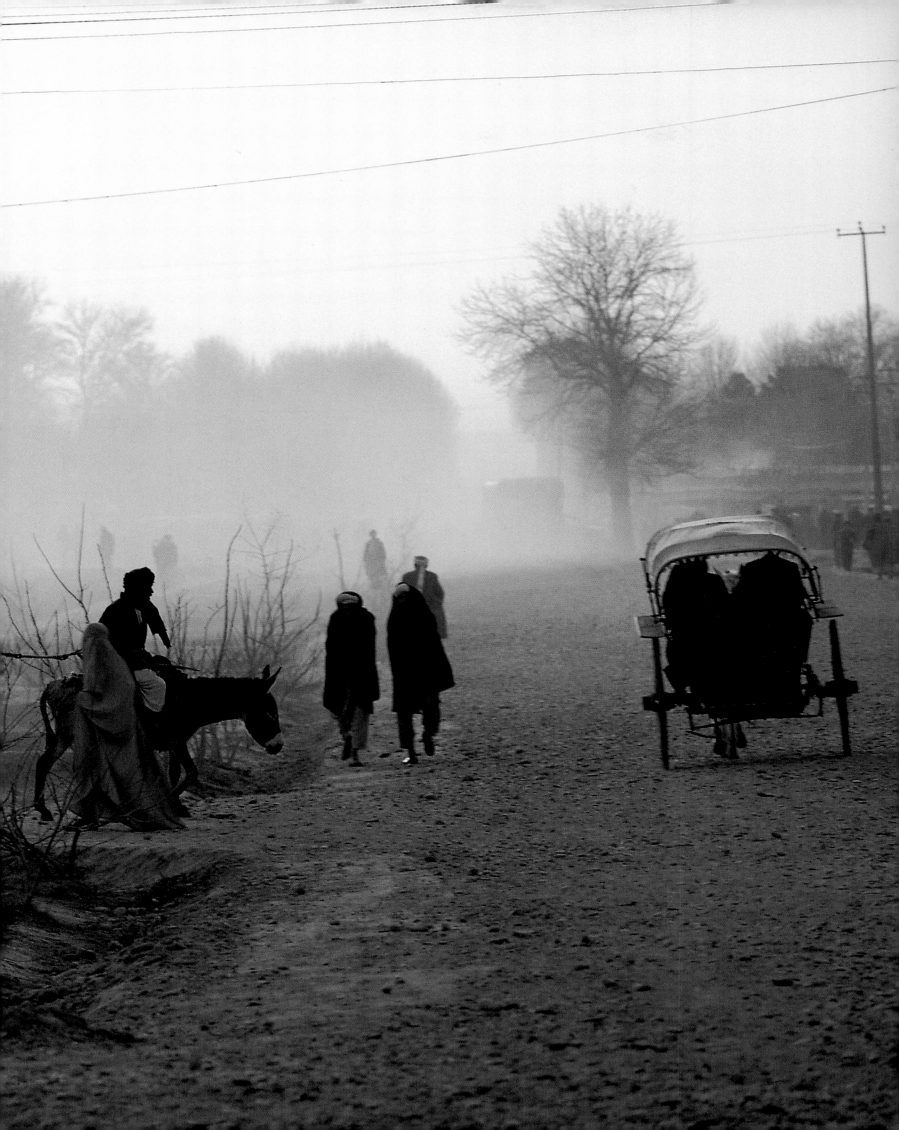

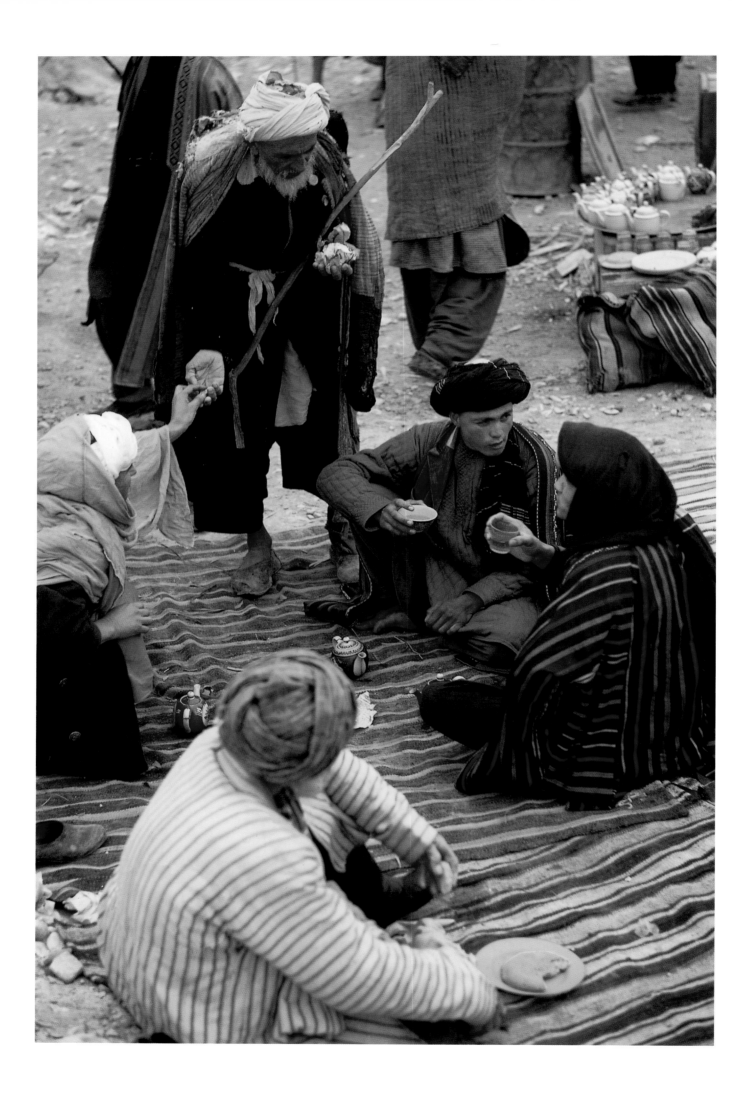

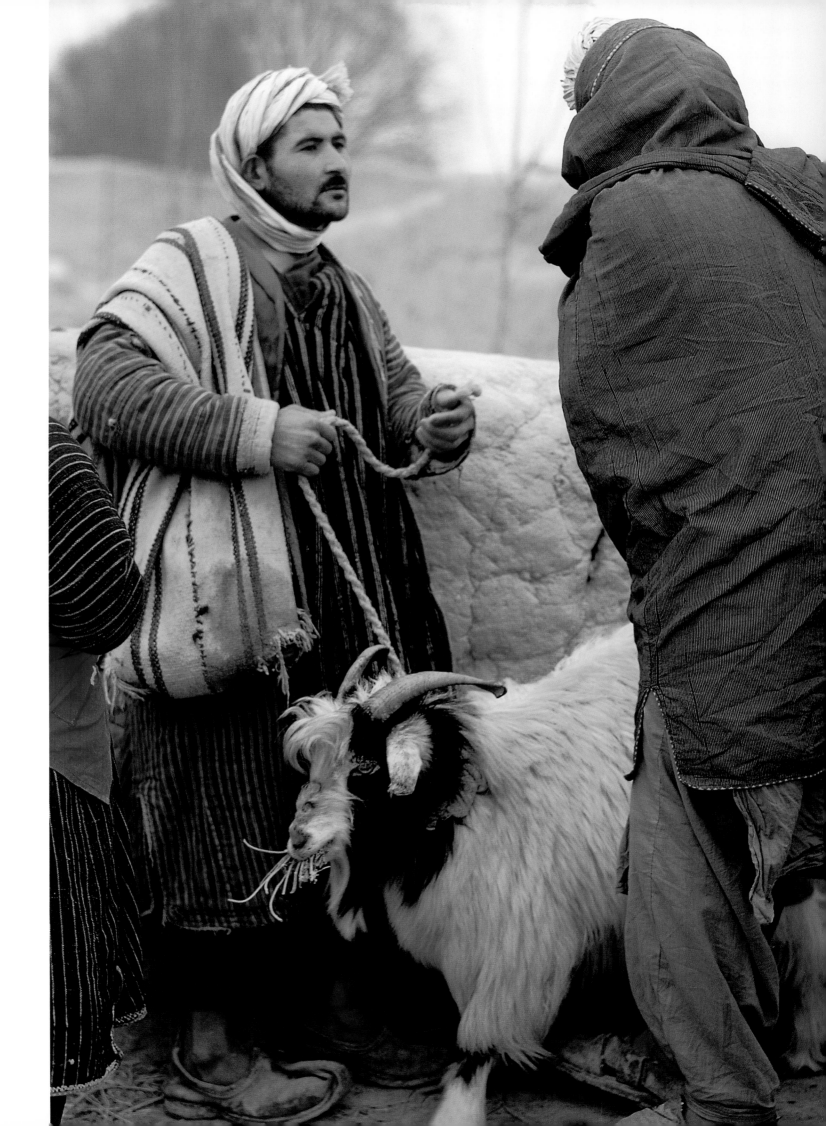

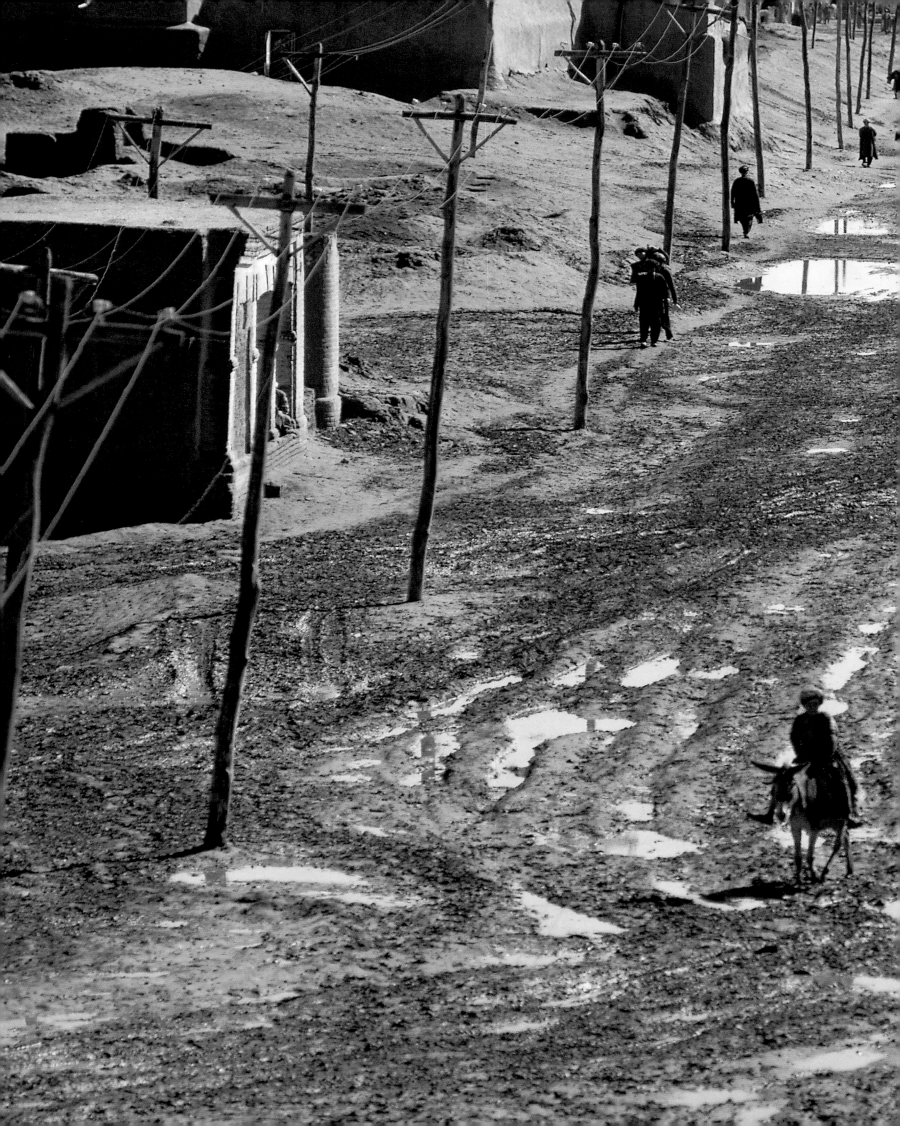

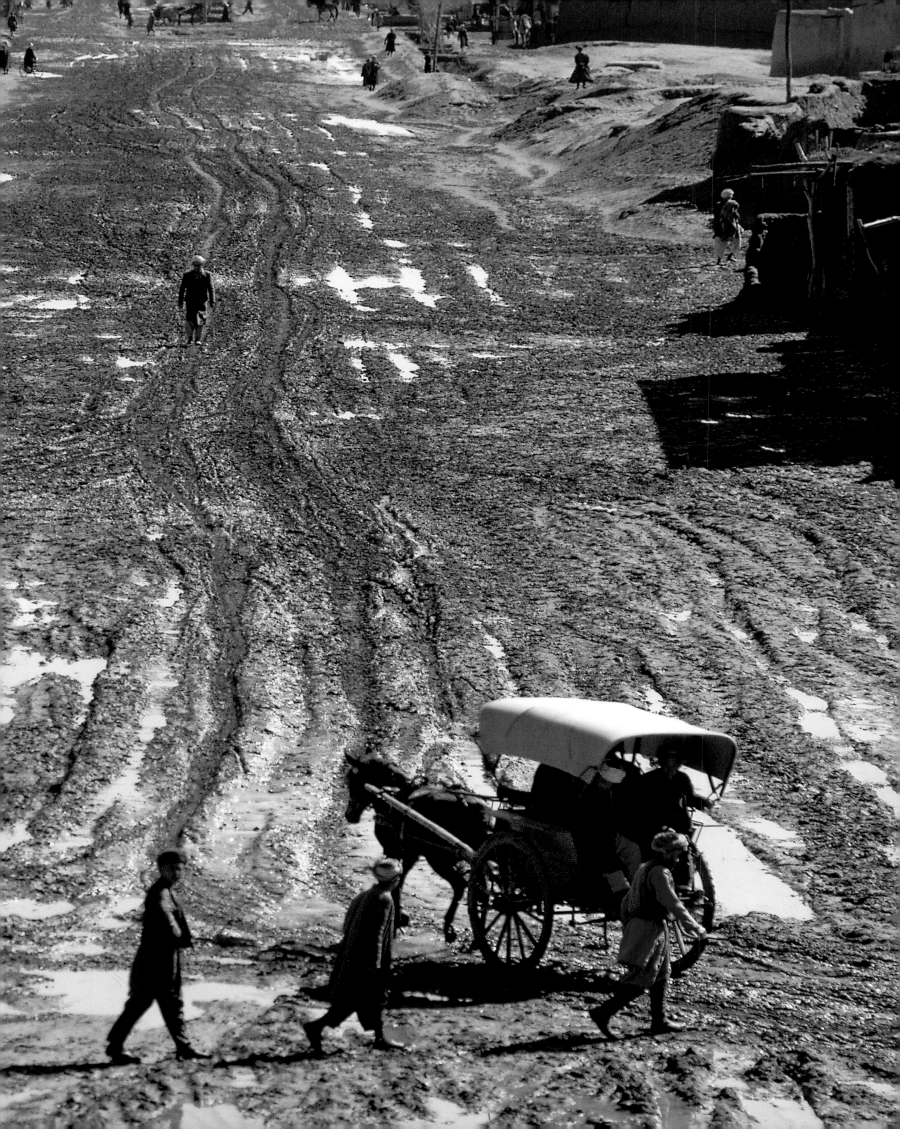

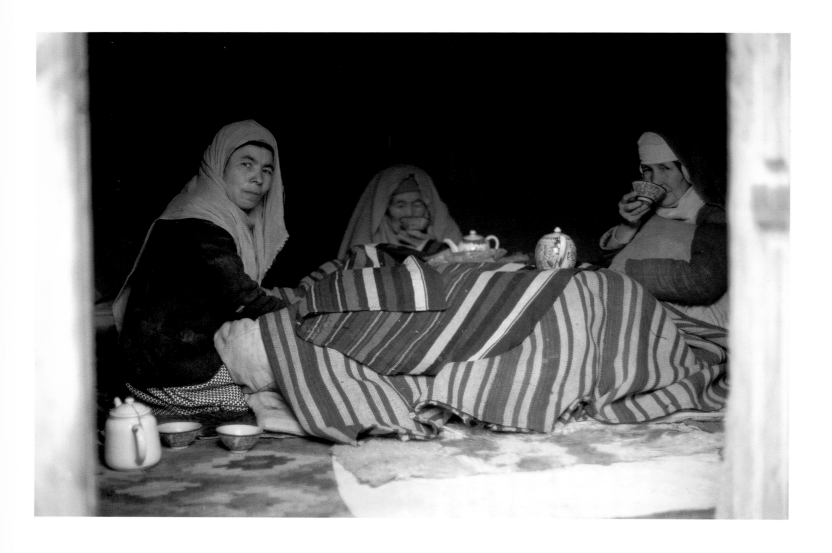

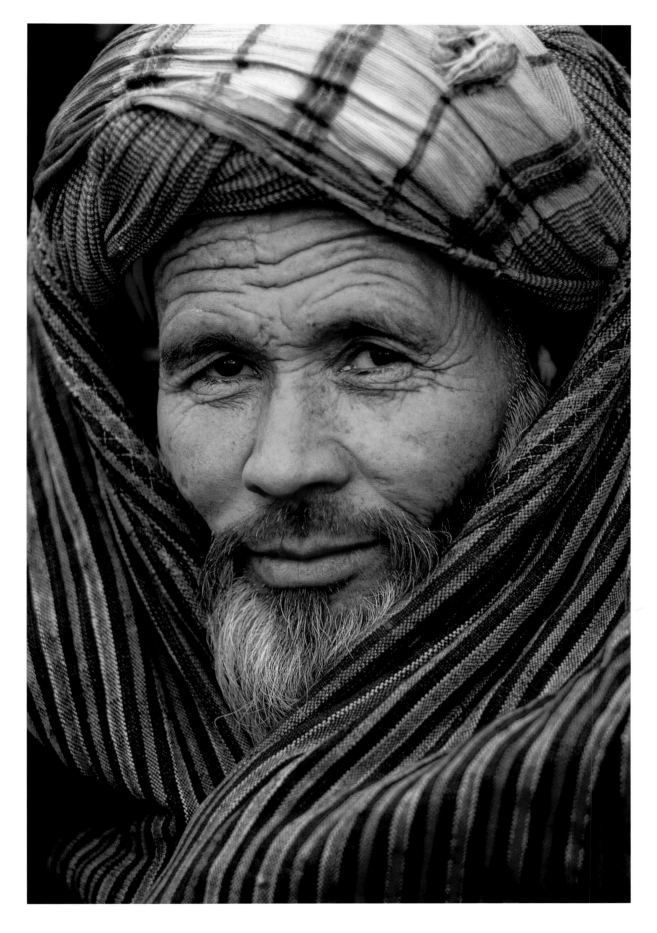

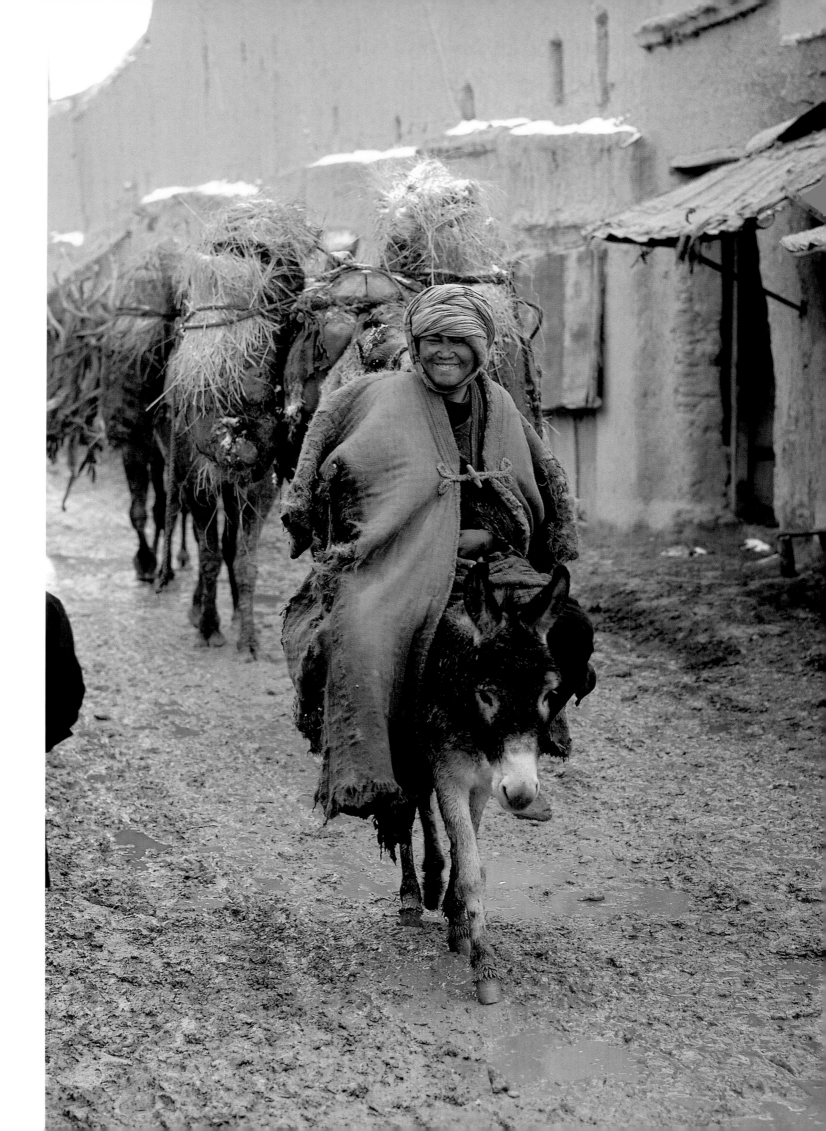

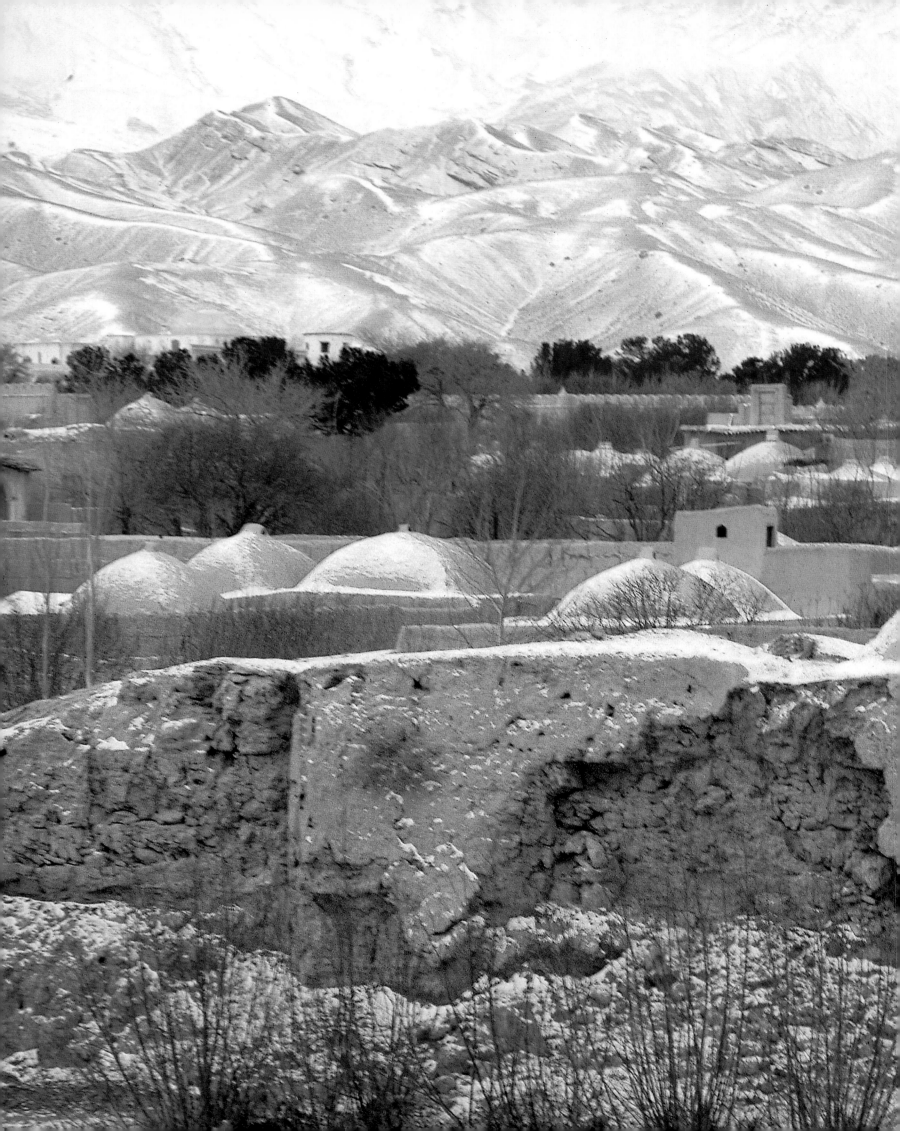

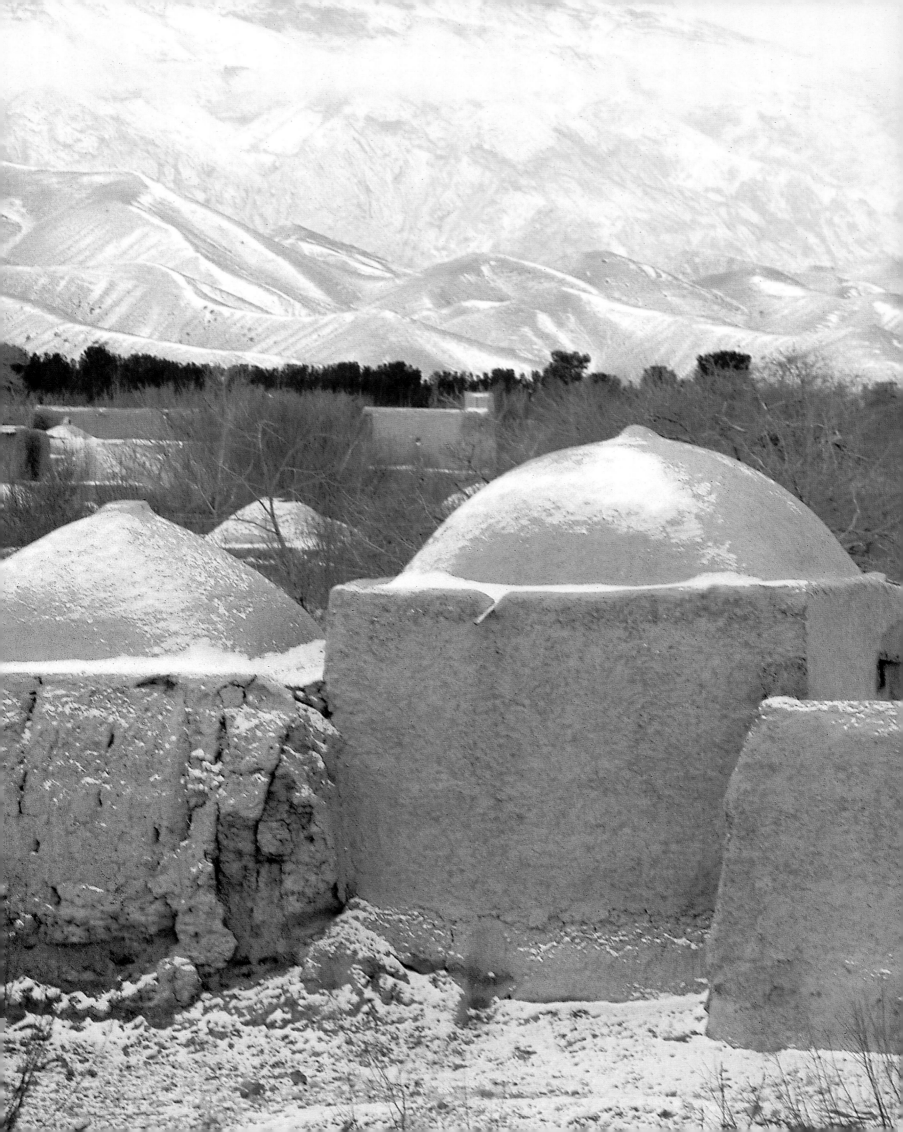

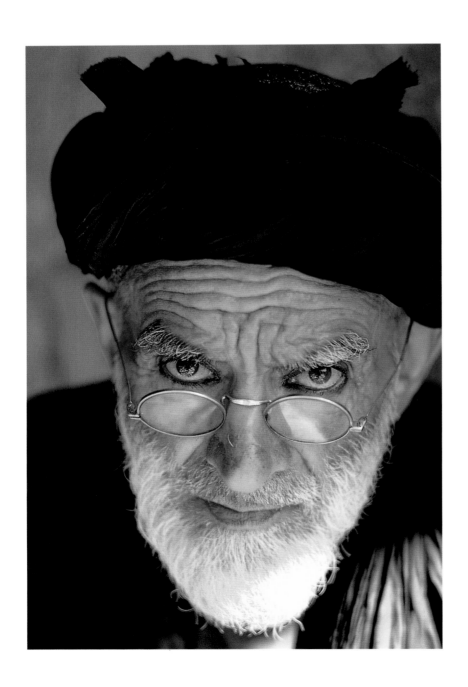

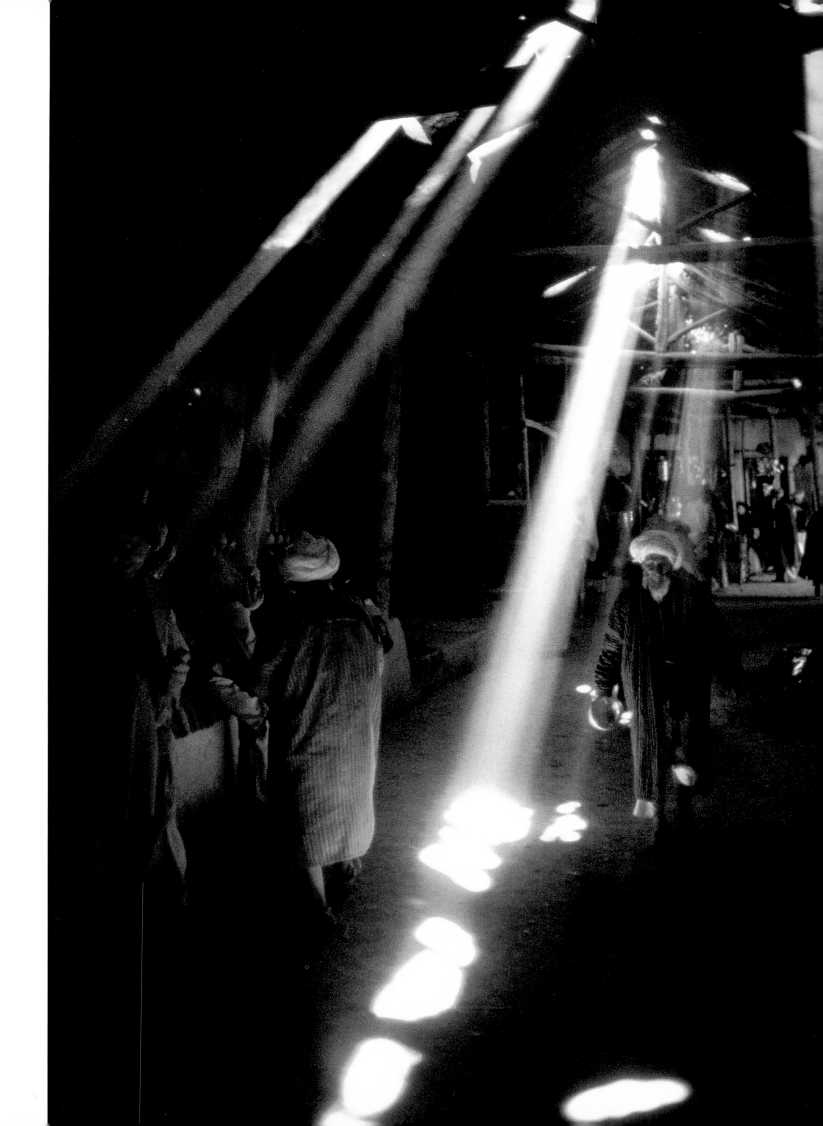

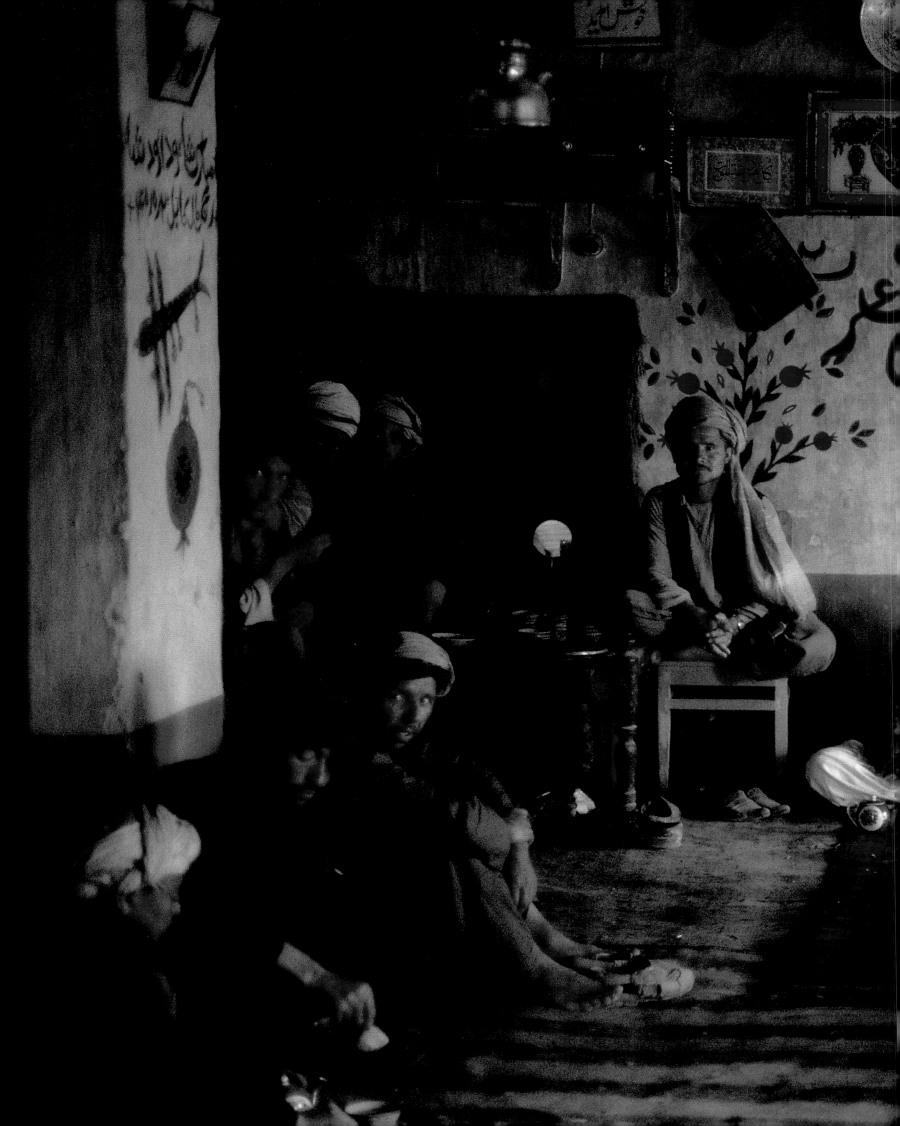

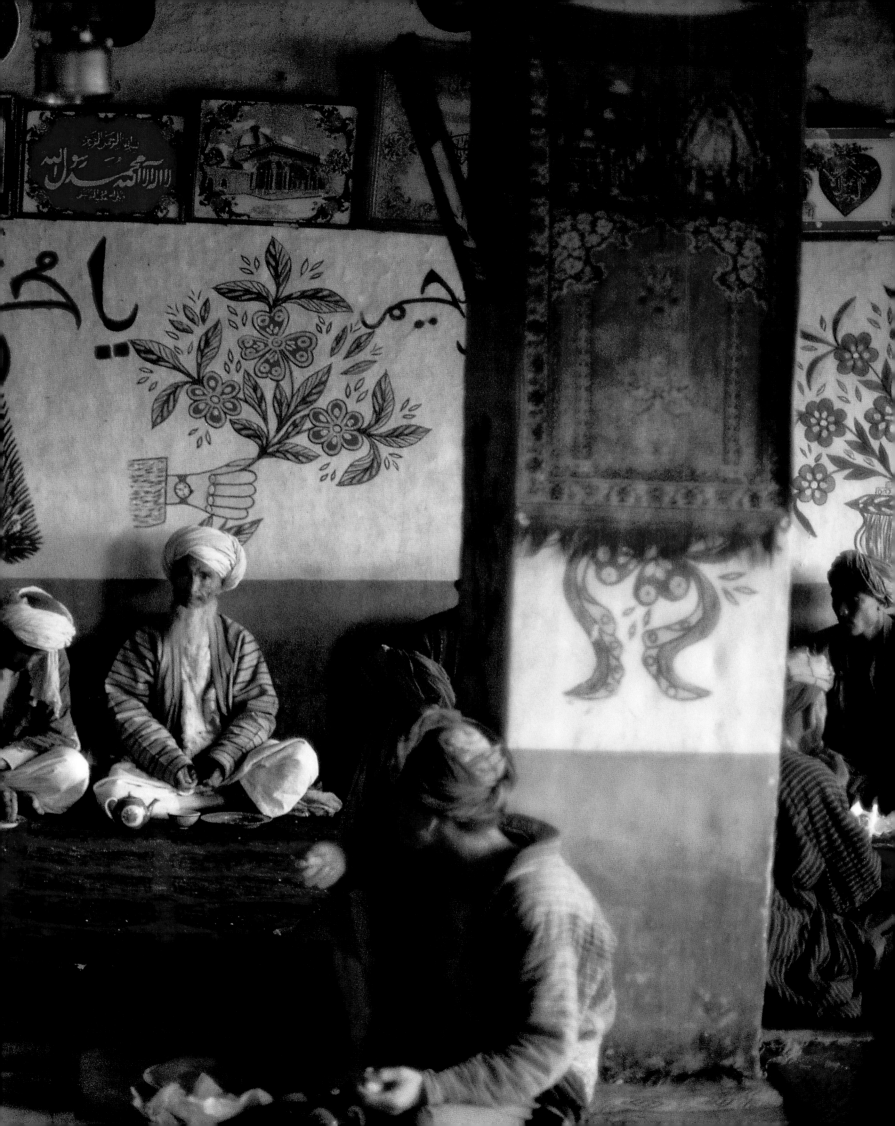

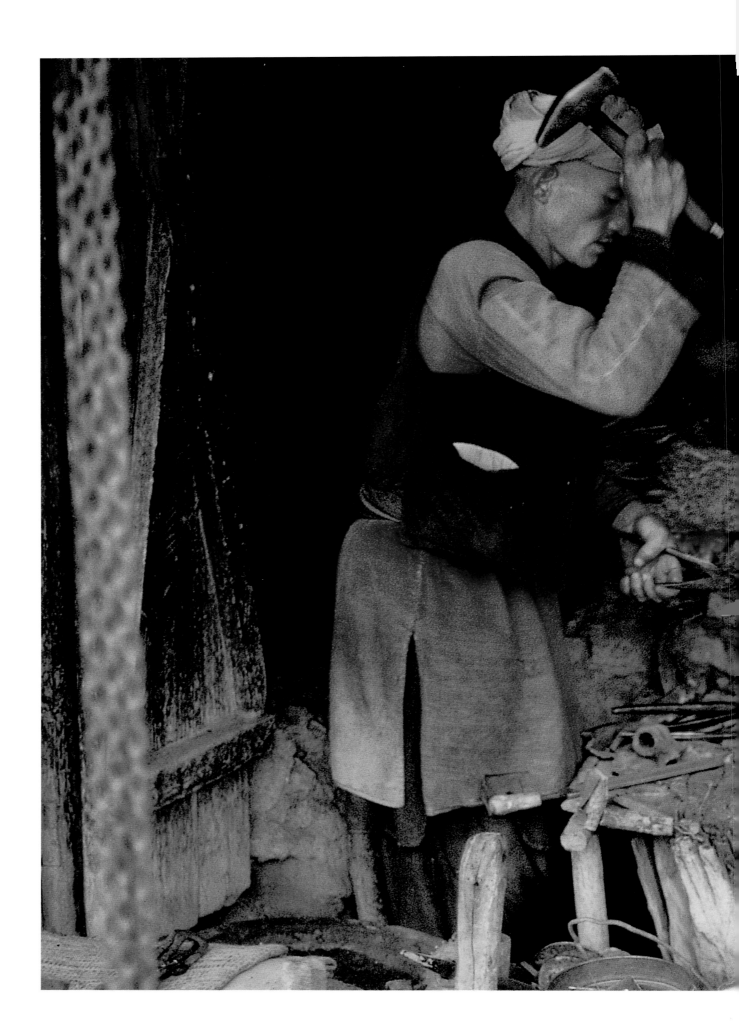

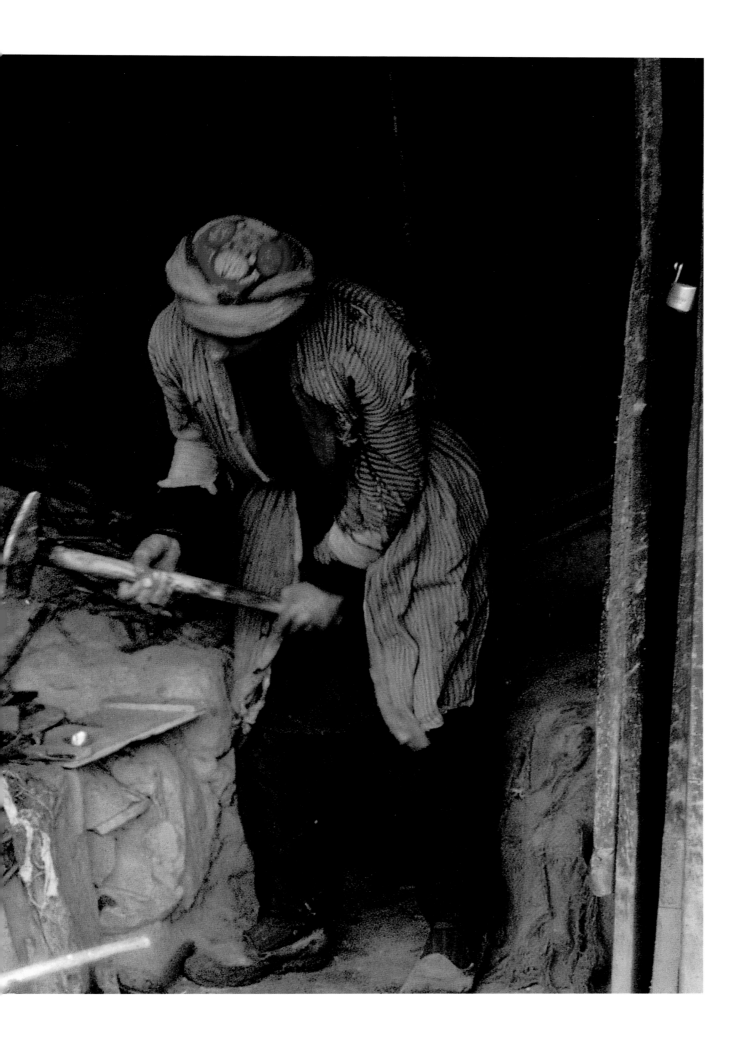

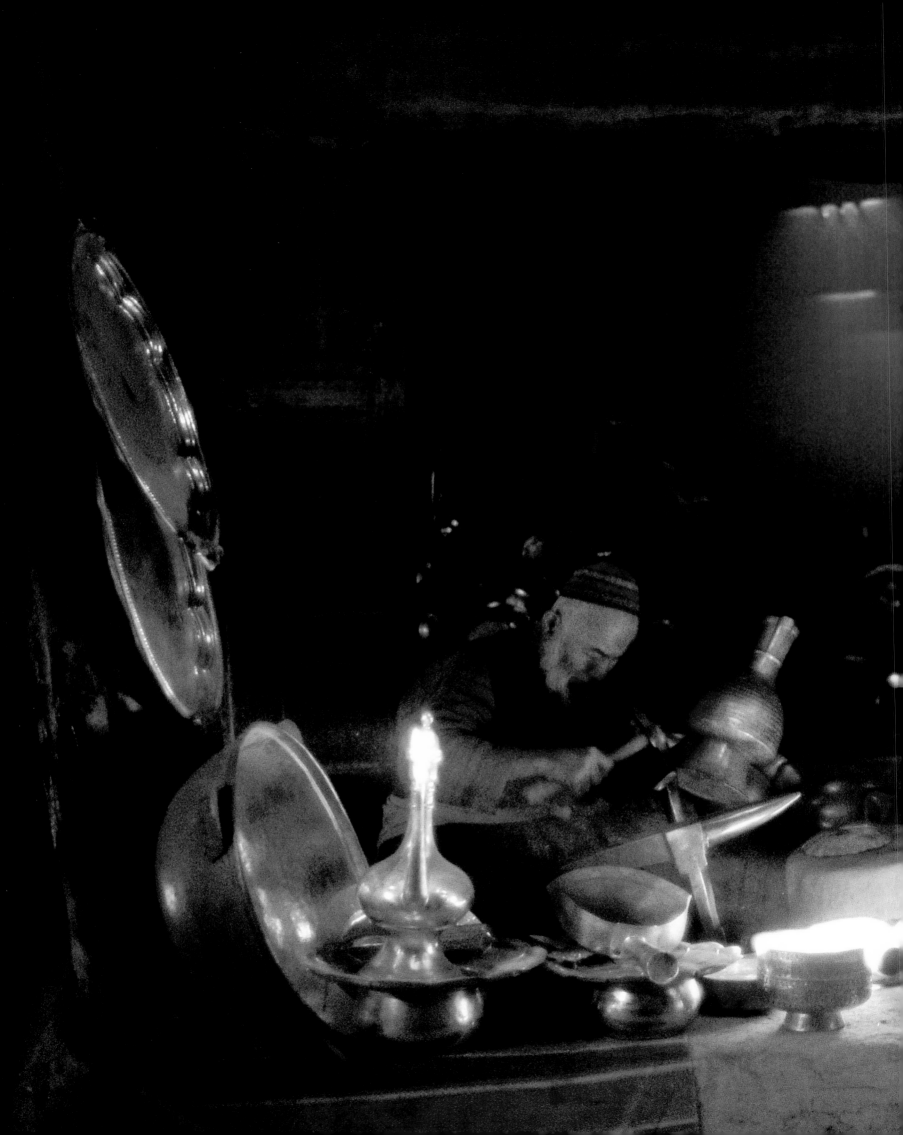

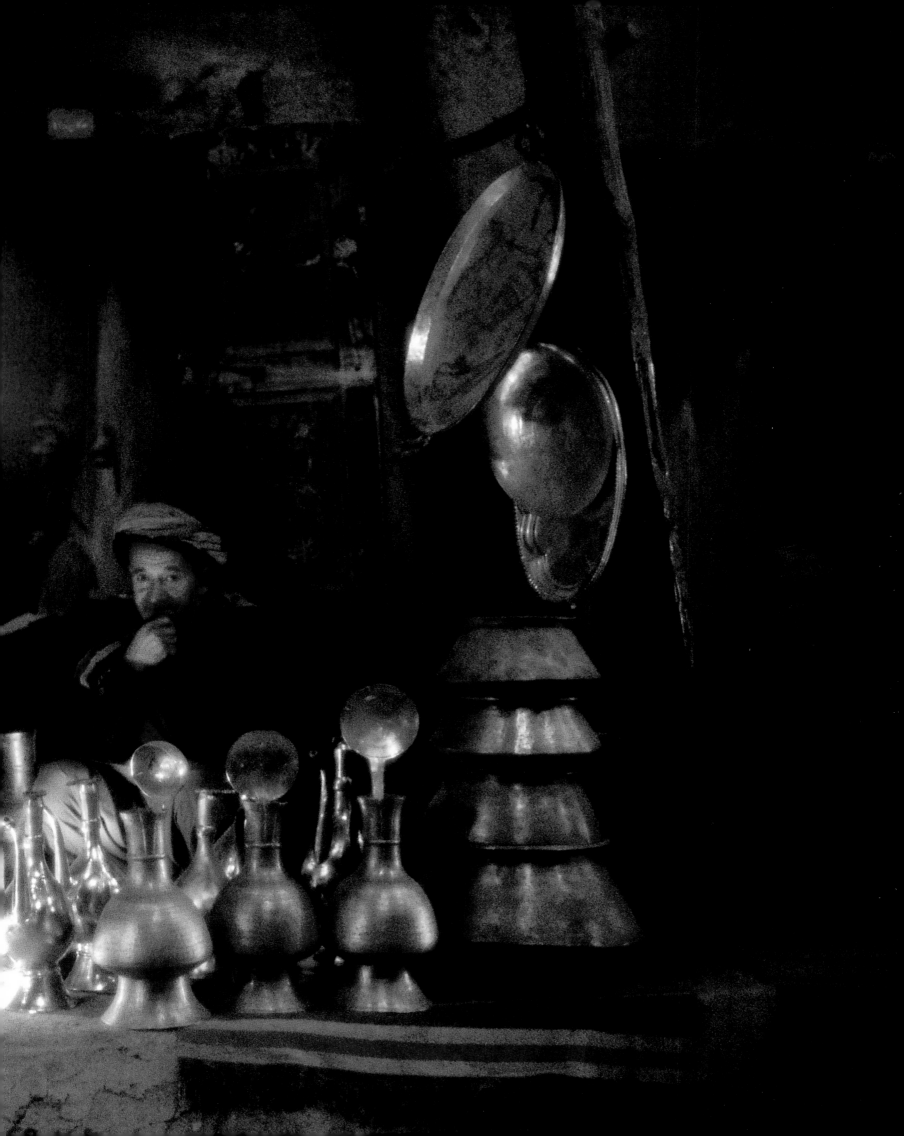

It was Tashkurghān in Afghanistan,
a place that was for a long time
like the city of the soul.

ANDRÉ VELTER

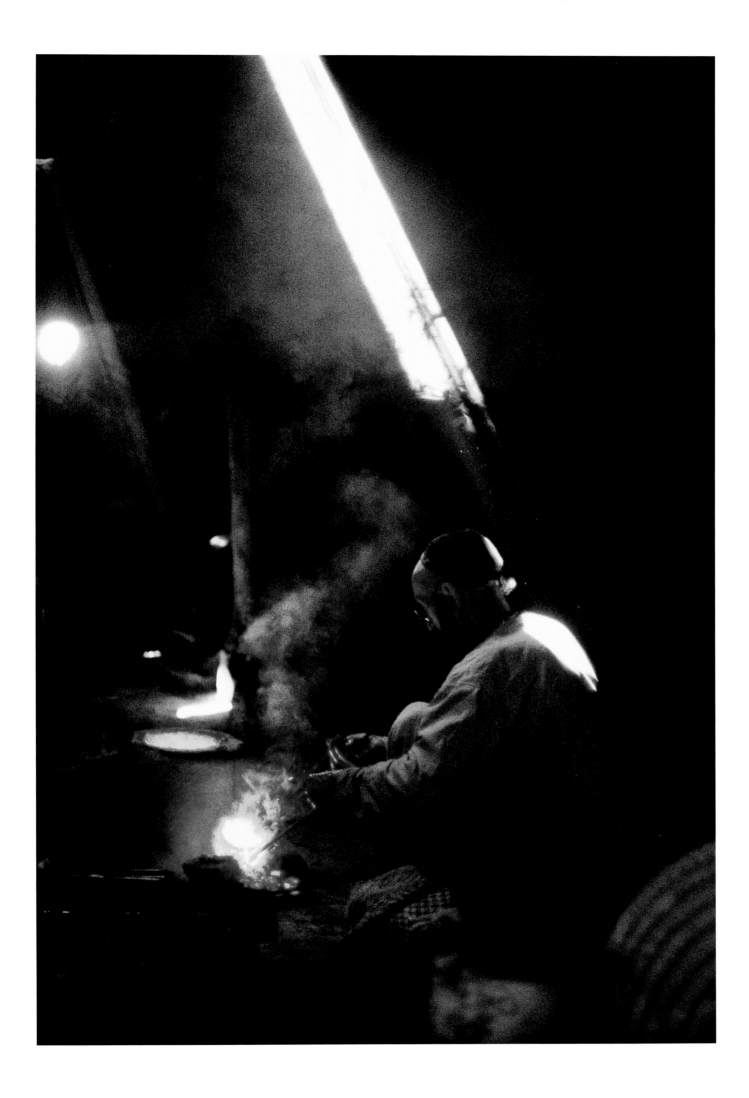

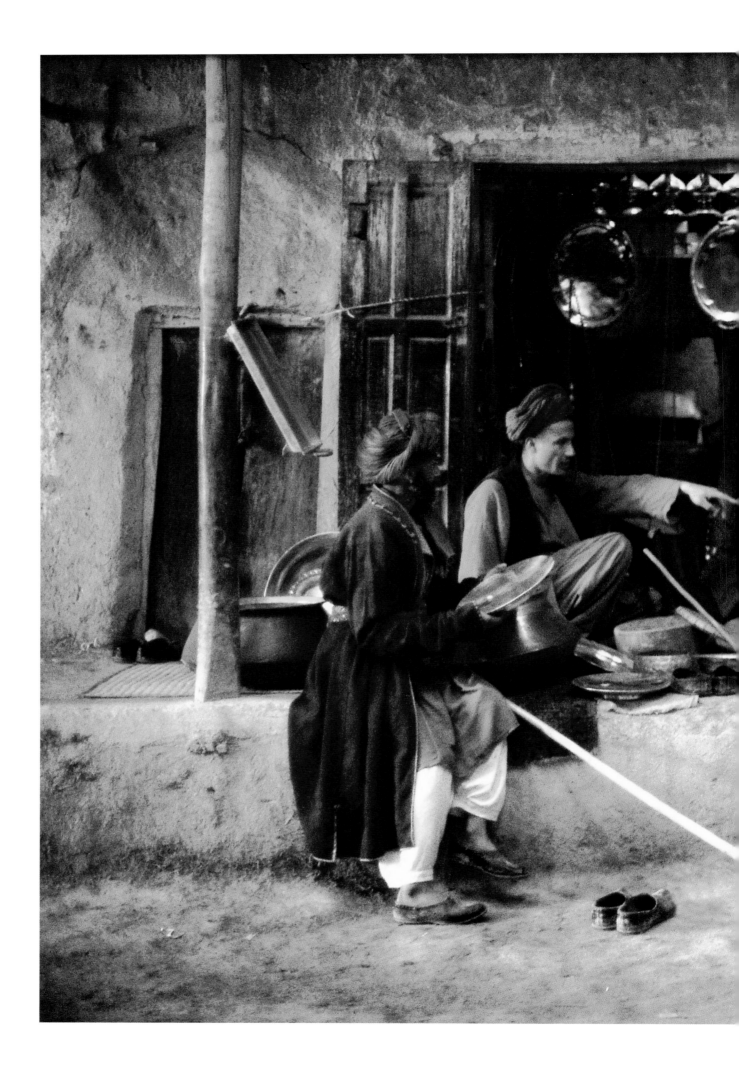

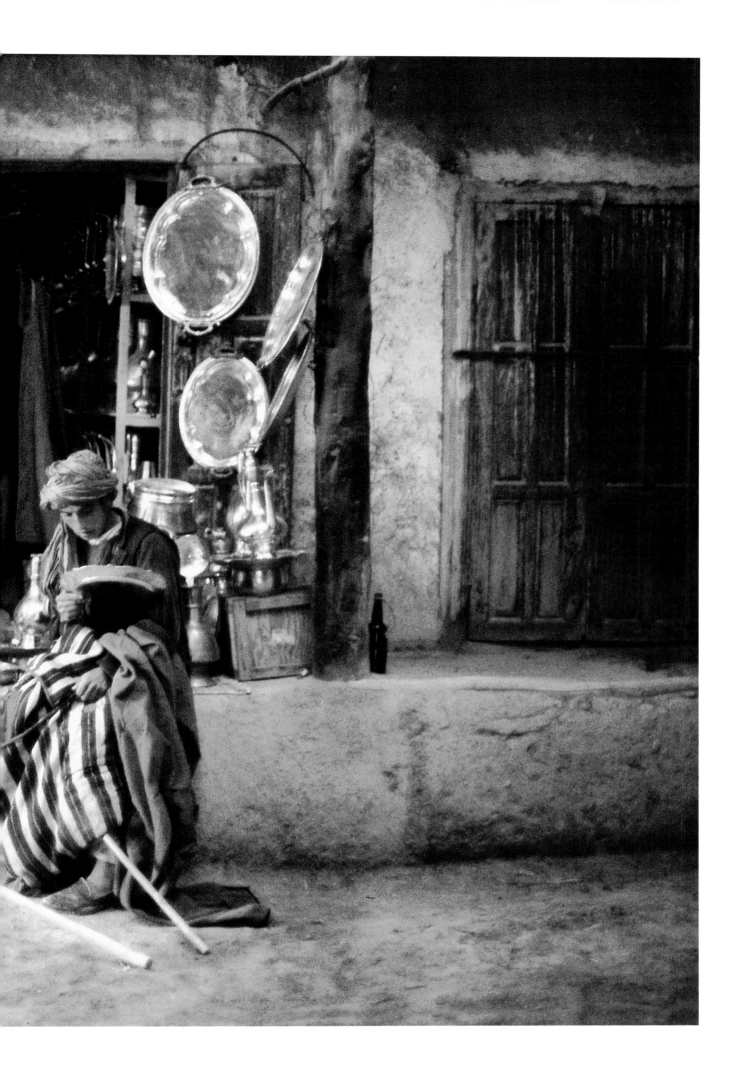

Birds and flowers
are the Afghan's two luxuries.

RENÉ DOLLOT

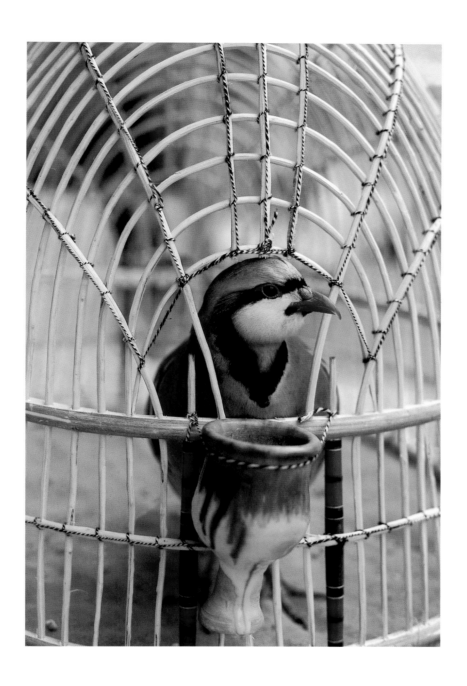

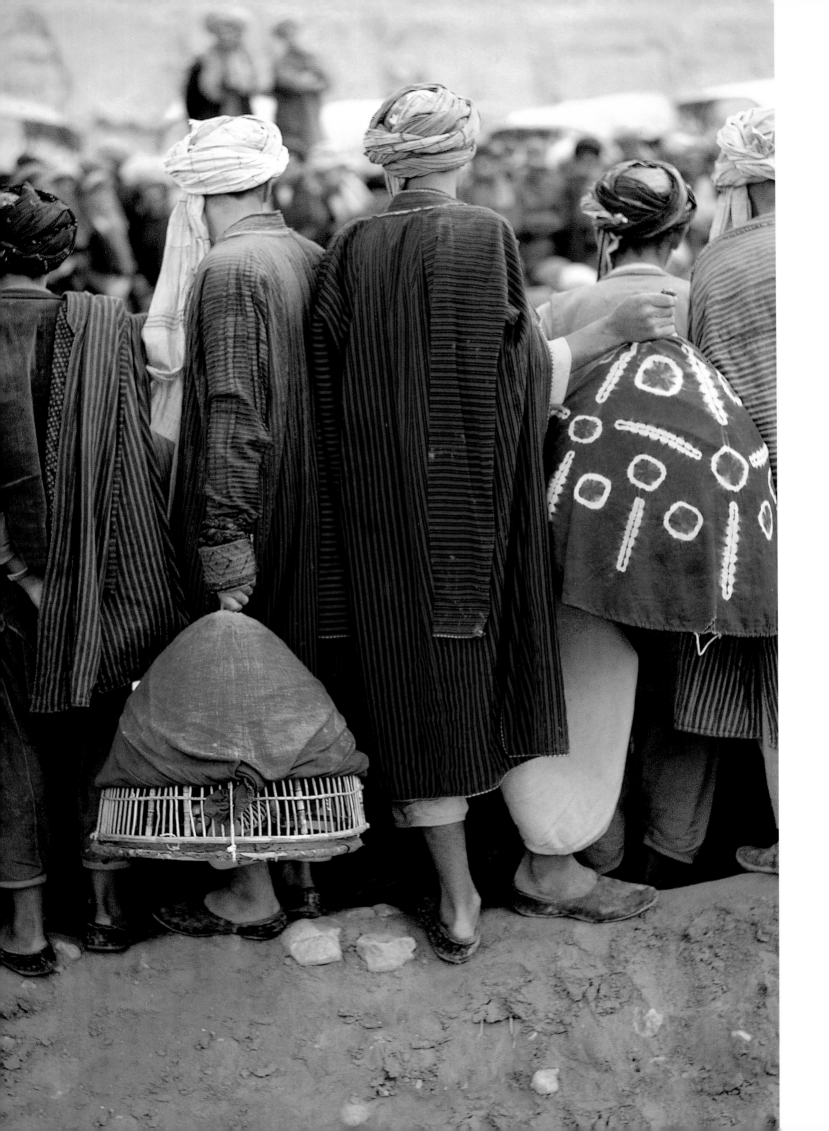

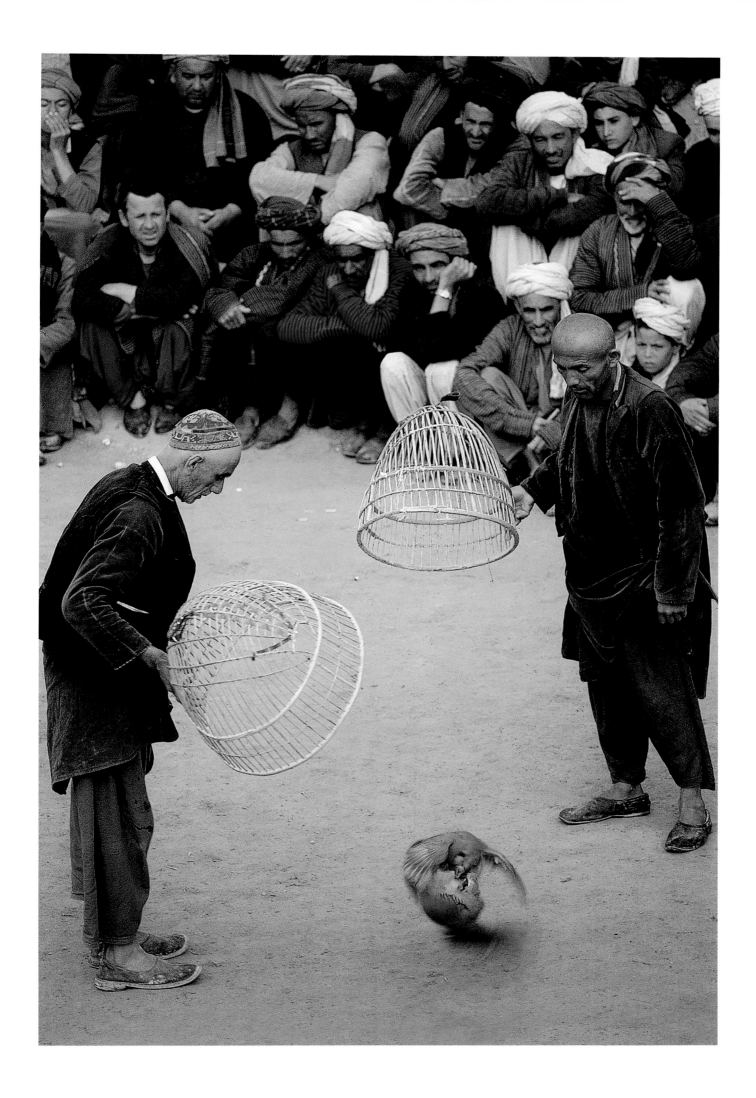

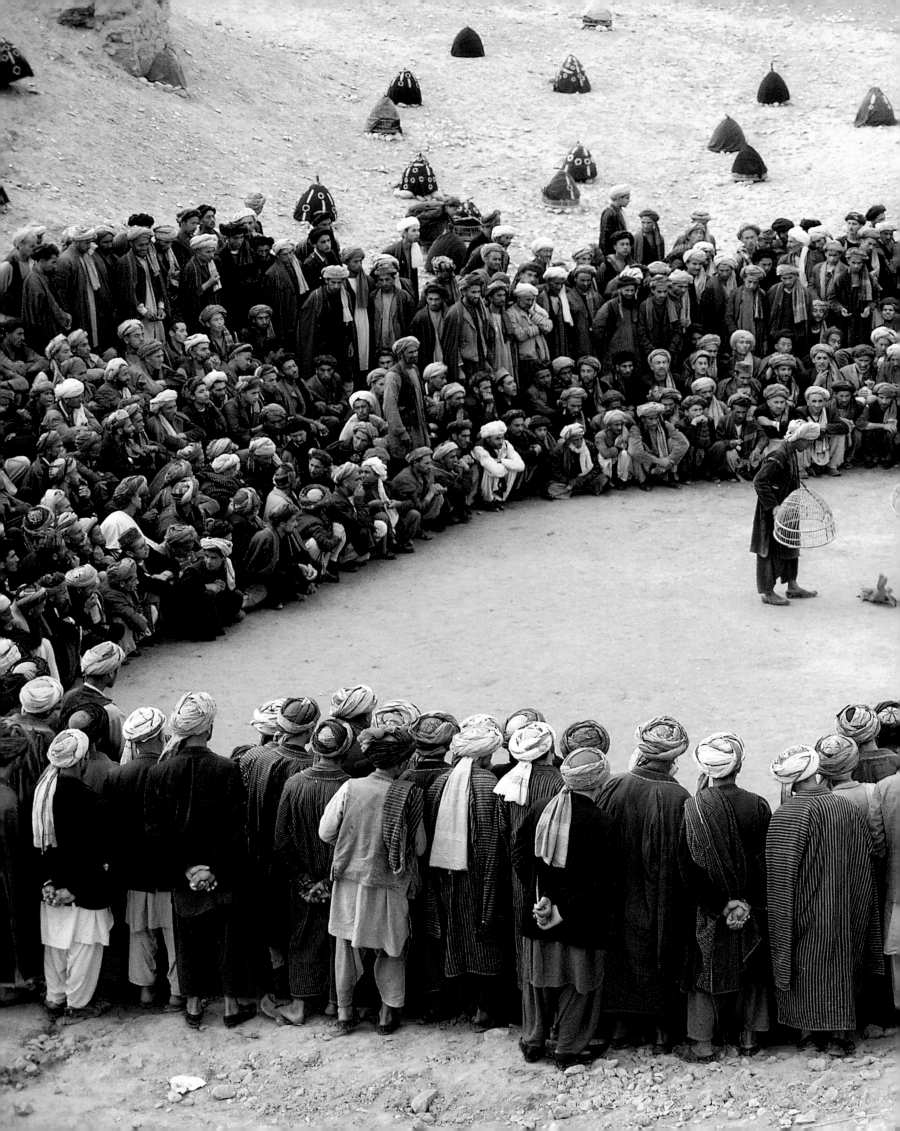

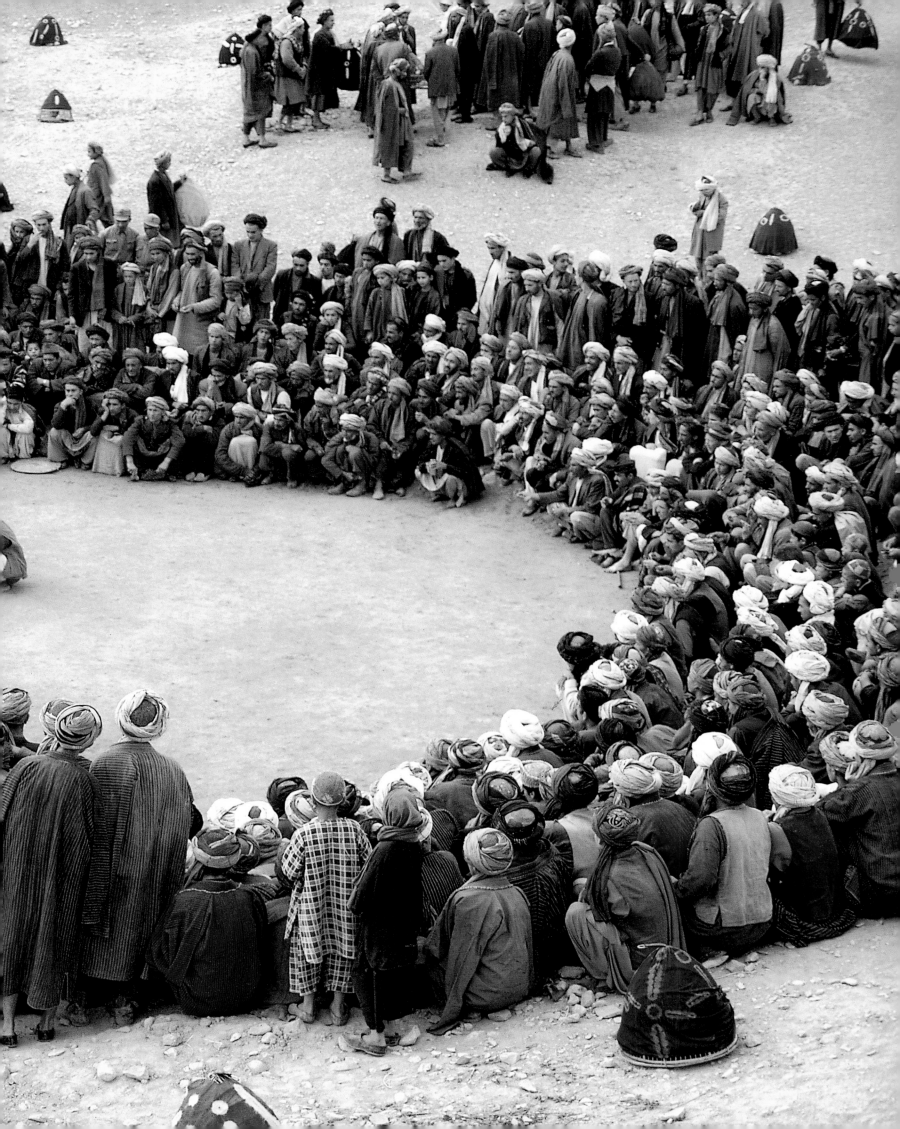

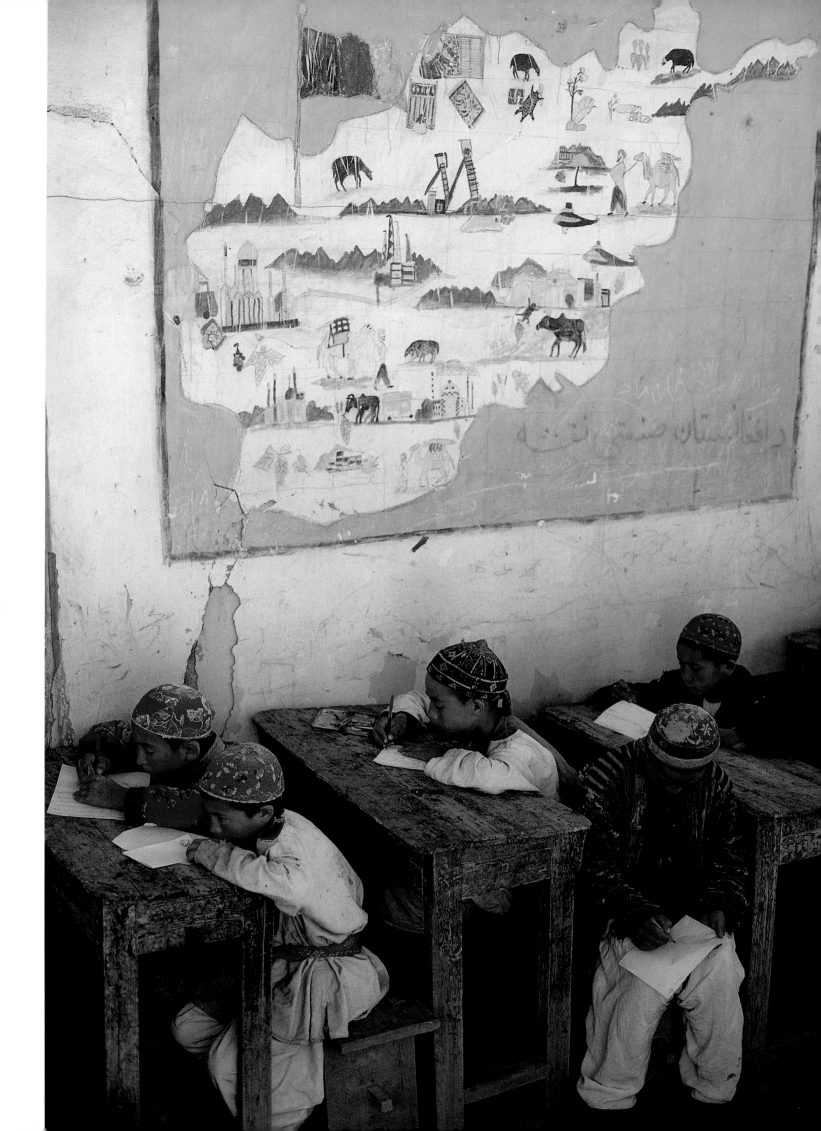

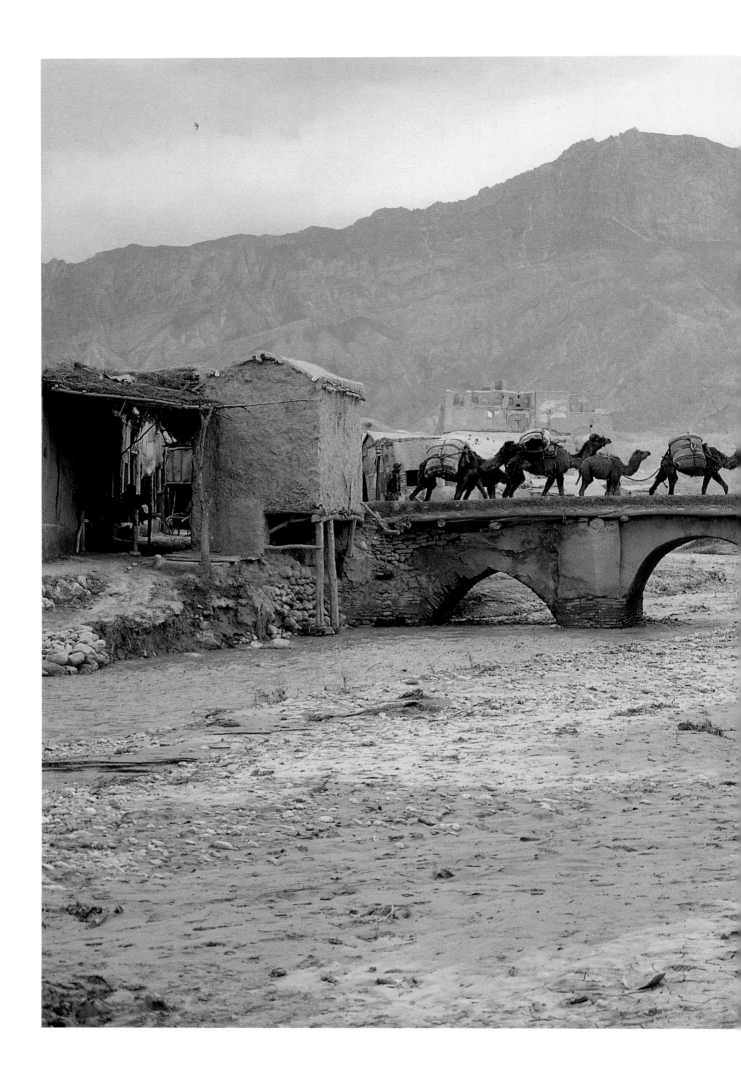

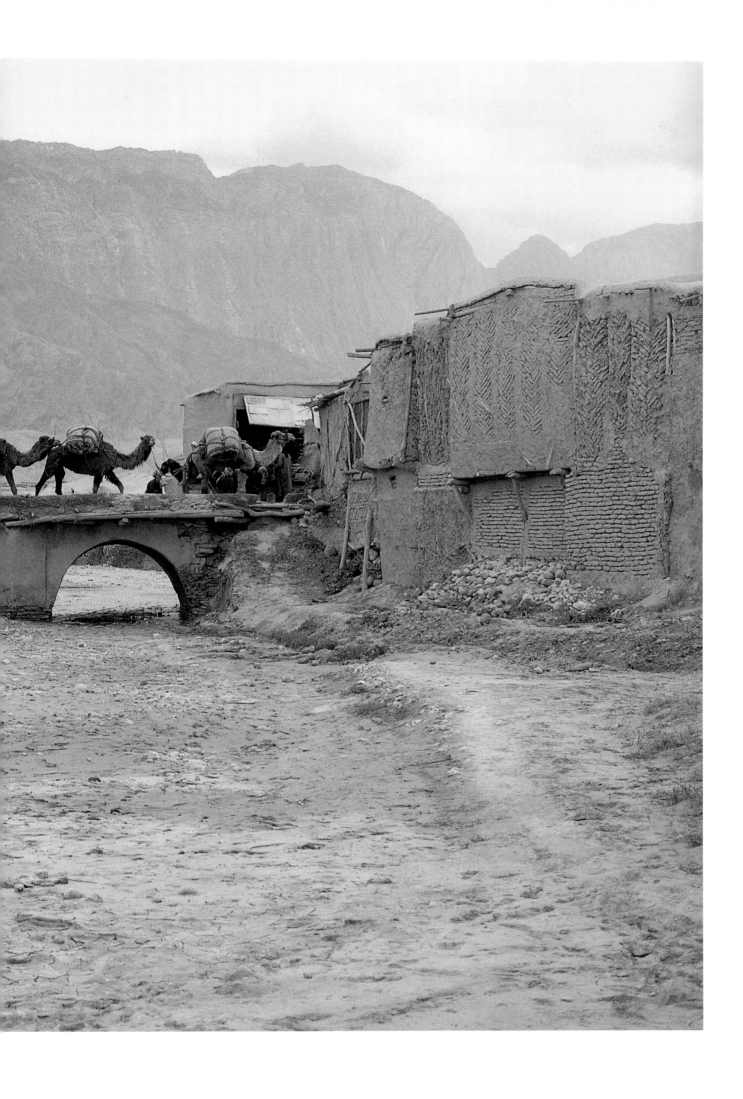

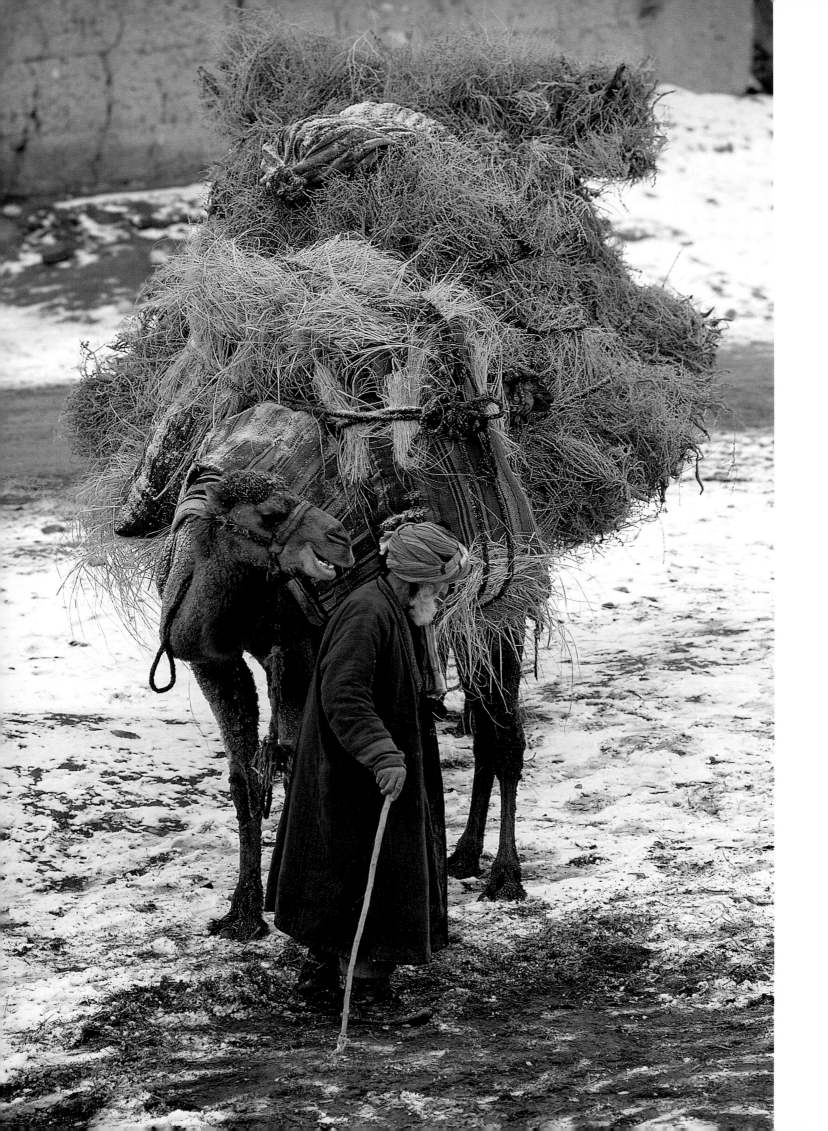

Rise up, friends, let's away. It is time to leave this world.

The drum resounds from heaven, behold it calling us.

See: the camel driver has risen, he has prepared the caravan

and wants to leave. O travelers, why still sleep?

Ahead of us, behind us, there rises the tinkling

of the bells, the tumult of departure.

RŪMĪ

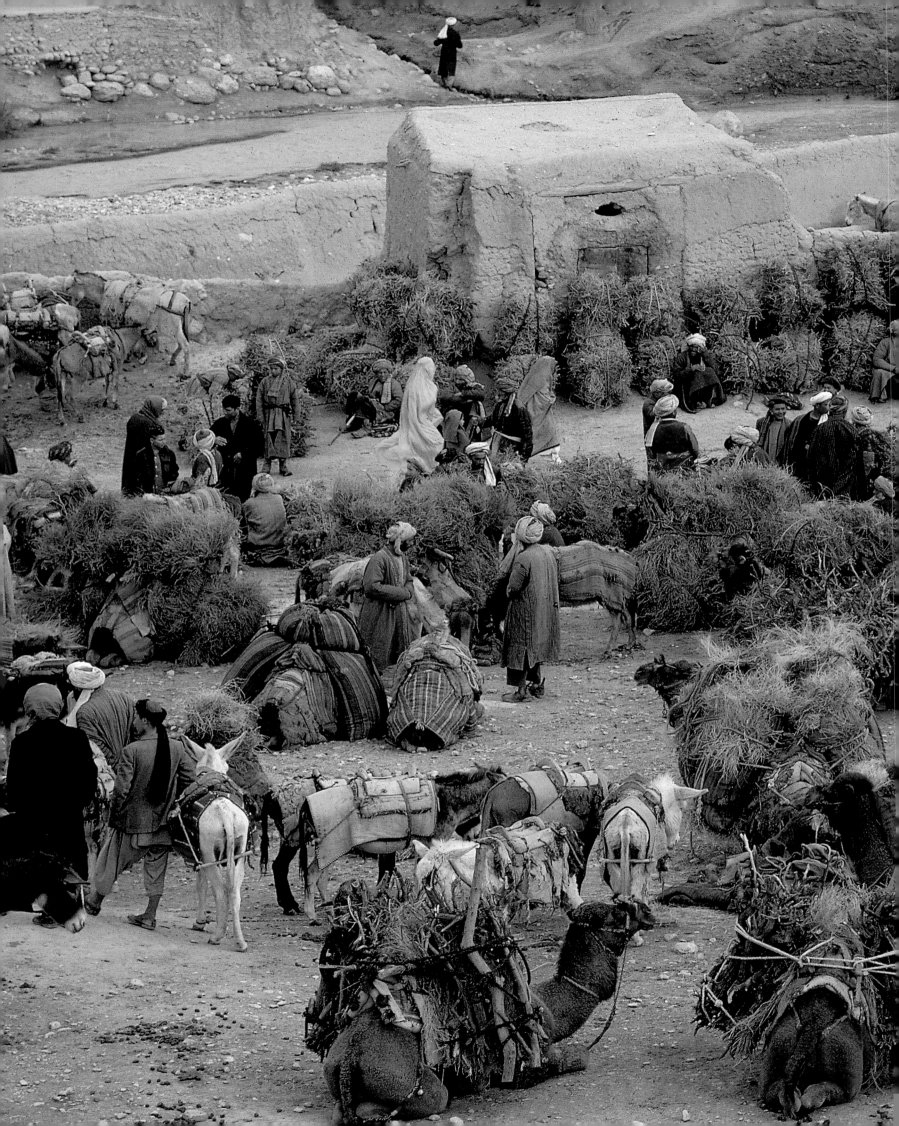

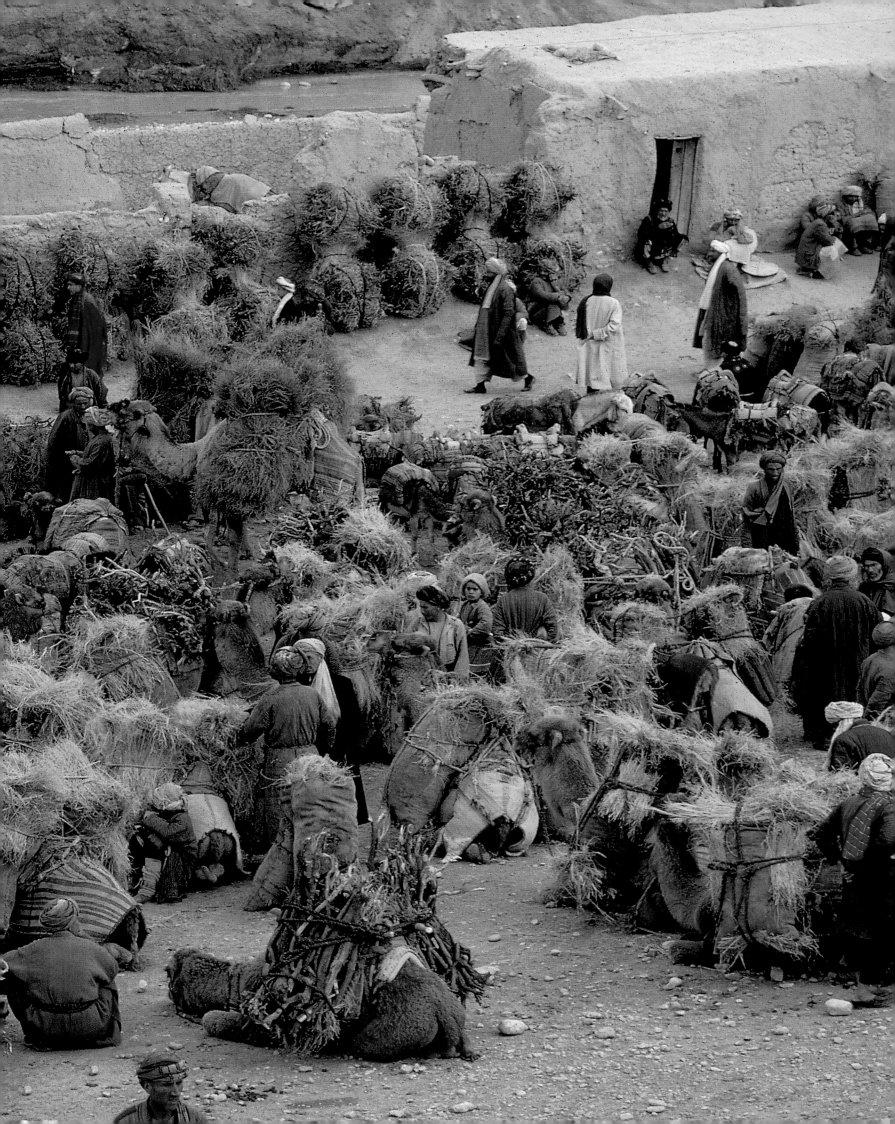

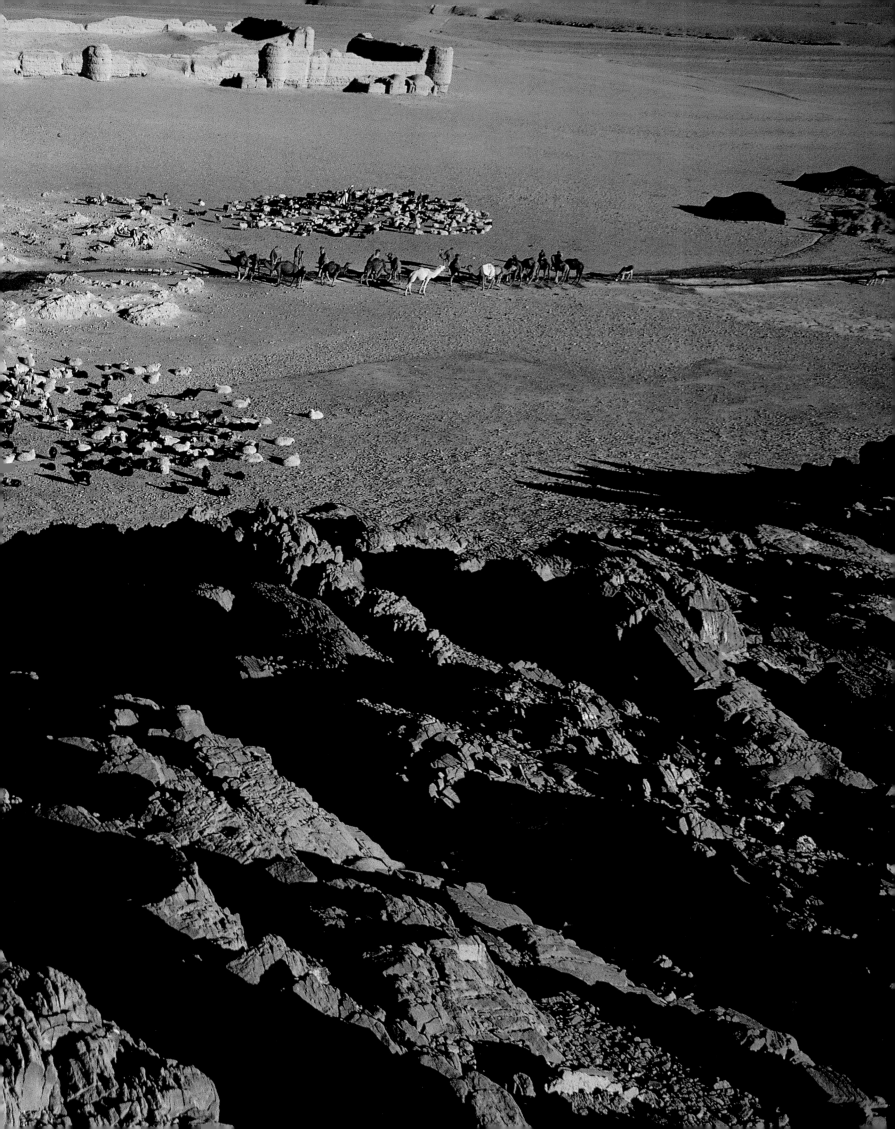

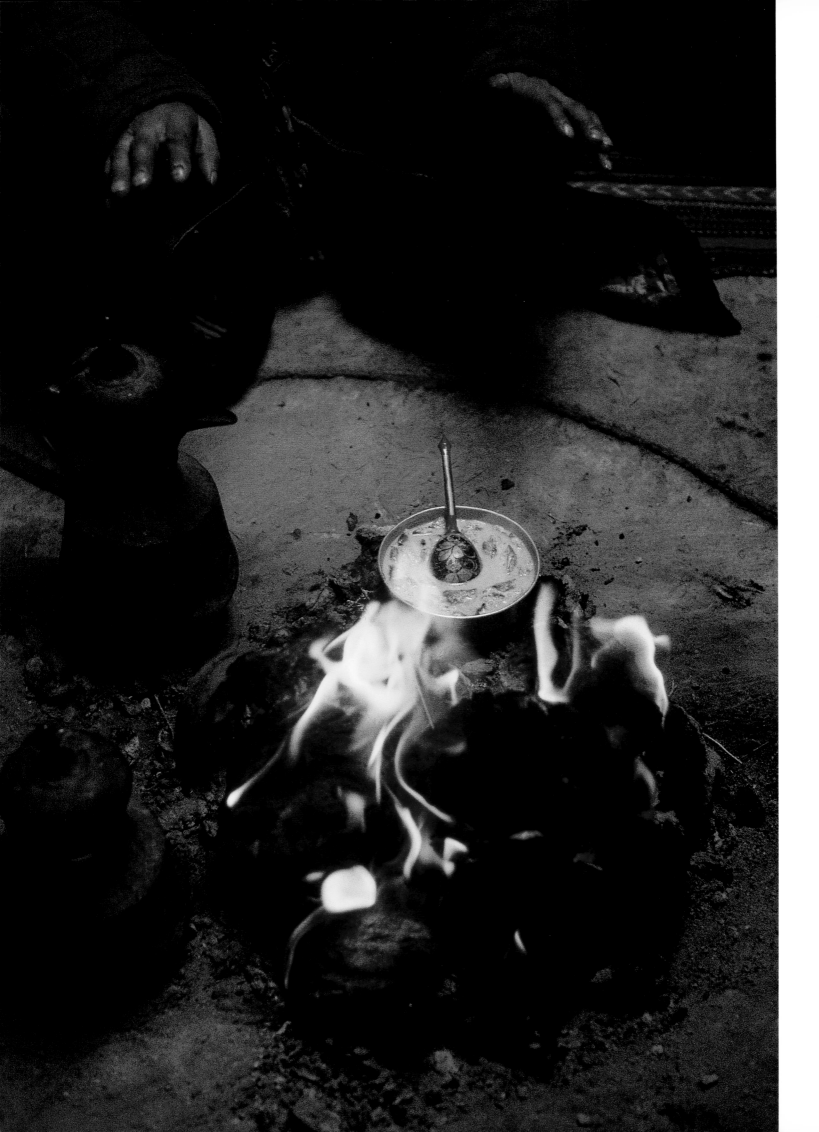

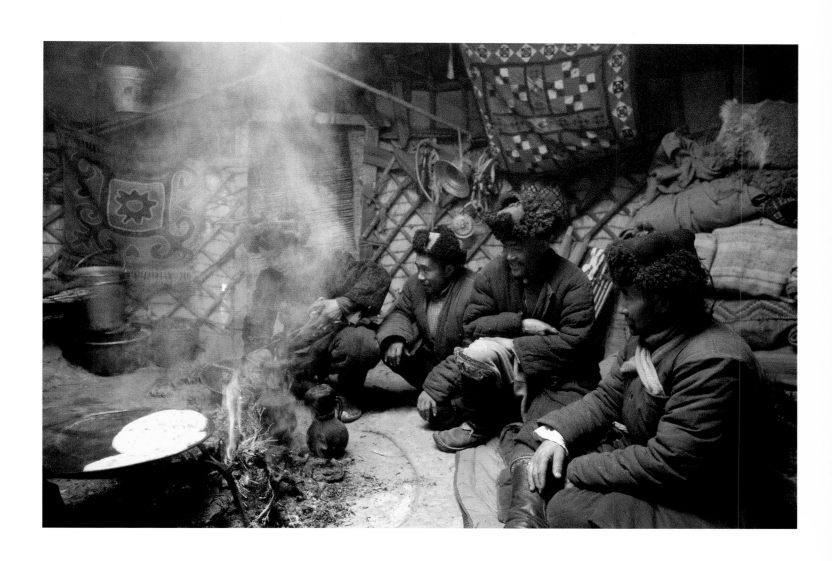

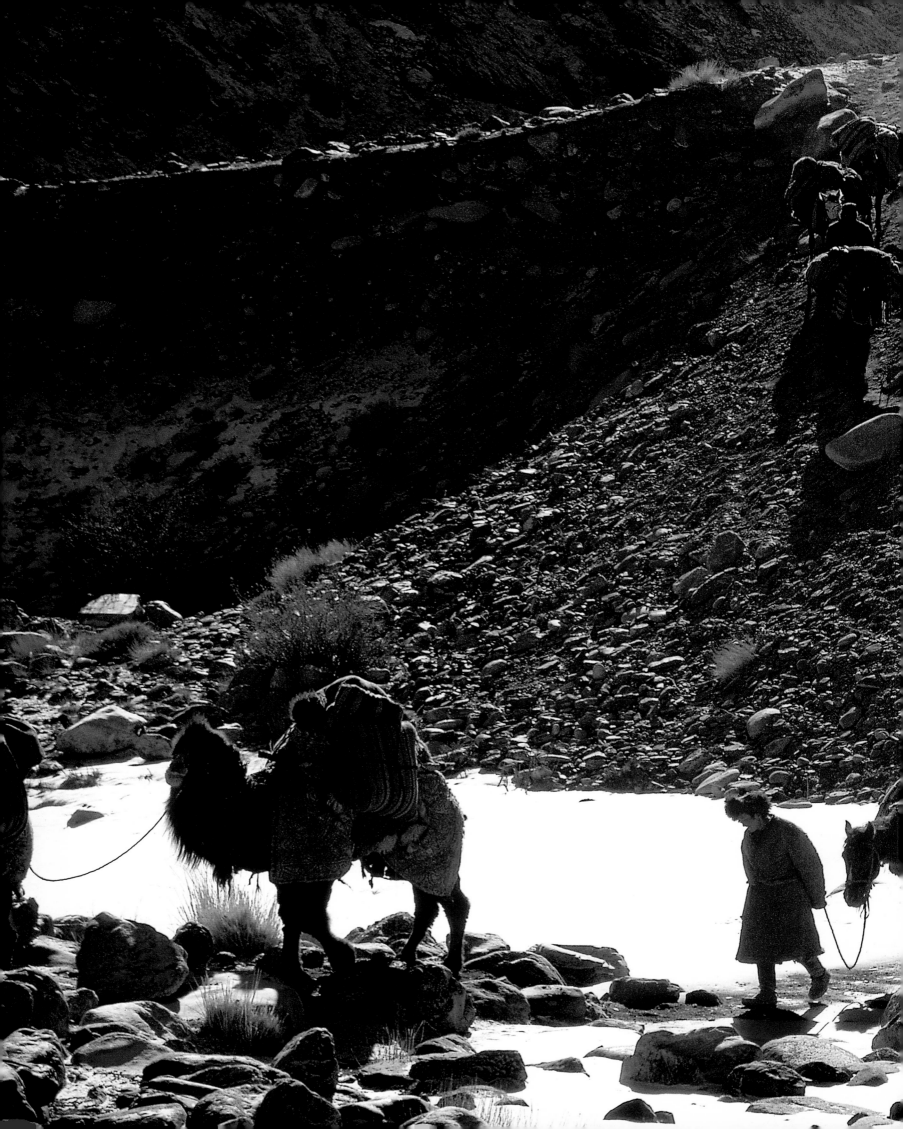

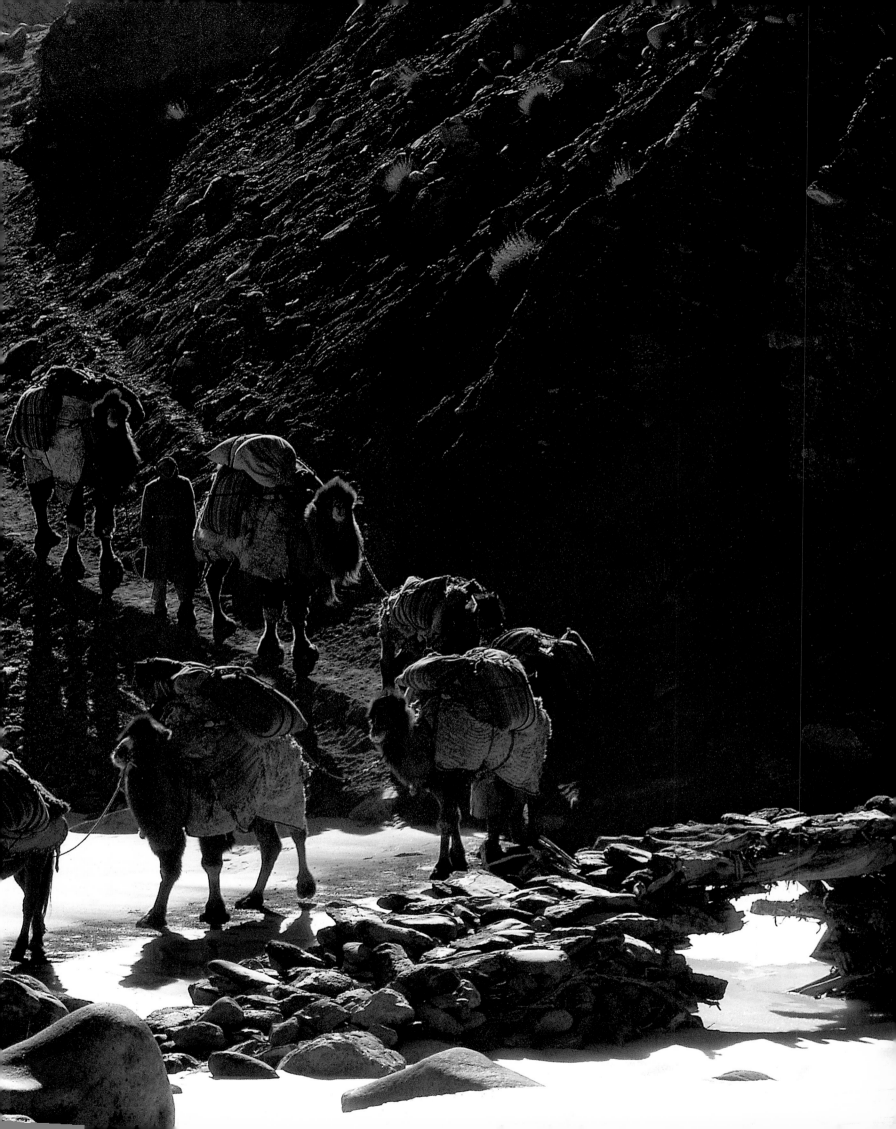

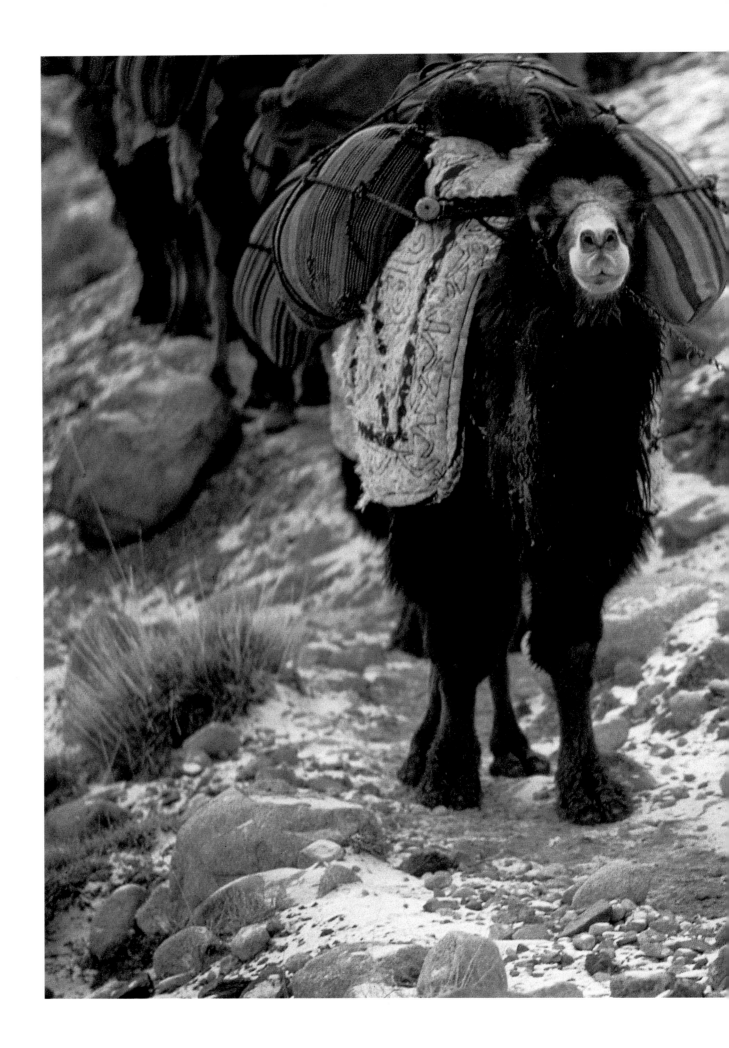

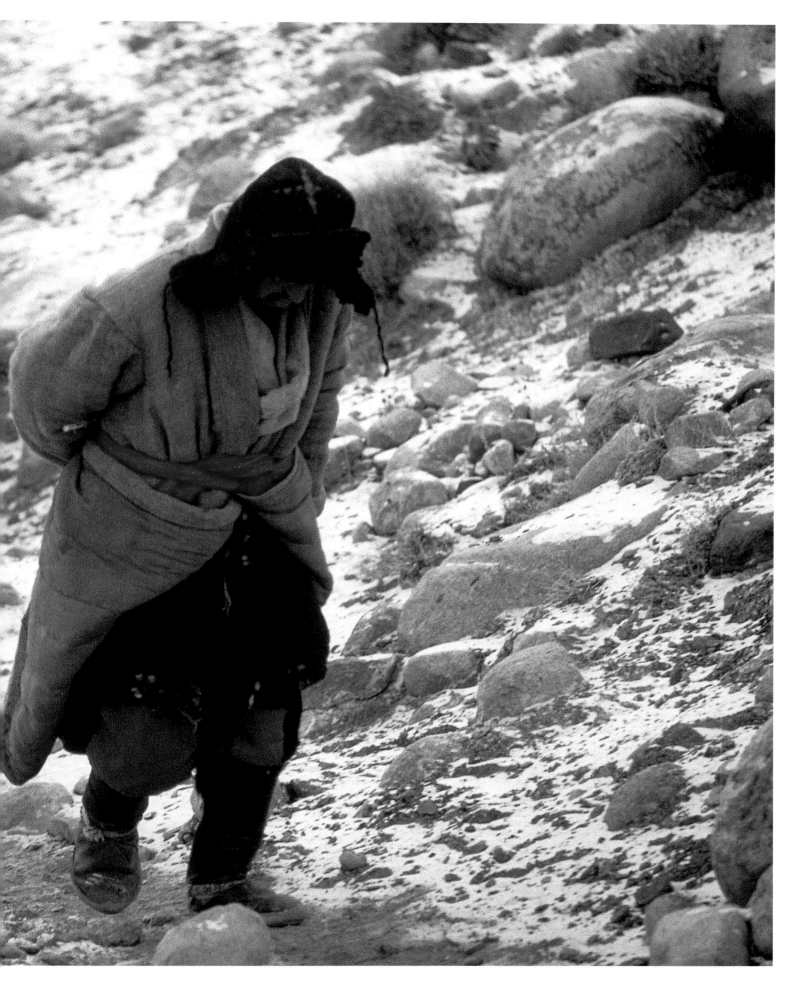

And coming down from the Pamir where the lost camels
call through the clouds…

ANDRÉ MALRAUX

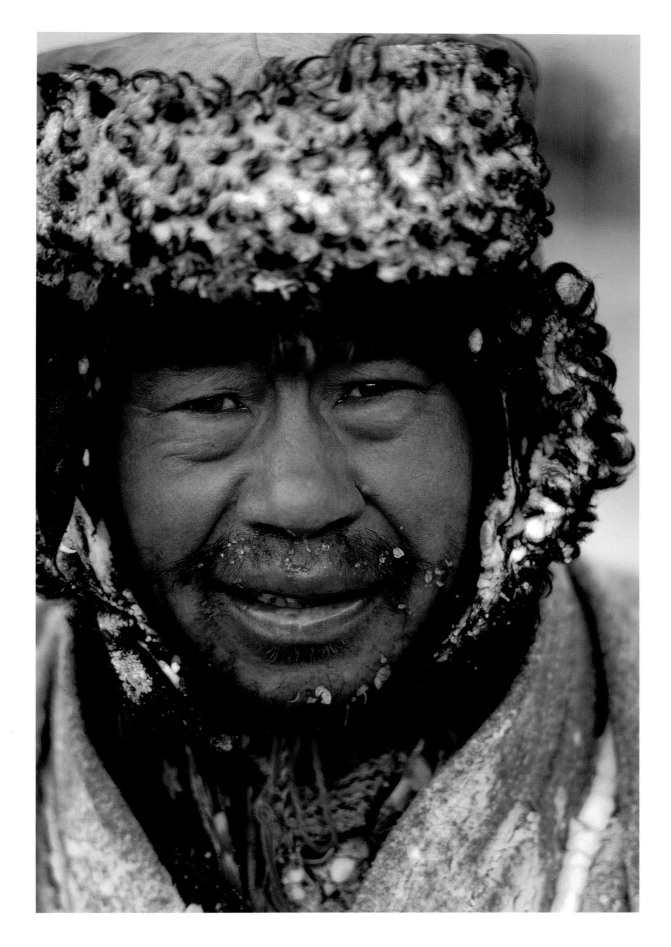

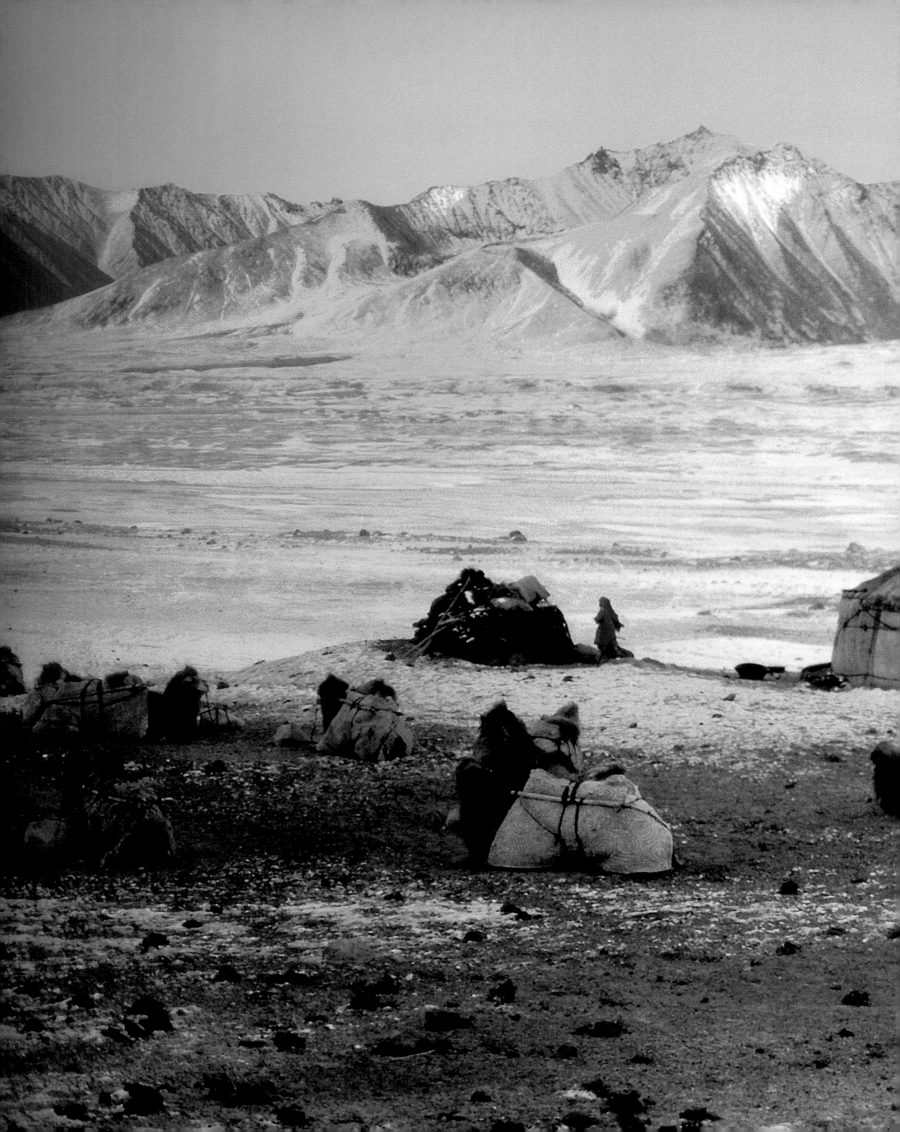

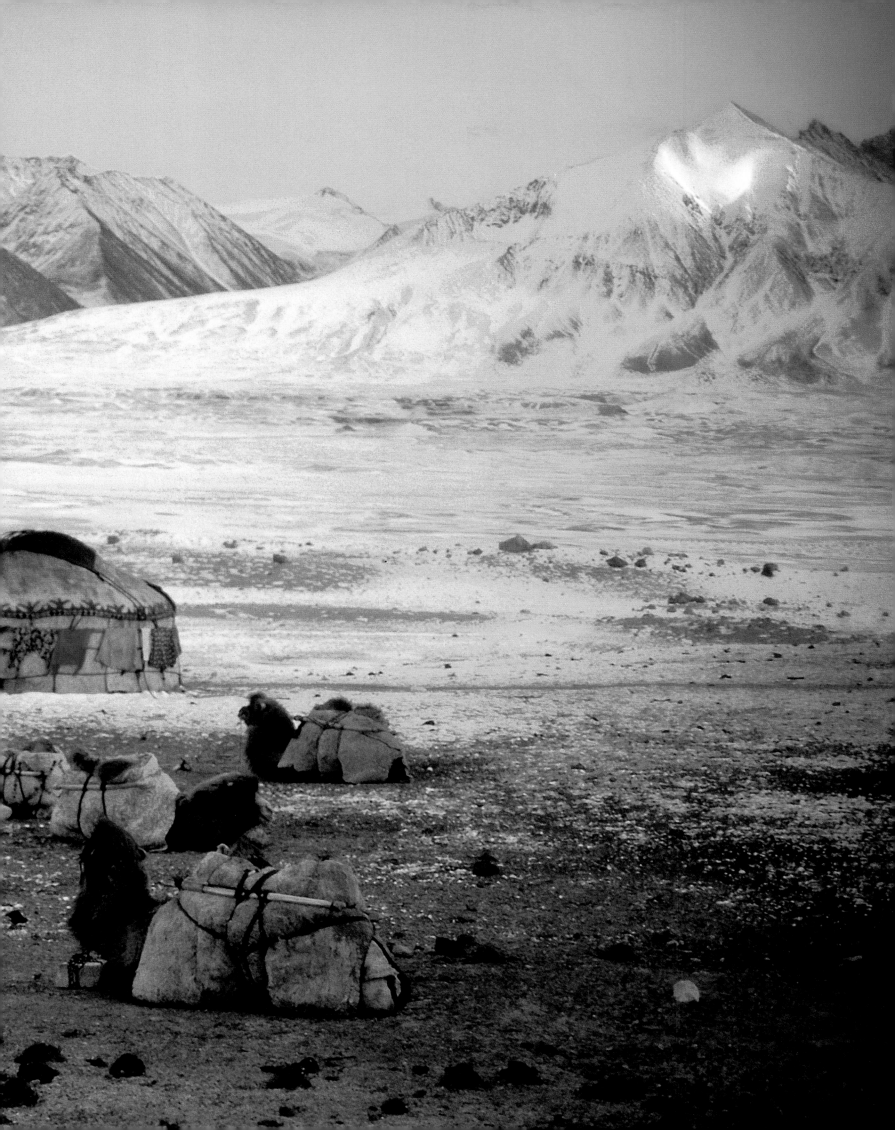

The mountains here are so high that birds
themselves can only cross the peaks on foot.

ROLAND AND SABRINA MICHAUD

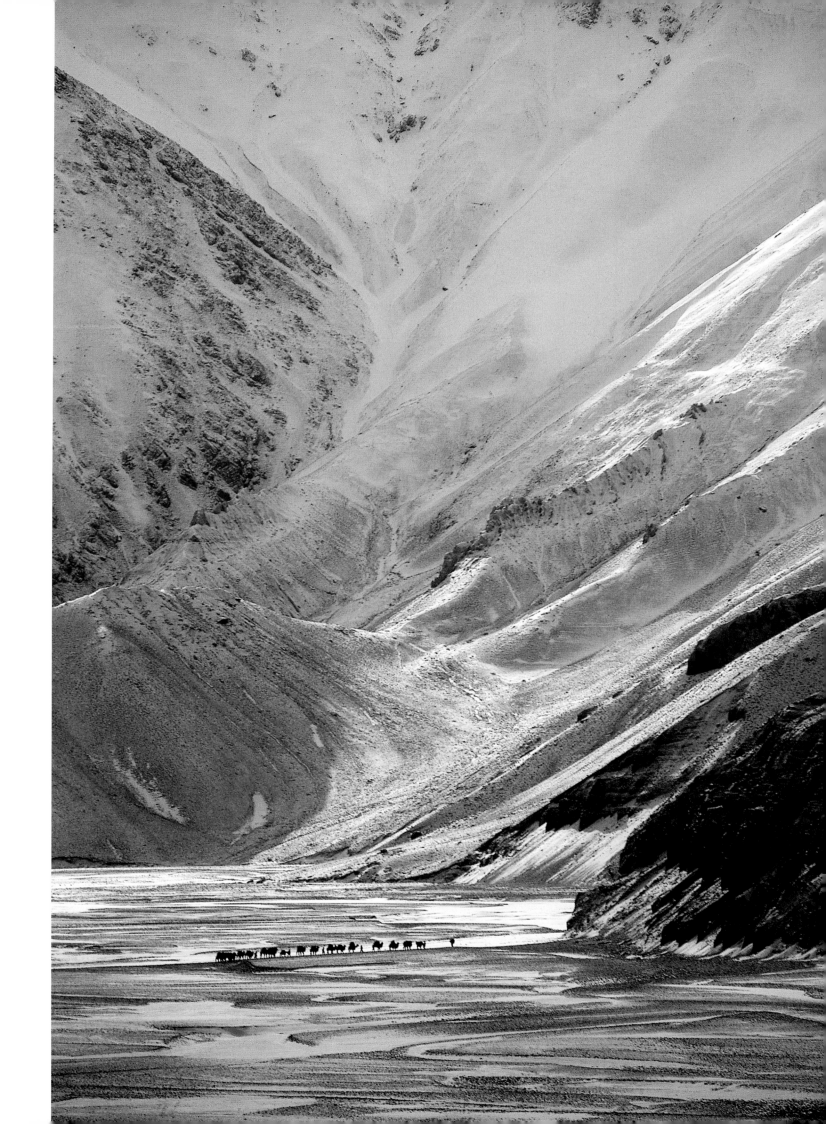

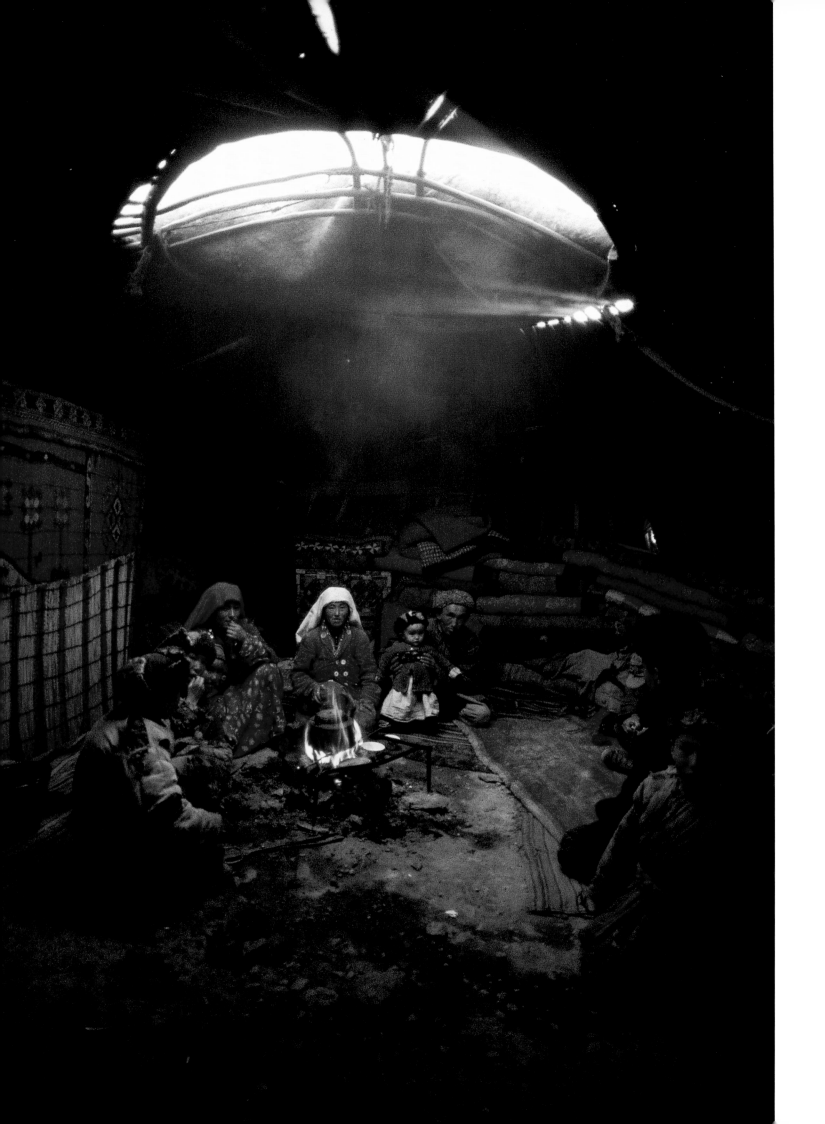

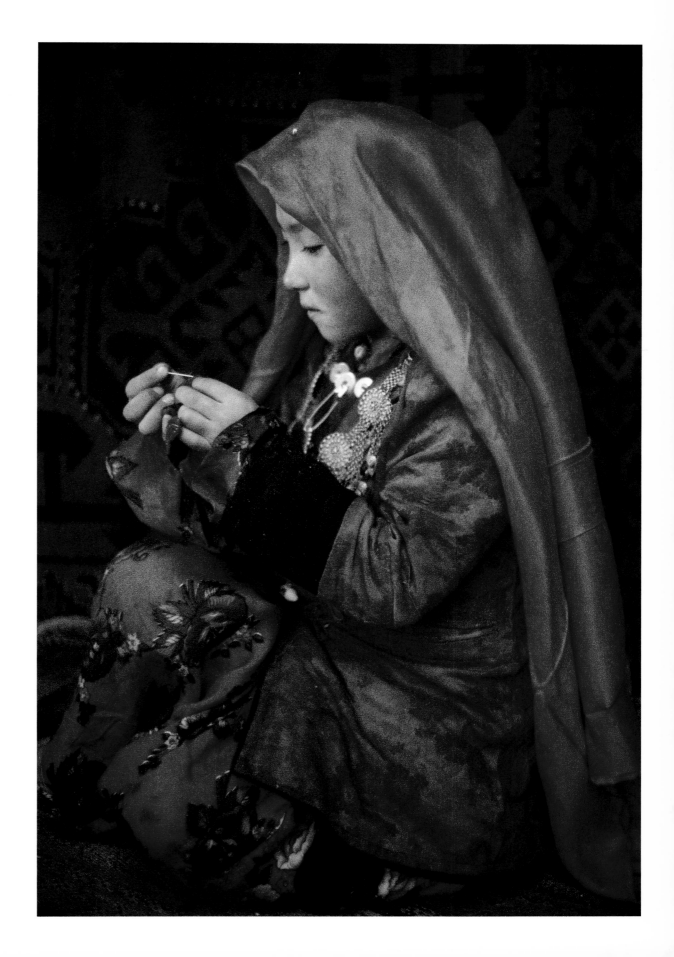

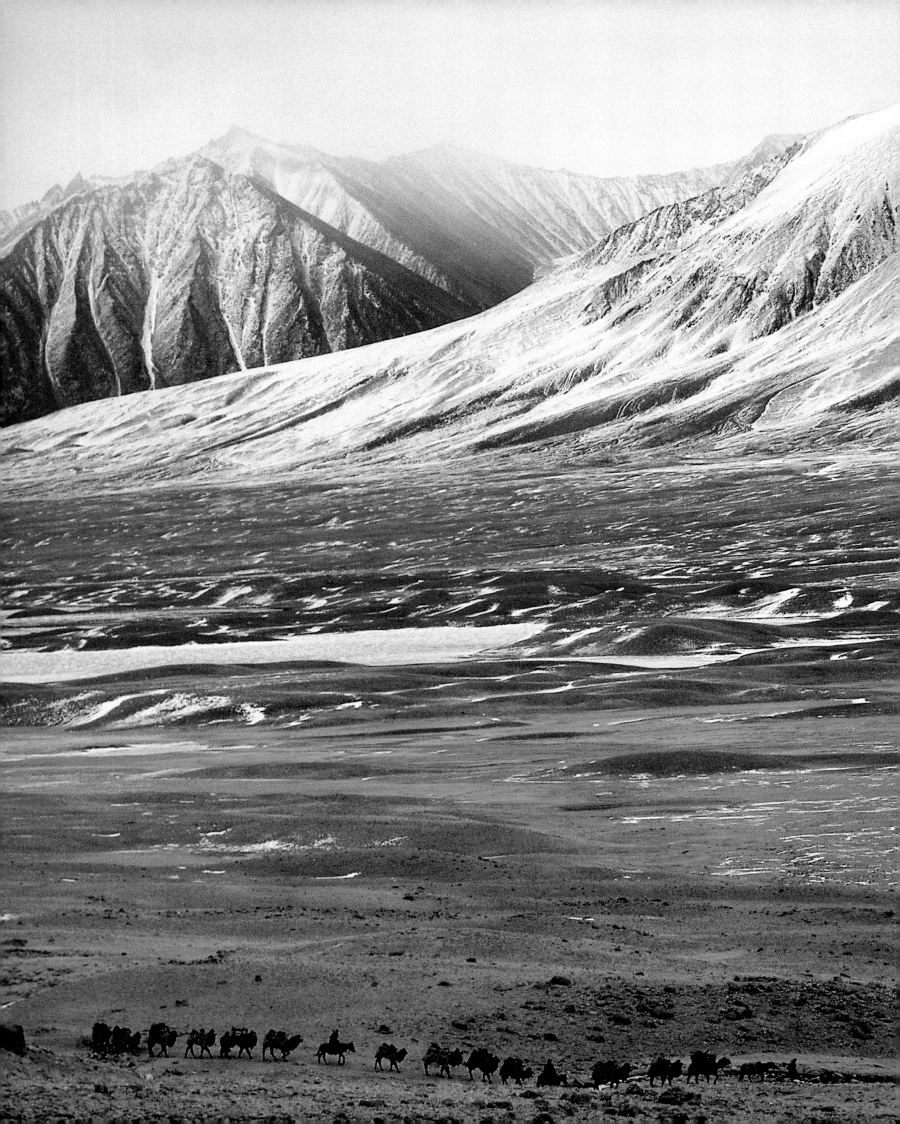

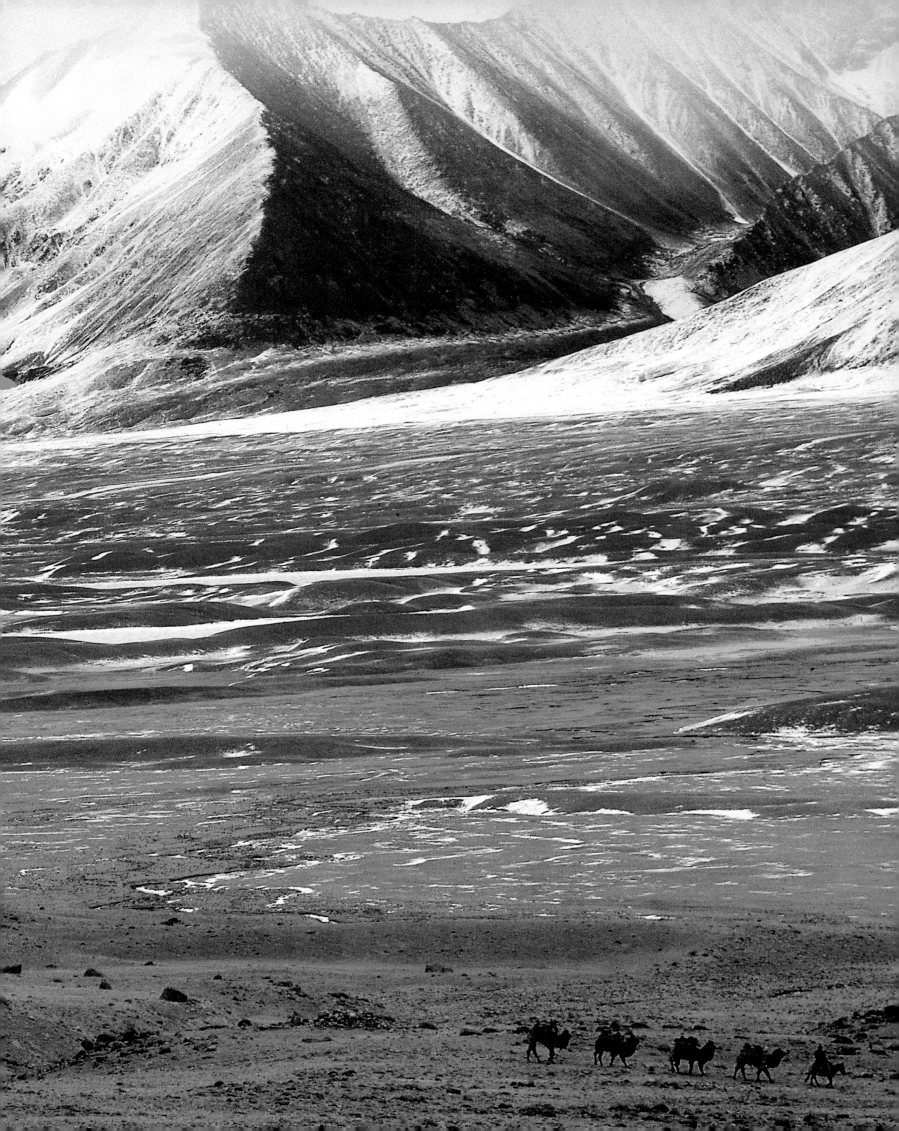

Having dreamt so long of an Orient that was both civilized and barbarous, we set out for the east in search of a mystic El Dorado. We met it in Afghanistan, this heart of Asia, or more precisely, Afghanistan revealed to us the El Dorado that is dormant in each one of us.

In these places of emptiness and space, rude and virile, we wandered to the rhythm of the seasons in the sun and wind, from gray trail to gray trail and from miserable village peopled with silence to silent village peopled with misery. During these years of peregrination, camel drivers, dervishes, and troubadours became our true companions. In their eyes, and in the eyes of the falconer and his falcon, we contemplated the reflection of the One Beauty.

Our photographs—of faces and landscapes—are intended to bear witness to this beauty, these instants of eternity snatched from fleeting time.

ROLAND AND SABRINA MICHAUD

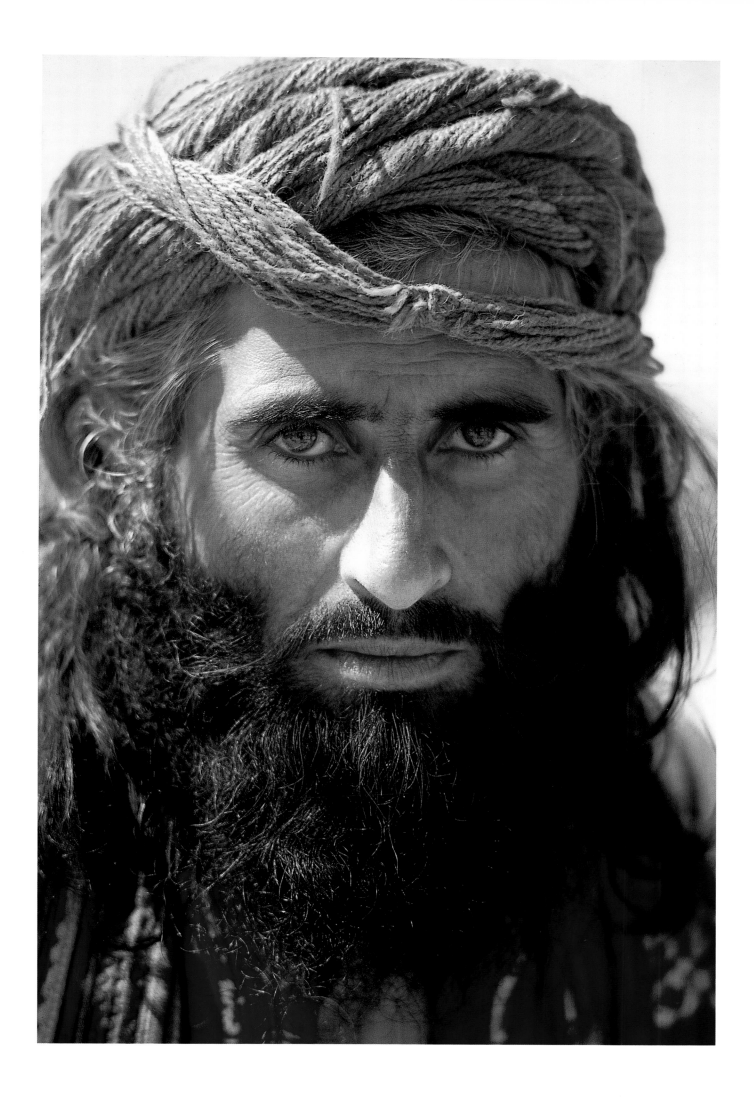

CAPTIONS

Pages 10–11

September 1964. Citadel of Herāt.
Founded by Alexander the Great in 330 B.C., the fortress has dominated the city skyline for more than twenty-three centuries. In 1416 Emperor Shāh Rokh had these walls covered with ceramic, only a few fragments of which remain today. This photograph of the citadel dates from 1964, before its last-minute rescue by UNESCO in 1975. Shorn of its protective ceramic covering, it is at the mercy of the winter rains and the sandstorms of summer.

Page 13

May 1967. Mahmad Niyaz.
This upholsterer of saddles for donkeys and horses in the Tashkurghān bazaar stops working from time to time to take a rose from his treasure box and inhale its scent with the greatest delicacy. The elderly artisan seems for a brief moment to leave the world behind.

Page 14

July 1977. Partial view of Herāt.
Photograph of one of the six minarets of the Great Mosque. Also known as the Friday Mosque, it is the city's most venerated monument; it sums up eight centuries of reigns, invasions, and revivals. In 1964 major restoration work was undertaken thanks to a special tax on sugar imposed by the city government with the people's approval. Ansari, the eleventh-century Sufi poet and philosopher and patron saint of the city, called it "noble heart," proclaiming: "The Sun is down there, and the rays here; and who has ever seen a ray separated from the Sun?" In the thirteenth century the noted historian and geographer Mustawfi Qazwini wrote:

"If anyone should ask you: Of the cities, which is the most beautiful? and if you want to answer well, tell him: Herāt! If this world is like the sea and Khorāsān is like the oyster, then the city of Herāt is its pearl."

Page 15

September 1964. Great Mosque of Herāt.
This column covered with panels of colored tiles gives some idea of the wealth of subjects depicted.

Pages 16–17

December 1964. Tomb of Mahmūd.
Ghazni was the capital of the first great Muslim kingdom founded in the tenth century on Afghan soil. Emperor Mahmūd enriched the town with the treasures pillaged in India during his successive expeditions, but now little remains of its splendor other than a citadel, two minarets, and this magnificent restored tomb. Mahmūd surrounded himself with renowned artists, poets, and scholars, including Firdawsī, author of the *Book of the Kings*; the scholar al-Bīrūnī, who translated fragments of Indian wisdom from Sanskrit; and the Sufi Sanā'ī, whose memory remains strong today.

Page 18

November 1977. Mollah in Herāt.
Blue gate at the entry to the mausoleum of Shahzadeh Abdullah. Built in the fifteenth century, this mausoleum still retains some very fine tiled panels.

Page 19

June 1967. Elegant lady in the city of Herāt.
"They shall have beauties with large black eyes, beauties like the pearls so carefully hidden" (Koran, sura LVI, verse 22).

Pages 20–21

May 1971. Teahouse set up in Herāt.
Samawat, derived from the Russian *samovar,* means a teahouse, although the Persian term *chaī khana* is also used. Both copper samovars, one of which heats water while the other is in use, work simultaneously. In magnificent porcelain bowls, patrons can drink either the warming black Indian tea or the refreshing green tea of China. Each patron receives an individual teapot. It is accompanied by either a saucer of powdered sugar or *noqqul*, which are sugar candies in the shape of blackberries, unless it is ordered without sugar. Teahouses, often furnished with carpets (shoes are removed at the door), are frequented by minstrels, storytellers, and the madmen of God, and are good places to catch up on the news.

Page 22

May 1967. Portrait of an Uzbek woman.
Sar-i-Pul, Turkistan. Inside the high earthen walls women have their domain, where they lead a harmonious life around a small garden, described this way: "By its nature it is hidden and secret." Yakub Bane sets off her light complexion not just with a blue veil but also, with a female coquettish touch, a piece of turquoise pierced in her nostril.

Page 23

May 1967. Women preparing tea.
Sar-i-Pul, Turkistan.

Pages 24–25

December 1967. Village near Sarobi.
The remarkable mimesis of houses, which merge with the mountainside, serve not just to protect the village but also to

express the sense of the ephemeral and of the humility of which every Afghan is so fully aware; aren't humans, after all, meant both to attune themselves to the earth on which they live and also to return to dust?

Page 27

February 1978. Brahui camel driver.
The Brahui are the true men of the desert of Seistan; unfazed by hardship, they withstand the greatest fatigue, the longest and most painful trips, even in the burning sun. They are masters of the sands because they alone can endure thirst and hunger without complaint.

Pages 28–29

January 1978. Ruins of Shahr-e-Gholghola. This "City of Lamentations" is hidden in the sands of the Seistan desert. To reach this fortified citadel, we had to zigzag through a labyrinth of crescent-shaped dunes, at least 90 feet (30 meters) high. Sculpted by the wind, these giant dunes seem frozen in their exuberance. Their immobility is deceptive, since they move at the rate of 6 inches (15 centimeters) a day by the force of the wind. The Turks of Central Asia, familiar with a similar phenomenon in their country, call these dunes *barkane* ("walkers"). These waves of moving sand have a great destructive power, swallowing up everything in their path.

Page 30

January 1978. Brahui woman in Registān.

Page 31

September 1978. Nomad campsite. Bādghis province, northeast of Herāt.

Page 33

January 1968. Nomad school.
This open-air school was set up among the Pashtun nomads at Khost in Paktia province.

Pages 34–35

January 1978. Village of Juwain in Seistan. These openwork screens, filled in with thorny plants, are sprayed with water in summertime so that the wind passing through them can cool the indoor temperature.

Pages 36–37

March 1973. Piper.
Kona Kala near Shor Tepe in Afghan Turkistan. The flute is a major theme in Muslim mysticism, or Sufism. The great Sufi, Jalāl ad-Dīn ar-Rūmī (Rūmī), explains in a verse:
I asked the reed,
"What do you complain of?
How can you lament although you have no tongue?"
And the flute replies:
"They have taken me away from the sugarcane
and I cannot go on living without moaning and lamenting."

Page 39

May 1967. Pashtun man in Aq Chah.

Pages 40–41

February 1978. Suburbs of Kandahār. Kandahār is the second-largest city in Afghanistan, capital of the Pashtun of the Durrani tribe, and noted for its fruits and bazaars. In the 1970s horse-drawn vehicles (*gadis*) were more common than automobiles. This *gadi* is passing through Deh Khataī, the brick-oven district.

Pages 42 and 43

October 1978. Fruit vendor in Kandahār.

Pages 44–45

September 1978. Bakers.
Wardak province. The word for "bread"—*nan*—also means "to eat." The Afghans are great consumers of bread. It is a sacred food, and no one throws away the smallest morsel. The baker's whole activity is organized around the *tandur,* the oven that will receive the flat rounds of dough that bake in just a few minutes.

Pages 46–47

May 1971. Teahouse in Chaghcharān.

Page 49

February 1978. Pashtun with green scarf. Shahr Dara, region of Kundūz.

Page 50

May 1971. Young Pashtun girl.
Qaisar, Faryab province.

Page 51

September 1978. Pashtun tent.
Darzab region, Sar-i-Pul, Turkistan. This is the brown goatskin tent, similar to those of the Bedouin of Arabia, placed like a bat on the slopes of bald hills.

Pages 52–53

September 1978. Pashtun nomad campsite. Bādghis province. Banks of the Murghab River.

Page 55

February 1968. Pashtun nomad woman. Kundūz region.

Pages 56–57

February 1968. Pashtun nomad campsite. Kundūz region. The Pashtun nomads of southeastern Afghanistan are oblivious to borders. Well-armed, they drove their innumerable flocks all the way to Pakistan. This is an artificial boundary, the Durand

Line drawn in 1896 by the British officers of the Army of India. Living on both sides of it are some twelve million Afghans, the Pashtun. Still half-divided between Afghanistan and Pakistan, these rough nomads and mountain men, of course, have never recognized this border separating them from their brothers and cousins; they continue to cross from one country into the other. All forms of nomadism are found in Afghanistan, but the country is the last domain of the great nomads, essentially Pashtun, who are proud and arrogant. Since time immemorial, two million Pashtun have practiced transhumance—seasonal grazing between the summer grasslands on the high plateaus of the Hindu Kush and their winter quarters on the river banks as far away as the Indus in Pakistan. For them, transhumance is a vital necessity. They take their orders from their herds.

Pages 58–59

January 1978. Teahouse.
Khost region in Paktīa province.

Page 60

December 1964. Portrait of a Pashtun.
Kandahār. With their henna-dyed beards and eyes made up with kohl, they have a dashing appearance but they are highly sensitive and proud of their warrior reputation.

Page 61

October 1964. Pashtun nomad woman.
Chaghcharān, Hazarajat. The women often have a wild beauty, with their fine features, mysterious tattoos, and hearty laugh.

Pages 62–63

January 1968. Wood-bearing caravan.
Paktīa province. Snowy winter among the pines: a dromedary caravan, heavily laden with wooden beams each weighing a quarter ton, struggles along mountain paths toward Pakistan. They are part of a lucrative contraband trade carried out by the Afghan Pashtun, who have little regard for boundaries.

Page 65

December 1967. Village of Kushtuz.
Nuristan. This region of about 3,000 square miles (8,000 square kilometers), cut off from the rest of the country, is carved into the sides of the mighty Hindu Kush. This is a region of wild valleys framed by peaks as high as 16,000 feet (5,000 meters) and separated by passes that are blocked by snow for four or five months of the year. Here and there, small villages perch like eagles' nests on the sheer mountain walls. Kafiristan, "country of the Infidels," was the name of this region until an Afghan emir converted its people by force in 1895 and baptized it "country of the Light," meaning the light of Islam.

Page 66

December 1967. Nuristani village.
Children sliding on the ice of a frozen stream.

Page 67

December 1977. Nuristani dwelling.
Wooden beams carved with notches serve as ladders and staircases.

Pages 68–69

December 1977. Nuristani dwelling.
Nuristan. The two characteristics of this Nuristani village are obvious at once: on the one hand, the arrangement of plantings on terraces on parcels of land irrigated by an ingenious, complex system of canals; on the other hand, the strategic choice of the village location on a landscape so rough as to make it nearly inaccessible. The flat-roofed houses, fitting snugly into one another like pieces of a Lego set, form a giant staircase on the steep face of the mountain. They stop short of the edge of the ravine overlooking the river. A wooden bridge crosses it. At that point one reaches the foot of the village, somewhat like being at the foot of a fortress.

Pages 70 and 71

December 1977. Children in a Nuristani village.
On Christmas Eve, it was snowing on the village of Saret.

Pages 72–73

December 1977. By the river.
Nuristan. In the snow, Shukur Khan takes his horse to drink at the river lined with reddish willows.

Pages 74–75

December 1977. Village of Saret.
Nuristan. Children running a race on their hands.

Page 77

December 1977. Young girls with baskets.
Afsaī, Nuristan. Returning after fetching wood, these young girls slide nimbly down the slope, despite the conical baskets held by straps. The baskets, made of goat's wool threads stretched around a wooden frame, serve to carry wood, grain, manure, or children.

Pages 78–79

December 1967. Hunter with bow.
Kamdesh, Nuristan. This is a stone bow with a double cord linked in the middle to a piece of leather.

Page 81

May 1967. Young Kabuli eating a carrot.

Pages 82–83

February 1968. Footbridge over the Kabul River.

In the background stands the Pul-e-Khesti mosque in wintertime. The Afghan flavor is provided by the kite caught in telephone wires. "The *godiparanbaz*, literally 'those playing with the dolls of the wind,' are at once artisans working in wood, paper, glue, and string before they launch their fragile craft against the sky in a show of dexterity. They use hammered glass to prepare the sharp string that will mean success or failure during the contest each Friday" (A. Velter and E. Delloye, *Les Bazars de Kaboul*, A.-M. Métaillié, publisher).

Pages 84–85

March 1968. Partial view of Kabul.
A photograph taken from Bala Hissar (High Fort). The city rolls around the Kabul River. In the area south of the Pul-e-Khesti (Brick Bridge) mosque, bazaars alternate with labyrinthine narrow streets interrupted by a great commercial avenue, Jada-e-Maiwand.

Page 86

July 1967. Syrup vendor.
Kabul. Afghanistan is renowned for its fruits, as are the syrups for which they serve as a base.

Page 87

January 1968. Street scene.
Kabul. Chahar Chata (Four Roofs), the great Kabul bazaar, was known throughout the entire East.

Pages 88–89

January 1968. Bāmiān cemetery.
In the background is the cliff of the Buddhas, where it is possible to make out, on the left, the small Buddha 115 feet

(35 meters) in height. Bāmiān, nestled in the Hindu Kush range at a height of 8,500 feet (2,600 meters), is one of the major sites in Afghanistan. Although the fanatical Taliban recently destroyed these Buddhas, the spirit lives on in the valley.

Page 91

January 1968. Great Buddha of Bāmiān.
The Buddha is 180 feet (55 meters) high.

Pages 92 and 93

December 1964. Fetching water.
Ghazni region.

Pages 94–95

December 1964. Dancers in the snow.
Ghazni region. In an otherworldly setting, a Pashtun dancer executes a frenzied dance during which he beats his face with his hair. He is accompanied by his son, who is playing a large drum called the *dhol*.

Page 97

December 1964. Fetching water.
Ghazni region.

Pages 98–99

December 1964. Portrait of a Pashtun.
Ghazni. Dark-skinned, with their shiny black hair roughly cut, strong nose, and eyes circled with kohl, they are a fiercely independent breed of men.

Pages 100–101

January 1968. Frozen waterfalls of Band-i-Amir.

Pages 102–103

October 1964. Band-i-Amir in autumn.

Pages 104–105

May 1971. Band-i-Amir in spring.

Pages 106 and 107

September 1978. Village mosque.
Nao Darra, near Qaīsar, Faryab province. Prayers in front of the exterior *mihrab*. Inside mosques, the *mihrab* is the niche indicating the direction of Mecca. Mosques and teahouses are often decorated with naive paintings representing trees and flowers.

Pages 108–109

February 1973. Irrigation canal.
Daulatabad, Balkh province. It rains very little in Turkistan, and crops and plants depend on water carried from the mountains by rivers and distributed in the fields by irrigation canals. The building and maintenance of canals is therefore crucial to the prosperity of the region. Here, all the men of the village are busy with the major spring cleaning of a canal fed by a neighboring river, which in turn is swollen from melting snow. Armed only with a bucket or shovel, each person takes part in this huge project in proportion to the quantity of water that he uses to irrigate his fields.

Pages 110–111

February 1973. Fetching water.
Qarqin region, Turkistan. When irrigated, the earth is extremely fertile. In antiquity, the Greek geographer Strabo already called the plain south of the Oxus River (now called the Amu Darya) the jewel of Afghanistan.

Page 113

February 1973. Turkoman horsemen.
Village photographed from the top of the Hazrat-e-Salé minaret, near Zadyan.

Pages 114–115

February 1971. Sowing.
Badakhshān province.

Pages 116 and 117

February 1973. Young Turkoman.
His talisman serves to ward off the
evil eye.

Pages 118–119

February 1973. Preparing for a feast.
Kara Buyn locality, Aq Chah region. On the
occasion of a circumcision, kitchens have
been set up outdoors to provide meals for
hundreds of guests.

Pages 120–121

May 1967. Donkey drivers and horsemen.
Daulatabad bazaar, Balkh province.
At any time of the year, the smallest
pedestrian or horseman on the roadway
raises a blinding cloud of dust that
insinuates itself everywhere, a powder so
fine that it even forms a spot of mud in
the teary corner of an eye.

Pages 122–123

September 1967. Pastoral.
Kundūz region. The setting sun trans-
forms the dust particles into a golden
powder.

Page 125

May 1967. Uzbek mother with child.
Sar-i-Pul, southern Shibarghān.

Pages 126–127

February 1973. Dust storm.
Main street of Andkhüi, Afghan Turkistan.
Glacial in winter, burning in summer, the
wind stirs up whirls of yellow loess, a silty
dust, the epidermis of the Asian earth.
Settlers from Iran to China used loess to
coat their villages and build their irrigation
canals. "Where there is loess and water,
there will be a peasant," a proverb affirms.
Andkhüi is the heart of Turkoman
country. It stands at a crossing of roads
linking Herāt, Balkh, and Samarkand, and

since the Middle Ages has been a major
caravan center.

Page 128

August 1967. Man in embroidered bonnet.
Kabul. Even until recently it was possible
to recognize an individual's geographic
origin from the embroidered patterns
decorating his bonnet, which varied from
one village to the next.

Page 129

March 1968. Teahouse in Mazār-i-Sharīf.

Pages 130–131

May 1971. Pastoral.
Shepherd with his herd of Astrakan sheep
in a cloud of dust in the Hazarajat region.
The terrain here is marked by small brush
grass that feeds the famous sheep with
their thick tails, the *karakul*, known to us
as Astrakan sheep.

Pages 132–133

January 1973. Turkoman yurt campsite.
Steppe south of Amu Darya River.
Amid the desert of dunes and gray sand,
threads of smoke indicate a yurt
encampment. This round tent, typical of
the Turko-Mongolian peoples from
Central Asia, consists of a collapsible
willow wood structure, on which a thick
felt layer is spread, an excellent insulator
from cold. Although it is white when new,
this tent is known in Turkish as *kara uyi*,
"black chamber," because of the color it
assumes very quickly from contact with
the smoke from the hearth. In front of
the yurt are piles of scented brush, which
serve as camel feed and also fuel for fire.
These "camel thorns," the only edible
produce of the steppe, are sold in all the
markets of the small caravan cities of
Turkistan.

Page 134

June 1967. Under a Turkoman yurt.
Andkhüi region.

Page 135

January 1973. Young Turkoman girl.
Andkhüi region.

Pages 136–137

January 1973. Bride's camel.
Kaldar region. The men have just lifted the
bride onto her camel and placed her under
her dais.

Page 138

February 1973. Turkoman wedding.
Kaldar region. These Turkoman women
are celebrating a wedding to the sound of
tambourines.

Page 139

March 1973. Turkoman bride.
Korchangu, Shibarghān region. Bibi
Ateme, a young bride of twenty-five, in
her traditional bridal costume and jewelry.
Turkoman jewelry is astonishing in its
wealth and variety. In Turkistan, women
do not wear flashy costume jewelry and
are very attached to the traditional silver
jewelry. Handed over as dowry, this jewelry
is the bride's property under Muslim law.
The average weight of the jewelry worn by a
young bride can be as great as 17½ pounds
(8 kilograms).

Pages 140–141

June 1967. Hunting with slingshot.
Alti Bulaq, near Andkhüi. These school-
children are hunting birds near a pond.

Pages 142–143

November 1978. Rug market in Kizil Ayak.
Near Shibarghān. It is Friday, the day of
the rug bazaar, when men come to sell
fabric woven by their wives and daughters.

These rugs are a major source of revenue for the fathers. For this reason they give up their daughters in marriage as late as possible, which explains the practice of kidnapping that still occurs today. As soon as they have sold a few carpets, these same fathers immediately reinvest part of their earnings in jewelry for their wives and daughters.

Page 144

May 1967. Turkoman weaver woman. Zadyan, near Balkh. The renowned Turkoman carpets, known as *bukhara*, form one of the rich resources of Turkistan. Women weave these magical fabrics, with their deep, muffled reds and their flowing streams bathed in light and shadow—a reproduction of paradise on earth, as the Koran states. These rugs are the Turkoman's furniture.

Pages 146–147

February 1968. *Bozkashi*. Samāngan. In Persian, *bozkashi* means goat catching. In this game, a troop of horsemen savagely fights over the remains of a goat—*boz*—that has been decapitated. Today, a calf is generally used. The animal is placed in the middle of a circle outlined in quicklime and called a *hallal*, or "circle of justice." The players, ranging from ten to an unlimited number of horsemen, gather around the circle, and on a signal from the chief of the *bozkashi*, jump on the decapitated animal. To score a point, a player must seize the animal and escape with it, then ride around a mast planted far off in the steppe before returning to the circle of justice to throw down the spoils.

Pages 148–149

February 1968. *Bozkashi*. Daulatabad, Balkh province. These elite horsemen are known as *chopendoz*. Their whips descend, striking without mercy, indifferently slicing nostrils and sometimes faces, leaving them with gaping wounds. They show no mercy on their horses, as can be seen from the animals' wild eyes, dilated nostrils, and foaming mouths as they neigh and rear up.

Page 151

October 1967. *Bozkashi*. Kabul. Just seconds before throwing himself into the fray, his whip at the ready, a *chopendoz* lets out his war cry—a long piercing ululation, something like that of a wolf on the hunt.

Pages 152–153

October 1964. Runaway. Kabul. A *chopendoz* has managed to free himself from the scramble, holding his precious prey tight against himself.

Pages 154–155

February 1968. *Bozkashi* scrummage. Daulatabad, Balkh province. This close shot reveals the intensity and violence of the game. The men's hoarse panting is mixed with that of the horses. The bonnets release an acrid odor of suint. The horses' robes become brighter, and any touch of crimson sets off dramatically the shades of gray, blue, mauve, or wine of the striped coats.

Pages 156–157

February 1968. A *chopendoz* quenching his thirst. Samāngan. With his face contorted, brow tightened, and sharp-eyed, a *chopendoz* avidly refreshes himself, drinking directly from a ewer, catching the water as it falls. One drop of water runs down his neck.

Pages 158–159

February 1968. *Bozkashi*. Samāngan. The *bozkashi* gives us a sense of the major role that the horse plays in the history of the people of the steppe. Any cavalry had undeniable advantages over an infantry force and was guaranteed to win a battle. This game expresses the constant, sometimes violent rivalry between the khans, or chiefs, which could be either ethnic, political, social, economic, or even personal in nature. In Central Asia a man's qualities are closely linked to those of his mount, and the khan uses the pretext of a game to affirm his superiority and prestige: possession of land or herds, generous hospitality, wisdom in behavior. A Turkoman proverb states: "To make a horse from a colt, the owner must become a dog." The horse here takes precedence over women and children.

Page 160

February 1968. *Bozkashi*. Daulatabad, Balkh province. "Better to be a poor rider on a good horse, than a good rider on a poor horse" (Turkoman proverb).
The renown of the horses of the *bozkashi* spread over the centuries from China to Italy. The Chinese considered them superior to all other breeds and called them heavenly creatures. They were worth a fortune, and only the great landholders could maintain the stables and pay the experts to raise them.

Pages 162–163

September 1964. Prayer at sunset. Bala Murghab region, Faryab province. "I declare that there is no other god but Allah…I declare that Mohammed is his Prophet." Call and recall. Five times a day, to remind man of the original pact that links him, the Servant, to his Lord. To the question: "Am I not

your Lord?," has man not answered
"yes."

Pages 164–165

January 1974. Ramparts of Balkh.
Balkh is one of the oldest cities on earth.
Zoroaster preached there. Alexander
married Princess Roxana there.
The Greek kings of Bactria ended up
converting to Buddhism there. The Arabs
translated into their language its Greek
surname, "mother of cities." One of the
greatest mystic poets of Islam, a Persian
poet, Jalāl ad-Dīn ar-Rūmī (Rūmī), was
born there in 1207 and the residents still
call him Jalāl ad-Dīn ar-Balkhi. Destroyed
in 1220 by Genghis Khan, it is an ordinary
town today, but its spirit survives.

Page 167

December 1967. Malangs.
Jalālābād. Through their presence alone,
these men testify that the universe cannot
be absurd, and that life does have meaning.
They are attuned to the cosmos, dancing
with the stars, murmuring with the stream,
gnashing their teeth with the millstone.

Pages 168–169

September 1978. Naked hillsides of
Turkistan.
The local architecture is surely inspired by
the shapes offered by nature on every side.

Page 171

January 1973. Discussion in front of the
mosque.
Balkh. This charming mosque, standing on
the tomb of a holy dervish, has kept nearly
intact its cupola, so typical of Timuride art
of Central Asia, with its exposed ribs and
its marvelous fifteenth-century tiles.

Pages 172–173

March 1968. Teahouse in Mazār-i-Sharīf.

Pages 174–175

May 1967. Musicians in Tashkurghān.

Page 177

May 1967. Shoeing a donkey in
Tashkurghān.

Pages 178–179

October 1978. Melon market.
Aq Chah. The savoriness of Afghanistan's
fruits has been sung by the poets for
twenty centuries: blackberries, almonds,
apricots, pomegranates, but above all
grapes and melons, especially the latter
known as the "sultan of fruits." You hear it
said that the skin of certain melons of
Turkistan, when they are perfectly ripe,
bursts at the mere sound of horses' hooves.
Emperor Bābur, ruling in India, sent for
melons from Kabul, their scent making
him "weep real tears." These melons
were packed in snow and enclosed in
leaden boxes.

Pages 180–181

February 1968. Caravan.
Mazār-i-Sharīf. The best-known
pilgrimage in Afghanistan is the one to
Mazār-i-Sharīf, the Noble Sepulcher
where Ali, son-in-law of the Prophet, is
said to be buried. In the courtyard and
around the mosque, thousands of
pigeons and turtledoves murmur and
fly up in a cloud of white feathers.
Tradition claims that gray birds turn
white after forty days.

Pages 182–183

May 1967. Flour market.
Tashkurghān. Weighing is an operation
demanding a whole ritual, because it
means so much. The Koran states
expressly: "And he raised up the heaven
and established the scales so that you
would not cheat on weight. Weigh fairly

and do not distort the scales" (Koran, sura
LV, verse 7).

Pages 184–185

February 1968. Caravan in Mazār-i-Sharīf.

Page 186

November 1977. Beggar.
Herāt. Traditionally, a merchant, before
feeling the need to be generous, must
have a profitable day in the bazaar, and
the beggar, in order to allow him enough
time, must refrain from his activity all
afternoon.

Page 187

February 1973. Livestock market.
Daulatabad, Balkh province. The bazaars
throughout northern Afghanistan take
place twice a week: Mondays and
Thursdays.

Pages 188–189

See pages 126–127.

Page 190

January 1973. Uzbek women in the *sandali*.
The *sandali* is an effective heating
system that consists of placing a blanket or
quilt over a small brazier.

Page 191

February 1973. Portrait of a Tajik.
Daulatabad, Balkh province.

Page 193

January 1973. Caravan driver.
Tashkurghān.

Pages 194–195

January 1973. Houses in the snow.
Tashkurghān. At the crossroads of the
ancient trails from India to Bukhara, from
Persia to Chinese Turkistan, the small town
of Tashkurghān typified the Central Asian

bazaar, the last witness of the great caravan trade of past centuries. Even recently, skins and furs were traded there for tea from Yarkand. This extraordinary place, full of harmony, charm, courtesy, and humor, symbolized the true art of living.

Page 196
May 1967. Master artisan in Tashkurghān.

Page 197
May 1967. Covered bazaar. Tashkurghān. In a subtle play of light and shadow, sunbeams penetrate through the branches and braided mats, and fall in a blue haze on the gold and silver of the ewers and samovars. Filtered light bathes the faces of merchants, draped in their *chapans*, quasi-royal robes, and wearing turbans as majestic as crowns.

Pages 198–199
May 1967. Teahouse in Aq Chah, Turkistan.

Pages 200–201
November 1978. Blacksmiths in Tashkurghān.

Pages 202–203
November 1978. Tinsmiths in Tashkurghān.

Page 205
May 1967. Blacksmith in Tashkurghān.

Pages 206–207
May 1967. Tin merchant in Tashkurghān.

Page 209
May 1967. Chukar partridge.

Pages 210, 211, 212–213
May 1967. Partridge fight in Tashkurghān. Afghanistan's partridges—*kaouk* in Persian—are captured entirely for purposes of training for battle. They are fed on wheat in winter and on almonds, apricot pits, and raisins in summer. Each owner strives to strengthen the bird's claws, wings, and beak using well-tried methods. In springtime the fights take place at dawn to avoid the heat of the sun. A large circle of devotees form the simplest of stadiums. Two referees, one for each contestant, enter the circle and set up the birds. The fighters lunge at one another and fight bravely, chopping away with their beaks while brandishing their wings. It's a real spectacle, since the partridges fight with finesse. Bets are made at the same time between the owners of birds and the spectators. Fights never result in a death.

Page 215
June 1967. Turkoman classroom. Alti Bulaq, near Andkhüi.

Pages 216–217
May 1967. Caravan in Tashkurghān.

Page 218
January 1973. Caravanner in Tashkurghān. His camel is laden with thorn branches, the only fuel in the region.

Pages 220–221
February 1968. Thorn branch market. Tashkurghān.

Pages 222–223
December 1970. Watering hole. Khorāsān. View of the watering hole with herds gathered to drink, along with a nomad camp and the ruins of a caravanserai.

Page 224
January 1971. Kirghiz fondue. The favorite dish of Kirghiz people is *qurut*, a stone-hard clotted-milk cheese, which they blend slowly with a spoon in some water, until they've made an oily paste. They add in some oil and pieces of bread.

Page 225
January 1971. Inside a Kirghiz yurt. Afghan Pamir. Caravanners warm up under the felt yurt around a fire of *argol*, dried yak dung.

Pages 226–227
January 1971. Kirghiz caravan. Afghan Pamir. After negotiating a mountain, the caravan descends back down to the frozen river.

Pages 228–229
January 1971. Caravan climbing a mountain. Afghan Pamir.

Page 231
January 1971. Kirghiz camel driver.

Pages 232–233
January 1971. Winter campsite. This campsite is at a place called Mulk Ali, 13,000 feet (4,000 meters) in altitude.

Page 235
January 1971. Pamir valley. For nine days we shared the life of a caravan of seventeen camels that, traveling on frozen rivers as tracks, set out for the winter campsite of the Kirghiz on the Roof of the World. This caravan is entirely economic in nature: the basic Kirghiz food, made up of dairy products, became insufficient in wintertime. The people set out to obtain wheat from the farmers in Wakhan, who live in the deepest valleys and barter wheat for felt and sheep.

Page 236
September 1967. Inside a Kirghiz yurt. Afghan Pamir.

Page 237

January 1971. Young Kirghiz girl. Afghan Pamir.

Pages 238–239

January 1971. On the Roof of the World. Afghan Pamir. The winter caravan continues inexorably to its final destination, the winter campsite of its chief, Rahman Qul, on the Chinese border.

Page 241

March 1968. Malang in Mazār-i-Sharīf. The malangs, as dervishes are called, had a breadth of vision that contrasted with the narrow-mindedness of certain mullahs, who strongly distrusted them. The people, on the other hand, treated the malangs with the kind of respect they paid to no other authority, not even the government.

SOURCES OF QUOTATIONS

Page 38: Nicolas Bouvier, *L'usage du monde.* © Éditions Payot, 1992.

Page 48: Joseph Kessel, *Le Jeu du roi.* © Éditions Plon, 1969.

Page 54: Cited by Sayd Bahodine Majrouh, *Le Suicide et le chant,* Poésie populaire des femmes pashtounes (translated from Pashto, adapted, and presented by André Velter and the author). © Éditions Gallimard, 1994.

Page 64: Rudyard Kipling, *The Man Who Would Be King.* © Oxford Press, 1987.

Page 80: Nicolas Bouvier, *L'usage du monde.* © Éditions Payot, 1992.

Page 90: Charles Masson, *Narrative of Various Journeys in Balochistan, Afghanistan, and the Panjab.* © Oxford Press, 1974.

Page 124: André Malraux, *Antimémoires.* © Éditions Gallimard, 1947.

Page 145: Sabrina Michaud, *Caravanes de Tartarie.* © Éditions du Chêne, 1977.

Page 150: Joseph Kessel, *Le Jeu du roi.* © Éditions Plon, 1969.

Page 161: Sabrina Michaud, *Les Cavaliers.* © Éditions Nathan.

Page 166: Ansari, *Cris du cœur* (translated from Persian by Serge de Laugier de Beaurecueil). © Éditions Sindbad, 1988.

Page 204: André Velter, *L'Arbre-Seul.* © Éditions Gallimard, 1990.

Page 208: René Dollot, *L'Afghanistan.* © Éditions Payot, 1937.

Page 219: Eva de Vitray-Meyerovitch, *Roûmî et le soufisme.* © Éditions du Seuil, 1977.

Page 230: André Malraux, *Antimémoires.* © Éditions Gallimard, 1947.

Page 234: Roland and Sabrina Michaud, *Caravanes de Tartarie.* © Éditions du Chêne, 1977.

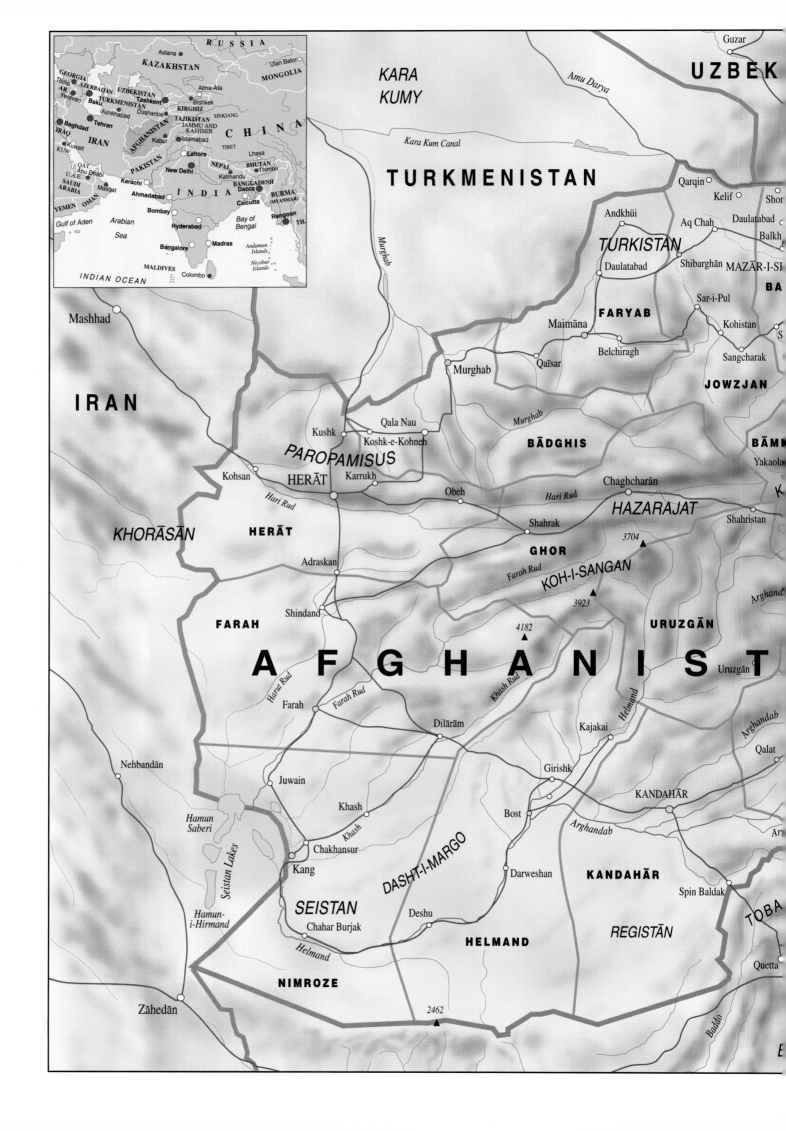

RUSSIA

Guzar

UZBEK

Amu Darya

KAZAKHSTAN

Astana •

Ulan Bator •

MONGOLIA

KARA
KUMY

GEORGIA
Tbilisi • **AZERBAIJAN**
AR. • **UZBEKISTAN** Tashkent
Yerevan • Baku • **TURKMENISTAN**
Ashkhabad • Dushanbe **KIRGHIZ** Bishkek •
Baghdad Tehran • **TAJIKISTAN** SINKIANG
IRAQ • Kuwait **AFGHANISTAN** **JAMMU AND** **C H I N A**
QAT. Kabul • Islamabad **KASHMIR**
Abu Dhabi **PAKISTAN** Lahore • TIBET Lhasa •
U.A.E. New Delhi • **NEPAL** **BHUTAN** Thimbu
SAUDI Karachi • Katmandu • **BHUTAN**
ARABIA Masqat • **BANGLADESH**
Ahmadabad • Dacca • **BURMA**
YEMEN OMAN Bombay • **(MYANMAR)**
Gulf of Aden *Arabian* Hyderabad • Calcutta •
Sea *Bay of* Rangoon • TH.
Bangalore • Madras • *Bengal* *Andaman*
MALDIVES *Islands*
Nicobar
INDIAN OCEAN Colombo • *Islands*

Kara Kum Canal

TURKMENISTAN

Qarqin •
Kelif • Shor
Andkhüi • Aq Chah Daulatabad
Balkh

TURKISTĀN Shibarghān MAZĀR-I-SH
Daulatabad • BA

Maimāna • Sar-i-Pul
FARYAB Kohistan
Belchiragh •
Qaïsar • Sangcharak

Murghab • *Murghab* **JOWZJAN**

IRAN

Mashhad •

Murghab

Kushk • Qala Nau **BĀDGHIS**
Koshk-e-Kohneh
PAROPAMISUS Chaghcharān BĀMK
Kohsan • **HERĀT** Karrukh Obeh *Hari Rud* Yakaola
Hari Rud **HAZARAJAT**
Shahristan •
KHORĀSĀN Shahrak • 3704 ▲
HERĀT **GHOR** **KOH-I-SANGAN**
Adraskan • *Farah Rud* 3923 ▲ **URUZGĀN**

4182
Shindand • ▲
FARAH Uruzgān •
A F G H Â N I S T

Harut Rud *Khash Rud* *Helmand*
Farah • *Farah Rud* *Arghand*
Dilārām • Kajakai •
Nehbandān • Qalat •
Juwain • Girishk • *Arghandab*
KANDAHĀR
Khash • *Arghandab*
Hamun Bost • Ar
Saberi *Khash*
Chakhansur • Darweshan • **KANDAHĀR**
Kang • **DASHT-I-MARGO** Spin Baldak •
Hamun- **SEISTAN** Deshu • **REGISTĀN** **TOBA**
i-Hirmand Chahar Burjak •
Helmand **HELMAND**
NIMROZE Quetta •

Zāhedān • 2462 ▲

Seistan Lakes

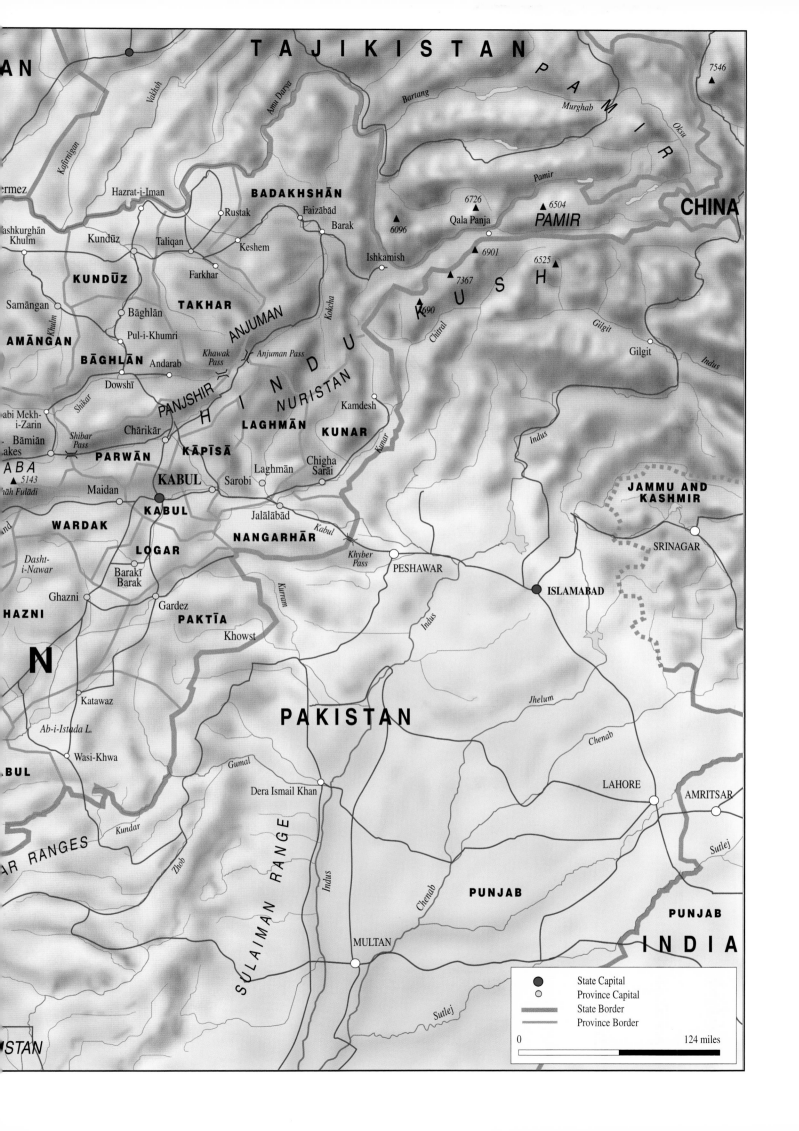

TAJIKISTAN

CHINA

Vakhsh

Amu Darya

Bartang

Murghab

Oksu

▲ 7546

P
A
M
I
R

Pamir

6726 ▲

▲ 6504

Kafirnigan

ermez

Hazrat-i-Iman

BADAKHSHĀN

Rustak

Faizābād

Barak

Qala Panja

PAMIR

ashkurghān
Khulm

Kundūz

Taliqan

Keshem

6096 ▲

Ishkamish

▲ 6901

6525 ▲

KUNDŪZ

Farkhar

▲ 7367

H

Gilgit

Samāngan

Bāghlān

TAKHAR

A
N
J
U
M
A
N

Kokcha

K

U

S

Chitral

6690 ▲

S

H

AMĀNGAN

Pul-i-Khumri

Khulm

BĀGHLĀN

Andarab

*Khawak
Pass*

Anjuman Pass

P
A
N
J
S
H
I
R

H
I
N
D
U

Gilgit

Indus

Dowshī

NURISTAN

abi Mekh
i-Zarin

Shikar

Kamdesh

*Shibar
Pass*

Chārikār

LAGHMĀN

KUNAR

Kunar

Bāmiān
akes

PARWĀN

KĀPĪSĀ

Laghmān

Chigha
Sarāi

Indus

▲ 5143

āh Fulādi

ABA

Maidan

KABUL

Sarobi

JAMMU AND
KASHMIR

KABUL

Jalālābād

Kabul

SRINAGAR

WARDAK

LOGAR

NANGARHĀR

*Dasht-
i-Nawar*

Barakī
Barak

*Khyber
Pass*

PESHAWAR

Ghazni

Gardez

Kurram

ISLAMABAD

HAZNI

PAKTĪA

Khowst

Indus

N

Jhelum

Katawaz

Ab-i-Istuda L.

Chenab

LAHORE

Wasi-Khwa

Gumal

AMRITSAR

BUL

Kundar

Dera Ismail Khan

Sutlej

PAKISTAN

5

AR RANGES

S
U
L
A
I
M
A
N

R
A
N
G
E

Zhob

Indus

Chenab

PUNJAB

PUNJAB

ISTAN

MULTAN

INDIA

Sutlej

●	State Capital
○	Province Capital
▬▬	State Border
▬▬	Province Border

0 124 miles

Roland and Sabrina Michaud
regret that they cannot thank by name
all those who in one way or another
helped them in their Afghan adventures.
Travel is only worthwhile through personal encounters,
and our journeys were remarkably rich.
To our Afghan friends and everyone else,
our heartfelt thanks.

Translation from the French by Lenora Ammon and David J. Baker
Project Manager, English-language edition: Susan Richmond
Jacket design, English-language edition: Judy Hudson
Design Coordinator, English-language edition: Tina Thompson

Library of Congress Cataloging-in-Publication Data

Michaud, Roland.
 Afghanistan : / Roland and Sabrina Michaud.
 p. cm.
 ISBN 0-8109-3490-6
 1. Afghanistan—Pictorial works. I. Michaud, Sabrina. II. Title.
 DS352 .M528 2002
 958.1—dc21

 2002005745

Printed and bound in France
10 9 8 7 6 5 4 3 2 1

Harry N. Abrams, Inc.
100 Fifth Avenue
New York, N.Y. 10011
www.abramsbooks.com

Abrams is a subsidiary of

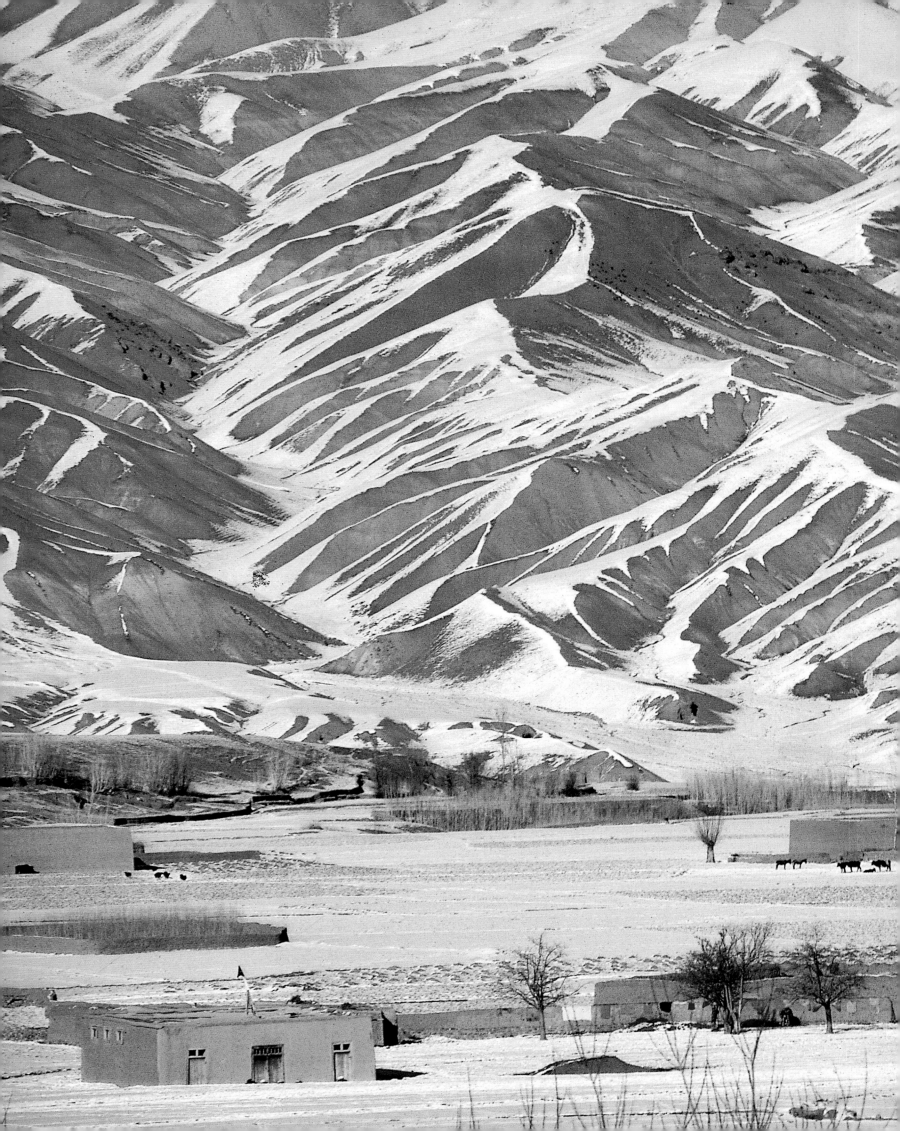